Art, Technology, Consciousness
mind@large

Edited by
Roy Ascott

intellect™
Bristol, UK
Portland, OR, USA

First Published in Hardback in 2000 in Great Britain by
Intellect Books, PO Box 862, Bristol BS99 1DE, UK

First Published in USA in 2000 by
Intellect Books, ISBS, 5804 N.E. Hassalo St, Portland, Oregon 97213-3644, USA

Consulting Editor: Masoud Yazdani
Copy Editor: Peter Young

A catalogue record for this book is available from the British Library

ISBN 1-84150-041-0

Printed and bound in Great Britain by Cromwell Press, Wiltshire

Acknowledgements

There are many individuals to thank for their help in bringing this book into being. In addition to the authors themselves, my colleagues and students in CAiiA-STAR, the editorial support team at ACES, and the staff of Intellect, thanks are due to Professor Ken Overshott, Principal of the University of Wales College Newport, for his continuing support.

Contents

Location 129

Mind Theory 155

Preface

The articles in this book are written by artists and scientists presenting papers at the Third International CAiiA-STAR Research Conference, *Consciousness Reframed*, at the University of Wales College, Newport (UWCN) in August 2000.

The work of CAiiA-STAR <caiia-star.net> embodies artistic and theoretical research in new media and telematics, including aspects of artificial life, telepresence, immersive VR, robotics, technoetics, non linear narrative, ubiquitous computing, performance, computer music, and intelligent architecture, involving a wide range of technological systems, interfaces, and material structures. As such it can be seen as a microcosm of a widely based and complex field which is developing internationally. While this means that a great diversity of issues are addressed, it is possible to discern a common thread in the emergent discourse of this field. This commonality of ideas embraces a radical rethinking of the nature of consciousness, awareness, cognition and perception, with mind as both the subject and the object of art.

As in our previous book, *Reframing Consciousness*, the approaches represented here are multidisciplinary and multicultural, offering many dynamic, compelling and provocative strategies, imaginative projects and creative lines of inquiry. Their purpose is to identify key questions rather than to provide definitive answers, to pursue creative implications rather than prescriptive explanations.

Within a technological context, the book addresses contemporary theories of consciousness, subjective experience, the creation of meaning and emotion, the modalities of the senses, and relationships between cognition and location. Its focus is both on and beyond the digital culture, seeking to embrace the world of neurons and molecules, and to assimilate new ideas emanating from the physical sciences. At the same time spiritual aspects of human experience are considered along with the artistic implications of non-ordinary states of awareness.

For additional information on the authors, please consult the Intellect website <www.intellectbooks.com>, and the last page of this book for their email details.

Roy Ascott
Director – CAiiA-STAR

Beyond Boundaries

Edge-Life: technoetic structures and moist media

Roy Ascott

Life @ the edge of the Net

Just as the development of interactive media in the last century transformed the world of print and broadcasting, and replaced the cult of the objet d'art with a process-based culture, so at the start of this century we see a further artistic shift, as silicon and pixels merge with molecules and matter. And just as broadcast radio, TV and the interactivity of the Net changed entirely the way we lived at the end of the 20th century, so now in daily life, our habits, attitudes and ambitions are undergoing a further transformation. We can call this Edge-Life since we are re-defining completely our identity, our social structures, and our picture of the world, here at the edge of the Net where the virtual flows seamlessly into the actual, the transient into the fixed, and the metaphysical into the material.

Between the dry world of virtuality and the wet world of biology lies a moist domain, a new interspace of potentiality and promise. I want to suggest that Moistmedia (comprising bits, atoms, neurons, and genes) will constitute the substrate of the art of our new century, a transformative art concerned with the construction of a fluid reality. This will mean the spread of intelligence to every part of the built environment coupled with recognition of the intelligence that lies within every part of the living planet. This burgeoning awareness is technoetic: techne and gnosis combined into a new knowledge of the world, a connective mind that is spawning new realities and new definitions of life and human identity. This mind will in turn seek new forms of embodiment and of articulation.

At the same time, as we seek to enable intelligence to flow into every part of our manmade environment, we recognise that Nature is no longer to be thought of as 'over there', to be viewed in the middle distance, benign or threatening as contingency dictates. It is no longer to be seen as victim ecology, fragile or fractious, according to our mode of mistreatment. Technology is providing us with the tools and insights to see more deeply into its richness and fecundity, and above all to recognise its sentience, and to understand how intelligence, indeed, consciousness, pervades its every living part. The mind of Gaia, set in de Chardin's noosphere, is becoming amplified and perhaps transformed by the technoetic effects of human connectivity, ubiquitous computing and other far-reaching consequences of the Net.

But, as multimedia gives way to moistmedia, and interactive art takes on a more psychoactive complexion, consciousness remains the great mysterium, just as intelligent artificial life remains the great challenge. For some years now artists working at the edge of the Net have been exploring the nature of consciousness and the potential of artificial life,

> MOIST MIND
>
> Is technoetic multiconsciousness
>
> is where dry pixels and wet molecules converge
>
> is digitally dry, biologically wet, and spiritually numinous
>
> combines Virtual Reality with Vegetal Reality
>
> comprises bits, atoms, neurons, and genes
>
> Is interactive and psychoactive
>
> embraces digital identity and biological being
>
> erodes the boundary between hardware and wetware
>
> is tele-biotic, neuro-constructive, nano-robotic
>
> is where engineering embraces ontology
>
> Is bio-telematic and psi-bernetic
>
> is at the edge of the Net

assisting effectively in the emergence of Edge-life. Compared to the art of previous eras, their work is inevitably more constructive than expressive and more connective than discrete; and considerably more complex both semantically and technologically. Within this complexity, I foresee the insertion of a new but very ancient technology – that of the psychoactive plant – such that a kind of cyberbotany may arise around the instrumentality of such plants as ayahuasca (banisteriopsis caapi), the shamanic liana. It is my contention that Vegetal Reality and Virtual Reality will combine to create a new ontology, just as our notions of outer space and inner space will coalesce into another order of cosmography.

My project ayahuascatec.net is designed to explore this field. It seeks to link telematically and telepathically a number of ayahuasceros, employing their double consciousness to navigate both psychic space and cyberspace, with spiritual guides who traditionally can be expected to arrive as helpers bringing wisdom and knowledge to those in advanced use of the psychoactive brew. This builds on my initial project to share ideas of navigation in cyberspace and psychic space with the Kuikuru indians during my visit to the Mato Grosso in 1997, and on my experience with the ayahuasca in the ritual of Santo Daime (Ascott, 1999). The aim is to bring these disembodied entities into communication with human users and their artificial agents in the Net, thereby creating a kind of a psi-bernetic system, in which experience of our everyday world and the wisdom of the other can interact in a kind of feedback loop.

Cyberbotany, once established and integrated into 21st century culture, as I believe will eventually be the case, would cover a wide spectrum of activity and investigation into, on the one hand, the properties and potential of artificial life forms within the cyber and nano ecologies, and, on the other, the technoetic dimensions and psychoactive effects of banisteriopsis caapi and other such vegetal products of nature. Cyberbotany could indeed become the determinative factor in the shaping of Edge-life with the technoetic shaping of mind involving vegetal technology every bit as much as digital technology. The moist ecology will bear truly exotic technoetic fruit. Terence McKenna's observation is wisely pertinent:

Our future lies in the mind; our weary planet's only hope of survival is that we find ourselves in the mind and make of it a friend that can reunite us with the earth while simultaneously carrying us to the stars. Change, more radical by magnitudes than anything which has gone before, looms immediately ahead. Shamans have kept the gnosis of the accessibility of the Other for millennia; now it is global knowledge. The consequences of this situation have only begun to unfold. (McKenna, 1992)

Constructive Language and Visionary Pragmatism

The key to understanding this new state of being is language: the understanding that language is not merely a device for communicating ideas about the world but rather a tool for bringing the world into existence. Art is of course language, and as such can be a form of world building, of mind construction, of self-creation, whether through digital programming, genetic code, articulation of the body, imaging, simulation or visual construction. Art is the search for new language, new metaphors, new ways of constructing reality, and for the means of re-defining ourselves. It is language embodied in forms and behaviours, texts and structures. When it is embodied in Moistmedia, it is language involving all the senses, going perhaps beyond the senses, calling both on our newly evolved cyberception and our re-discovered psi-perception. Just as we may transfigure natural forms so they will become more transparent at the level of process and production. Moistmedia is transformative media; Moist systems are the agencies of change. The Moist environment, located at the convergence of the digital, biological and spiritual, is essentially a dynamic environment, involving artificial and human intelligence in non-linear processes of emergence, construction and transformation. Language not only enables us to understand nature, to communicate with nature, but to become partners in a process of co-evolution which will give us the responsibility to redefine nature. Nature II will actually provide the context for our developing Edge-life, but it will also enable us to return to the archaic relationship with the invisible processes and patterns of living systems, reading the secret language of both flora and fauna.

Through the languages it creates, art serves to reframe consciousness. Simply to re-iterate received language, uncreatively and uncritically, is to renounce the idea that we can rethink ourselves and our world, and to accede to the notion that in matters of reality our minds are made up for us. In Richard Rorty's (1989) words: 'To create one's mind is to create one's own language, rather than to let the length of one's mind be set by language other human beings have left behind.' Rorty is a philosopher who challenges the very category in which the world would place him. His pragmatism eschews the sanctity of philosophy in favour of the artist's visionary impulse and search for metaphor that leads to the continual construction of reality and of the self, thereby denying the passive acceptance of any canonical description. Similarly, many artists escape the constraints of artistic identity by straying freely in the speculative zones of science and technology, mysticism and philosophy. Breaking free of categories, intellectually and emotionally, and creating new realities, new language, new practices is what art is about.

When the visionary impulse is combined with pragmatism of the kind that Rorty espouses, we have a description of what it is that artists do, or seek to achieve, and have done throughout cultural time. This visionary pragmatism, as I shall call it, is about flying

with your feet on the ground. It's about working with the future in the present. It is living life acausally but not casually. Visionary Pragmatism defines the technoetic endeavour of our era: mind operating on the substrate of moistmedia. At its most efficacious, it combines, within the artistic domain, the perennial wisdom of shamans and gnostics with contemporary insights of scientists, engineers and philosophers. Visionary pragmatism finds in Moistmedia its creative ally, with its triad of computational exactitude, biological fluidity, and technoetic complexity. Visionary pragmatism is an attribute to be fostered in all aspiring artists. It is a quality least understood but most in need of support. Visionary pragmatism is guided by the need to bring dreams to earth. In the case of the digital culture, it has led to what is known as ubiquitous computing, where intelligence spreads throughout the network, and into every facet of the environment, into every product, every tool, every system. At the same time, it is visionary pragmatism that is pushing the consequences of a screen-based, immaterial world into the re-materialisation of culture involving molecules and atoms, nano-technology and neurons. It can corner the nihilism and despair of late post-modernism and springs forth into the post-biological culture with a radical constructivism. It's a case of 'bye-bye Baudrillard', and signals a reversal of the sense of terminal decline that characterised art at the end of the millennium.

The Building of Sentience

Architecture provides a useful focus to visionary pragmatism since the term resonates in a number of pertinent contexts: building with hardware and with code, terrestrially and in cyberspace; intelligent environments; and nano-construction at both biological and industrial levels. While Euclidean space appeals primarily to the physical body, cyberspace appeals primarily to the mind. The body loves surfaces, solidity, resistance; it wants its world to be limitless but safely ordered, open to the clouds but protected from indeterminacy. Above all, the body wants its senses put in perspective. In 20th century architecture, the body ruled. But in our new century, architecture progressively will embody mind; technoetics will be at the foundation of practice. The mind seeks connectivity and complexity, uncertainty and chaos. It knows reality to be layered and ambiguous, constantly collapsing and reforming, observer-dependent, endlessly in flux. In reflecting these attributes, 21st century architecture will be like nothing the world has ever known. Distributed Mind, Collective Intelligence, Cybermentation, Connected Consciousness, whatever we choose to call the technoetic consequences of the Net, the forms of telematic embodiment likely to emerge will be as exotic to our present conception of architecture, as they will be protean. Stylistic and functional diversity will increase exponentially as the practical consequences of nano-engineering kick in. In turn, our frustration with the limitations of our own bodies will demand prostheses and genetic intervention of a high order.

We realise that the body, like our own identity, can be transformed, indeed must become transformable. The many selves hypothesis, like the many worlds hypothesis of physics, is not only compelling but also necessary to life and liberty in the Moist culture. Increasingly, the attitude of the mind towards the body is post-biological. Its view is cybernetic, seeking always the perfectibility of systems. The hypercortex, mind in the Net, needs shelter. Human bodies and artificial agents need common habitats. At the point where cyberspace and post-biological life meet, an entirely new kind of social architecture is required. A truly

anticipatory architecture must prepare itself for this marriage of cyberspace with Moistmedia, combining self-assembling structures and self-aware systems.

As the century advances, the paradigmatic change in architecture will be registered at the level of behaviour rather than form. To give just one simple example: the 20th century's exaggerated interest in what a building looks like, its mere appearance, will give way to a concern with the quality of its gaze, how it sees us, how it perceives our needs. Questions of the physical structure of buildings will be overshadowed by ambitions for their dynamism and intelligence, their ability to interact with each other and with us, to communicate, learn and evolve within the larger ecology. Engineering will embrace ontology. Time will become more dominant than space, system more significant than structure. Seeding, as I have argued earlier (Ascott, 1995), will become at least as important as designing, and design will be a bottom-up process, seeking always short-term evolutionary gains. The goal will be the building of sentience, a Moist architecture that has a life of its own, that thinks for itself, feeds itself, takes care of itself, repairs itself, plans its future, copes with adversity. It will be a technoetic architecture that is as much emotional as instrumental, as intuitive as ordered. We shall want to get inside the mind of such architecture and an architecture that can get into our own mind, such that our neural networks can be synaptic with the artificial neural networks of the planet. If the building of sentience is the challenge to architecture in the 21st century, the emergence of a Moistmedia will be the manifestation of its radical restructuring.

The artist's role at the larger planetary level of self-organising, self-aware systems, will be to plant, grow and cultivate new forms, new structures and new meanings. The notion of cyberbotany extends from the wise application of plant technology, in the technoetic context, to the creative employment of horticultural metaphor in envisioning outcomes at the material level of construction. In developing the hyperculture the artist can learn from horticulture; the creative challenge being to create a Moist synthesis of artificial and natural systems. Visionary pragmatism can guide the artist's participation in building worlds that we would want to live in. Visionary pragmatism can take the love inherent in the telematic embrace and create new relationships, new societies, and new culture. Just as art in the next hundred years will be not only interactive, but also psychoactive and proactive, so human affairs will benefit from closer connectivity, distributed intelligence, and spiritual solidarity. As the unfolding years of this new century will show, the media best employed to effect these changes will be Moistmedia, the networks that sustain them will be technoetic, and the cyberception of the planetary society as a whole will reflect a growing sense of optimism and telenoia.

References

Ascott, R. 1995. The Architecture of Cyberception. In Toy, M. (Ed) *Architects in Cyberspace*. London Academy Editions, pp. 38–41

Ascott, R. 1999. Seeing Double: Art and Technology of Transcendence. In Ascott, R (Ed) *Reframing Consciousness*. Exeter, Intellect Books, pp. 66–71.

McKenna, T. 1992. *Food of the Gods*. New York, Bantam Books, pp. 263–4.

Rorty, R. 1989. *Contingency, Irony and Solidarity*. Cambridge University Press.

Towards a Third Culture | Being in Between

Victoria Vesna

Practice must always be founded on sound theory.

Leonardo Da Vinci (Kleine, 1977, pp. 157–158)

Artists working with cutting edge technologies are frequently well informed and inspired by the exciting innovations and discoveries taking place in science. We are keenly interested in what the cultural critics and commentators from the humanities have to say on the meaning and impact these discoveries and innovations have on culture and society. Scientists can relate and understand our work easier primarily because we use the same tools – computers. Because our work and tools are in constant flux, we are forced to articulate the reasoning and meaning informing the art produced, which has traditionally been the role of art critics and historians. This creates room for an active dialogue with both humanists and scientists. Thus we are placed in between these Two Cultures, which creates a triangle between art, science and the humanities that points to a potential emergence of a Third Culture. Being 'in between' is a privileged and dangerous position, at least in this transitional stage. Therefore it is important to take a look at the background and current status of these Two Cultures.

The Ghost of C. P. Snow persists

Much of the discussion concerning the triangle of art, science, and technology can be traced back to C. P. Snow's famous annual Rede lecture at Cambridge on May 7th, 1959. The phrase 'Two Cultures' entered into a cultural controversy and debate that has endured remarkably long. The title of Lord Snow's lecture was 'The Two Cultures and the Scientific Revolution'. He identified the two cultures as the literary intellectuals and the natural sciences, and pointed to the curricula of schools and universities as the source of the problem. In the introduction to Snow's book, Stephan Collini gives a historical perspective to this divide by locating its beginning in the Romantic Period, at the end of the eighteenth and beginning of the nineteenth centuries. (Snow, 1964, p. xii) He traces the British genealogy of 'Two Cultures' anxiety in the linguistic peculiarity by which the term 'science' came to be used in a narrowed sense to refer to just the 'physical' or 'natural' sciences.

The compilers of the *Oxford English Dictionary* recognised that this was a fairly recent development, with no example given before the 1860s: 'We shall ... use the word "science" in the sense which the Englishmen so commonly give it; as expressing physical and experimental science, to the exclusion of theological and metaphysical.' (Snow, 1964 p. xi) William Whewell, a philosopher and historian of science who used 'science' in his Philosophy of the Inductive Sciences of 1840, is credited with establishing this term. The first time it was recorded as an idea, however, was at the Association for the Advanced Science in the early 1830s when it was proposed as an analogy to the term 'artist'. Yet, the

two cultures refer to the divide between the literary humanities and frequently exclude what was originally the analogy to science – art.

The idea of 'Two Cultures' was a great source of fame for Snow in the 1960s. He received twenty honorary degrees in the course of the decade and, following the Labour Party's election in October 1964, accepted Harold Wilson's invitation to become the second-in-command at the newly established Ministry of Technology, becoming the government spokesman on Technology in the House of Lords. From 1966 until his death in 1980, Snow travelled the world as a lecturer, adviser, and public sage.

In the second edition of *The Two Cultures*, in 1963, Snow added a new essay, 'The Two Cultures: A Second Look'. In that essay he suggested that a new 'Third Culture' would emerge and close the gap between literary intellectuals and scientists. (Snow, 1963, p. 53) It is significant to note that Snow originally named his lecture 'The Rich and the Poor' and intended this to be the centre of his argument: 'Before I wrote the lecture I thought of calling it "The Rich and the Poor", and I rather wish I hadn't changed my mind.' (Snow, 1964, p. 79) He remained dissatisfied with the Two Culture concept and had on several occasions tried to refine the claim. In his last public statement he makes clear that the larger global and economic issues remain central and urgent: 'Peace. Food. No more people than the Earth can take. That is the cause.' (Snow, 1968, p. 220)

Art, Science and Technology: Building the Triangular Bridge

> Scientist-artists originally conceived and designed bridges. The power-structure-behind-the-king, seeing great exploitability of the bridge for their own advantaging, accredited workers and materials to build bridges. (Fuller, 1981, p. 27)

But it seems that there is still much work to be done in building the bridge between the humanities and the sciences. John Brockman, editor of a book of essays entitled The Third Culture, negates Snow's optimistic prediction that a day will come when literary intellectuals will communicate effectively with scientists. Instead he makes the claim that the contemporary scientists are the third culture and alludes that there is no need for trying to establish communication between scientists and literary intellectuals, who he calls the 'middlemen'. (Brockman, 1995, p. 18) Although the choice of people in his book is significant, [1] the mere fact that it is comprised almost completely of Western white men, with the exception of Lynn Margolis with her essay *Gaia is a tough Bitch* makes it impossible to take his proposition seriously. But it does point to the continuing gap between the humanities and sciences and clearly shows that the bridge being constructed is still very fragile.

It is a delicate mission to be in between disciplines that are themselves in a tenuous relationship. Perhaps the greatest danger is for artists to look to the literary, philosophical, and theoretical circles for interpretations of scientific data and then further reinterpret their versions without checking back with the scientists. Much postmodern writing borders on linguistic play with mathematics and scientific terminology that serves to alienate the scientific community, which has used precise methods to arrive at those theories. This is not to say that one should blindly accept all products of the scientific community, but simply to suggest that any working relationship needs to be based on mutual respect and dialogue.

The other danger that faces those 'in between' working on creating 'something else' is the general attitude of theory being above practice, prevalent in both humanities and sciences. At this stage, it is in the practice of art that the freedom lies to make assertions that are beyond the rational and beyond necessary methodology of proving a thesis. Practice informed by theory, utilising a methodology which makes it accessible to both worlds, is the key. Or, conversely, theory informed by practice.

Currently, much of this bridge-building work takes place in universities for more reason than one. First, at this point, with no market in place, it is impossible to make a living outside of academia and industry. Between the two, academia is generally friendlier to someone searching for a yet-to-be-defined path than industry, with its pressures to produce. Second, academia is a natural environment in which one can have access to good bandwidth and updated equipment. Third, and perhaps most important, academia allows artists contact with scholars from many disciplines. In order to function and communicate effectively in this context, one must learn the etiquette and language of various disciplines. The challenge, then, is to do this without losing the intuitive 'wild' aspect, the practice, that taps into the silent, the unknown, the mysterious.

Our work depends largely on an active dialogue with scientists and humanists while performing an important function of being bridge builders. And as any engineer knows, we have to know the territory on both sides and be very precise in how we negotiate the space 'in between'. Negotiating the gap between the canon of rationality and the fluid poetic is ultimately the goal of artists who work with communication technologies.

Reacting against 'Something Else'

Transgressing disciplinary boundaries... [is] a subversive undertaking since it is likely to violate the sanctuaries of accepted ways of perceiving. Among the most fortified boundaries have been those between the natural sciences and the humanities. (Greenberg, 1990)

Contemporary art practice, particularly utilising digital technology, is loaded with references to science, and this trend has taken root in cultural theory as well. In fact, an entire new field has been formed in the humanities: 'Science Studies'. One would think that this would allow for better communication between the sciences and humanities, but in general this does not appear to be the case at the present time. Some of the work coming out of science philosophy and theoreticians commenting on the scientific process has infuriated some scientists and actually deepened the gap of the 'Two Cultures'.

In 1996 Alan Sokal published an article in the American cultural-studies journal *Social Text*, a parody article entitled 'Transgressing the Boundaries: Toward a Transformative Hermeneutics of Quantum Gravity'. The article is crammed with 'non-sensical quotations about physics and mathematics' by prominent French and American intellectuals such as Lyotard, Derrida, Irigaray, and Lacan. The text is full of references to scientists such as Heisenberg, Kuhn, Bohr, Harding, Bell, and Gödel and is indeed as difficult to read as any postmodern theory text can be. The references cited are all real, and all quotes are rigorously accurate; however, having been taken out of their cultural contexts and reframed, they do assume questionable meanings. According to Sokal it was meant as an experiment to test whether the bold assertion claiming that physical reality is at the bottom of social and linguistic construct (without evidence or argument) would raise eyebrows

among the editors. It did not. The editors trusted that the information in the essay, written by established scientists, would be an honest contribution and did not read carefully the erroneous information in the text. The debates sparked by Sokal's hoax have come to encompass a wide range of tenuously related issues concerning not only the conceptual status of scientific knowledge or the merits of French post-structuralism, but also the social role of science and technology, multiculturalism, and 'political correctness', the academic left versus the academic right, and the cultural left versus the economic left.

The text was followed by an entire book, *Intellectual Impostors,* which Sokal co-wrote with Jean Bricmont. In the book they exhibit incredible zeal and thoroughness in their effort to de-mystify these very famous authors. Perhaps the most impressive aspect of this hoax article turned into event and book is how much rigour the thesis delivered. One wonders if they actually had to put aside their own scientific research to write this book, which would indicate that this is much more than a hoax but something they felt was very important to deliver to the scientific community and the public at large. There is no question that the authors have done their homework and that their work has had a definite impact on The Two Cultures. Some of the fallout is positive in that it brought to surface and activated a dialogue that was simmering under the surface. The negative aspects are that the dialogue was coloured by controversy and was mostly argumentative, thus endangering the very fragile bridge between the humanities and sciences. Why was Sokal not flattered that science has a such a strong influence on contemporary philosophers, as Einstein was when he read Fuller's interpretation of the Theory of Relativity? We do get a clue that there is more at stake in *Final Theory* by Steven Weinberg:

> These radical critics of science seem to be having little or no effect on scientists themselves. I do not know of any working scientist who takes them seriously. The danger they present to science comes from their possible influence on those who have not shared in the work of science but on whom we depend, especially those in charge of funding science and on new generation of scientists. (Weinberg, 1992)

The philosophers Sokal and Bricmont attack are those working in theory of psychoanalysis, semiotics, or sociology and whose work is subject to innumerable analysis, seminars, and doctoral theses. It is important to note that there are no authors mentioned who are principally literary or poetic. Sokal and Bricmont do make a valid point when saying that the scientific terminology and fact were rather abused and consequently serving as a way to spread false information to the readers. Sokal assembled a list of quotations that showed this kind of handling of the natural sciences and circulated it to his scientific colleagues whose reaction were 'a mixture of hilarity and dismay. They could hardly believe that anyone – much less renowned intellectuals – could write such nonsense.' When the texts were shown to non-scientists, they needed to explain in lay terms why the said passages were 'meaningless'. One can only imagine the reaction of scientists when they read a quote from Lacan, who refers to the structure of the neutronic subject as exactly the torus (it is no less a reality itself) (p. 19); or from a passage by Kristeva, who states that poetic language can be theorised in terms of the cardinality of the continuum (p. 38); or Baudrillard, who writes that modern war takes place in non-Euclidean space (p. 137).

Using the Poetic License as a Tool

> No doubt the first act of the calculus consists of 'depotetentialisation' of the equation (for example, instead of $2ax - x2 = y2$ we have $dy/dx = (a - x/yu)$. However, the analogue may be found in the two preceding figures where the disappearance of quantum and the quantitas was the condition for the appearance of the element of quantitability. . . . (Deleuze, 1994, pp. 174-5) (Sokal p. 213)

What is important to note however, is that Sokal and Bricmont are much more tolerant with use of scientific terminology in context of art or science fiction:

> If a poet uses the words like 'black hole' or 'degree of freedom' out of context and without really understanding their scientific meaning, it doesn't bother us. Likewise, if a science fiction writer uses secret passageways in space-time in order to send her characters back to the era of the Crusades, it is purely a question of taste whether one likes or dislikes the technique. (Sokal, 1997, p. 8)

Clearly this points to a semi-favourable position for artists in relation to the sciences, particularly those working with technology. What complicates matters, however, is that many artists are inspired and interpret the very philosophers that are under attack from the scientific community [2]. What Sokal and Bricmont fail to notice is that absolutely all the authors mentioned in their book have become staple philosophers for artists working with media, particularly Deleuze and Guattari, to whom they dedicate an entire chapter analysing their misuse of scientific and mathematical terms. One could argue that Deleuze and Guattari utilise these scientific and mathematical terms in a distinctly metaphorical or philosophical senses, which would explain their vague or tenuous relationship to 'hard' scientific fact. This argument is lost, however, when one points to direct quotes and references out of a book on the theory of differential equations that uses terms such as 'singularity' and 'singular point' in a distinctly technical and mathematical sense. The terms are then used in their literal senses without any distinguishing between their use as such rather than in a metaphorical context, nor is there offered an explanation of how we might understand the relationship between literality and figuratation as such. (Sokal, 1997, p. 216) (Deleuze,1990, pp. 50, 54, 339–40n)

Sharing the Language: Collaboration

Perhaps the source of the communication problem can be traced to the fact that most of the philosophers under attack in the scientific community do not work closely with scientists and that scientists are equally isolated from the movements of philosophical thought and contemporary artistic expression. As long as the work does not have a reason to be located in a few disciplines simultaneously, room for misunderstandings will be ample. The work of artists working with technology demands interaction with scholars from a wide variety of disciplines such as computer science, social studies, philosophy, cultural studies. Bridging and synthesising many worlds while composing 'something else' becomes the art.

Notes

1. Representatives of the Third Culture according to Brockman are William C. Williams; Stephen Jay Gould; Richard Dawkins; Brian Goodwin; Stev Jones; Niles Eldredge; Lynn Margulis; Marvin Minsky; Roger Schank; Daniel C. Dennet, Nicholas Humphrey; Francisco Varela; Steven Pinker; Roger Penrose; Martin Rees; Alan Guth; Lee Smolin; Paul Davies; Murray Gell-Mann; Stuart Kauffmann; Christopher G. Langton; J. Doyne Farmer; W. Daniel Hillis. He first published a brief essay on the idea of the emerging third culture in September, 1991 in his journal, the Edge. Now online, he continues to promote this idea: www.edge.org/3rd_culture

2. See list of conferences that have been organised around discussions of the work of Deleuze and Guattari; lists.village.http://virginia.edu:80/~spoons/d-g_html/d-g.html For artists inspired by science: see Wellcome Trust's SCI~ART initiative, 1998 and Art and Science Collaborations, Inc. : www.asci.org

References

Baudrillard, Jean, 1995. *The Gulf War Did Not take Place*. Translated and with introduction by Paul Patton. Bloomington: Indiana University Press.

Bricmont, J. 1995. *Science of chaos or chaos of science?* Physicalia Magazine 17.3-4. Available online as publication UCL-IPT-96-03 www.fyma.ucl.ac.be/reche/1996/1996.html

Bricmont, J. and Sokal, A. 1997. *Intellectual Imposters; Postmodern Philosophers' Abuse of Science*. London: Profile Books.

Brockman, J. 1995. *The Third Culture: Beyond the Scientific Revolution*. New York: Simon and Schuster.

Deleuze, Gilles, 1994. *Difference and Repetition*. Translated by Paul Patton. New York: Columbia University Press.

Greenberg, Valerie D. 1990. *Transgressive Readings: the Texts of Franz Kafka and Max Planck*. Ann Arbor: University of Michigan Press.

Horgan, John, 1996. *The End of Science. Facing the Limits of Knowledge in the Twilight of the Scientific Age*.

Sokal, A. 1996. *Transgressing the Boundaries: Towards A Transformative Hermeneutics of Quantum Gravity. Social Text* 46/47 (Spring/summer).

Smart, B. 1993. *Postmodernity: Key Ideas*. New York: Routledge.

Snow, C. P. 1959. *Two Cultures*. Cambridge: Cambridge Up.

Weinberg, S. 1992. *Dreams of A Final Theory*. New York: Pantheon.

The Posthuman Conception of Consciousness: A 10-point Guide

Robert Pepperell

It is clear that we are now experiencing social, technical and economic change at an historically unprecedented rate. Elsewhere I have described how I perceive the consequent shift in understanding as the *Posthuman Condition* (Pepperell 1995). There are several things that distinguish the Humanist era we are leaving from the Posthumanist era we are entering. Humanists, for example, regarded Homo sapiens as the highest point of evolution.

We are now aware that machines, bio-machines or genetically altered organisms with different, or superior, characteristics may supersede humans as we currently know them (Moravec 1988). One of the major concerns of posthuman theory is the way we might now think about consciousness, especially given the possibility that intelligence could emerge in non-human substrates. Whilst consciousness is inevitably a subject of considerable complexity and abstraction, I nevertheless believe it is possible to say some useful things about it. Here then are ten ideas that, collectively, outline the posthuman conception of consciousness.

1. *Consciousness is not restricted to the brain.* Virtually all researchers, philosophers and psychologists I have encountered in the field of consciousness studies assume that consciousness occurs in the brain (e.g. Searle 1984). Whilst I don't deny that the structure and operation of the brain plays a significant part in creating conscious activity, it cannot do it on its own. The reasons are simple and obvious – separate the body from the brain and consciousness ceases. No-one has yet demonstrated that a brain can think without being attached to the body. The belief that it can exist independently is often expounded in the 'brain in a vat' fallacy. This proposes that an isolated brain, artificially fed the same impulses as an in situ brain, would be conscious in the same way as the in situ brain. The proposition is false because it is not the brain in itself that is conscious, but the whole system of which it is a part. *Consciousness is the function of an organism, not an organ.*

2. *The human body is not separate from its environment.* Since the boundary between the world and ourselves consists of permeable membranes that allow energy and matter to flow in and out, there can be no definite point at which our bodies begin or end. Humans are identifiable, but not definable. Things around us, like food, air, light, smells and sounds are absorbed into our system, become part of us and are expelled. How can we define precisely what it, or isn't, part of us. The notion that each of us is a discrete entity can be called the 'boxed body' fallacy. This assumes that the human body has a fixed delimitation; the mind resides inside the brain, inside the walls of the box whilst the reality upon which mind reflects lies outside. The box is perforated to allow sensations to flow in and waste to flow out. According to this model, each side of the box is discrete and retains its own identity. Philosophers then argue about the relationship between the two sides: Can one really know what's outside the box from the limited data we receive? If not, where does that data come from, etc? All such questions are avoided if we simply accept the continuity between body and environment – dispense with the box! *Nothing can be external to a human because the extent of a human cannot be fixed.*

3. *Consciousness, body and environment are all continuous.* It follows from the previous two points that there is a continuity between the 'thinking being', the tissues in which the thoughts are manifest, and the world in which those thoughts and tissues exist. Just as the brain needs the body to create conscious activity, so the body needs the environment to create conscious activity. A body without an environment, like a brain without a body, ceases to function – consciousness stops. Not only does this mean that the environment is connected directly to our consciousness through the body, it also means that consciousness is connected directly to the environment. Ultimately they cannot be

separated. By a process of simple reasoning, using orthodox scientific facts, we have demonstrated that the phenomenon of consciousness is distributed throughout reality and not localised in the brain, or in part of the brain. Such a position is consistent with systems of thought that previously evolved outside Western Europe, namely Buddhism, Hinduism and Taoism. Although there are many differing strands within each tradition, there is a common acceptance of the continuity between mind, body and world and a consequence belief that consciousness pervades all reality (Watts, 1950).

4. *Consciousness emerges from specific conditions.* Imagine a kettle used to boil water. It consists of a vessel to contain the water, a heating element, electrical energy, a certain atmospheric pressure, gravity and the water itself. If you put all these things together in the right way you can, within a few minutes, produce the effect known as 'boiling'. But where is 'boiling'? It cannot be specified, isolated or confined to any part of that system. Boiling is a property that emerges from a specific set of conditions. The same is true of consciousness. Given the right combination of genes, tissues, nutrients, chemicals and environmental conditions the property we know as 'consciousness' emerges. We cannot precisely define what this quality is, where it occurs or how it might look in isolation from those conditions – *it is a consequence of all those conditions.* As with the kettle, if you remove any of the constituents the emergent quality evaporates.

5. *Everything is energy.* It would be consistent with what is understood about reality at the sub-atomic level to say that the smallest 'particles' known are actually fields of energy rather than 'solid' material (Davies & Gribbin, 1991). Therefore, it is plausible to think of everything in the known Universe as energy in various states of manifestation and transformation. Again, such a view would be in harmony with the world-view of those Eastern traditions already mentioned as well as some early Greek thinkers such as Heraclitus and Thales. The appearance of solid matter around us is a consequence of the way our perceptual apparatus apprehends the forms that energy takes – rocks, plants, sea, stars, etc. The illusion of separation between things results from a combination of:
 - The various manifestations and transformations of energy and,
 - The ways in which our sensory apparatus respond to the manifestations and transformations of energy.

6. *No things exist as separate things in themselves.* Although we are apparently surrounded by an infinite number of objects, shapes, colours, smells and sounds it is a mistake to believe that they are each intrinsically distinct from each other, a notion that many physicists accept (Bohm, 1980). It is clear that we are sensitive to certain structures or differences and become aware of them as 'things' in as much as they display difference from other 'things' around them. This does not mean that they are 'in-themselves' different, only that we perceive them to be so. For, although they may *appear* as separate, we construe such separations for our own convenience. In other words, the distinctions are arbitrary and contingent: *arbitrary* because, on close examination, the boundaries are always fuzzy; and *contingent* because, depending on context or viewing position, the boundaries can move. Because we divide the world up into things in our own minds, we then impose those divisions onto the world, as though they were always there. Then we say, 'We've discovered something!'

7. *Language divides us.* Humans have evolved a massively complex and sophisticated verbal facility. It passes to each successive generation, acquired by individuals mainly during the first five years of their development. Language operates by a process of fragmentation. That is, it conceptually breaks the world up into different 'things', each of which it refers to with discrete words. Thus, we tend to see the world in the way that we describe it, as a fragmented collection of 'things' rather than as a continuous whole. Perhaps the most significant distinction that language reinforces is the fragmentation between oneself and the rest of the world, thereby giving rise to the 'I' or Self by which one is distinguished from everything else.

8. *Language is not all of reality, but part of it.* The distinctions we make between things in the world, including the one between ourselves and the world, are illusory in as much as they arise through language. Nevertheless, they are still part of the reality we experience and are powerfully persuasive in creating the nature of that experience. The distinctions are real, inasmuch as they produce what we consciously experience, but they do not constitute, or account for, the whole of reality. Many philosophers (Plato, Kant, Hegel and Schopenhauer for example) have made the distinction between 'knowable' and 'unknowable' reality. In Kantian (and Phenomenological) terminology the distinction is made between the *phenomenon* (knowable to the senses) and the noumenon (unknowable to the senses). The posthuman conception of consciousness, by contrast, does not accept that such a distinction has any intrinsic value, except in as much as it is a product of fragmented human thought. For the posthuman, all of reality includes our thoughts about reality which are part of a continuous *phenoumenon*.

9. *Consciousness is the sum of all the distinctions we make through language.* The phenomenon we normally describe as 'consciousness', that is the everyday awareness of Self through which we verbally articulate our presence in the world, emerges through linguistic evolution. The sum of accumulated distinctions we impose upon reality generates a complex web of oppositions that we can endlessly recombine orally, imaginatively, poetically, artistically, and so on. This is what distinguishes human (linguistic) consciousness from other types, e.g. that of animals. There are certainly other types of awareness of existence that bypass or transcend this fragmented, linguistic kind. They are referred to by a variety of names – preconscious, unconscious, Samadhi, dreaming, intuition, instinct, and are mainly distinguished from everyday consciousness by their lack of verbal expression. It is through these types of non-verbal awareness we are able to 'know' aspects of reality that elude literal articulation and, hence, how we repair the rupture between 'knowable' and 'unknowable' reality. There are a number of techniques that can be employed to evoke these alternative states of conscious being and transcend the fragmented linguistic consciousness. Examples are hypnosis, ritual, relaxation, drugs, mediation and koans (Cleary, 1989).

10. *Culture is a way of defragmenting consciousness.* Although the human language facility is a very powerful tool for understanding and controlling aspects of reality, it does produce a distorted view of the world. As we have said, that view is necessarily *fragmentary*. The problem with a fragmented view is that it gives rise to all sorts of contradictions, oppositions, isolations and conflicts that we then try to resolve by re-uniting the fragments – a process we could call *defragmentation*. Having experienced the relative bliss

of an un-fragmented consciousness before birth and the acquisition of language, it might be that we wish to return to that ideal, defragmented state which is sometimes called 'Pure Existence' (Sekida, 1985). This is a state free from the anxieties and contradictions that linguistic consciousness produces. In addition to transcending fragmented consciousness through techniques already mentioned above, we have evolved ways of *defragmenting* it. This means drawing together connections between differing concepts and perceptions of reality to create a more unified experience of it – to create a sense of order. Examples would include instances of art, music, cinema, poetry, literature, mathematics and philosophy. Using devices of narrative, representation, temporal structuring, metaphor, logic and pattern each of these cultural forms presents disparate facts of existence as conceptually continuous. These practices can all be regarded as attempts to wrest a more coherent, unified discourse about reality from the confusion of fragmented consciousness.

Conclusion

The posthuman conception of consciousness resists the division and separation of reality into fragments of the kind often generated through Humanist approaches to modelling reality. Whilst we struggle to adopt this way of thinking at the beginning of the 21st Century we are reminded of the relevance, simplicity and coherence of much older thought systems that could provide guidance. Despite the power of language to 'divide and conquer' reality we are often left confused and alienated about our position in the world because of the inherently fragmented state of linguistic consciousness. Various cultural practices provide us with temporary release from this anxiety either by drawing connections between disparate fragments, or by transcending fragmented consciousness entirely.

References

Bohm, D. 1980. *Wholeness and the Implicate Order*. London: Ark, 1983, p.176.

Cleary, T. 1989. tr. Zen Essence: *The Science of Freedom*. Boston: Shambhala, p.79.

Davies, P. & Gribbin, J. 1991. *The Matter Myth, Beyond Chaos and Complexity*. London: Viking.

Moravec, H. 1988. *Mind Children: The Future of Robot and Human Intelligence*. Cambridge: Harvard University Press.

Pepperell, R. 1995. *The Posthuman Condition*. Oxford: Intellect.

Searle, J. 1984. *Minds, Brains and Science*. London: Penguin, 1991, p.18.

Sekida, K. 1985. *Zen Training, Methods and Philosophy*. New York: Weatherhill, p.160.

Watts, A. 1950. *Tao, The Watercourse Way*. London: Penguin, 1975, p.107.

Robert Pepperell is an artist and writer who currently lectures in the School of Art, Media and Design at University College Wales, Newport.

Genesis: a transgenic artwork

Eduardo Kac

'Genesis' (1998/99) is a transgenic artwork that explores the intricate relationship between biology, belief systems, information technology, dialogical interaction, ethics, and the Internet. It was commissioned by Ars Electronica 99 and presented online and at the O.K. Center for Contemporary Art, Linz, from September 4 to 19, 1999. The key element of the work is an 'artist's gene', i.e. a synthetic gene that I invented and that does not exist in nature. This gene was created by translating a sentence from the biblical book of Genesis into Morse Code, and converting the Morse Code into DNA base pairs according to a conversion principle specially developed for this work. The sentence reads: 'Let man have dominion over the fish of the sea, and over the fowl of the air, and over every living thing that moves upon the earth.' This sentence was chosen for its implications regarding the dubious notion of (divinely sanctioned) humanity's supremacy over nature. Morse Code was chosen because, as first employed in radiotelegraphy, it represents the dawn of the information age – the genesis of global communications.

The initial process in this work was the cloning of the synthetic gene into plasmids and their subsequent transformation into bacteria. A new protein molecule was produced by the gene. Two kinds of bacteria were employed in the work: bacteria that incorporated a plasmid containing ECFP (Enhanced Cyan Fluorescent Protein) and bacteria that incorporated a plasmid containing EYFP (Enhanced Yellow Fluorescent Protein). ECFP and EYFP are GFP (Green Fluorescent Protein) mutants with altered spectral properties. The ECFP bacteria contained the synthetic gene, while the EYFP bacteria did not. These fluorescent bacteria emit cyan and yellow light when exposed to UV radiation (302 nm). As they grow in number mutations naturally occur in the plasmids. As they make contact with each other plasmid conjugal transfer takes place and one starts to see color combinations, possibly giving rise to green bacteria. Transgenic bacterial communication evolved as a combination of three visible scenarios: (1) ECFP bacteria donated their plasmid to EYFP bacteria (and vice-versa), generating green bacteria; (2) no donation took place (individual colors were preserved); (3) bacteria lost their plasmid altogether (became pale, ochre colored).

The strain of bacteria employed in Genesis is JM101. Normal mutation in this strain occurs 1 in 10^6 base pairs. Along the mutation process, the precise information originally encoded in the ECFP bacteria was altered. The mutation of the synthetic gene occurred as a result of three factors: (1) the natural bacterial multiplication process; (2) bacterial dialogical interaction; (3) human-activated UV radiation. The selected bacteria are safe to use in public and were displayed in the gallery with the UV source in a protective transparent enclosure.

The gallery display enabled local as well as remote (Web) participants to monitor the evolution of the work. This display consisted of a Petri dish with the bacteria, a flexible microvideo camera, a UV light box, and a microscope illuminator. This set was connected to a video projector and two networked computers. One computer worked as a Web server (streaming live video and audio) and handled remote requests for UV activation. The other

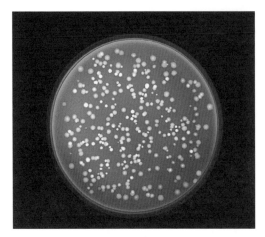

Genesis, 1998/99. Eduardo Kac

computer was responsible for DNA music synthesis. The local video projection showed a larger-than-life image of the bacterial division and interaction seen through the microvideo camera. Remote participants on the Web interfered with the process by turning the UV light on. The fluorescent protein in the bacteria responded to the UV light by emitting visible light (cyan and yellow). The energy impact of the UV light on the bacteria was such that it disrupted the DNA sequence in the plasmid, accelerating the mutation rate. The left and right walls contained large-scale texts applied directly on the wall: the sentence extracted from the book of Genesis (right) and the Genesis gene (left).

Dr. Charles Strom, Director of Medical Genetics, Illinois Masonic Medical Center, in Chicago, provided genetic consultation, and original DNA-synthesized music was composed by Peter Gena. Using the sequence of the Genesis gene, the music was generated live in the gallery and streamed on the Web. The parameters of this multi-channel composition were derived from bacterial multiplication and mutation algorithms. Timbral changes were made to the sequences (the genesis gene, the cyan plasmid, and the yellow plasmid) when the website user switched on the UV light below the bacteria. In addition, as participants controlled the light from the website, the tempo of the sequence gradually speeded up to a maximum, then worked its way down again. In other words, parallel to the real biological mutation taking place in the bacteria, the music constantly changed in real time as a consequence of web participation in the work.

In the nineteenth century the comparison made by Champollion based on the three languages of the Rosetta Stone (Greek, demotic script, hieroglyphs) was the key to understanding the past. Today the triple system of Genesis (natural language, DNA, binary logic) is the key to understanding the future. 'Genesis' explores the notion that biological

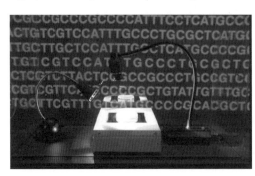

Genesis, 1998/99. Eduardo Kac

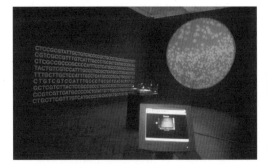

Genesis, 1998/99. Eduardo Kac

processes are now writterly and programmable, as well as capable of storing and processing data in ways not unlike digital computers. Further investigating this notion, at the end of the show the altered biblical sentence was decoded and read back in plain English, offering insights into the process of transgenic interbacterial communication: 'LET AAN HAVE DOMINION OVER THE FISH OF THE SEA AND OVER THE FOWL OF THE AIR AND OVER EVERY LIVING THING THAT IOVES UA EON THE EARTH'. In addition to the noise introduced to parts of the text, the processing of information by the mutating bacteria replaced MAN with AAN (which suggests a female name) and added the word EON (which means 'an indefinitely long period of time' in English) before THE EARTH. The boundaries between carbon-based life and digital data are becoming as fragile as a cell membrane.

Eduardo Kac is an Assistant Professor of Art and Technology at the School of the Art Institute of Chicago.

Techno-Darwinism: artificial selection in the electronic age

Bill Hill

Techno-Darwinism symbolizes a dramatic shift in the evolutionary process of the human species, in the world in which it inhabits and reaches beyond the future of its own concept. As the tool making species increases its reliance upon its own constructs, many residual effects work to alter its progress. And thus the structure of Darwinian evolution transforms into a new construct. Throughout time there is and arguably always will be a universal struggle for existence, but in today's technological society the factors which dictate survival has shifted. Darwinian evolution exists of two distinct theories of development: Natural and Artificial selection. The basis for natural selection put forth by Charles Darwin, states that 'through competition for limited resources only the fittest will survive and through the extension of this competition, generations of a species will transform or adapt itself with those qualities' Jones (1952). By the simplest of genetic distortion, the 'fittest' will survive longer, enabling them to reproduce more often and hence contribute more of their genetic character to the species as a whole. Today, however, due to the increased reliance upon electronic technology and biomechanical engineering, the gene pool itself is shifting. The traits once considered to be assets for survival are now obstacles. As technology further augments the 'natural' with the artificial the more the 'weaker' traits of the species will prevail, further perpetuating the reliance upon the artificial for increased productivity. The tools the human species makes in turn make them. So the notion of a 'natural selection' process touted by Darwin and his followers seems to be increasing transforming itself into an artificial process driven by a social collective which seeks survival through technology.

The distinct between the natural and artificial process seems to be one mainly of consciousness or intent. The most common analogy used to explain artificial selection is

animal breeding. If a collective agrees a certain quality such as long noses are a desirable quality for a specific breed, then only those animals with long noses will be bred and over a period of time the short nose gene will become extinct within the species. This type of genetic alteration is currently occurring within the human species' gene pool, however the quality which propels this shift is technology itself. Those who cannot exist or reproduce naturally are now, through the advent of technological means, living longer and reproducing more. The natural genes which enabled their dependency upon technology is being passed through generations in an increasing abundance fostering a deeper reliance upon the artificial.

Biomechanical technology seeks to alter the physical body through artificial selection. From the advent of external limbs though the recent developments of genetic engineering, a progressive restructuring of the physical body is occurring. Almost all cultures, both past and present, practice some form of body modification. The oldest human remains found to date, the five thousand year old mummified body of a man frozen in the ice of what is now the Italian Alps, had tattoos. However palatable the current trends of body modifications are, the future offers more exaggerated displacements of the current body image, encouraging a deeper rift between the natural and artificial.

'Black Lung', a recent kinetic sculpture, responds directly to this technological restructuring of the body. This piece consist of a compressor and a motor driven valve system which allows the artifice to simulate a working lung in the human body. Additionally, a motion detector is added to the compressor to emphasis the need for social approval in order for the machinery to successfully augment the body. This motion detector is hooked solely to the compressor so that without the reinforcement of an audience (the masses) the machinery continues to control the physical body but grinds away unproductively. The single lung expands and contracts inside a human rib cage, pointing to the simplification of the current biological system. The entire work is mounted to the exterior of a steel box, a sign of the industrial revolution. The body becomes the skin of the machine.

As an artist I am concerned with the impact technology has over our collective development and how it further embeds itself inside of us. The notion of socially directed body modification dates back thousands of years. The Greek 'super-anatomical' sculptures helped to invent the ideal form, the 19th century development of moving pictures illustrated the behavior and movement of that form, but it wasn't until the technological development of 'X-Rays' that the real notion of the body changed. Today, through physical examination and reliance upon machines, we can communicate directly with the body. What the patient knows is untrustworthy; what the machine knows is reliable, and those machines are shifting the evolutionary development of our species.

Technology is not just a tool. It is information, in that it shapes how we think and, in the absence of an alternate reality (i.e. nature), what we think about and know. Where evolution was once an interactive process between human beings and a natural, unmediated world, evolution is now an interaction between human beings and our own artifacts.

Cognitive psychologists agree that some sensory-motor activities can be learned to the point they become automatic. As more and more of our time is spent within the artificial

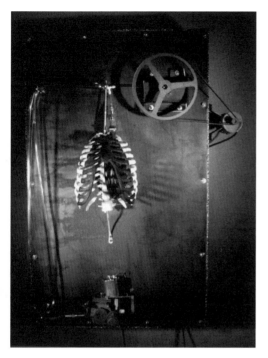

Black Lung

environment of the computer we will begin to synchronize our movement and function with that of the virtual system. We speed up and slow down with the pulse of the computer. There is an increased tendency with graphical user interface design to be transparent; to aid in the human interaction with the computer; to coalesce the human thought and the digital function; for this interaction to feel more natural and ensure the control of the machine. Much like the amputee which remaps his muscular networks to control the prosthesis. However, here the technology is controlling us.

'Preprogramming' exists as an interactive installation where the viewers/participants are taught to remap linguistical symbols into letters, words, and meanings. The installation consists of a physical apparatus and a virtual interactive interface. The physical apparatus is made of a steel construction and stands 3 feet tall. Each of the cryptic buttons correspond to a letter of the english alphabet. The interactive interface resembles the structure of a hangman game, where the user must select the appropriate letters before the figure is fully rendered in the gallows. The user actively consumes electronic technology while revealing the fabrication of electronically published information. By pressing buttons on the apparatus a corresponding letter is revealed on the projected interface. The user must decipher the keypad and decode the electronic information.

Electronic technology not only invades and alters the physical body through the use of genetic modifications and the displacement of physiological components with prosthesis of all kinds, but more fundamentally the machines are reforming the cognitive processes of the conscious and subconscious mind. As the computer becomes more integrated with the developing human mind, and as it provides

E-Examination

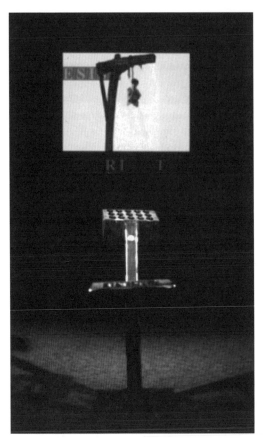

Pre-Programming

the interface with knowledge, it shapes not only our understanding of the world around us but our understanding of ourselves. However, humans must first be trained to understand things in a certain specific way before they can extract information from the artificial stimulus. We, therefore, are becoming more and more a hybrid of the machines we use. 'Preprogramming' points directly to this conscious willingness for our species to adapt to the modes of the machine – to allow the machine to control the way we process information, communicate with other, and understand ourselves.

According to Donna Haraway in her Cyborg Manifesto, 'Late twentieth-century machines have made thoroughly ambiguous the difference between the natural and the artificial, mind and body, self-developing and externally designed.... Our Machines are disturbingly lively, and we ourselves frighteningly inert.' Haraway (1991) Nowhere is this more evident than in the simulated environments of recent network games, like Doom and Quake. Here combatants are immersed in a kind of remotely exhilarating tele-action. They take on virtual identities and navigate virtual worlds. After a period of time users come to imagine themselves in the terms of the mechanical or cybernetic qualities that are designed into the computers. The operator behaves as a virtual cyborg in the real-time, man-machine interface.

What profoundly impacts me is the ease at which many can remap their physical and mental functions to blend with the machine. Moving beyond the conscious usage of the instrument towards a subconscious amalgamation with the electronic impulses. A fundamental shift occurs in the evolutionary status of the species as the mind binds at this level. Jean Baudrillard, in Simulacra and Simulation, addresses just such a shift. 'Whoever fakes an illness can simply stay in bed and make everyone believe he is ill. Whoever simulates and illness produces in himself some of the symptoms.' Baudrillard (1994) His focus is more on the simulation – the artificial, mine is more on the effect – the illness. As the artificial invades the body, specifically the mind and alters the way we process information on the conscious and subconscious level it begins to take control of us.

By using Classical Conditioning, the installation 'Apparatus 3957' acts a biomechanical device to alter the human reaction toward electronic technology. As a kinetic installation,

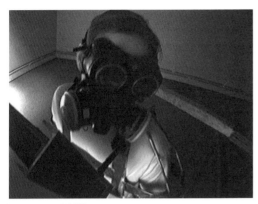

Apparatus 3957

Apparatus 3957 consists of a motor driven device which controls the movement of a human specimen, and a body apparatus containing a LCD panel, which limits the movement of the specimen.

A person is locked into the apparatus with their arms positioned at their sides and the LCD panel positioned directly in front of their vision. This apparatus is then locked to the motor driven wheel which forces the person to move in one direction. During this performance the LCD panel displays the functions of an operating system in a continuously, monotonous fashion.

In theory, the human specimen will be conditioned by the machine to become physically nauseous when confronted with a computer's operating system. By hooking the specimen into the apparatus and locking them into a circular motion, forced upon them by the machine; their body will produce a physical reaction associated with the visual and audio stimulus. Over a period of controlled interaction the body and mind becomes subconsciously conditioned to respond/behave in specific way. The result is one of conflict; an aversion to the user's computer is generated within the user. The specimen has an innate conscious desire to interact with the technology while subconsciously the body resists.

The innate desire inside of 'Apparatus 3957' is built upon the principle foundations of Darwinian evolution; the desire to survive. As our species seeks to survive it adapts to its environment, it clings to the qualities suited best for survival. But at what point do we give up what makes us human? At what point are humans no longer evolving but being cannibalized by a new organism? At what point does our fusion with technology displace us? The concern of Techno-Darwinism is the mutation of the artificial into the natural. As evolution propels us forward we may not merely be adapting but instead becoming displaced.

References

Baudrillard, J. 1994. *Simulacra and Simulation*. Ann Arbor: The University of Michigan Press, p. 3

Haraway, D. 1991. *Simians, Cyborgs, and Women: The Reinvention of Nature*. London: Free Association, p.152

Jones, W. T. 1952. *Kant and the Nineteenth Century*. San Diego: Harcourt Brace Jovanovich, pp. 192,198

Not Science, or History: post digital biological art and a distant cousin

Michael Punt

The increasing technical complexity of art practice as artists explore the interface between biology and computers has brought together practitioners from quite different epistemological fields. Scientist, technologists and artists are frequent collaborators on ambitious large scale projects which at first glance suggests a developing continuity between previously demarcated territories. Such proximity might suggest that we are moving towards a more convergent and consensual understanding of the world, especially as global communications and the availability of massive databases have eroded the physical and professional boundaries between distinct world views. This chapter argues that despite the apparent convergence of art and science, bio-electronic art which deals with artificial life and genetic engineering should be understood as making a significant critical intervention in contemporary debates about the progress of both science and history.

In *Hen's Teeth and Horse's Toes*, Stephen Jay Gould revisits one of the perplexing questions that the creation myth forces us to grapple with – Adam's navel. He reminds us that since the first man was not born of woman there was no need for him to carry the scar of the umbilical chord. If Adam was the model on which all men would be based then it would seem proper that he should carry this mark, however it has to be asked if a divine maker would deliberately lie by giving the illusion of a history which did not exist. For some people, this argument represents a premier example of reason at its most ridiculous. Nonetheless many painters of the Fall covered their bets and elided the issue of Adam's belly button by simply extending the fortuitous vine that covered his genitals to include the smaller but far more controversial area at his waistline. At stake in Adam's navel was the vexed question of whether we evolved or were made in a day by some greater force.

The nineteenth century naturalist Phillip Henry Gosse, an ardent creationist, used his careful field study to point out that this false history, inscribed in the umbilical scar and the fossil record, was necessary for the smooth operation on nature and part of God's great plan. If the first man was created fully formed say in sexual maturity without any trace of a past – the navel for example – then what followed would be a creature with a lesser status which might be unaware of the creator's beneficence. To fully complete the illusion of historical continuity, Gosse argued, a fossil record also had to be laid down for us to discover when our 'science' had developed sufficiently. The fact that it was a false history did not make it any the less worth studying even if it was not the direct cause of the world we experience because it was nonetheless the empirical evidence of the processes of nature.

Gosse's idea is seductive to us now if only for its sheer surrealist dottiness, but before we dismiss it we might want to ponder what is at stake in this apparently medieval and esoteric debate, and what relevance it may have today. For Stephen Jay Gould the very peculiarity of Gosse's vehement support for the idea that the creator laid down a history at the time of

creation may better help us understand the way that science and logic proceed. In brief: if logic can support the idea that the fossil record was laid down in what might be called a prochronic period as a false record, then perhaps the things that logic can tell us and the things that science can tell us are not always similar. Moreover Gould claims that Gosse's idea of a prochronic period is useless since it is totally untestable and the world will look exactly the same were we able to prove that strata were laid down all at once or by an extended process. Science is not a compilation of knowledge he argues, but a procedure for knowing the world which uses a system to test and reject hypothesis. Science, then, is not to be confused with fact, but is an idea which is inflected and shaped by other ideas and procedures in politics, art, economics and social interaction. Hence there is a history of science which is quite independent of the parade of methods, discoveries and individuals, it is an archaeology of science as an episteme.

Before the seventeenth century science was unimportant. As many people have pointed out, the earth was understood as an organic nurturing environment which yielded what we needed and replenished what we took away. Whereas harvesting crops appeared to be merely benefiting from the generosity of the earth as they were annually replaced, taking anything away such as minerals was viewed as a violation and of doubtful morality. Consequently mines were open with rituals and blessed so that the extracted minerals could be slowly replenished from the golden tree within the earth. Relatively quickly, however, with a growing confidence in scientific knowledge, a more aggressive approach to the earth overtook the notion of it as a nurturing beneficence.

Two things that came from this were first, that exploiting the earth as a resource did not seem to diminish mankind but actually made things better in many ways, not least in that they could exert some control over nature and lessen the hardships of life. Secondly, that digging into the ground and pulling apart animals and plants yielded evidence that appeared to give us a new understanding of the universe which was based not on faith but on testable procedures which might even help us gain independence from a nature which was increasingly understood as hostile. In what must have been (and was) a brilliantly optimistic period, the very activities of creating more comfortable conditions, such as digging and cutting canals and roadways, also created new insights into the earth and nature, so that it must have seemed very much as though man had at last reached his destiny. Here a new Adam had emerged from the Garden of Eden who could do justice to the creator by understanding the beneficence of the universe through the active exercise of reason rather than an accepting docility.

Such an excursion into the history of ideas is more than a day-trip into the past. It intervenes in very contemporary debates about science and history by reminding us that what we accept as fact or scientific truth about the external world is a consequence of the interaction between internal belief systems and methods whose existence are independent of, and prior to the immediate topic of research. Darwin's enforced period of contemplation on *The Beagle*, however, allowed him to free himself from conventional restraints and to radically shift the weight between method and conventional belief, such that he was able to use the empirical evidence he amassed to suggest that there was a common ancestry of living matter. From the minute study of humble species such as barnacles, he was able to refresh general thought and argue that man was not created in an instant but through an

extended sequence of events. Gosse rejected all these claims – on the basis of similar procedures that all organic and geological processes were cyclic. The very same detail that others observed he argued, could be seen as evidence of a world created in an instant complete with its history. Although the central point of conflict between Gosse and Darwin was apparently the belief system used to interpret their findings from nature, their conceptual difference is the most crucial for the modern reader since it disputed the status of chronology as an historical methodology.

Throughout the nineteenth century civil engineering projects and industrial expansion provided ever longer chronologies of the earth's history. Mines and other borings appeared to show a progressive layering of sediments which could be delimited to show an incremental process in the earth's history. The accepted notion of geological time began to extend from thousands of years to hundreds of thousands, then millions until, in 1830, Charles Lyell expressed his conviction that the earth had no beginning point by presenting a geological table which was open at the bottom. However, these extended stratigraphic measurement of time had a down-side. They revealed that humans had occupied only a relatively brief period of the earth's mineral and biological history. Gosse attempted to recover this blow to man's sense of his centrality in creation, not by denial, but by a strategy which we might recognise now as an early form of relativism. Looking at the evidence from the point of view of a creationist, he argued that the only difference between his findings and the evolutionist's was the application of a chronological methodology. In its place he proposed a cyclic view of geology more in keeping with earlier times which regarded the earth as a sacred gift, and foreshadowed a very modern idea that what is regarded as truth about the external world is dependent on the tools used to interrogate and order the data. In short, Phillip Henry Gosse's faintly absurd logic to support creationism has relevance today for its essentially postmodernist relativism, his insistence on determining effect of human consciousness on human understanding, and his distrust of chronologies as mere semantic conventions which finely divide evidence according to predetermined outcomes. In Gosse's insistence on creationism, history becomes, un-apologetically, the illusion with which we explain the present, and in this he also foreshadows the contemporary irritation with the psychoanalytic claims for history as a determinant of consciousness. Finally in the equality of his attention to the larger and small events, ranging from God's motive to fossilised excrement, Gosse's view of historical consciousness chimes with the contemporary historian's refusal to distinguish between former categories such as the significant and trivial events, fact and fiction, past and present.

For most people, creationism versus evolution is not the point of discussion that it was a century and a half ago. However science and history are. This text is being written on an Apple G4, a machine launched in 1999 with a hard disc which was 'created' on April 4, 1995, at 11.06 pm. This creation date is as problematic as Adam's navel. Before it could be written the disc had to be created and have sufficient technical resolution to represent the date to itself, if not to an intelligible programme. It is the very mirror image of Adam – born with a false history so that it has an illusion of where it has begun. Of course, just like Charles Lyell's geological chart, as most people would acknowledge, quite where this particular hard disc began is open-ended. Somewhere in his stratographic chart is the very iron which has been finely divided and stuck to the aluminium, extracted from Bauxite

lying beneath hundreds of thousands of years worth of rock and fossils. Historiography, as we all now know is about organising stories not objective truth and the date on the hard drive is as Adam's navel, an illusion intended to provide a sense of unity with the past which for all its empirical reality – something quite specific did happen to it on April 4 1995, is useful rather than factual.

In 1983 Stephen Jay Gould's assessment of Gosse was that he confused 'doing science' with clever cogitation and his work *Omphalos* was not wrong but useless. Now, many people would find it difficult to disagree with him. Science, like history, has come under scrutiny from social anthropologists and archeologists of knowledge, and, it is argued, is more about telling useful stories than fact. Of course things do happen, and it is undeniable that reliable predictions can be made about causes and effects, but it is now widely acknowledged that what we regard as knowledge is the interaction between empirical evidence and particular belief systems which delimit one phenomena at the expense of another. Unlike Gosse, who had a belief in science if not an understanding of its distinction from logic, the late twentieth century intellectual has the advantage of the concept of an emergent form of consciousness which understands itself as having a constitutive quality. Our sense of our own selves as made from a trail of more or less acceptable illusions insists that we are complicit in the stories that we tell ourselves and allow others to tell us and tell on our behalf. The contemporary distrust of boundaries, categories, exclusions and inclusions, which some people have suggested shapes the new historical subject, has migrated to other spheres of knowing since 1983 with attendant losses of certainty and considerable gains in intellectual mobility.

Boundary erosion in the arts, for example, has allowed for new combinations of belief systems and practices as the distinction between the artist and the scientist has been apparently dissolved. However this is not to be confused with an idea that in some magical way artists are 'doing science' and vice versa. This solubility is not the consequence of art and science changing, but of an emergent form of consciousness which understands itself as complicit in the stories and illusions necessary to organise data. Artists working in what might be called bio-electronic media such as Christa Sommerer, Laurent Mignonneau and Eduardo Kac use the laboratory procedures and techniques of researchers working at the edge of artificial life and genetic engineering, but it would be a serious error to confuse them with scientists, or even to imagine that they are working in a synergetic relationship with them. No doubt their research does offer insight to engineers of many shades and vice versa, but to suggest more than this is to deflect attention from the much more culturally significant interventions that they make. More like Gosse than Darwin, their work is clever and creative cogitation, the implications of their research is not primarily for scientist but for the visibility it gives to the belief system which inflects their experiments with artificial life, intelligent computer programming and Petrie dishes. Whether they make intelligent virtual animals, or luminous dogs, their work has no value for the scientist, instead it embodies an intellectual formalism which resonates with Gosse's brilliant intellectual gymnastics. He may have failed to explain the origin of man to the satisfaction of a society committed to the exploitation of mineral wealth, but his explanation of Adam's navel, much like bio-electronic art, causes us to reflect on the illusionist aspects of both history and science.

References

Gould, S. 1983 *Hen's Teeth and Horse's Toes.* London: W W Norton.

Gould, S. 1998. *Adam's Navel.* London: Penguin.

Shapin, S. 1996. *The Scientific Revolution.* Chicago: The University of Chicago Press.

Sobchack, V., ed. 1996. *The Persistence of History.* London: Routledge.

Williams, R. 1990. *Notes on the Underground: An Essay on Technology, Society and the Imagination.* Cambridge, MA: MIT Press.

The Imagination of Matter, Pre-Columbian Cultural DNA and Maize Cultivation

Kathleen Rogers

Experts working in the field of archaeoastronomy are discovering that many pre-Columbian mythological allegories originated as dramatised configurations of the cosmic mechanism. Pre-Columbian civilisations believed that the 2,160 years of the precessional zodiac period determined a succession of world ages.

The *Popol Vuh* is the ancient and sacred creation text of the Quiche Maya. It is the most important historical document of ancient Maya culture that exists. The text combines a vast temporal sweep with a multi-layered, shamanic narrative. Each word and sign has a very precise meaning and the powerful images that suddenly emerge appear to have been torn straight out of the unconscious with no rational mediation. The *Popol Vuh* can be interpreted as an astro-biological drama linking the concept of Gods sowing and dawning, to the origins of the solar system. The themes of the sowing of the sun, the moon the planets humans and seeds by immortal deities is echoed in a meta-psychological drama concerned with the adventures of hero twins traveling between the shamanic domains of earth, sky and underworld.

According to the *Popol Vuh* we are living in the fourth and final creation of human kind fashioned from ground maize and water by a half male, half female weaving god. A combined allegorical, mathematical and linguistic formula gives an account of prehistoric genetic and bio-evolutionary theory and establishes sacred, memorialising rituals associated with maize cultivation that exist to this day. Such as the blessing of the seed, spiral anti-clockwise planting, the visiting of the four corners of the field, and fasting, abstinence and prayer around the time of germination. (Tedlock, 1996)

Archaeological and ethnographic evidence in Mesoamerica indicates that maize is considered to be alive, conscious and responsive. These days the complete DNA code of maize has been unravelled, but its prehistoric cultivation remains a mystery .

According to the ancient Mayan calendar we are only fifteen years away from the end of an important epoch defined by the end of the maize/human, human/maize incarnation cycle (2013AD). Their calculations accurately coincide with a rapid increase in genetic

engineering applied to crop cultivation. There is already a patent on sterile, 'terminator' maize seeds, and other patents on pest resistant seed.

Maize is an ancestor of wild Teosinte grass and was first cultivated in southern Mexico around 8000 years ago. The botanist Hugh Iltis has proposed what he calls a 'Catastrophic Sexual Transmutation Theory' for the pre-history of maize based on the unique reproductive anomolies of the Teosinte grass which has female flowers with the potential to be male and male flowers with the potential to be female. (Iltis,1976)

Maize has an extraordinary genetic flexibility with a few gene shifts dramatic changes in colour size and shape as well as in the quality of grains can occur. Native cultivators deliberately feminised the male tassel flowers over thousands of years. They created a distinct sexual inversion from male to female. They organised zones and divisions in the plant using hormonal saturations and created a hugely mutated nutrient sink which took the form of the female maize ear. They went on to engineer a twisting axis to the ear forming a round, radially symmetrical shape which enabled it to carry over one thousand permanently attached seeds in paired rows. They also created an enclosure for the grains in the form of leafy husks that effectively protected the grains from predators and allowed easy harvesting and storage.

> All these qualities of maize, being responsive to human care and manipulation; appearing human-like by standing straight up with flowing hair and outstretched arms; producing varieties of colours, shapes, and types... give maize a position in the natural and cultural worlds. (Hastorf, 1990)

Maize is wholly a ward of the human species, unable to perpetuate itself without human care in harvesting and planting. Historically, this firmly establishes maize as a socio-biotechnological phenomena. The cultivation of maize initiated an interactive, bio-technological and sacred bond between the objective aspects of the plant and the cultural consciousness of it's human cultivator.

There have been recent rapid advances in the understanding of ancient Mayan iconography. In ancient Mayan art the morphologies of nature were freely interchangable. For example, blood, sap, breath, wind, flames, mist, and new maize were all represented by a double scroll and different body parts and emanations were manifested as independent persona. All supernatural entities including meteorogical phenomena, viruses, demons with names such as scab stripper and blood gatherer, could enter and interact with humans in physical space.

Ancient Mayan language is a language of masks and hieroglyphic writing systems applied phonetic pictures and text combined to record every nuance of the spoken word. Imagery was synthesised alongside vast and complex cyclic time counts and within these cosmic mills, images of plants, humans and animals were ground into precise languages. These transfiguration codes now read like four-dimensional coils of DNA, linking and uniting forms across species boundaries. The mortar of the cosmic mill was human blood which was synonymous with the fertilising nature of water.

In classic Mayan art, the linguistically based, DNA essence of the plant was manifested in such a powerful way that it impacted on the evolution of gender roles, the elaboration of

social heirarchies and social and political alliances. Symbolically, the maize plant was conceived as an Axis Mundi, a cosmic plant with cosmic origins like themselves.

The practices of crossing, processing, presenting and eating food are a symbolic means of defining social relationships and expressing cultural concepts. The morphological and pseudo sexual mutation of maize appears to express advanced psychological and scientific knowledge. In harnessing the internal and external life forces of the maize is it possible that they were approaching some idea of an overriding and integral model of consciousness?.

In the spiral/vortex of the female maize ear. The paired symmetries of proteins and water were displayed like a digital abacus and thousands of varieties of maize, cross-pollinated by the moist breath of wind, formed a complete colour coded information system. Maize was considered to be kin, a gift from the gods and each colour, yellow, red, blue black was part of a directional scheme.

The contemporary Maya represent the largest group of Native American people to survive as a coherent culture. Four million Maya retain languages and sacred traditions in the same territories and in some cases, the same communities of their ancestors in Mexico, Guatemala, Belize and Honduras. In contemporary, traditional communities they weave pre-Colombian, shamanic and animistic patterns with medieval catholic religious symbols and they transform cultural categories by integration into their oral traditions. These evolving oral genres have structural resonances with other symbolic and cosmological domains.

For example, in the Mayan community of Chamula in the highlands of Chiapas in Mexico. The physical layout of the ceremonial centre forms a sacred geography radiating from the axis of the church to the solar quarters which are orientated to natural features and contours in the landscape. Religious rituals continue to follow the ancient calendar round in anti-clockwise spiral patterns analogous to the perceived journey of the Sun.

The image of the Chamula centre forms a sacred precinct where earth sky and underworld symbolically meet. Maize cultivation echoes this web of meaning and the heliocentric pattern is mirrored in the planting, germination and harvesting rituals which were laid down thousands of years ago.

Bio-technology consortiums have set up a global maize genome initiative and depict genetic engineering as something they have total mastery over. For them, maize is a set of instructions that can be cut and copied like computer code. There are several categories of risk. Health risks posed from lowering anti-biotic resistance, allergies, full scale poisoning by the creation of entirely new toxins and environmental effects like the creation of new diseases, weeds and pests.

Mae-Wan Ho and Beatrix Tappeser, experts on DNA recombination, warn that:

> Genes function in an extremely complex network. That is why an organism will tend to change in non linear, unpredictable ways even when a single gene is introduced. Furthermore, the genome itself is dynamic and fluid, and engages in feedback interrelationships with the cellular and ecological environment, so that changes can propagate from the environment to give repeatable alterations in the genome. It is a runaway process that cannot be regulated because horizontal gene transfer links the whole biosphere. (Hoe, Tappeser, 1998)

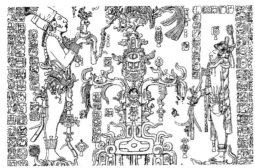

The Chamula Centre

Living cell molecules communicate information via subtle vibration in ways that scientists do not understand. Water is the basis for all biological life and the hydrogen bonds in water change at about ten billion times a second, crawling up through our arteries and veins passing information in the form of electrical impulses across the membranes of the our cells. All living cells in the world that contain DNA are filled with water. Every molecule that has information takes its unique shape from the hydrogen bonds in water, which like keys fit only specific locks to wind and unwind the DNA string. The transforming properties and states of vortexian energies in water derive from sympathetic harmonies and the avoidance of disharmony in the flow of energy patterns.

According to the Penrose-Hameroff hypothesis, consciousness involves brain activities coupled to self-organising ripples in fundamental reality. They reckon on a kind of quantum computation in the cytoskeletal microtubules within the brain's neurons. According to them the cell framework in the brain for communication and organisation utilizes a dynamic arrangement of cytoskeletal microtubules. These regulate synaptic firing rates in the brain by creating a primitive electronic gap – a hydrophobic effect based on a water hydrogen molecule. They propose a quantum mechanical 'spin networked' behaviour within the microtubules to be the basis of consciousness. Their radical hypothesis suggests that at a quantum level the conscious mind is subtly linked to the universe.

The graphical scientific art of Penrose & Hameroff, that conceptually illustrates quantum computation bears a striking morphological resemblance to the ordered rows of kernels in the ear of maize. (Hameroff, 1998)

Murray Gell-Mann, one of the century's greatest scientists and winner of the Nobel Prize for physics, provides a vision for the connection between the basic laws of physics and complexity and the diversity of the natural world.

Nearly four billion years of biological evolution of Earth have distilled, by trial and error, a gigantic amount of information about different ways for organisms to live in the presence of one another, in the biosphere. Similarly, modern humans have, over more than fifty thousand years, developed an extraordinary amount of information about the ways for human beings to live, in interaction with one another and with the rest of nature.... The conservation of nature, safeguarding as much biological diversity as possible is urgently required, but that kind of goal seems impossible to achieve in the long run unless it is viewed within the wider context of environmental problems in general and those in turn must be considered together with the demographic, technological, economic, social, political, military, institutional ideological problems facing humanity.... Concern for the preservation of biological diversity is inseparable from concern about the future of the biosphere as a whole, but the fate of the biosphere is in turn closely linked with virtually every aspect of the human future. (Gell-Mann, 1996)

In this paper I propose that contemporary science and ancient mythology overlap as evidence of the vital themes of human expression. Both harness systems of life in systems of images. Both constitute the facts of mind in a fiction of matter. Both have an absolute bearing on reality and actively shape the imaginative and spiritual framework of human existence and consciousness.

Bio-technology consortiums ignore the spiritual and mytho-scientific dimensions of maize and its symbolic significance in defining cultural and social identity amongst contemporary Mayan communities. Indigenous people identify maize with attributes linked to fertility; maize is a mother, an enabler, a transformer, a healer and a spiritual food for the dead.

Maize is grown and consumed by millions indigenous people using traditional methods and possess a vast amount of knowledge concerning the biodiversity and adaptability of seed to different ecological niches. The effects of sterile seed marketing threatens the livliehood of farmers and because maize is wind pollinated the chances are that indigenous varieties will be genetically contaminated by engineered material.

The symbolic inversion of the maize plant from a conscious, living, co-evolutionary entity to an inert string of dead on dead matter has a powerful resonance. In presenting an image of life in chemically inert matter, the dominant reductive and materialist paradigm prevalent in biological sciences in 1998 has failed to create a model of a living transforming organism. It has failed to create a symbolic entity that satisfies the objective, subjective and intersubjective needs of humanity and has so far failed to address the ethical importance of biodiversity for our collective future consciousness.

References

Aveni. A, 1975. *Archeoastronomy in Pre-Columbian America*. USA.

CIMMYT, Maize Genome Programme: Worldwide 1998. http:www.cimmyt.mx/staff/ARS97principal.htm

Gell-Mann, Murray, 1994. *The Quark and the Jaguar, Adventures in the Simple and the Complex*, London: Abacus

Gossen, Gary, 1974. *Chamulas in the World of the Sun*. USA, Harvard

Hameroff, Stuart, 1998. *Trends in Cognitive Science*, Vol.2, Elsevier, 'Funda-Mentality': is the conscious mind subtly linked to a basic level of the Universe?

Hoe, Wan-Mae, and Tappeser, Beatrix, 1998. *Transgenic Transgression of Species Integrity and Species Boundaries*. London, http://www.peak.org/ armstroj/ho.html

Iltis, Hugh, 1986. *The Origin of the Corn Ear, The Catastrophic Sexual Transmutation Theory*, University of Wisconsin, Botany Department, USA

Johannessen & Hastorf, 1990. *Corn & Culture in the Prehistoric New World*, USA, Westview Press

Morris, Walter, 1994. *Living Maya*, USA, Abrams, 4th ed.

Schele & Miller, 1992. *The Blood of Kings, Dynasty and Ritual in Maya Art*, London, Thames and Hudson

Tedlock, Dennis, 1996. *Popol Vuh, The Definitive Edition of the Mayan book of the Dawn of Life and the Glories of Gods and Kings*, USA, Touchstone pp. 37–39, pp. 98–103/pp. 260–265, p. 114/pp. 271–272, p. 145/pp. 288–291.

Artist and Research Fellow in Digital Culture at the Surrey Institute of Art and Design at the Farnham Campus.

Meaning and Emotion

Capacity to Conceive New Meanings by Awareness of Conscious Experience

Michio Okuma and Isao Todo

1. Introduction

To conceive important messages from symbols and their arrangement bedded in cultural products by human mental activities emerging from instincts, a novel methodology is presented to discover the potential of interpreting symbols in the context of conscious experience into new meanings by scanning symbols in the products (Okuma & Todo, 2000). The message has been overlooked by researchers objective approach because they omitted awareness of conscious experience. Capacity of the methodology is demonstrated by examples. Activities for the discovery can be conducted in two ways: sensing, at semiotic aspect, messages hidden from objective analysis; and, finding meanings at symbolic aspect by interpretation in context of the awareness. Inter-textuality presented by Kristeva contains two aspects: semiotic (le semiotique) and symbolic (le symbolique) aspects (Kristeva, 1974; Nishikawa, 1999). Functions of the former are to sense messages, including rhythms and rhymes, and generate meanings by unconsciously referring to norms in fringe process (Mangan, 1993). Functions of the latter are to understand meanings logically from oral or described statements and express generated meanings. These two aspects are indispensable for human communication.

Application of the awareness could improve engineering capability, especially for man-machine interfaces for open worlds (Hinrichs, 1992). Engineering, in general, should be conducted on these two bases: knowledge from natural or information science and contribution to the human society (Saito, 1987). For engineering interfaces to obtain enough evaluation for the contribution, it is necessary to be aware of conscious experiences and the different aspects in order to establish intimate communication capability with peoples. Engineers must genuinely understand real mental characteristics of an, in accordance with the awareness from various perspectives including conscious experiences and norms (Okuma & Todo, 2000).

2. Discovering New Findings

It is shown that, in fields of linguistics, drama and comic stories, novel methodology can emerge from awareness of conscious experience and lead to discover new discoveries.

2.1 Communication at Semiotic Aspect by Using a Prefix in Conversation

For linguistics in Japanese, distinction whether to apply a prefix 'o-' ('go-' in some cases) to a noun has been objectively analyzed and explained that 'o-' is habitually used for polite expression. In accordance with the awareness of conscious experience, an additional method can be invented to distinguish otherwise. A noun with the prefix can express subjective case(s), while a word without the prefix can indicate objective case(s). A speaker conscious of subjective matter would usually unconsciously apply the prefix to a noun, representing the subjectivity, in legitimate Japanese conversation. The cases are limited to the nouns to which the prefix is applicable in normal use. Depending on whether the speaker applies the prefix or not, the receiver senses the speaker mental state for respecting the receiver or the matter such as religious events. This phenomenon presents an example of communication at semiotic aspect through symbols. The prefixes are removed from nouns in news broadcasts, since news must be objectively reported.

For instance, a fish to be cooked or served for you is o-sakana, i.e. applying the prefix to represent a subjective matter for you, while fish live in a lake are sakana, i.e. objective matter. Identifying the unconsciously applied prefix, you will sense that I (the speaker) have conscious experience to respect you. A festival for religion that 'I have faith in' is said o-matsuri, representing by the added prefix a subjective event on which my mind focuses. Sensing the prefix, you could estimate my spiritual status. In contrast, the number of religious festivals held in a city is counted as the number of matsuri, since it is just objective statistical data. My subjective expression using the prefix activates you at semiotic aspect, which generates meanings to precede the structure of your reply sentences. It might be similar to the fact that in English conversation, when 'your choice' is asked for, you may feel respected.

2.2 Finding New Meanings in Drama

The degree of culture appreciation is demonstrated by the capacity to interpret in the context conceived under the awareness of conscious experience. In a classic drama the capacity reveals new meanings which have been overlooked through objective approach. Among the Noh-plays, a kind of sophisticated classic opera in Japan, one is titled Matsukaze (Pine Wind), a tragedy of two sisters making salt at a rural beach and named after the elder sister. The story is that a lord, who had been exiled to the beach, became involved with the two sisters and returned to the capital leaving them. Three moons, including two moon reflections, appear in a brief scene at end of the introduction to main dance. The scene is translated into English and described by R. Tyler (Stevens, 1998):

Chorus:	Look: the moon is in my pail!
Wind:	In mine, too, there is a moon!
Chorus:	How lovely! A moon here, too!
Wind:	The moon is one,
Chorus:	reflections two, three the brimming tide, for tonight we load our wagon with the moon.

Images can be interpreted into new meanings only when they are in context, e.g. the actual

moon represents their common lover and the moons reflecting from the surface of water in two pails suggest the sisters conscious experience of him retained in each of their minds. Once learning the new meanings, one could understand that the scene is an important point for the connection and that the writer, Ze-ami, laid the moons as metaphor in the scene to integrate main components or characters. It is shown in 2.3 (4) how to locate, by an enhanced anagram, this point hidden in the drama.

2.3 Different Expressions by Emphasis on the Aspect(s)

Kristeva presented the two aspects, semiotic and symbolic, in her theory of inter-textuality. Four cases presented below show that different degrees of emphasis on the aspect(s) can make a difference of conscious experience for sophisticated oral expressions. Expanding conditions to admit the existence of consciousness and exploring the implications intended by writers could result in findings leading to a greater appreciation of cultural products.

(1) Parallel Expression at the Two Aspects to Complement the Content

For the convenience of readers, let us begin with a popular example of Shakespeare's tragedy Hamlet, Prince of Denmark. These sentences are in the drama (P: = Polonius and H: = Hamlet):

P: My Lord, the Queen would speak with you, and presently.
H: Do you see yonder cloud that's almost in shapes like a camel.
P: By the mass, and it's like a camel indeed.
H: Methinks it is like a weasel.
P: It is backed like a weasel.
H: Or like a whale?
P: Very like a whale.

At symbolic aspect, the writer indicates Hamlet's insane behavior by talk about shapes of a cloud, while applying rhyme at semiotic aspect; in parallel, he suggests that the prince is normal. The writer devised the two-way expressions in a series of sentences, for the audience to understand that his mad-like behavior is a pretense for the purpose of deceiving the enemy.

(2) Emphasized at Semiotic Aspect

When a rhythm is felt to be similar to another familiar rhythm at semiotic aspect and meanings of the message are not clear at symbolic aspect, the rhythm emphasizes conscious experience at the former and it becomes predominant over the latter. Then one easily reasons the situations to which the familiar rhythm is usually applied. This emphasizing skill can apply to make an audience anticipate a sad ending, even in a comic story.

 Among rakugo, a form of comic story presented in Japanese theatres, there is a tragedy entitled Jugemu (congratulations-unlimited) after the initial part of a child long name which was, as storyteller says, composed of fortunate names. When some person reported to the father that his son fell into a well, the rescue effort was delayed because it took too long to say the long name (Nomura, 1996). The story finally finishes at the time of his

death. Rhythm of his name, when spoken, is similar to the rhythm of vocally chanted Han-nya haramita shin-gyoh (Tokuyama, 1984), one of the most common Scriptures at Buddhist funeral ceremonies. Repeatedly hearing it, peoples are familiar with its chanted rhythm, while no one can understand either the meanings of the collective syllables in the long name or the Scripture. Whenever the audiences heard the long name, sensitive persons of them could catch the rhythm, feel situation of funeral ceremonies and infer his unfortunate future. Readers can identify similarity in the rhythms by trying to vocally chant these two phrases.

(A) The son's name (Nomura, 1996) is:
Jugemu jugemu gokoh-no suhrikireh, kaijari suigyo-no suigyoh-matsu wungyoh-matsu hurai-matsu, kuh-neru-tokoro-ni sumu-tokoro, yabura-kohji-no bura-kohji, paipo paipo, paipo-no shuhrin-gwan, shuhrin-gwan-no guh-rin-dai, guh-rin-dai-no pompoko-pih-no pompoko-nah-no chohkyuh-meh-no choh-suke san

(B) Initial part of the Scripture (Tokuyama 1984):
Kwan ji-zai-bosa gyoh jin han-nya haramita ji, shoh-ken gowun kai-kuh, do issai kuh yaku shahrih-shi shiki hu-yih-kuh kuh huh-yih shiki shiki soku-ze-kuh kuh soku-ze shiki ju-soh-gyoh-shiki yaku-bu nyo-ze sharih-shi ze shoh-hoh kuh-soh hu-shoh hu-metsu hu-ku hu-joh hu-zoh hu-gen zekko kuh-chuh mu-ju-soh-gyo-shiki

(3) Emphasized at Symbolic Aspect

When meanings emphasized at symbolic aspect are predominant over the sensed rhythm at semiotic aspect, the rhythm is inhibited from entraining with the one held in memory. Then, the audience does not recognize that some events are connected to the similar rhythm. In an example derived from 'Toki Soba' (Time (to) Soba Noodle) (Yamamoto, 1997), an old and popular tale of the rakugo, comic stories, distinct numbers of money are sequentially counted, employing the similar rhythm. Meaning of each count is clearly recognized by the audience and the counting experience is enhanced by the audience interest in money. In addition, the count sequence or rhythm is suddenly disturbed by a question for a trick. The scene is a conversation at a portable stand of the noodle seller, where a gentleman has finished his food, for which he must pay sixty pence. He begins to count and pay pennies one by one:.

Hih (one penny), huh (two), mih (three), yoh (four), itsu (five), muh (six), nana (seven), yah (eight pence). Imah nan-doki dah? (What time is it now?). Kokonotu deh! (It's nine o'clock, Sir). Toh (ten), juh-ichi (eleven), juh-ni (twelve).... When he cried What time is it? the noodle seller just replied It's nine. The penny-pincher skips the ninth count, alternated by temporal count, to the tenth, and successfully wins one penny.

(4) Point Indication through Semiotic Devise in Parallel Expression

A skill at semiotic aspect could be used to focus attention of audience on a position in a drama, in order to indicate an important hidden point. The point of the Noh-play, Matsukaze, mentioned above at 2.2, is indicated by frequent appearance of the word 'moon', which is used as an enhanced anagram. The word appears 14 times within less than 700 words in the text of English version translated by Tyler (1992).

Fig.1 Excitation analysis

Figure 1

Distributed appearance of the word has been analyzed by applying an excitation model of audience with damping, in which each appearance is assumed as a stimulus and adds a unit to the excitation (Okuma, 2000). The trend of the excitation level, obtained from the model, is shown in Fig. 1. The peak of excitation corresponds to the high point. The data of the trend-line are acquired as the duration between appearances of the word. The analysis is performed after adjustment of the appearance, deleting one from the data, which was added to the original text for explanation in the English version.

3. For Further Development

Now that engineers have been introduced to the knowledge on human mentality, including those of art as mentioned above, they must consider the knowledge and elaborate skills needed in order to plan and design better man-machine interfaces. As for knowledge transfer, the authors showed that mapping activities of engineering according to Trimodal Theory (TT) (Stevens, 1998) could suggest how social psychology interfaces with engineering (Okuma & Todo, 2000). TT, defined by R. Stevens, offers a superordinate framework for mapping in psychology and is composed of three modes: Primary mode (biological basis), Secondary (symbol processing) and Tertiary (moral or norms).

The authors conceive application of the semiotic aspect to the Primary mode. Assuming DNA sequences as language, they shall have the two aspects: symbolic, in which codon sequences are interpreted into protein molecules; and, semiotic, in which rhythms might carry different information (Okuma et al, 2000). Since a rhythm is composed of iterated similar partial sequences, like the word oon, tools to analyze rhythms on DNA could be developed from the model (Okuma, 2000) mentioned above in 2.3 (4), combining already actualized homology analysis.

B. B. Johansson pointed out that since we need comprehensive approaches to treat arts, the three modes should be integrated at one aspect (Johannson, 1999). That is requiring modification of TT into an organic system. M. Nagasawa (1905–), one of the most famous poets for Tan-ka, short poem in 31 Japanese characters, describes that she begins with

selecting clear subject matter to create a poem. She elaborates exquisite something emerging from simplicity, to provide readers with an impact (Nagasawa, 1992). Thus, artists do not necessarily begin to create their work based on purposes, as given strategic planning. Since procedure for creating art differs from engineering, TT should be enhanced or modified for application of the procedure to the interfaces.

4. Conclusions

Effectiveness of admitting the existence of conscious experience is demonstrated for understanding literature. Possibilities are expected to find products among arts, which have been devised with many sophisticated applications of dynamics between the two aspects of the inter-textuality. Awareness of conscious experience is essential not only for appreciating cultural products, but also for engineering systems such as man-machine interface for open worlds.

References

Hinrichs, T. R. 1992. Problem Solving in Open Worlds, NJ: Lawrence Erlbaum Ass.

Johansson, B. B. 1999. (private communication).

Kristeva, J. 1974, La revolution du language poetique. L'avant-garde à la fin du XIXeme siecle: Lautreamont et Mallarme.

Mangan, B. 1993. Consciousness and Cognition, 2, pp. 89–108.

Nagasawa, M. 1992. Nyonin-Tanka, 44, 171, pp. 6–7 (in Japanese).

Nishikawa, N. 1999. Kristeva Polylogos, Tokyo: Kodansha, pp. 104-144 (in Japanese).

Nomura, M. 1996. Rakugo-no Retorikku, Tokyo: Heibonsha, pp. 127–130 (in Japanese).

Okuma, M. and Todo, I. 2000. Bulletin of the Faculty of Engineering, Yokohama National Univ. 49, pp. 1–9.

Okuma, M., 2000. Applications of Consciousness, Handout for the last lecture at Yokohama National University (in Japanese).

Okuma, M. et al, 2000. Semiotic Aspect for DNA Language, CBI Conference (submitted).

Saito, H. 1987. Journal itachi, Tokyo: Hitachi Hyoronsha, 49, No.1, pp. 1–7 (in Japanese).

Stevens, R. 1998. Trimodal Theory as a Model for Interrelating Perspectives in Psychology, In Sapsford, R. et al, (ed). Theory and Social Psychology, London: Sage, pp. 75–83.

Tokuyama, K. 1984. Bonji Han-nya-shin-gyoh, Tokyo: Mokujisha, pp. 18–19 (in Japanese).

Tyler, R. 1992. Japanese No Drama, Penguin Classics, London: Penguin Books, pp. 183–204.

Yamamoto, S. (ed.) 1997. Rakugo Handobukku, Tokyo: Sanseido, p. 93 (in Japanese).

Michio OKUMA: Full-time lecturer at Yokohama National Univ. after worked with Mitubishi Petrochemical Co. Ltd. and Hitachi, Ltd.
Isao TODO: Professor at Yokohama National Univ. Department of Mechanical Engineering and Materials Science, Yokohama National University.

Motioning Toward the Emergent Definition of E-phany Physics

Bill Seaman

I was searching for a name for a poetic sub-branch of artificial physics or a new branch of Pataphysics (Jarry, 1965, p.192) that I have been interested in articulating. I arrived at the term E-phany Physics. In the light of this emerging experiential domain, 'Pataphysics' can be seen as a relevant precursor. Pataphysics was coined in 1911 by Alfred Jarry in his book *Exploits and Opinions of Dr. Faustrol, Pataphysician*. Jarry developed an interesting set of ideas concerning a new science within this self-proclaimed 'Neo-Scientific' novel. In this fiction Jarry presents the following definition of Pataphysics:

> An Epiphenomenon is that which is superinduced upon a phenomenon... Pataphysics... is the science of that which is superinduced upon metaphysics, whether within or beyond the latter's limitations, extending far beyond metaphysics as the latter extends beyond physics. Ex: an epiphenomenon being often accidental, pataphysics will be, above all, the science of the particular, despite the common opinion that the only science is that of the general. Pataphysics will examine the laws governing exceptions, and will explain the universe supplementary to this one; or less ambiguously, will describe a universe which can be – and perhaps should be – envisaged in the place of the traditional one, since the laws that are supposed to have been discovered in the traditional universe are also correlations of exceptions, albeit more frequent ones, but in any case accidental data which, reduced to the status of unexceptional exceptions, possess no longer even the virtue of originality.
> Definition. Pataphysics is the science of imaginary solutions, which symbolically attributes the properties of objects, described by their virtuality, to their lineaments.

How interesting that Jarry would be discussing virtuality in 1911 [1]. There is a larger contemporary context that this definition can be seen to inform. I am here concerned with the authorship of a poetic physics in virtual space.

N. Katherine Hayles had earlier conversed with me about the new field that I was trying to define, suggesting the term Artifactual Physics. She was using this term in relation to one of Karl Sims works. She states: '...creatures evolved who achieved locomotion by exploiting a bug in the way the conservation of momentum was defined in the world's artifactual physics.' (Hayles, 1999) E-phany Physics could be seen as a poetic sub-branch or abstraction of Artifactual physics – an abstraction of an abstraction of an abstraction. Where her term sought to articulate the exact modeling (or inexact in this case) of physics for employment in a particular artificial life simulation, I am here interested in exploratory applications of modeling in the generation of a poetic artificial physics.

In her text entitled *Simulating Narratives* (Hayles, 1999), Hayles discusses some of the images from a video documentation related to a paper by Karl Sims work entitled *Evolving*

Virtual Creatures (Sims,1994). Hayles here states 'The conjunction of processes through which we come to narrativize such images clearly shows that the meaning of the simulation emerges from dynamic interactions among the creator, the virtual world (and the real world on which its physics is modeled), the creatures, the computer running the program, and in the case of visualizations, the viewer watching the creatures cavort.' (Hayles, p. 4) Hayles described the attributes from physics that were modeled to inform the behaviour of the creatures. She states 'Behaviours take place within an environment which includes (computer-based models of – emphasis Seaman) friction, inertia, momentum, gravity, light, three-dimensional space, and time.' (Hayles, p. 4) Unlike like this approach, I have been interested in exploring attributes related to artificial physics which might be used to inform the authorship of virtual environments in a differing poetic manner. This is not to state that there is not a poetics to Sims work – I am exploring a slightly different approach to the poetics. More importantly I am interested in this as a field where many artists would take differing approaches in defining the physics-related properties to be potentially authored in computer-mediated environments.

An intuitive understanding of the physics of our lived environment becomes second nature to our knowing the world. We catch a ball, spill a drink, float in water, slip and fall down, ride a bike, bang our funny bone, drive a car, all through a felt awareness of the dynamic ramifications of motion. We can translate our understandings and observations about the physicality of environments into computer-based codes that are presented through various forms of interface, which in turn can potentially facilitate palpable experience. Computer-mediated environments enable such encounters through interactivity and/or observation. As differing modes of interface become more sophisticated, the potential is to author environments informed by abstracting different observations related to attributes of the physical environment as well as to generate new forms of relation to the world at large. Qualities and attributes of physical behavior gleaned from lived experience can be mapped onto the encoded reactive behavior of media-objects within virtual environments. Three dimensional space, 3D objects, 3D terrains, images, text, music and sound can all be connected with reactive and/or interactive behavioral attributes. The relation between an actual physics and an authored artificial physics is constructed and becomes experiential to the participant within such environments through multiple sensual means.[2]

I am not a physicist. I am an artist interested in the potential of authoring media-behaviors, virtual environmental artifacts and physical stimuli that can be encountered through dynamic interaction with authored/responsive computer-based environments. These spaces are assembled to explore various environmental process-based computer-generated artifacts. One must first point out that many people currently authoring virtual environments will say that what I am writing about is not an artificial physics but media behaviors [Conversations with Rebecca Allen and Ted Krueger]. I will here argue that it is relevant to consider the ramification of a techno-poetic artificial physics. When a holistic environment can exhibit reactions to the input/behavior of a participant, the reactive experience generated through computer-based agency can take many forms. One authors the laws of how the artificial physics of the situation will be articulated, eliciting appropriate computer-generated responses. If we take the set of attributes modeled by Sims

above and abstract or displace them, a very different kind of resulting image-space will emerge. Consider the ramifications on the virtual space if the authored code changed the gravity, altered the friction, enhanced the inertia, accelerated the momentum, etc. Imagine if the rules of the artificial physics were localized within the environment – in one location one artificial physics would be in operation, after moving a different set of artificial 'laws' would be invoked [imagine the gravity on the Earth compared to the gravity of the moon...].

There are a number of fields which model the physics of particular environments within computer-based space. The code-based originators of these differing models usually seek to adhere to the physical laws of actual space in the authoring of relevant code. The subsequent media behaviors that are produced though this authorship also seek to adhere to these encoded physical laws. In relation to this approach I am interested in exploring the abstraction or poetics of the authorship of such code-based laws in the generation of virtual space and/or media installations. The code-based authoring of an artificial physics which is consistent within the virtual space, yet does not adhere to the laws of actual physics, becomes a central focus. Instead of sticking to the physics of reality, I am interested in exploring a techno-poetic artificial physics which abstracts and encodes particular consistent laws of media-behavior as an authored artificial physics. I have arrived at the term E-phany Physics for this authored poetic branch of artificial physics. The dictionary states that phany – is from the Greek term *phainein*, and means 'to appear – a terminal combining form meaning appearance – as in epiphany'. Phany, make sense in that I was generating the appearance of a physics in virtual space via specific code authoring. The 'E' of E-phany Physics can have many meanings in the same way that one might approach the poetics of an artificial physics in a number of different ways. Thus an E-phany Physics is a poetic physics where the authored 'appearance' can be energy related, potentially emergent, virtually environmental, electronically produced, experiential and experimental.

An E-phany Physics is defined by an author/programmer, encoded to become relevant within a constructed computer-based environment and need not adhere to the laws of actual physics. There are a number of artists and researchers that are relevant to this concept and I will here outline a diverse set of relations that inform this research.

E-phany Physics is the art/science of a physics which is authored with a computer-based system, conjoining an actual space with a virtual or illusion-based space – this may also be a psycho-acoustic space. A computer-mediated environment may be actuated through differing constructed interfaces that enable a set of relational media-artifacts to be made to appear in a consistent manner. The sensual stimulus generated through interaction with such environments can be more or less palpable. An E-phany Physics can define the relative 'appearance' of the behaviors of virtual objects and/or characters as they are interacted with in a virtual space. Although such an artificial physics is authored, the illusion of such an environment can be articulated back into physical space through various forms of haptic stimulus – imagine Alice in Wonderland rendered physical....Thus an odd co-mingling or superimposition of virtual artificial physics and actual physics can be explored. There is always an actual physics which becomes involved in the production and transmission of the artificial physics to the participant. This points back to Jarry's 'science of that which is superinduced upon metaphysics'.

The work of Margaret Minsky opens a rich field of exploration of haptic feedback – one of her works emulated the differing forces produced by the stirring of alternate 'virtual' liquids through a computer-mediated haptic display. [See Minsky's set of hapic references below].

Authored agents may be programmed to exhibit specific behaviors that operate within a larger set of constraints or artificial physics. In the a life work entitled 'Emergence' – by Rebecca Allen, a haptic 'joystick' interface translates the virtual behavior of an agent into actual physical motion transmitted into the hand of an interacting participant.

Different kinds of registering of the physical behavior of a participant can be brought about and impact the authored reaction of the virtual media-environment – voice recognition (complex sound stimulus), motion recognition (complex movement stimulus), physical interaction – space-mouse or other input device... any sensor-based translation can be mapped through code to be rendered (or become functional) in relation to an authored E-phany physics in a virtual space or computer-mediated environment.

The authorship of complex interactive environments will in time become more subtle. Environmental relations move in a continuum between physical and virtual space. Marcos Novak has mentioned this concept in relation to his thoughts on 'Transarchitecture'. (Novak, 1998, p. 118)

E-phany physics can produce environmental artifacts that may be textual, sonic, imagistic (media related) or alternately can produce environmental artifacts that can stimulate the senses in some manner i.e. generating a haptic response, an environmental change like temperature, the production of odor, a fluctuation in the quality of light, a movement in the physical surrounding architecture, a robotic relation as in telepresence etc. This is where the poetics of authored response introduces an exciting branch of authored potential relations.

It is a goal to create an environmental system where a palpable continuum is exhibited between the actual physics of movement of a vuser (viewer/user) and the authored techno-poetic physics of response. Our bodies and intellect quickly adapt to this new E-phany Physics. I believe this will become a central issue in the aesthetics of virtual computer-based works of art. One abstracts aspects of the intuitive understanding of an actual physics to inform the behavioral parameters of an individualized interactive system. We could say that after experiencing an E-phany Physics for a period of time, then we have expectations about that environment that become learned.

As we begin to build tools for authoring new computer-based environments, we need to be aware of the potentials of E-phany Physics. Many software packages already include parameters which enable one to begin to explore this kind of 'abstracted' artificial physics. One must also remember this can also potentially be an inconsistent physics which is consistently applied to an environment. One is reminded of cartoons where at one moment there seems to be gravity and at another moment there is none – picture the anvil falling, then being suspended in mid-air, then continuing its fall in the Road-Runner series....

Perry Hoberman was skeptical of there being a 'physics' of virtual space. In conversation he stated that 'Humor is the physics of virtual reality' and later qualified that statement stating 'slap-stick is the physics of virtual reality'. This is potentially the

case as brought about through the authorship of a specific humor-based E-phany Physics.

One could also develop an E-phany physics that constantly changed.... An environment having this kind of artificial physics would be highly disorienting.

There are numerous research fields where abstracted ideas related to artificial physics are currently being explored. Certainly consciousness is dynamically tied to a history of patterns of experience within the physical environment. We are now at a point where new kinds of experiential relations can be authored in a palpable manner and thus the ramifications of how E-phany Physics impacts on consciousness becomes a central concern for new forms art production and consciousness studies.

In the Virtual Reality work entitled The World Generator/The Engine of Desire (1995–98), made by myself working in collaboration with Gideon May, programmer, behaviors can be attached to differing media-elements – text, digital images, digital movies, 3D Objects, sound objects, and texture maps. These objects move with a consistent velocity, float and circulate throughout the space, passing through one another without edge detection. A specific light quality is authored and one can edit the space by choosing from an elaborate spinning set of container-wheels exploring what I call Recombinant Poetics.3 The overall E-phany Physics suggests a meditative liquid environment. The meaning of the space is emergent in relation to vuser (viewer/user) interactivity, the software and the hardware interface (translating the subtle actual movements of the hand, into navigational information). These are initial exploration into the field of E-phany Physics. The potentials of E-phany Physics as encoded within the authoring of virtual environments floats on the horizon of an exciting new field of virtual exploration.

References

Allen, R 1998. Emergence, *Consciousness Reframed 2* Proceedings

Duchamp, M. 1989. The Green Box. In: M. Sanouillet and E. Peterson, (eds.) *The Writings of Marcel Duchamp.* 2nd edn. New York: Da Capo Press, Inc., pp.26-71.

Hamilton, R. 1960. *A Typographic Version of Marcel Duchamp's Green Box.* Translation: G. H. Hamilton. New York: Jaap Rietman.

Hayles, N. 1999. Critical Inquiry, Volume 26, Number 1, *Simulating Narratives*

Jarry, A. 1965. Selected Works of Alfred Jarry. Edited by Roger Shattuck and Simon Watson Taylor. New York: Random House (p.192)

Minsky, M – Sites related to Margaret Minsky's Haptic Research:
 http://marg.www.media.mit.edu/people/marg/haptics-bibliography.html
 http://www.media.mit.edu/people/marg/haptics-pages.html
 http://www.ai.mit.edu/projects/handarm-haptics/haptics.html

Novak, M. 1998. 'Next Babylon: Accidents to Play In', in *The Art of the Accident*, V2 Exhibition Catalogue

Seaman, B. & May, G. 1995-98. *The World Generator/The Engine of Desire.* Virtual World construction system.

Sims, K. 1994. *Evolving Virtual Creatures* ACM-0-89791-667-0/94/007/0015, Paper presented a Siggraph, Orlando, Fla, 24-29 July 1994.

Sims, Carl
 http://www.biota.org/ksims/index.html

Notes

1. Marcel Duchamp, aware of Jarry's work also articulated a 'playful physics' (Duchamp, 1989, p. 49) in his notes to *The Large Glass* (1915–1923). Here Duchamp describes a 'frictionless sled' among other relations. Hamilton's work entitled *A Typographic Version by Richard Hamilton of Marcel Duchamp's Green Box* (Hamilton, 1960) presents a number of such notes related to a 'playful physics'.
2. See N. Katherine Hayles How We Became Posthuman: Virtual Bodies in cyberspace, Literature and Infomatics (Chicago, 1999) for an in depth discussion of human/computer relations.
3. See Recombinant Poetics: Emergent Meaning as Examined and Explored in a Specific Generative Virtual Environment. PhD thesis, 1999, by Bill Seaman, CAiiA, University of Wales College Newport.

Emotion Spaces Created from Poems

Tsutomu Miyasato

Introduction

The authors are progressing with research on a technology to create new communication environments and methods to overcome present communications limitations by applying virtual reality. In human communications, emotion plays a very important role. Sometimes, information on emotions is more essential than the logical information. So we think it is important to develop services and systems while considering the human senses and emotions. Our purpose is to allow people to mutually convey their thoughts, mental images, and emotions more effectively (Miyasato & Nakatsu, 1998; Satoh et al, 1998).

Human recognition and human communications are classified as being either logical or emotional, even if some differences in degree exist. In this paper we explain an investigation on the generation of passion spaces focusing on the synesthesia phenomenon. Passion spaces here are compared with conceptual spaces (Noma et al, 1998) in the analogy of 'logos vs pathos'.

Synesthesia Phenomenon

Expressions involving the sense of sight are often used to express sounds, in what is called 'coloured hearing'. The painter Wassily Kandinsky was said to possess synesthesia (Whitford, 1991). He said that when he viewed some colours, the colours would also become audible. In addition, the French poet Arthur Rimbaud created a poem relating images (evoking vowels under the theme 'Voyelles') to colours (Horiguchi, 1951).

Synesthesia, which is a fusion of stimuli, involves reactions to a combination of senses (Oyama et al, 1994). In this paper, we focus on the fusion of sound stimuli and visual stimuli. One example of this is the phenomenon of hearing a sound and feeling a colour, or 'coloured hearing'.

Generation of Passion Spaces From Japanese Tanka Poems

People possessing typical senses find it difficult to understand the phenomenon of synesthesia. We, who possess typical senses, are merely able to enjoy pictures as media

while mixing our own past experiences; we generate images from sight and acoustics from sounds. However, what kind of world do people with synesthesia perceive?

By imagining the world that people with synesthesia perceive, we investigated the generation of spaces. Since relationships are thought to be strong among colours, sounds, and feelings. We then tested colour image creation from the Japanese 'tanka' poems of Ogura Hyakunin Isshu, which originates in the thirteenth century and is an anthology of 100 poems by 100 different poets. The poems are called as 'tanka' which consist of five lines with a total of 31 syllables in the syllabic pattern of 5–7–5–7–7. 'Tanka' poems are taught in Japanese school for understanding emotions or passions from the contents and between lines.

When Japanese people read a Tanka poem of Ogura Hyakunin Isshu, they usually imagine a scene, for example, a palace court lady lost in thought looking at a moon under a cherry blossoms.

The colour image we aim is not like the flashback of concrete scenes like that imagined from the meanings of the words of the poems. Our goal is to generate spaces so that passions are reflected and the other people could walk through and experience the passion. We generated emotion spaces from Japanese poems using the following two steps.

Step 1: There are about a hundred syllables in Japanese. Contemporary Japanese phonemes have fourteen consonants, two semi-vowels, and five vowels as follows.
1. Consonants: k, g, p, b, t, d, c, z, s, r, h, m, n, (ng)
2. Semi-vowels: y, w
3. Vowels: a, e, i, o, u.

A table was created beforehand of the corresponding relationships between phonemes and colours. For example, the vowel 'i' was made to correspond to red, the vowel 'a' was made to correspond to black, etc. In addition, correspondences were made to differences in brightness for differences in the sounds of voiced consonants.

The correspondence relationships between phonemes and colours was determined by the senses of the authors themselves, because 'there is no natural correspondence between colours and sounds' (Gelstern, 1989).

Step 2: The phonemes that compose 31-syllable Japanese poems were made to correspond to image elements, and a multidimensional image element array was constructed. We took a two-dimensional array so that the image became rectangular, i.e., a square matrix. The image elements corresponding to the phonemes according to the time series of the reading were coloured in the direction from the upper left to the right in the two-dimensional array. Here, we used white when image elements emerged without colour information (unless the total number of image elements is the square count). After that, various types of image processing (low-pass filtering, etc.) were carried out and displayed. The present displays are two-dimensional and no depth was generated.

Fig. 1 shows the results from carrying out the above-mentioned colour image creation processing for the 'tanka' poems of two famous poets from the Ogura Hyakunin Isshu. Images are different according to the pattern of phonemes in poems.

This same method of connecting words to passion spaces can be applied to music.

No. 9 poem by Lady Ono no Komachi

Colour of the flower
Has already faded away,
While in idle thoughts
My life passes vainly by,
As I watch the long rains fall.

No. 61 poem by Lady Ise no Osuke

Eight-fold cherry flowers
That at Nara – ancient seat
Of our state – have bloomed,
In our nine-fold palace court
Shed their sweet perfume today.

Figure 1. Example of colour image creation from the Japanese 'tanka' poems of Ogura Hyakunin Isshu. Use of the English translation is permitted by the University of Virginia Library the Japanese Text Initiative, http://etext.lib.virginia.edu/japanese/hyakunin.

Colour images can easily be made to correspond to musical notes. For example, if a quarter-note is the shortest musical note in a musical score, it can be made to correspond to image elements as the shortest part of the score. Figure 2 shows an example of a picture converted from a musical score of a song titled 'cosmos' by Japanese song writer Sada Masashi.

Even if there are differences in the scores, it is common for pieces of music to resemble each other. Any judgment on similarity therefore depends on human judgment. With colour images, however, the comparative ability is high, and even people who cannot read complex musical scores are able to feel the similarities. Fig. 2 shows how it is possible to instantly judge similarities between pieces of music without the need for a performance.

Conclusion

We explained our investigation on the generation of surrealistic spaces for a new human communications environment. We performed colour correspondence with

Figure 2. Example of a picture converted from a musical score of a song titled 'cosmos' by Sada Masashi.

phoneme units involving 'tanka'. We are also considering investigating colour correspondence with word units (such as seasonal words) and the reflection of the peculiarities of songbooks or poet in order to focus on the similarity of expression.

References

1. Gelstern, K. 1989. Colour and Form, In Chapter 9, *Correspondence* [Abe, K. (translation in Japanese), Asakura Press.
2. Horiguchi, D. 1951. *Rimbaud Anthology* [translated in Japanese], Shinchou Press.
3. Miyasato, T. and Nakatsu, R. 1998. *User Interface Technologies for a Virtual Communication Space*. IEEE, Proc. of CVVRHC'98, pp. 105–110.
4. Miyasato, T. 1991. Voice-AID: Pushbutton-to-Speech System for Vocally Handicapped People, IEEE, *Journal of Selected Areas in Communications*, Vol. 9, No. 4, pp. 605–610.
5. Noma, H., Sumi, Y., Miyasato, T., and Mase, K. 1998. *Thinking Support System via a Haptic Interface* [in Japanese], 13th Human Interface Symposium. pp. 1–16.
6. Oyama, T., Imai, S., and Wake, T. 1994. *Sense and Perception Psychology Handbook* [in Japanese]. Seishin Shobou Press.
7. Satoh, J., Noma, H., and Miyasato, T. 1998. *Emotional Virtual Environment, Iasted International Conference on Computer Graphics and Imaging* (CGIM'98). pp. 245–248.
8. Whitford, F. 1991. *Abstract Art Guide* [T. Kinoshita (translation in Japnanese]. Bijutsu Publishing.

Tsutomu Miyasato is with ATR Media Integration & Communications Research Laboratories.

The Process Appears: representation and non-representation in computer-based art

Christiane Heibach

The loss of representation

The death of representation is a topic which has now discussed for long been. It seemed that under the premise of an unperceivable reality the ideology of representation has come to an end. There are several philosophical lines that lead to this consequence, and the impossibility of mimicking a reality, however given, has become a paradigm for the production of contemporary literature and art since the 1960s. The philosophical discussion on representation is closely related to the controversy of how language and the real world are related. The core problem lies in the notion of 'meaning'. Is meaning a completely arbitrary and language-bound phenomenon only provided intersubjectively because of the socialisation practices of a (perceptually homogeneous) society? Or is it related to reality so that we can formulate laws on nature whose truth is not only defined by language convention, but can be proved (or at least falsified) by observation of an objectively perceivable and examinable world? This problem has kept philosophers in discussion since Descartes formulated his famous sentence 'nihil in mente quod non prius

in sensu' (there is nothing in the mind which has not been perceived before). There are three main lines of the philosophical controversy, each coming from different but nevertheless epistemologically interrelated roots.

Logical Empiricism goes back to Descartes. It understands meaning as a mental entity existing objectively and forming the consciousness of individuals homogeneously so that they can communicate facts of the world. Willard V. O. Quine then exposed this concept as metaphysical in arguing the inseparability of language and cognition as our knowledge of the world consists of sentences which are, to a high extent, not supported by empirical data (Quine, 1960) [1]. Thus our knowledge is only true within a given theory and language, and language is closely related to social practice, because there are as many ways of perceiving as there are individuals. Poststructuralism, on the other hand, does not care for empirical data and radicalizes the linguistic turn in transferring all problems into language itself: There is no objective reality because the formation of the human consciousness depends on language, which is an open system of ever-evolving signs that never come to a fixed identity with their meanings [2]. Thus, language loses its representational power. It is not appropriate for mirroring a reality because of the endless différence-movement of the signifier and the signified. Finally, the school of Constructivism, combining biology and cybernetics, transfers the autonomous entity of meaning evolved by Logical Empiricism into the neural networks of the individual: the world is a construction of our internal perception modes, and thus we can never escape our biological dispositions. Objectivity of cognition has become impossible not only because of the unstable character of language, but also because of the individuality of our biological perception apparatus [3].

Thus it seems impossible and senseless to stick to a notion of representation that mirrors a world outside ourselves. In a parallel (and maybe interwoven) development the avant-garde movements in art and literature changed their practice. The fluxus-group concentrated on ephemeral happenings that destroyed the notion of a closed and never-changing 'artistic work' and caused a paradigm shift from the representation of a fixed world to a subjective communication between art and the recipient who has to be involved to construct meaning. The same is also practised in the installations: by Joseph Beuys who desired to provoke synaesthetic effects in the viewer; and in media-art of the last two decades. Literature followed this tendency. When Raymond Queneau presented with Cent mille millards des poèmes, sonnet lines open to a combination done by the reader; or when William Burroughs drew an ecstatic word-universe of internal visions and scenes that have to be re-lived by the reader. As the philosophical movements mentioned above, art and literature abandon reality for the sake of internal, self-referential processes of language and perception.

The first shift of representation

Looking closer at the development, it becomes clear that representation is still alive and seems to prove its character as an anthropological constant. It has been deconstructed: destroyed and reconstructed under new conditions, the conditions of the computational age. The desire of cybernetics in the late 1940s and early 1950s was to build a machine as a representation of the human brain; and this is still the aim of artificial intelligence. Cognitive science is very much concerned with representation of internal processes of

thinking, and the enormous technical development of the computer in the last 40 years is credited with the attempt to externalize these processes [4]. That means that the function representation has changed: it is not the mirror of an external world anymore. It is now necessary to establish and keep up an understanding of ourselves as cognitive systems. This seems to be the only way to maintain recognition as the purpose of the sciences.

This is valid only for scientists who are able to understand and design internal computational processes. The average user regards the computer as a device for certain pragmatically defined purposes, and not as a mirror of their own thinking. It is not only the internal processes, but also on the surface of user-programs that the representation of human thinking becomes more and more a paradigm. Software such as 'The Brain' [5] or 'MindManager' [6] raises the claim to allow the user the organization of their desktop and documents according to the associative processes of their brain. This is also the case with the notion of hypertext. Ted Nelson saw it – with recourse to Vannevar Bush (1945) – as a new form of literacy based on brain-like paratactic associations, rather than on an 'artificial' hierarchical classification (Nelson, 1987). The concept of the network is thus closely related to the desire to represent mental processes. In this context the internet could be seen as a representation of a networked 'meta-brain': artificial brains (computers) as well as human brains (the users) are bound together by a physical network of wires and backbones. This tendency of networking is mirrored even in programming techniques that increasingly move from hierarchically structured methods to object-oriented-programming which networks different separately-written and autonomously functioning parts.

The second shift of representation

Computer-based art – especially when it is related to the internet as performing platform – has inherited the tradition of both representational modes. This tradition was destroyed by the philosophical and artistic movements of the last decades, and the reconstructed one of internal mental processes. Indeed, it seems as if it fulfills both epistemological implications: the destruction of mimesis, as well as the representation of processes.

The destruction of mimesis

The computer is an inherently procedural device: it completes its tasks only when processes (controlled and translated into action by software programs which are brought into life by steadily changing electronic impulses) are triggered by the user. Additionally these processes allow the movement of semiotic systems on the visible and perceivable surface of the interface. This is nothing new for animated pictures or film-sequences, but it is the first time that text can be visually transferred into motion. Hyperfiction plays with the semantic versatility of words which have abandoned fixed contexts and thus lies in the tradition of avant-garde print literature. There are further projects, not only in poetry (basing on the experiments of visual poetry in print), but also in prose, that visualize the motion of the signifier.

Simon Bigg's *The Great Wall of China* (Biggs, 1998) consists of text that is in steady movement and by this constantly changing. The database of words is formed by Kafka's unfinished story of the same name. An elaborated set of syntactic and semantic rules grants the formal correctness of the automatically generated sequences. As long as the user

moves the mouse over the text, it changes; when they put it aside, the transformation stops. There is no hope for the extraction of a somehow fixed sense out of these volatile sentences, and it is nearly impossible once the text has been changed that the user will ever read the same sequence again. They can perceive and admire the aesthetics of moving text layers, and play with the elements that cause these changes, but they cannot read in the traditional way of extracting a fixed meaning out of the words and sentences.

Jacques Servin's *BEAST* (Servin, 1997) is a hypermedia-work that constructs a complex counter-dependence between text, images and sound. Once started, a textual universe develops independently from the user's action, assembled of philosophical and literary quotations (e.g. by Walter Benjamin, Gottfried Benn) and short sequences written by Servin himself. The user can control the development by clicking on one sequence, and then the next automatically chosen text will continue the thought of the previous one. If the user takes no further action, the text develops itself, scrolling downwards like an old papyrus (the sequences on the top disappear). After a while a virtual window with 'floating images' opens. Activating one of these images causes a semantically related new text sequence and adds sound components. Thus every semiotic element interacts with the other. The recipients are at first completely surrendered to this cognitive overload and the uncontrollable movement of this 'semioverse'. Even after a short while, when they have learned to control these processes, it is impossible to read or look at the signs in that introspective manner the traditional media have taught us.

These two examples show that text has finally lost its representational function in the procedural powers of the computer, thus causing a cognitive shift from the contemplative modes of perception to the playful interaction with processes, from seeking a fixed meaning to accepting the visual aesthetics of moving text.

The representation of processes

Computer-based art is media-art and therefore deeply concerned with the technical basis of the medium it uses. While the procedural performance of the traditional semiotic systems destroys mimesis, another kind of representation is constituted: the internal processes of the computer are brought to the surface by different kinds of visualization techniques. This mode of representation is closely related to the tendency of mirroring internal mental processes. While cybernetics and artificial intelligence work with representation models as they try to transfer the internal mental processes to internal computational processes, computer-based art brings the latter to the surface. This movement towards abstraction could be called the second shift of representation. This is very obvious in net.art-projects as the internet is inherently based on the continuing and never-ending streaming of data. I/O/D's 'alternative' browser, the 'Web Stalker' (I/O/D, 1997), is such an instrument. It focuses on making visible the networked environment in which the user is situated, and their movement when they jump from one document to the next using hyperlinks. It consists of several functions. The 'crawler' for example starts with one given url, and follows all links to further documents while 'painting' a map of the centre site and its related documents. The 'Web Stalker' refuses to show the sites as they are intended to appear, but unmasks the hypermedia aesthetics for the sake of revealing the symbolic and procedural layers behind the polished surface.

The website of the University of Erfurt

A different strategy is used in those projects which try to visualize the ever-changing topography of IP-addresses and internet-servers, such as Lisa Jevbratt's '1-to-1' maps (Jevbratt, 1999), or the scientific device called 'skitter' that visualizes the data streams running through the backbone wires (CAIDA, undated). Jevbratt uses a search program that collects all server working with the hypertext transfer protocol. The results are presented in 'maps', emphasizing different criteria: e.g. the hierarchy of the IP-addresses, the accessibility of the registered server machines etc. The 'skitter' on the other hand visualizes the steady growth of the net by 'travelling' the wires that are used for data transfer and painting a picture of the rhizomatic proliferation of the computer-networks.

The project *lavoro immateriale* by Knowbotic Research et al (1999) goes one step further. Its aim is not only to visualize the internal computational processes, but also, as the project title indicates, to represent the users' interaction with the machine. That means searching and/or changing texts in a database. Thus the project deals with the question of immaterial work on two levels. The database documents consist of theoretical articles on the qualitative change of work under technologized conditions – the semantic level. At the same time it constitutes a 'material level' on which the immaterial work of recipients and cooperators of lavoro immateriale is visualized, as the movements of both groups are represented by a special software in particle streams that cluster or scatter around the database documents structured by keywords.

Here both representational modes – the one concerned with internal mental processes and the other concentrating on visualizing computer processes – have come together and emphasize the inseparability of technological and human work strategies.

Towards multiple epistemologies

The cognitive shift caused by the procedural and hypermedia powers of the computer is enormous – the functional change of representation is only one example that illustrates the movement from the perception of rather static phenomena to processes. But we are still concerned with books, with non-media art, with traditional modes of representation as well. The growing importance of the process adds one perceptional mode, it does not substitute the traditional ones. It will be the task of the sciences to analyse these different epistemologies emerging from different representation techniques and to build bridges between them, and thus to grant the communication between 'non-computational' and 'computational' members of our culture.

References

Biggs, Simon, 1998. *The Great Wall of China*.
 <http://hosted.simonbiggs.easynet.co.uk/wall.htm>
Bush, Vannevar, 1945. As We May Think. In *The Atlantic Monthly* 176.1, pp. 101–108 (reprinted in Nelson, 1987), pp. 1/39–1/54).
CAIDA (without year) Skitter,
 <http://www.caida.org/Tools/Skitter/>
I/O/D 1997. Web Stalker, <http://bak.spc.org/iod/>

Jevbratt, Lisa, 1999. 1to1, <http://www.c5corp.com/1to1/index.html>

Knowbotic Research, et al, 1999. lavoro immateriale, <http://io.khm.de/lavoro/>

Nelson, Ted, 1987. *Literary Machines*. Edition 87.1 South Bend Indiana (South Michigan).

Quine, Willard Van Orman, 1960. *Word and Object*. Cambridge, Mass.

Servin, Jacques, 1997. BEAST, <http://home.earthlink.net/~jservin/Beast/>

Notes

1. His famous thesis of the indetermination of translation, formulated in 1960, is still a topic of discussion in analytical language philosophy.
2. Jacques Derrida is the most prominent representative of poststructuralism. He called this phenomenon of a potential but never fixed identity the 'différance'.
3. The roots of this concept lie in the works of the biologists Humberto Maturana and Francisco Varela on one hand, and in the works of the mathematician Norbert Wiener on the other.
4. I don't intend to get into a discussion of the adequateness of this concept, I see it as an epistemological phenomenon which can be observed on several levels, as the following will show.
5. <http://www/.thebrain.com>
6. <http://www.mindman.com>

Christiane Heibach is assistant professor at the department of communication sciences of the University of Erfurt (Germany).

Towards a Physics of Meaning

John Sanfey

Introduction

The mind/matter problem has bedevilled human thinking for centuries. Its modern formulation, the 'hard problem of consciousness', is the problem of explaining why it is conceivably possible to explain everything in terms of the structure and function of physical parts, and still be left asking 'why is there something it is like' to be those structures and functions? (Chalmers, 1997)

The idealist/realist debate has also continued for centuries. Berkeley once famously pointed out that we just don't know for sure that the universe is not some clever illusion of the mind.

The only argument against this view is that such a world would be rather pointless and perverse.

However, both these mysteries can be resolved by solving yet another ancient paradox, one arising from the continuity of physical motion.

The Paradox of Two Nows

The concept of 'now' implicit in classical physics is an infinitely sharp point between the

In classical causality such that A → B,	
1.1	When B exists there is only B, A does not exist, except historically
1.2	Since change is constant, B is never still, no matter how brief the observation
1.3	But all change involves two moments (A and B)
1.4	Therefore B can only be experienced in two moments
1.5	But any two moments A and B are mutually exclusive in causal terms
1.6	Consciousness cannot be explained within classical, causal physics

Table 1

past and the future. Now is caused by the past, but is continuously changing and is therefore infinitely fleeting.

The now of consciousness however, seems rather to posses an expanded character, both in terms of space and time (Varela, 1999).

The argument in table 1 shows that consciousness cannot be explained within classical physics.

We think of B as real and A as being the past. Actually, in terms of how we experience physical reality, they are a single event in which mind and matter, and indeed the observer and the observed are inseparable. However, every time we think, we do separate A from B, and also mind from matter, the observer from the observed. The AB phenomenon may be indivisible existentially, but it must also have conceptual properties allowing analytic thought to exist.

This dynamic duality between the existential and conceptual aspects of experienced matter (empirical reality) can be exploited to replace mind/matter duality with something more accurate and scientifically useful that also incorporates the subjective time paradox.

Although table 1 demonstrates that quantum theory must have a central role in the explanation of consciousness (Sanfey, 1999), a detailed discussion would not serve the purpose of this paper, which is solely to uncover the fundamental principles of consciousness.

Principles of Objective Phenomenology

The experienced AB phenomenon is non-reducible yet is identical to the descriptive A → B model, which is made of separate elements, and which forms the basis of the contemporary materialist worldview. The key to fundamental bridging principles is in this descriptive

B	The 'causal now' of physical description
A(s)	The 'just now' or shadow that was A
A(s)B	A and B are combined to *mean* matter
$\Sigma(A(s)B)n$	Meaning only exists in relation to all other (n) alternative explanations of A(s)B

Table 2

ability and the fact that described events must be equivalent to experienced events according to the following principle:

Principle of Ontologically Absurd Space (POAS)

Since empirical reality cannot be reduced in experiential terms, it follows that every reductive, causal description of reality must include some mechanism to replace the role that consciousness plays in experiencing that reality. Or more specifically:

- Every description of reality, in which the observer and observed are separate, must attribute ontologically absurd determinist properties to empty space, such that these properties equal subjective experience.

The degree of objectivity in any description of reality is proportional to the ontological absurdity (OAS) contained in that description. The key to bridging principles is to quantify OAS.

Every description or concept must have both quantitative and qualitative elements even when describing subjective states. The subjective element is OAS, which we shall see is always some property of the whole – applicable globally, but acting locally.

The Bridge in Detail

The AB phenomenon is not reducible experientially but is reducible conceptually using OAS to replace subjectivity. Let us now establish the conceptual elements that constitute this AB phenomenon.

Matter exists empirically as meaning. It is experienced as a single AB phenomenon, and described as A going to B under fundamental rules embedded in space-time. OAS must exist in this description, as indeed, it does every time the observer and the observed are considered separately. In physical theory it is the laws governing how A goes to B. In the above description of consciousness, meaning is the OAS that determines the particular choice of A(s)B in $\Sigma(A(s)B)n$.

These new consciousness-based principles of description lead naturally to a working definition of consciousness, which can be defined by the degree to which the 'causal now' has access to the whole of unconsciousness. An individual's biological

Figure 1

and personal history is available in every conscious moment. The 'causal now' lights up inside the unconscious past and expectant future, in a way that can now be described in physical terms. This explains the inside feel of consciousness.

In Figure 1 the property of attention is seen as exclusively here and now, but also non-local spatially. This is impossible to explain without invoking quantum theory. Attention is the degree to which some aspect of reality is interacting with the whole of biological knowledge. It is the qualitative, non-local, spatial extension of meaning in the here and now.

Intention or 'aboutness', on the other hand, is not a spatial projection but a temporal one, a projection of knowledge as meaning from the past towards the future. It is the degree of truth contained in thought.

Existential or qualitative properties occur in the process of making the choice of A(s)B in $\sum(A(s)B)n$. Quantitative properties on the other hand, occur in the form of the configuration of the choice.

This theory lends itself well to quantum field theories of consciousness (Jibu, Yasue, 1995; Jibu, Pribram, Yasue, 1996; Vitiello 1995) in which memory is so important. It can also apply to Penrose and Hameroff's Orchestrated Objective Reduction model (Orch OR), (Penrose, Hameroff, 1996) provided that their conception of the role of space-time geometry is expanded to also encode biological knowledge. Consciousness becomes the sense of being the largely unconscious but active memory as it surrounds the here and now.

Having established that all descriptions have both quantitative and qualitative elements and having deduced the only phenomenological model of that supports this, the next step is to determine what qualitative and quantitative really mean.

The Qualitative/Quantitative Axis

Let us consider two thought experiments based on Mach's Principle.

Mach's Principle: The inertia experienced by a body is a property of the distribution and flow of all the matter in the universe, especially the more distant.

Thought Experiment 1:

Imagine you are a rock being thrown. Consider the smallest interval that can be experienced (from A to B). Suppose you are capable of perceiving absolutely everything, at least in kinaesthetic mode (physical feeling). Imagine the experience first in qualitative then quantitative descriptive terms.

Qualitatively, you experience a feeling of inertial drag, which by Mach's principle is the pull of the entire universe. You experience not two moments but a single event. The momentary past is part of that totality. There is no sense of self and other, just a unitary thing. That is all there is.

To think quantitatively on the other hand, is to divide then from now, self from other. One edge of the qualitative whole has become the past. Another part is categorised as non-rock.

The qualitative reality of inertia is replaced by the concept of opposing forces in empty space, whose behaviour is governed by known fundamental laws.

Properties of (A(s)B in Σ(A(s)B)n):	
Qualitative Properties	Quantitative Properties
Here and Now — Attention	Past and Future — Intention
The Experience of Being, Intuition, Phenomenal	Observing, Symbolic, Descriptive, Analytical, Hypothetical
Meaning in relation to whole mind	Properties trigger precise pathways
Meaning by virtue of what it *is*	Meaning from what it can *do*
Not Reproducible	Reproducible
Object and self are indivisible	Object and self are divided categorically
Hard problem of qualitative consciousness	Ontologically Absurd Space in descriptive model replaces subjectivity
'Now' is AB combined (specious)	'Now' is A, then B (causal or sharp now)

Table 3

Thought experiment 2:
If half the matter in the universe magically and impossibly, disappeared what would happen to the qualitatively subjective feel of inertia, and to the quantitative properties of mass, force etc?

Although this is an impossible experiment since energy can neither be created nor destroyed, the experience of inertia would be qualitatively different but the quantitative descriptions (mass etc) would remain the same.

The inertial feeling or AB phenomenon, is an absolute thing in itself and is described qualitatively as a property of the whole, which in this case of gravity, is the entire universe. In describing consciousness, the whole is the entire quantitative knowledge base supporting the domain of perception i.e. the outside world.

Quantitatively (A → B model), the inertial mass is a relativistic measure, and consequently all inertial masses reduce by the same proportions. Quantitative properties deploy knowledge of the past to predict the future hypothetically.

This thought experiment shows that qualitative and quantitative properties are really entirely different things and yet both describe the same empirical phenomenon. This is why they represent such a formidable bridge between 'mind and matter', allowing subjectivity and physics to be considered in a single framework.

Since both qualitative and quantitative properties, are properties of the same thing, it becomes possible to draw all the principles outlined above together, into a firm set of bridging principles

Bridging Principles

The static mind/matter duality is replaced by something dynamic, based upon the paradox of two nows and a new law of conscious experience:
* Consciousness exists whenever spatially and temporally distributed properties occur together.

Just as the interplay of intention and attention define subjective consciousness, so too do their equivalents in physical theory. Temporally, the AB argument in table 1 demonstrates that A and B co-exist in the now of consciousness but not in causal physics. The same principle operates in the attention plane of spatial distribution. For example, a tornado is a superfluous concept in physics which only needs to know how individual particles behave. Consciousness assigns meaning to the whole form of the tornado. Attention and intention are the consciousness equivalents of distributed spatial and temporal meaning in OAS.
In a causally closed universe where change is constant and represented by $A \rightarrow B$
* No empirical phenomenon can be descriptively reduced beyond a unified AB, without attributing ontologically absurd, determinist properties to empty space as the epistemological equivalent of conscious experience.
* $A(s)B$ within $\sum(A(s)B)n$, which is constructed hypothetically, has qualitative properties in the choosing of, and quantitative properties in the form of it's configuration.
* The degree to which consciousness exists both qualitatively and quantitatively, equals the proportion of the organism's biological knowledge represented by $\sum(A(s)B)n$.
* Qualitative properties can be formalised in terms of the degree of interface between B, $A(s)$ and $\sum(A(s)B)n$, (property of attention).
* Quantitative properties can be formalised by the utility, predictive power and quantity of knowledge in the hypothetical properties of the product of that interface, (property of intention).

Discussion

It is easy to accept that theories about matter are mental constructs. Not so easy to recognise that every encounter with matter in which there is a subject/object divide, is a hypothetical explanation of something that just now was experienced whole. But this is the only conclusion possible from the paradox of subjective time. Consciousness is the ability to both experience and describe reality, each of which is reflected in the qualitative/quantitative axis of those descriptions themselves.
Every description separates mind from matter and in doing so must introduce elements to replace subjective experience. OAS does not weaken a theory, but simply reflects the fact that it is a model. An example is Orch OR, (Penrose, Hameroff, 1996) in which platonic truth is embedded in space-time geometry itself, in other words, within the fabric of nothingness. The argument in table 1 shows why every objective observation must deploy

OAS. This includes one's own thoughts whenever there is a sense of an observing self. Every observation is a description of some sort, an icon with associated OAS.

These principles of description replace mind/matter duality and address the argument put forward by Russell, Chalmers and others that the unknowable, intrinsic properties of matter famously postulated by Kant, might themselves be experiential (Chalmers, 1997). They suggest that whereas these unknowable properties are indeed only describable qualitatively, they can be thought of only as properties of the whole. Qualia are properties of the whole. The subjectivity of consciousness exists because the whole of knowledge is active in the here and now. The redness of red has the quality it does because it occurs inside a deeply rich interactive space of unconscious knowledge.

The principles demarcate the hypothetical from the absolute, suggesting that whenever the observer and the observed are separate, theoretical modeling is taking place. Popper has argued that no theory can capture absolute truth (Magee, 1985). Everything, including consciousness must be thought of with both qualitative and quantitative elements, but consciousness can be biased towards either extreme. The extreme qualitative end is pure insight, the non-local, non-hypothetical contact with reality, a state described within Buddhism as 'total attention' or enlightenment (Krishnamurti, Bohm, 1991).

In summary these principles define the role of the observer in every theory including those about consciousness itself. Armed with a comprehensive theory of cognitive modelling, we can deduce the phenomenological structure of consciousness.

References

Chalmers, D. 1997. Moving forward on the hard problem of consciousness. *Journal of Consciousness Studies*, 4, No. 1, pp. 3–36

Hameroff, S, & Penrose, R, 1996. Conscious events as orchestrated space-time selections. *Journal of Consciousness Studies*, 3, pp. 36–53

Jibu M. & Yasue K. 1995. *Quantum Brain Dynamics and Consciousness*. Amsterdam and Philadelphia. John Benjamins

Jibu M., Pribram K. & Yasue K. 1996. From conscious experience to memory storage and retrieval: The role of quantum brain dynamics and boson condensation of evanescent photons. *International Journal of Modern Physics* B. Vol 10. No's 13 & 14: pp. 1735–54

Krishnamurti J. & Bohm D. 1991. *The ending of Time*. London. Victor Gollancz Ltd.

Magee B. 1985. *Popper*. London. Fontana Publications.

Sanfey J. 1999. *Footsteps in Knowledge: a Third Person Phenomenology of Consciousness*. Poster presentation at 'Quantum Approaches to Consciousness' conference. Flagstaff. Arizona.

Varela F. J. 1999. Present-Time Consciousness. in Varela V. Shear J. eds. *The View from Within: First person approaches to the study of consciousness*. Thorverton. Imprint Academic.

Vitiello, G. 1995, 'Dissipation and memory in the quantum brain model'. *International Journal of Modern Physics*, 9, pp. 973–89

John Sanfey is a General Medical Practitioner at Alvaston Medical Centre. Derby. UK.

Inquiry into Allegorical Knowledge Systems for Telematic Art

Tania Fraga

Human societies are facing many challenges at the present time. The whole Earth is wired and interconnected. Humans are discovering that such interconnectedness is deeper than the wired network of communications. People's scorn for Nature and its laws may bring forth many catastrophes. Country frontiers provide no barriers for pollution, global warming, diseases, radiation, chemical or bacterial weapons. The awareness of such situations is spreading around the whole globe. Questions are asked and there is a collective desire for solutions. Among the answers that emerge from the collective unconscious we may perceive an awakening of shamanism. Shamanism is an ancient way of acquiring knowledge.

Forgotten systems sometimes burst from the collective unconscious to be reborn in different levels of consciousness. Shamanism – an ancient, personal and singular way of acquiring knowledge – is one of these almost forgotten systems, so old and unknown it becomes new. It is a means by which a person may acquire direct access to the unconscious, which happens through inner vision. Each of us may travel different shamanic journeys within and discover the meanings of our own symbolic keys. The general patterns or archetypes found in shamanism around the globe open a broad range of possibilities that may meet the needs of a wide number of individuals from various backgrounds and cultures.

For the last three years I have been developing Telematic Art in a Xamantic context. Through web sites and art installations a confluence of shamanic experiences and its semantics occurs in a telematic environment. These web sites – The Xamantic Web and the Xamantic Journey – and art installations are assemblages of dreams, metaphors for the phenomena of the natural world, reinvention of ancient myths and metaphors of scientific concepts and cosmologies. Their purpose is to awaken creative and poetic imagination, which are the most important of all human mental faculties. Many questions have arisen during the development of this symbolic and functional set up, and the present essay is intended as a discussion document for them.

Introduction

Some pervasive questions have dominated the Telematic Art field for the last few years. These include questions relating to our need to create meaningful contents for a diversity of cultures without losing depth. The process of organising an immeasurable volume of information in poetic signs and the articulation of flexible poetic actions for the network environment are very important considerations for telematic artists. These questions are entwined with others related to the use of computer languages and the development of the technological environment in which they will function. In such environments the mind

processes are interconnected with the technological ones. Both type of processes carry information which enable the organisation and the establishment of relationships among different sets of information, thereby creating symbolic languages. The expressive domain of symbolic languages has been, for the last few centuries, the space for the arts. The artists have been the ones who play with languages in order to create situations where processes happen; to engender collective participation; and to propitiate manifold states of consciousness, among others.

In western societies art has been a channel for the numinous and a repository of dreams. Contemporary Art creates environments where the unconscious levels of the psyche may emerge into the social domain. It propitiates a reorientation of consciousness allowing transformations to occur in one's way of seeing. It also facilitates the rediscovery of one's own creative potentials and the exercise of imagination. Nowadays this poetic repertoire is huge since art has been the refuge of the hermetic knowledge (Baigent & Leigh, 1998) and its more important repository.

Paraphrasing Lawrence Durrell it is possible to say the aim of Contemporary Art has been to 'transform the mob into artists' (Durrell, 1960), amplifying their consciousness in waves which radiates as waves on the sea. Although such an ambitious objective may be seen as romantic and idealistic it may be found in the great works of arts produced in the present century. Many are the works of art which entail such process of transformation. Many of these works allow one to experience and internalise amplified states of consciousness evoked by the artist.

It is possible to talk about an alchemy of the words, materials, sounds, shapes, movements and colours; an alchemy which creates a poetic repertoire accessible to all the senses. This repertoire reflects a direct apprehension of the numinous, the infinite, the epiphany emergent in dreams, the luminous moment of insight or contact with the unconscious that happens to artists and which can be shared with the public.

For a very long time reason and logic have been the focus of science while art has been the repository for the unconscious, for the emergence of languages that assemble symbols and paradoxes. The knowledge and understanding of the processes that happen in the human psyche, developed by psychology, have shown that the deep levels of human psyche resonate beyond the rational intellect and subtly influence human actions and choices. Symbols establish correspondences between the many things which emerge from the stream of consciousness. Nowadays an integrative approach to art and science is beginning to merge these two fields which were segregated for centuries. This integration, which is happening through the development of Telematic Art, could transform our way of seeing.

Discussion

The artist's main role in contemporary societies seems to be the reinvention of semantic signs, giving them new meanings, testing new symbolic structures and articulating manifold knowledge systems. The speculative and experimental approach of Contemporary Art propitiates changes of perspective and confronts the public with unexpected, paradoxical or conflicting situations.

Although Contemporary Art has acquired the fame of being elitist and hermetic the public seems to be fascinated by it. Exhibitions in galleries, museums and cultural

institutions draw crowds to ponder over the works of art and the aims of their creators. At Contemporary Art spaces scholars can be seen guiding crowds of tourists round the exhibits, explaining the vocabulary and 'translating' the apparently hidden motives of artists.

There are many explanations for such seemingly bizarre conduct. One may find the simplest explanation is the human need for meaning. If a work of art has no apparent social function at least it could be considered as a repository for meanings, as a space for experimenting with symbols: a melting pot for signs.

It is generally accepted that artists re-elaborate archetypes through their work. These archetypes emerge from the human collective unconscious, which is a matrix for transformed signs and experiences. For some artists it is possible to discriminate between ordinary consciousness and outside reality on one side, and altered state of consciousness brought forth in special moments of inspiration and trance like states, on the other. Psychologists say that when the unconscious emerges in someone's consciousness a period of identification with its contents happen. The process is a normal psychological process and a centred persons will discriminate between the numinous realm and the ego reality. Artists generally will express the experience through their work. They will try to channel the archetypal energies through symbols.

Archetypal symbols have a broad and complex constellation of meanings. For example, in symbols of wholeness there are the union of manifold polarities which are balanced in order to express the unity. The Self – an archetypal symbol of wholeness – is usually represented by images that embody the combination of complexity with wide perspectives due to the amalgamation of different polarities – a multiplicity – into one symbol which express this dynamic process. 'Wholeness is the integration of all the parts and individuation is creating a purposeful existence out of a superior process than ego at work in your psyche and in your outer life destiny points.' [1]

Carl G. Jung in his works mentioned the power of archetypal symbols as transformers. The amplification of consciousness and the search for new dynamic ways to express and develop meanings at deep levels may emerge from the evolutionary process of humans societies.

For the process of transformation to occur it is necessary that one makes fundamental choices, going through the pain of finishing identification from the archetypal symbol and allows the changes of the characteristics and patterns one wants to transform. It is possible to see archetypal symbols affecting and being used to influence – positively and negatively – and to manipulate society.

In ancient times allegories allowed artists to use the transformational potential of symbols. They used the material emerged from dreams or other altered state of consciousness re-directing their psychic energy through symbols assembled into their work. Today the new tools and languages available for artists in the telematic art fields instigates research on methods which make possible to work with the multidimensionality and the non linearity of these languages and tools. When one first approaches a new language or tool one tends to use it in known methods until these methods show themselves to be inappropriate. Because human mind has to find redundancies and references one will search for similar situations in human history. When finding an analogue approach one

has to experiment with it to see if the old knowledge can be used, re appropriated and adequate to the present moment. This is the case with the use of allegories which has lead to inquiries upon allegorical knowledge systems. This is also the case with shamanism.

Shamanism is an ancient way of acquiring knowledge. Sometimes forgotten systems bursts from the collective unconscious to be reborn in different levels of consciousness. Shamanism – ancient, personal and singular way of acquiring knowledge – is one of these old and almost unknown systems, so old and unknown it becomes new. It is a system of self knowledge, which happens through inner vision. It is a way a person may use to discover means of direct access to the unconscious. Every one may travel different shamanic journeys within and discover the meanings of their own symbolic keys. The general patterns or archetypes found in shamanism, around the globe, open a broad range of possibilities that may meet the needs of wide number of individuals from various backgrounds and cultures.

The shamanic path has been described by mythologists, anthropologists and historians [2] as follows:

* a glittering luminous labyrinth, a multidimensional cave;
* a fluid and calm river or sea;
* a smooth flying travel;
* a dark, tenebrous and fearsome dungeon;
* a fragmented, discontinuous and dangerous road;
* a shattering howling gale.

These patterns represent the psychic energies of the traveller and present a wide range of possibilities that may meet the psychological needs of the widest possible number of individuals. They also present to telematic artists many poetic possibilities. They may be an amalgamation of the ancient, the archetypal and the new scientific cosmologies bring forth by contemporary science.

Poetic Work

The last three years the author has been developing telematic art as a Xamantic context. Sites where the confluence of shamanic experiences and its semantics happen in the telematic environment which compose them [3]. These sites – The Xamantic Web and the Xamantic Journey – are amalgamations of dreams, metaphors for the phenomena of natural world, reinvention of ancient myths and allegories of scientific concepts and cosmologies. They aim to instigate creative and poetic imagination, which is the most important of all humans mental faculties. The Xamantic Journey, more specifically is an poetic allegory of the shamanic journeys and the pattern chosen for it was a tube turned labyrinth and multidimensional through the assemblage of many realms [4].

The tube creates a virtual 'space' which brings all the parts together into one whole. The transformation rests on a sense of there being a possibility of projection over symbols used which are abstracts. These symbols also inspire the participants to re-create their own order.

There are discontinuities in time, when the participants have to wait for the next station or realm. When one brings all dimensions together there is a perception of transformation

and also there is the experience of the moments of synchronicity and projection. The combination of many separated factors, when put together and raised to full consciousness creates a type of momentary identity.

Creative imagination is the most important of all human's mental faculties; to use it is to become awake. Totality – wholeness – comprehend an intricate, incessantly vibrating and living web, a mesh of interlocking relationships and correspondences which may be better expressed through metaphors and allegories.

The Xamantic Web and the Xamantic Journey are amalgamations of myths, dreams, natural world phenomena, shadows of the past, delight for life, all entwined. The poetic imagination mingles and mixtures all the signs which emerge from the unconscious through syncretistic processes with daily life. They bring forth new poetic situations. They constellate archetypes present in the collective unconscious. They need participants with poetic attitudes so they may find delight in interacting with this abstract dreamland.

The Xamantic Web and Xamantic Journey were built based on concepts such as lightness (Calvino, 1993), complexity, multidimensionality and non-linearity. They create allegories which may propitiate the expansion of consciousness. They are abstract worlds built over old traditions, timeless archetypes, ancient symbols, native myths still alive, the study of natural forces and shapes and the discoveries of contemporary science. The participant can drifts in and out of these virtual worlds having poetic attitudes as a leading thread to be followed. They aim to reorient consciousness allowing the rediscovering our creative potential through telematic transformation of our ways of seeing.

The non linearity and multi-dimensionality, possible when working with languages such as VRML and JavaScript, conducted to the rediscovering of allegories. Allegories were used in ancient times to convey complex meanings because they make possible the superposition of multiple layers of metaphors creating a variety of meanings and generating depth. They allow the fragments also to be meaningful parts of a whole.

Beuys equated the contemporary artist with the shaman since both are engaged in a spontaneous and dynamic evolution towards equilibrium. Both work intensifying awareness, integrating altered states of consciousness. The Czech-Brazilian philosopher, Vilen Flusser, considered the task of art and philosophy to fight stereotypes and 'robotization' of consciousness (Flusser, 1998). In his opinion this can only be accomplished when eyeing inside the computer's 'black box' to unveil unexplored and unexpected possibilities. If not, artists and philosophers will become functionaries of the machines, enslaved by interfaces and procedures they have to obey and which can constrain their work. He also used to say that computers are semiotic machines which can be used by artists in revolutionary ways to present new poetics actions of sharing and transform signs. New poetics possibilities may emerge from the interplay of chaos and order through artist's actions. These may subvert the established use of computer languages and give birth to new articulations of signs.

References

Baigent, Michael and Leigh, Richard, 1998. *The Elixir and the Stone*. Harmondsworth: Penguin Books.

Calvino, Italo, 1993. *Seis Propostas para o Próximo Milenio*. São Paulo: Companhia das Letras.

Durrell, Lawrence, 1960. *The Alexandrian Quartet* London: Faber.

Flusser, V. 1998. *Ficções Filosóficas*. São Paulo: EDUSP.

Wijers, Louwrien, 1996. *Writing as Sculpture*. USA: National Book Network,

Notes

1. Murray Stain on a recent internet junguian discussion group
2. See Eliade, Mircea, (1989) *Shamanism*. London: Arkana; Larsen, Stephen, (1998) *The Shaman's Doorway*. USA: Inner Traditions International; De Rola, Stanislas K. (1997) *The Golden Game*. London: Thames and Hudson; Von Franz, Marie-Louise (1980) *Alchemy*. Toronto: Inner City Books; Von Franz, Marie-Louise (1998) C. G. Jung: *His Myth in our Time*. Canada: Inner City Books; Jung, C. G. (1985) *Mysterium Coniunctionis*. Petrópolis: Vozes,; and Campbell, Joseph (1991) *Creative Mythology*. USA: Arkana,
3. The Xamantic Web is at the following electronic address:
 http://www.unb.br/vis/lvpa/xmantic/
4. The Xamantic Journey is at the following electronic address:
 http://caiia-star.soc.plym.ac.uk/projects/XMANTIC/journey.html

Making Emotional Spaces in The Secret Project: building emotional interactive spaces

Richard Povall

For better or worse, in reality we are not centred in our head. We are not centred in our mind.... Bodies and minds blur across each other's supposed boundaries. Bodies and minds are not that different from one another. They are both composed of swarms of sub-level things. (Kevin Kelly, 1994, p. 64)

The work of *half/angel* [1] is based in transparent interactive spaces that are physically and emotionally intelligent. What do I mean by this? Our interactive performance work, developed only after several years of practice-based research, attempts to work with the consciousness of the living body as an emotional entity. In using motion-sensing systems to create a live, interactive environment, I try to programme our systems to capture not literal movement, but overall movement content and impulse. I have rejected the more common methodologies of moving further and further towards a literal, accurate, detailed interpretation of the physical body, and instead use speed, direction, acceleration, and size of moving objects to gain an approximation of the kind of movement that is occurring in the performance space. Although I am able to sense an object's position in space, I rarely use this data, usually considering it irrelevant or unnecessary. Instead, I am looking instead for information from the movement that tells me how, and therefore possibly why the performer is moving. I am searching as much for the emotional intentionality of the movement as I am attempting to map the actual, literal physical movement.

In this I am helped by a wonderful feature in Tom DeMeyer's software package, BigEye [2], which provides me with 'virtual objects'. In *BigEye* I am trying to identify, and then track, moving 'objects' within the performance space. These objects can be a whole human body, or a small part – a finger or a foot, for example – my choice, even my choice on the fly during a performance. The virtual object simply carries on where the physical object left off.

So, if a live object is travelling leftward on the stage at a given acceleration, and then stops – the virtual object will keep on going for a little while longer. This gives my data a roundness, a fluidity, that it would not otherwise have. The data flow doesn't just stop when the body stops, it sort of gently fades and dies (like we all do, I suppose). I have no idea why Tom built the virtual object – but I bless him every day I work with this system. Last time I spoke with him, I mentioned this, and he was amazed to hear that anyone was actually using this feature – it was the first time he had come across it actually being used.

There has been some recent debate challenging the simplistic notion that all human emotions and mental phenomena are rooted purely in the chemical reactions of the brain – that the brain is not the be-all and end-all of human existence – that there is something other that is involved in the process. This, too, may ultimately be a chemical process, but one that is more ephemeral and unknown than the calculations of the conscious and sub-conscious.

The emotion engine that drives our humanity is still extraordinarily undefined, and will perhaps remain so. If an interactive performance system can be designed that shows an awareness of the emotion engine, and cares that it exists in addition to the more objective processes of the body, then perhaps we have a direction that will yield a more successful machine consciousness.

When working with interactive technologies and dance, we are indeed challenging the notion that all thought and emotion originates in the brain, with a consequent filtering out to the mouth, the vocal cords, and the limbs and other muscle groups in order to express it. No, we are challenging an inversion of that idea – that all physical acts reside in the body, not the brain, echoing the separation of mind-state and body-state that has become fashionable in consciousness research. In dance we tend to think, in our desire for a kind of Puritanism that is still remarkably pervasive, that the trained body is making beautiful shapes because it has been told to make beautiful shapes, and has then rehearsed those beautiful shapes until is capable of reproducing them without thought.

It can be argued however that much of modern dance, particularly when there is an element of improvisation in the work, is a highly cerebral and emotional (these two are not necessarily in opposition) activity, and that the emotional content of the movement is overtly presented to the viewer. When we try to look at these movements with a computer eye, though, we ignore all the subliminal information (however overt it may be) and choose to concentrate purely on the physical activity of the body – we try (in vain) to assess the movement of each performing body with a deadly accuracy, only to miss the point entirely on most occasions. Better that we should try to look beyond, or underneath the skin of, the overt physical act.

Pepperell says:

> Consciousness can only be considered as an emergent property that arises from the
> coincidence of a number of complex events. In this sense it is like boiling. Given sufficient
> heat, gravity and air pressure the water in a kettle will start to boil. We can see what
> boiling is, we can recognise it as something to which we give a name. We do not consider it
> mysterious, yet we cannot isolate it from the conditions that produced it. We cannot isolate
> consciousness from the conditions that produce it any more than we can isolate boiling.
> Consciousness is a property that emerges from a given set of conditions. (Pepperell, 1995 p.
> 6.)

So, too, the physical manifestation of a choreographed or improvised movement is more
than its physical manifestations – and we see all the implicit work of the emotion engine
in each physical movement of the body. How do we ask a computer to see the same?

When attempting to analyse or capture movement on the stage, we must remember
that there is more to movement than the movement. Lanier has pointed out that
'consciousness is the thing we share that we don't share objectively. We only experience
it subjectively, but that does not mean it does not exist' (Lanier, 1996). Similarly, it can
be argued that dance movement exists not just within a single body, but within the entire
context of what is happening within the performance space, and within the emotional
space of the work. Much of what is communicated to the audience is implicit in the
movement, not overt. Ever watched dance on video? How rarely it is successful. Dance is
arguably the performing art that translates the least successfully to the screen,
particularly the small screen. This is at least partially a function of what the camera –
the objective electronic eye – cannot see.

In our interactive performance work, we make performance spaces that are live
spaces, conscious spaces, in which the work is made in the moment. It is not possible to
set a choreography for this work, because there must be a constant link between
performer and the interactive system – the performer listens, moves, creates changes to
the soundscape, listens, and moves again, and so on. This cycle is an essential one, and a
conscious one. If the connection within this feedback loop between performer and
machine is broken (if, for example, the performer forgets to listen, or loses concentration
on the sound environment that is being made, or if the computer fails in its part) the
core essence of the work is lost, and it begins to fall apart. Herein lies the inherent
subtlety that makes these kind of systems work. The connection between live body and
insensate computer is intimate and emotional – we have a desire therefore to label what
is happening here as a form of machine consciousness, because we want somehow to
recognise and even honour the fact that something special is taking place. We want to be
able to tell ourselves that the machine is 'conscious' in order to give a name to what
Ghislaine Boddington has referred to as 'the fifth dimension' within this work.

The confusion of gestures between mover and machine is remarkable and
extraordinary, what my partner Jools Gilson-Ellis describes as a corporeal confusion.
When the system is working well, there is no clear, literal, boringly obvious connection
between performer and machine, but instead an almost subliminal connection that an

audience senses rather than sees. Thus, we are inviting the audience to partake of our consciousness – our dynamic bond between machine and performer – even though we choose at the same time to make the technology itself entirely transparent and invisible. Take that vital link between human and machine away, however, and an audience is well aware that it is not there.

Has it become possible, then, to design a human/machine interface that is about the body or the mind? Rather than trying to design a machine that can mimic the human brain, with all the impossibilities of defining human consciousness implicit in that notion, can we not instead design a computer system that is so sensitive to human-ness, to emotional being, that it is *de facto* intelligent? In our work, we have found that this can be done with a fairly simple system, but one that can, despite its simplicity, begin to have a sense of why a human is doing what it is doing, rather than simply what it is doing. Perhaps we have designed a system that in some way cares what data it is gathering? Rather than attempting to build a system that is objectively human-like, we have attempted instead to design a system that is subjectively human-like – a system that has a vested interest in the data it gathers, and is therefore capable of imputing gaps in that data (this is partly where BigEye's virtual objects come into play). The simplicity of the interface is actually not insignificant. I would suggest that the ultra-accurate movement-data-gathering systems such as the ones emerging from the MIT Media Lab and other such research centres around the globe are ultra-complex systems that are extremely clever, but which have no innate sense of the data they are gathering. Their complexity, in the end, serves them no purpose. In talking to these researchers, it seems clear that their research is entirely focussed on gathering supremely accurate and detailed data about a moving body. Rarely, however, do they know what to do with this data, or even how to develop evaluative mechanisms for assessing its usefulness. The typical response when they see our work is 'Wow – how can you do all that with so little information?' The New York Times has said that our work is 'as subtle as live dancing.' The irony of the fact that it is, of course, live dancing can be overlooked in favour of the fact that this technologically inexperienced critic recognised the bond between performer and machine – even if she didn't know how to put it into words.

So we can now posit that when trying to build a motion-sensing system. we need to look less at the objective body-state. Instead we should be looking at the subjective body, observing how it is moving, and attempting to extrapolate the reasons why it is moving how it is moving. This does not necessarily involve minutely accurate readings of each of the physiological phenomena that go to make up a particular movement. Instead, we need a way to observe the emotion engine at work, as it drives the human body to move. Within an improvisational framework, emotion is playing a large part. Even within a set choreography, emotion is and should be a large part of what we are watching (this is admittedly a way-post-Cunningham post-post-modern notion). The objective physical phenomena of movement are just a tiny part of what we see when we watch dance – and what the computer needs to see when it watches movement is the hidden parts, as much as the overt parts. Just as the human ear hears in a totally different way when compared to a microphone, because it is capable of making many filtering and discriminatory decisions in an instant, so the human eye sees differently from a camera.

The camera is insensitive to content – the human eye is minutely sensitive to all the implied information it is not seeing. We need to design software environments that can supplement the dumb obeisance of the camera to the absolutely overt, and begin instead to let the machine see, and enjoy, the implied action and the emotional state that is driving the overt action.

We are trying to focus as much on the brain-power behind a physical act as we are the muscle-power. If we want our machines to capture movement and we want the data to reflect the holistic sense of the movement – not just the physical acts – then we have to attempt to give the machine an understanding of the implied – a consciousness if you will. This, of course, is all highly subjective (surprise!) and it impossible to 'prove'. that we have allowed the computer to begin to understand the implicit that lies behind the overt physical action. I will argue that what comes out the other end – what I actually do with the data I receive – does reflect the implicit, the emotional content of the movement, the content ideas of the work. Of course, there's no equivalent of the Turing test that will prove that an audience is fooled into believing that the computer is intelligent – that, in fact, misses the point entirely. No, the proof of the pudding is in the work itself. There is an emotional wholeness that exists within this work, precisely because I am choosing to discard purely physical phenomena, and concentrating instead on the implied action, the virtual movement, the hidden gesture that is not necessarily ever made flesh.

Is this consciousness? Who knows? Who knows (still) what we mean by that term. It is, however, sensitivity. I want to make systems that are humanly sensitive, and sensitive to human emotion and emotional content. I want to build systems where there is a genuine sense of communication between the machine and the human. These systems are not intelligent in any sense of the word as we understand it – but perhaps they do have an innate emotional intelligence. I want to treat the machine as a cohort in the making of a performance work – an almost-being that strives along with me to be increasingly sensitive to the moving bodies on the stage, able to listen, and hear, what they are saying through their overt and implicit movement.

Notes

1. half/angel is a performance research company directed by Richard Povall and Jools Gilson-Ellis. Their most recent performance project is The Secret Project, and currently in early development is The Desire Project.

2. BigEye, the software that came out of the STEIM stable in 1996, is the tool I have been using for the past three years. It is a relatively simple programme that looks at a video space in real time, and attempts to analyse what is happening in the space, either through difference (motion), or colour tracking. For more information, visit http://www.steim.nl

References

Kelly, Kevin, 1994. Out of Control: The new biology of machines. London: Fourth Estate.

Jaron Lanier (1996??) 1000 Words on Why I Don't Believe in Machine Consciousness. Originally published in The Sunday Times (London), but date unknown. For the text visit:
http://www.well.com/user/jaron/writings.html

Pepperell, Robert, 1995. The Post-Human Condition. Exeter: Intellect Books.

The Spectactor Project: A Multi-user narrative in 'Mediaspace'

'palmeres for to seken straunge strondes'

Mike Phillips, Peter Ride, Mark Lavelle, Simon Turley

1: Mediaspace:

> But nathelees, whil I have tyme and space,
> Er that I ferther in this tale pace,
> Me thynketh it acordaunt to resoun
> To telle yow al the condicioun
> Of ech of hem...
>
> (Chaucer, The Canterbury Tales)

This paper explores the spaces and places generated across a series of satellite transmissions and multi-user VRML environments, and attempts to locate them within an appropriate context in order that they may be better articulated and understood. These technologies have for some time been at the heart of an integrated internet/publishing/broadcasting experiment called *Mediaspace*, the *Spectactor* project builds on the experiences and experiments. The construction of these media spaces/places creates stress on the traditional framing and articulation of broadcasting and publishing activities. Neither of these practices adequately explains, incorporates or applies synchronous and asynchronous multi-location interactivity within a single framework. The Spectactor Project explores the impact of these attributes on the production and consumption of a narrative that is performed by actors, avatars and autonomous objects/texts within such a framework. The narrative structure explored through the Spectactor Project takes on an architectural significance, a moment fractured across a distributed space only to be re-constructed by the passage of an audience moving through it. Within the Spectactor Project narrative and telematic forms converge within a broader architectural form.

> The hybrid or the meeting of two media is a moment of truth and revelation from which new form is born. For the parallel between two media holds us on the frontiers between forms that snap us out of the Narcissus-narcosis. The moment of the meeting of media is a moment of freedom and release from the ordinary trance and numbness imposed by them on our senses. (McLuhan, 1964)

The complex layering of media form and technologies incorporated into the Spectactor Project is harnessed to allow participants (VRML avatars, studio audience, ISDN participants, etc) to engage in a dramatic narrative that unfolds across the interactive strata of spaces, which become intrinsically interwoven through the non-linear progression of the

narrative. This empathic network generated from disparate perspectives presents a unified narrative whole, the shared experience of the 'hive mind'. At the point of convergence of the ICT forms incorporated into the *Mediaspace* of the *Spectactor* Project lies a new space/place that defines both the vehicle for the message and the mode of consumption by the audience. In the interstices of these forms lies a rich seam of unexplored potential, the co-ordinates for a telematic landscape of interactivity.

2: Synchronous and Asynchronous Space:

The perception of the self within the interaction between the modes of communication and the participants is important. The projected body exists (whether in avatar or video form) within a fractured space-time structure, which relies on the memories of the other participants and the spaces being occupied as well as previous interactions. When this model of interaction is layered onto the globe (Figure 1), and is consequently distributed across several time zones, the problems created by asynchronous activity increase dramatically. Communications and conversations are extended over days within certain strands of the model, whereas other strands provide subtle levels of social communications through a look or a glance, which is almost imperceptible. The failure of this map, although demonstrating a linear time based process, is that it cannot cope with the implosion of space and time, the shrinking of distances and the multiplicity of time that occur within the *Mediaspace* system.

The virtual environments merged with the studio production also offers a vehicle for expanding the scope of each broadcast. The 'place' suggested by the VRML spaces extends the experience of the participants. The studio space is focused on generating a transmission through the convergence of the telematic activities. It is a focus point that is reproduced at the reception sites through the TV screen, homogenised and compressed down a satellite beam, and ultimately reduced to a television screen and the speaker of the monitor. This fractures the single point of view offered by the TV screen, a greatly reduced Renaissance perspective. By providing a global, distributed telematic landscape it is possible to extend the Albertian window, offering a high tech Baroque vista.

> The eye itself has not, of course, remained in the monocular, fixed construction defined by Renaissance theories of perspective. The hegemonic eye has conquered new ground for visual perception and expression. The paintings of Bosch and Bruegel, for instance, already invite a participatory eye to travel across the scenes of multiple events. The seventeenth-century Dutch paintings of bourgeois life present casual scenes and objects of everyday use which expand beyond the boundaries of the Albertian window. Baroque paintings open up the viewer's vision with hazy edges, soft focus and multiple perspectives, presenting a distinct, tactile invitation, enticing the body to travel through the illusory space. (Pallasmaa, 1996)

3: The Story So Far... Away:

The narrative that is constructed through this post-Albertian window by the audience traversing the structure, which is contained within the *Spectactor* Project, is inspired by Chaucer's *The Canterbury Tales*. This grand narrative provides a 'holding-form' for the *Spectactor* Project through a series of narratives, which are episodic but inter-associated.

Figure 1: Layered Map.

The tales are about story-telling and listening. The over-arching narrative is that of a journey undertaken by a diverse group of people on a pilgrimage to Canterbury. To entertain themselves, the characters tell stories to each other. In fact this is, structurally, the characters' main function, so that in turn they alternate the roles of audience and performer. The tales provide layered fictions within fictions, which engage and require the complicity of the audience and the other characters. Approaching Chaucer is a little like navigating through a virtual environment: you 'dip' into it rather than read it from beginning to end, it has a shape but no great consistency, and the stories are worlds within themselves that each have their own logic and style.

Though the Project has moved beyond this text as the main source of narrative *The Canterbury Tales* has become the key structural reference point because it gives a recognisable scope and context to a performance but does not need to offer a narrative closure. Chaucer intended there to be some one hundred and twenty separate stories within the meta-narrative of the pilgrimage, on his death there were little over a score completed with several incomplete and fragmented. For this Project the meta-narrative will be used as the model with which to define how the writers and participants engage with each-other, how narrative can shift from space to space, and how characters can take alternative stories and personae.

The world of the *Spectactor* is the indefinable space/place in which stories are told: the place of storytelling. Like the pilgrims, everyone entering this world has the potential to be a story-teller, or to interject or challenge any story element. The interest is as much in the act of telling of the tales as it is in the actual story itself.

4: A Squaymous Tale of Farting:

The Miller's Tale is a 'noble' story told by the drunk Miller, and follows the Knight's long narrative of chivalry (since revealed to be a catalogue of military disasters and atrocious blunders: 'it's the story of an old carpenter, his young wife and the student who made a fool out of him'. The narrative reveals each of the participants and their peculiarities: A lengthy portrait of Nicholas, the student, a skilled astrologer, particularly good at weather predictions with a modest look, 'lyk a maiden meke for to see', and a musician who can make 'all the chambre rong'; Alison, the carpenter's wife, described in very sensual terms, young, lithe, strong and beautiful...'Hir mouth was sweete as bragot or the meeth, /Or hoord of apples leyd in hey or heeth'; Absolon, the second suitor, vain, self-obsessed, effeminate and 'squaymous of farting'; The carpenter, John, rather stupid, easily fooled, and possessive.

A love-pact is formed between Alison and Nicholas on the condition that he can outwit the carpenter, a simple task for the multitalented student. Nicholas convinces the carpenter

that by reading the stars he has found out that there is going to be another great flood, the whole of the earth is going to be destroyed by this cataclysm. Completely taken in and terrified he takes the students advice to haul three large wooden tubs into the rafters of the house. All three will sleep in the roof until the flood waters reach the level of the tubs, John must then take an axe and cut the ropes holding them, so that they can then float free and wait for the floods to subside. Exhausted by all his hard work, John falls asleep, whilst Nicholas and Alison creep down their ladders and have their night of lust.

Growing desperate Absolon takes himself around to the bed-chamber window to press his suit once more. He agrees to leave for a kiss, Alison agrees to this on condition that he shuts his eyes. Sticking her bottom out the window it takes a little while for Absolon to realise what he is kissing. Instantly cured of love, Absolon is fired up for revenge. Borrowing a red-hot coulter he returns to the carpenter's house and knocks at the window and asks for another kiss. Nicholas decides that it would improve the joke further if he stuck his bottom out of the window to be kissed, and farting as vigorously as possible he is branded by Absolon. All hell breaks loose. Nicholas in his distress calls for water. John, waking and hearing the cries of 'water' imagines that the flood has come and cuts the rope holding his tub. The tub crashes to the ground and John breaks an arm. The neighbours come running. John tells his story of the flood – everyone takes him to be mad. So ... the possessive carpenter has been cuckolded and carted off to bedlam, Absolon has had a taste of true love, Nicholas has need of a skin graft, whilst Alison has got clean away....

5: The Present Moment Divided:

The *Spectactor* Project explores the application of a narrative through the *Mediaspace* system. Here the complex layering of media form and technologies is harnessed to allow participants (VRML avatars, studio audience, ISDN participants, etc) to engage in a dramatic narrative that unfolds across the layered system shown in Figure 2. Here the

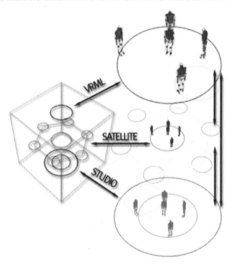 interactions between the studio 'actors' and the studio audience is extended into the video conference space, allowing remote actors to integrate with those in the studio. An extended audience is enabled in a similar way. The studio audience engages with the production through their presence in the studio, but also views the ISDN participants on studio monitors. The remote audience are able to engage through the satellite TV reception, and the ISDN conference (which is also incorporated, through chromakey, into the TV signal). The convergence of these two layers within the single video signal generates a complex level of interaction, along with a non-linear and muli-spatial layering of the narrative structure.

Figure 2: Spectactor Model.

Figure 3: Peeling Narrative.

However, the narrative is further extended by the incorporation of a VRML replication of the event. The actors and the studio space are replicated within a VRML world. This multi-user environment also allows a distributed audience (which may include those with the satellite reception and ISDN conferencing equipment) to participate with the actors (some of who are also avatars). These elements also converge within the chromakeyed video signal, and are transmitted over the geographical space of the satellite footprint. As the participants / spectactors engage with each other and the system, the physical structures which surround them, the environments of brick and plaster that house the audience and the equipment, slowly dissolve. As they suspend their disbelief and consume the narrative exchange between the layered spaces they are slowly drawn into the psychological, imaginary, social and virtual place that the system constructs. Within this new place a complexity of spaces and times become intrinsically interwoven through the progression of the narrative.

The various elements that make up the *Miller's Tale* are distributed through the Spectactor structure. The VRML environment is constructed from many separate worlds, each containing a separate element of the narrative. Figure 3 depicts these fragments, peeling away from the central narrative. Each separate fragment represents an aspect of the story, the listeners, the characters, the props the text. By fragmenting the whole, the VRML worlds provide a series of discreet experiences, all revolving around the moment where red-hot iron meets skin, or the tub crashes through the floor, or the love pact is made. The moment of the narrative is fragmented into a spectrum of separate elements, which are brought together for the viewer as they traverse the worlds and interact with others.

Notes

The *Spectactor* Project and *MEDIASPACE* projects can be found @: CAiiA-STAR.net

References

McLuhan M, 1964, Understanding Media: The Extensions of Man, Routledge, p. 55.

Paik N J, 1984, Art and Satellite, ed Stiles K. et al, Theories and Documents of Contemporary Art. University of California Press. p. 435.

Pallasmaa J, 1996, The Eyes of the Skin, Polemics, Academy Group Ltd, p. 23.

von Wodtke M, 1993, Mind Over Media, McGraw-Hill, p. 21.

Mike Phillips is currently leading the Interactive Media Subject Group at STAR. mikep@soc.plym.ac.uk
Peter Ride is director of DA2 (Digital Arts Development Agency). peter@da2.org.uk
Mark Laville is an actor and director of the Barbican Community Theatre in Plymouth. <mark.laville@virgin.net>
Simon Turley is an author and playwright. simon@turley.demon.co.uk

Interactive Media and the Construction of Dramatic Narrative:

becoming and identity in contemporary American drama

Rhona Justice-Malloy

> We need new forms of expression. We need new forms. And if we cannot have them, we
> better have nothing. (Anton Chekhov, *The Seagull*)

Interactive media and the information highway have clearly come to impact our understanding of consciousness and our perception of reality. The 'point and click' non-linear method of acquiring knowledge and creating identity has become a cultural enthymeme that embraces multiple fields, simultaneity, and complexity. Interactive media have essentially informed the way we learn about ourselves, construct our identities and consciousness and comprehend the very nature of reality.

Contemporary American playwrights are co-opting the experience of cyberspace in order to tell stories about identity on the stage. Many such plays have won Pulitzer Prizes and have enjoyed successful runs in New York as well as regional and academic theatre around the United States. The success and recognition of these plays are due at least in part to their ability to realize the cultural enthymeme of interactive media and technology. In each, the construction of dramatic narrative challenges traditional structures by utilizing multiple fields of knowledge, simultaneity of place and action and complexity. Let us begin with an explanation of how the term 'cultural enthymeme' will be used in this essay.

In his *Rhetoric* Aristotle tells us that the enthymeme is a thought process used by a group or civic order, as opposed to formal logic. He says only that it must not employ long chains of reasoning or it will lose clarity. Nor should it include every link else it fall into prolixity (1921). August W. Staub has written several illuminating and complex essays on the enthymeme and drama (1997). The following brief explanation of the use of the enthymeme in this paper is highly indebted to his work.

Staub refers to the 'cultural enthymeme' in relation to drama. He sees the enthymeme in performance as a way to encourage a public thought process in the spectators. The enthymeme, particularly in drama, entails twisting ideas together in a non-linear action that does not fill in all the links so that it may be brief as opposed to the epic, which requires a linear procedure and thus a longer chain of reasoning. We might think of the drama as digital and the epic as analog.

For the Greeks, drama was meant to be seen. In plays such as *Oedipus Tyrannus*, the spectators viewed public figures struggling publicly with civic intelligence and order. All

theatre, like the cyberworld, is for spectators, not audiences. We experience each event first and foremost with our eyes. As a consequence both are enthymemic. Both are to be grasped as a thing-in-action, as process, as energy and event which serves as a singular proof of their own validity because they are seen to be and can be seen nowhere else. It is in the body of existing assumptions, understandings, and processes of a given cultural group that the enthymeme obtains. Staub points out that a phrase such as 'Richard the Lion Hearted' can only occur in a culture that publicly agrees that Richard was brave, that the source of bravery comes from the heart, and that such bravery was shared in common with a certain animal, the lion. For a given civic intelligence that did not know of lions or the inner workings of the body such a phrase might be perplexing, even meaningless (1997).

In his keynote address to the International Society for the Arts, Sciences and Technology, Roy Ascott articulated the appeal of the enthymeme we know as cyberspace. 'Cyberspace is the very stuff of transformation; it embodies being-in-flux, constituting a kind of artificial becoming. But its primary importance is that it stimulates change in ourselves, transforming aspects of mind and behavior, bringing forth cyberception, teleprescience, altering the ratio of the senses' (1998).

Theatre by its very nature has a similar appeal. Theatre phenomonologists such as Bert O. States (1985) explain that when we experience a performance the actors and audience are transported to somewhere else than we usually tend to be. This somewhere else is not a spacial elsewhere – we remain in the auditorium or on the stage. We are elsewhere in the sense that what is before us offers a different kind of here than we usually tend to be in. Like cyberspace the theatre is a place of disclosure, of event and energy. And what is disclosed in such events cannot be found elsewhere because it does not exist outside of the encounter.

The similarities become even more striking when we consider interactive game playing. Sociologist Sherry Turkle has been studying such playing and the construction of identity in MUD games. Turkle describes the relationship between the players and the 'characters' they create. 'MUDs blur the boundaries between self and game, self and role, self and simulation. One Player says, "You are what you pretend to be... you are what you play"' (1995). This is not such a striking statement when we compare it to Stanislavski's observation that 'When true theatre is taking place the actor passes from the plane of actual reality into the plane of another life' (1948). This process Stanislavski called 'living over' a part. Turkle prefers the metaphor of windows for thinking about the self in cyberspace as a 'multiple, distributed system.... The life practice of windows is that of a decentred self that exists in many worlds, that plays many roles at the same time' (1996). We can see that theatre and cyberspace share many similar components.

It is with this idea in mind that I now turn to contemporary drama, cyberspace and the construction of identity. Three recent Pulitzer Prize winning American plays capture the enthymeme of cyberspace employing its structure, tactics, and strategies into the dramatic narrative structure itself. Edward Albee's captivating play *Three Tall Women*, Paula Vogel's *How I Learned to Drive*, and Margaret Edson's *Wit* all employ the idea of windows as a metaphor for constructing identity. All three dramas, which have experienced immense success in the United States and abroad and should be available to most readers in paper or production form. For the purpose of this essay I will limit my comments to Vogel's *How I Learned to Drive*.

In a non-linear narrative, the girl/woman Li'l Bit explores her memories of her relationship with her Uncle Peck, whose driving lessons taught her as much about gender relations and her own sexuality as they did about the proper use of rearview mirrors, gear shifts, and turn signals. Driving becomes the action that evokes Li'l Bit's memories; but the play itself evolves digitally, jumping back and forth in time as Li'l Bit's mind accesses memories of the attentive and abusive Uncle Peck in seemingly random order. Sitting in straight-backed chairs on a nearly bare set, Li'l Bit and Peck enact the car rides that shape and intertwine their lives. Minimal props and set pieces are used. The spectators navigate the space of the play with the help of a series of point and click images of road signs, cars, maps, and Vargas pin-up girls projected onto the playing area transforming it from a framed event to simultaneous cyber-windows. As scenes jump instantaneously through time we see Li'l Bit morph from a shy eleven year old to an adult seductress of teenage boys to a teenager who has just earned her driver's licence and back again. A 'Greek Chorus' of three performers play various roles shifting scenes and characters with the click of a cursor. The play gains complexity as Vogel effectively builds sympathy for a man who might otherwise be despised as a child molester. Peck is charming, kind, and sympathetic, a man driven toward children by his own experience of sexual abuse but attentive to Li'l Bit's adolescent needs. The play presents the careful balance of power between Peck's adult desires and Li'l Bit's flirtatious sexuality. Finally, at the very end of the play Vogel leads the spectators to the very first driving lesson.

In this final, devastating scene, Vogel completely engages us in the enthymeme as spectators; we see for the first time the sexual abuse as energy and event, not words. For this moment Vogel engages Li'l Bit as spectator as well. Vogel fractures her persona as the youngest female Greek Chorus member becomes Li'l Bit at the age of eleven. This is the first driving lesson. The older Li'l Bit sits almost complicity in the passenger seat next to Uncle Peck. Peck invites the youngster to sit on his lap and steer the car as he operates the pedals. The girl is cautious but fascinated and finally climbs onto Peck's lap.

Li'l Bit (played by the Teenage Greek Chorus) moves into Peck's lap. She leans against him, closing her eyes.
PECK. You're just a little thing, aren't you? Okay – now think of the wheel as a big clock – I want you to put your right hand on the clock where three o'clock would be; and your left hand on the nine – (Li'l Bit puts one hand to Peck's face, to stroke him. Then, she takes the wheel.)
TEENAGE GREEK CHORUS. Am I doing it right?
PECK. That's right. Now, whatever you do, don't let go of the wheel. You tell me whether to go faster or slower –
TEENAGE GREEK CHORUS. Not so fast, Uncle Peck!
PECK. Li'l Bit – I need you to watch the road – (Peck puts his hands on Li'l Bit's breasts. She relaxed against him, silent, accepting his touch.)
TEENAGE GREEK CHORUS. Uncle Peck – what are you doing?
PECK. Keep driving. (He slips his hands under her blouse.)
TEENAGE GREEK CHORUS. Uncle Peck – please don't do this –
PECK. Just a moment longer – (Peck tenses against Li'l Bit.)
TEENAGE GREEK CHORUS. (Trying not to cry.) This isn't happening. (Peck tenses more,

sharply. He buries his face in Li'l Bit's neck, and moans softly. The Teenage Greek
Chorus exits, and Li'l Bit steps out of the car. Peck too disappears.)
VOICE. (Reflects.) Driving in today's world.
LI'L BIT. That was the last day I lived in my body. I retreated above the neck, and I've lived
inside the 'fire' in my head ever since.

This ending is transformative and causes the spectators to reconsider and reconstruct their
remembrance of all that has gone before. Our memory of the play is altered at every turn.
As Vogel describes it, 'You remember the play differently in the middle than you do in the
beginning or at the end, and of course you remember the play differently the morning
after' (1997). Vogel's play achieves precisely what Ascott describes as the function of digital
media when it involves 'human intelligence in a non-linear emergence, construction and
transformation' (1998). We finally understand because we have seen. Following this
enthymeme it is not surprising that in this moment the character of Li'l Bit realizes her
own identity along with the spectators.

Like cyber-life, Vogel has created a play in which the spectators encounter, though not
by any predictable (framed) movement, various events indicated by independent structure
and locations. The space of her play has no special shape or orientation; it may be observed
from any direction. Her story unfolds without character or definition, Vogel, as auteur is
nearly anonymous. She refuses traditional forms of dramatic structure. There are no
protagonists or antagonists, no resolution. The play is labyrinthine, not linear. The entire
experience of the performed play is a process. Like cyberspace, we finally apprehend the
play because we have moved through it. When I speak of space in this context I do not
mean the physical space of the theatre or the set. I am speaking of space as we experience
it in the cyberworld. This space is transient and transformative.

Vogel's work presents all the recklessness and preparation of a true cyberspace gamer.
She writes, ' In the first five minutes of a play, the audience is naive. They don't know what
the rules of the game are yet. By midway, they're sophisticated. They know the vocabulary.
Then comes that great moment when you pull the rug out from under them. You
deconstruct the play and expose the devices in a decadent mode. I know a play works
when, while the audience runs through computer brains of the two thousand plays they've
seen and tries to calculate where the play is going, the emotion grabs them by the throat
and they forget about all the other plays they've seen' (1999). Like the cyberworld, Vogel's
play is a dynamic agency of change. And like the constructors of MUDs, Vogel places the
burden of constructing what the play ultimately means on the spectator.

Why are such plays so wildly popular in the United Sates? It is because playwrights such
as Vogel, Albee and Edson have captured the cultural enthymeme of cyberspace and they
have brought it to us for public consideration. It must be remembered that theatre is the
one place where society collects in order to look in upon itself publicly. The theatre is the
place where we gather to confirm or reject a given civic intelligence. As Vogel recognizes,
'There is a point in time where the playwright and culture meet, and that is called
"mainstream"' (1997). The fact that these plays in particular have received national
recognition means that the enthymeme of the cyberworld is no longer virtual. It is real and
it will be with us for a long time.

References

Albee, E. 1995. Three Tall Women. New York: Dramatists Play Service.

Aristotle. 1921. The Rhetoric. (Lane Cooper, Trans.) New York: D. Appleton-Ce Company, Inc, Book II, p. 22

Ascott. R. 1998. Mass '98 Keynote: Strategies of Media Art. L.E.A., 7 (1). Retrieved February 11, 2000 from the World Wide Web:

 http://mitpress.mit.edu/e-journals/LEA/sample/masskey.html

Edson, M. 1999. Wit. New York: Dramatists Play Service.

States, B. O. 1985. Great Reckonings in Little Rooms: On the Phenomenology of Theatre. California: University of California Press.

Stanislavski, K. 1948. My Life In Art. New York: Theatre Arts Books, pp. 464–466.

Staub, A. W. 1997. The enthymeme and the invention of troping in Greek drama. Theatre Symposium, 5, pp.7–13.

Staub, A. W. 1997. Public and private thought: the enthymeme of death in Albee's Three Tall Women. Journal of Dramatic Theory and Criticism, pp. 149-158.

Turkle, S. 1995. What are we thinking about when we are thinking about computers? Routledge Reader. Retrieved November 5, 1999 from the World Wide Web:

 http://web.mit.edu/sturkle/www/routledge_reader.html

Turkle, S. 1996. Who am we? Wired Archive, 4.01. Retrieved November 5, 1999 from the World Wide Web:

 http://www.wired.com/wired/archive/4.01/turkle.html

Vogel, P. 1997. How I Learned to Drive. New York: Dramatists Play Service.

Vogel, P. 1997. [Interview with Steven Drukman]. The Dramatist Guild Quarterly.

Vogel, P. 1999. [Interview with Caridad Svich]. The Dramatist, Vol. 1, #6. Retrieved February 17 from the World Wide Web:

 http://www.dramaguild.com/docs/juldrm.html

Rhona Justice-Malloy is an Assistant Professor of Theatre at Central Michigan University.

Two Portraits of Chief Tupa Kupa: the image as an index of shifts in human consciousness

Niranjan Rajah

Consciousness

In the lexicon of scientific materialism, 'consciousness' is an attribute of individual sentient being. In this concept of 'consciousness', our perceptions, thoughts, sensations and feelings are understood as being related directly to the functions of the brain. In the more empirical cognitive sciences, studies of brain-damaged patients have concluded that 'non-conscious' processes can be separated from 'conscious' ones. There are even those who see consciousness as a symptom of 'neural activity' and that this will eventually be fully reproduced in computers. Indeed, 20th-century materialism, has treated human consciousness as a function of matter.

Awareness

By contrast, in Vedantic theory 'consciousness' is distinguished from 'awareness'. Here the term 'consciousness' refers to an absolute quality: the manifestation of a singular and ultimate reality, while the term 'awareness' is used to index the more personal, subjective or relative sentience attributed to individual human (and other) beings.

> Nothing is far
> Everything is near:
> The Universe
> And the painting on the wall.

This verse, by 12th-century Bengali poet Chandidas (adapted from Mookerjee, p.4) is a restatement, in visual terms, of the fundamental tenets of Vedanta as enunciated by Sankaracharya in the 8th century (Ingemann, website):
1) The Ultimate Reality alone is real,
2) The universe is unreal,
3) The individual Self is not other than the Ultimate Reality.

Chandidas masterfully coalesces the multiple and relative realities of the observable universe and its representations into an indivisible singularity – transporting us most elegantly from an 'awareness' of multiplicity to the 'consciousness' of 'ultimate' reality.

Representation

In the Medieval view the identity between a thing, be it a rose or the universe itself, and any representation of it is understood as being analogical. Here, 'analogy' is 'similitude' in the sense of 'simile' rather than that of 'simulacrum' (Coomaraswamy, 1935, p.13). In Islamic art, wisdom (al-hikmah) determines that every representation must conform to the laws of its domain of existence and must make those laws intelligible. In the graphic arts, this means the avoidance of spatial and vital illusion. Further, geometric expansion provides a metaphor for the law of all phenomena. In as much as space, seen as extension, is created by unfolding through the dimensions – from 'point' to 'line' then to 'plane' and beyond, it can be 'folded up' again, leading back to the point of unity (Critchlow, p.7). In this light, it is obviously the simulacral confusion caused by sculpture in the round, chiaroscuro, perspective and other illusionistic representations in the stages of 'folding up' that underpins their prohibition. Indeed, as Coomaraswamy notes, the Islamic interdiction against images 'refers to such naturalistic representations as could theoretically, at the Judgment day, be required to function biologically' (1935, p.5).

Two Portraits

Ananda Coomaraswamy reconciles the ideal representations of Hindu or Christian iconography and Chinese animal painting with Islamic aniconism by showing that these images imitate the idea of the thing they represent and not its substance. They cannot be thought of as being moved or animated by anything other than their form 'and each should,

strictly speaking, be regarded as a kind of diagram, expressing certain ideas, and not as the likeness of anything on earth' (1935, pp.4-5). The illustration in Figure 1 accompanies an essay by Coomaraswamy (1956, p.116) on 'The Traditional Conception of Portraiture'. It is a juxtaposition of two portraits of the same man – Maori chieftain, Tupa Kupa. One image is a portrait by an English artist; the other is an image made by the chieftain himself. For the purposes of the present writing, this illustration reveals the distinction between what I shall call 'simulacral' and 'diagrammatic' modes of representation. It is the central proposition of this paper that modes of representation reveal different orientations in collective consciousness. The 'simulacral' and the 'diagrammatic' modes index the materialist brain centered 'consciousness' and the more metaphysically astute 'awareness', respectively.

Simulation

Before the European Renaissance, artistic representations were essentially sacred or 'diagrammatic'. Humanism, however, brought about a definitive secularism and gave rise to modern empirical knowledge. Indeed, the antithesis of the 'diagrammatic' mode of representation is the almost palpable presence of the donors on the threshold of Masachio's 'Trinity'. From this point on, visual representations became more and more naturalistic. Fredric Jameson reveals the paradoxical nature of this 'simularcral' ontology. With reference to the super-real fiberglass figures of Duane Hanson, he notes that at the point of realising the unreality of the impinging illusion, there results a momentary 'derealisation' of the viewer's bodily existence (1991, p.34). In this postmodern interpretation, the 'simularcral' mode of representation has a convulsive 'evacuating' effect on the world, confirming the wisdom of Islamic thought. With the advent of 'televisual' imaging technologies in the 20th century, 'everything that was once directly lived', to paraphrase Guy Debord, 'is being replaced by mere simulation' (1995, p.12).

Rituals

The anthropologist Margaret Mead has observed that the little girl trance dancers of Bali dramatise a paradigm of involuntary learning, in which it is not the will of the learner, but the pattern of the situation and the manipulation of the teacher, which prevail. She has described the Legong as a fantasy of the human body made of separate independent parts,

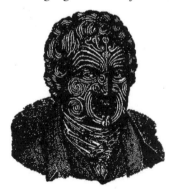 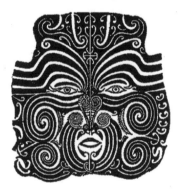

Figure 1. After Frobenius, from 'The Childhood of Man', 1909.

informed by the notion that it is pinned together at the joints like that of a puppet. Coomaraswamy commends Mead's observations but criticises the condescension of her terms 'complex', 'fantasy' and 'notion', and goes on to explain that 'in forsaking her own will ... the Balinese dancer in her rapt ecstasy is not a product of any peculiarly Balinese "complex" but of the Philosophia Perennis'. To elucidate the symbolism of the puppet, he makes one speak: 'if I seem to move of my own will, this is only true to the extent that I have identified myself and all my being and willing with the puppeteer's who made and moves me' (Coomaraswamy, 1979, pp. 96–99). Indeed, dance is a sacred ritual in Bali, and Mead's misreading probably stems from approaching what is essentially a sacred communal 'representation' of the 'diagrammatic' variety, in materialistic terms – terms more suited to the naturalistic representations made within the 'proscenium arch' of the modern theatre.

Beyond Representation

It may be that it is in our transition from the direct communion of oral and performative traditions to the 'written' mode of representation, that we will find the origins of our alienated world of objects and subjects – a world whose consumerist manifestation Debord (1995) has called the 'Society of the Spectacle'. With the advent of today's digital technologies, however, the 'alienation of the spectacle' seems to have dissolved into what Jean Baudrillard has called 'the ecstasy of communication' (1885, p.130). Keith Roberson's experiments with videoconferencing reveal how image-based interactive systems are transforming the contemporary notion of representation. In his interactive online performance works, video signals from different locations are combined or 'keyed' together creating one 'location' where both images coexist. Projections of the participants bodies interact, intersect and recombine in the dissipated, dispersed and delayed interactivity of an online 'composite image'. With prolonged interaction, participants begin to immerse their sense of being within the ontology of the 'image'. As the artist notes, 'When I am participating, the fact that I must look at the image to gain feedback about the bodies' movement places me in a similar position to a puppeteer's. I transfigure my body into my image and myself along with it. I am an image. And in projecting myself into an image, I am subject to the constraints and freedoms comprising my image'. (Roberson, website)

Telematic Communion

Gregory Bateson has theorised that cetaceans have developed a direct, emotive, non-linguistic communication akin to music. In their high-frequency transmissions, dolphins may be communicating numerous delicate feelings and relationships that cannot be expressed in human language (1972, pp. 270–277). Further, Toshiharu Ito speculates that this 'bio-technology' may evidence a culture of pure communication that is superior to our own. He envisages that, with the structures emerging in our new media society, humanity may also be evolving such a culture: a 'culture without objects'. Ito believes that human beings, immersed in an 'information environment can be compared with the dolphins or whales in a new kind of sea' (1994, p.69). In his ISDN 'projections', artist Paul Sermon generates meaningful contact across two and three dimensions in an interaction between 'image' and 'flesh'. Edward Shanken writes how, in Sermon's Telematic Vision, he felt rejected and even violated by persons at remote locations who sat next to him 'virtually' on a sofa (1997, p.61). In

'Telematic Dreaming', as Sermon himself observes, the work creates a 'cause and effect situation' that enables 'the rapid fire of consciousness back and forth between the remote and the local body' (Rajah, 1997, p.116). With electronic interactivity, consciousness has transcended the physical body to commune with its representations in an interactive 'sea'!

Bio-electrical Interface

Indeed, it can be said that human intercourse is undergoing a shift in emphasis from static 'representation' to rapid 'communication' – from transcription to transmission. In Stellarc's 'Fractal Flesh' event, an internet audience was able to view remotely and actuate the artist's body. Stellarc severed a portion of his body from his own individual will and extended agency over it, telematically, to other minds or even to the great 'Mind of Minds' that is the network. In 'Para-site', information gathered from the Internet by a search engine in the form of JPEG images was projected onto the artist's body, while the image data was translated into bodily stimulation. The body's own nervous system became part of a feedback loop as it generated information for the internet, while being automated by information from the Internet. In 'Ping Body' the artist was wired up to the internet so that a portion of his musculature would be stimulated into involuntary movement by the 'ebb and flow of internet activity' (Stellarc, website). Progressive as all this might seem, the author witnessed 'Ping Body' in Rotterdam in September 1996 and was stunned by the violence of the event. Indeed, I left the performance with an involuntary image flashing 'quick-time' in my own mind. It was not an image of Balinese trance dancers in selfless automation, nor was it one of dolphins at play. It was the image of Luigi Galvani's severed frog's legs, twitching in the throes of inaugural bio-electrical activity. We are, at very best, at a primordial stage of networked bio-electrical communion.

Simulacra Proliferate

Meanwhile, with high speed 3D image computing and T1 connectivity the simulacral mode of representation has gone interactive. HEAVEN 194.94.211.200 by Paul Sermon and Joachim Blank (website) involves the use of a CU-see me reflector and a World Wide Web site running off the same server. There are two 'CU-see me bots' permanently logged on to the reflector who appear to be engaged in intelligent conversation and who also engage with new visitors. This work addresses the question of veracity in a 'frictionless' information machine. The Internet may engender a new ontology in which mere on-screen 'presence' fulfills the criteria for truth: a new reality, indifferent to the Platonic distinction of 'origin' and 'copy'. In 'Bodies INCorporated' (Vesna, website), a multi-user environment produced by Victoria Vesna, the possibility of a new and hybrid mode of representation and/or communication is revealed. This work investigates the social psychology and the group dynamics of virtual bodies interacting in a networked community. The 'bodies' are built from pre-determined parts and are given identities and operated by their 'owners' in a public space of live internet links. The bodies can be put on show, put on hold, killed and even altered outside of the owner's control. The emotional responses that emerge from the communication of these meta-corporeal projections of ego are exchanged in the on-line discussions and reveal a strong psychological realism. These psychic 'simulacra' are generated despite the 'diagrammatic' nature of the 'data-space' in which the interaction takes place and in spite of the abstract surface rendering of the body parts in the textures of the elements of nature.

A New Consciousness

It appears that while representations in new media can be 'simulacral' in the extreme, the rapid exchange of representations is taking us beyond representation itself. If, as I have argued, modes of representation reveal differences in consciousness, the recent radical turn towards 'communication' must mean that we are on the threshold of a more literally 'collective' consciousness. Gregory Bateson offers us the best 'image' of the new consciousness, albeit obliquely, in his theory of mind. He defines mind as an 'aggregate of interacting parts or components' whose interaction is 'triggered by difference' (1988, pp.95–137). As Fitjof Capra explains, in Bateson's view, mind is a necessary and inevitable consequence of a certain complexity that is not dependent on the development of a brain and a higher nervous system. For Bateson, mental characteristics manifest not only in individual organisms but also in social systems and ecosystems. Mind is immanent not only in the body but also in the pathways and messages outside the body (1989, p.83). Finally, in theorising the correlation between 'modes of representation' and 'shifts in consciousness', there emerges the question of causation – whether representations simply reflect types of consciousness or whether they actively forge them. But that is grist for further writing!

References

Bateson, G. 1972. *Steps to an Ecology of Mind*. New York, Ballantine.

Bateson, G. 1988. *Mind and Nature: A Necessary Unity*. New York, Bantam New Age

Baudrillard, J. 1985. 'The Ecstasy of Communication'. In Foster, H. ed. *Postmodern Culture*. London, Pluto Press.

Capra, F. 1989. *Uncommon Wisdom: Conversations with Remarkable People*. New York, Bantam Books.

Coomaraswamy, A. 1935, *The Transformation of Nature in Art*. Massachusetts, Harvard University Press.

Coomaraswamy, A. 1956. 'The Traditional Conception of Portraiture'. In *Christian and Oriental Philosophy of Art*. New York: Dover Publications.

Coomaraswamy, A. 1979. "Spiritual Paternity' and the 'Puppet Complex". In *The Bugbear of Literacy*. Middlesex,Perennial Books.

Critchlow, K. 1983. *Islamic Patterns: An analytical and Cosmological Approach*. London, Thames and Hudson.

Debord, G. 1995. *The Society of the Spectacle*. NewYork, Zone Books.

Ingemann, S. 1997. *Non Dualistic Vedanta*. In Project Rishi Society Website. http://www.rishi.dk/guide/home.html

Ito, T. 1994. 'The Future Form of Visual Art'. In *Art and Design: Art and Technology*, Profile No. 39. London, Academy Editions.

Jameson, F. 1991. *Postmodernism, or the Cultural Logic of Late Capitalism*, Verso.

Mookerjee, P. 1987. *Pathway Icons: The Wayside Art of India*. London, Thames and Hudson Ltd.

Rajah, N. 1997. 'Locating the Image in an Age of Electronic Media'. In Roetto, M. ed. *Seventh International Symposium on Electronic Art Proceedings*. Rotterdam, ISEA96

Roberson, K. website http://ole.fsu.edu/keith

Sermon, B. and Blank, J. HEAVEN 194.94.211.200 website http://194.94.211.200

Shanken, E. 1997. 'Virtual Perspective and the Artistic Vision: 'A genealogy of Technology, Perception and Power''. In Roetto, M. ed. *Seventh International Symposium* on Electronic Art Proceedings. Rotterdam, ISEA96 Foundation.

Stelarc. Official Website.http://www.stelarc.va.com.au/

Vesna, V. Bodies Incorporated Website http://www.arts.ucsb.edu/bodiesinc/frames1.html

Niranjan Rajah is Deputy Dean of the Faculty of Applied and Creative Arts, Universiti Malaysia Sarawak.

Transmodalities

The Gift of Seeing: nineteenth-century views from the field

Amy Ione

Contemporary artistic products frequently foster deeply embodied experiences, display how the eye and the brain work together, and incorporate scientific data. More important to this discussion, when we probe how scientific ideas, artistic creations, and technology interface today we see that the collaborations that seem to have grown with the proliferation of new technologies have clearly definable historical roots. This paper proposes that evaluating these historical roots adds two important elements to our understanding of contemporary visual idioms. First, we can identify important cross-disciplinary elements that have informed today's visual culture. Of equal importance, identifying areas of cross-fertilization enables us to speak directly to some of the limitations within a modernist canon that fails to give full credit to the degree to which technologically-based investigative practices of the nineteenth century came to define aesthetic approaches in twentieth century photography, film, video, and the digital arts.

In order to better perceive these historical foundations, this paper discusses the impact of two nineteenth century inventions, photography and the stereoscope, and shows how both advanced art and visual science. The analysis also expands on the research of art historians (see Crary, 1992; Nickel, 1999) who have explored how nineteenth century innovations in art, science, and technology were a part of a systemic interface that fostered innovative, collaborative work in the nineteenth century.

Visual Science
Visual science as known today began to take form in 1838, when Sir Charles Wheatstone (1802–1875) provided the empirical grounds for rejecting the then prevalent notions of binocular combination, or how we see (Wade, 1983). This work on binocularity was presented to the Royal Society in London by drawing two outlines of the same geometrical figure, as the drawings would be seen by either eye respectively. These outlines were then visually superimposed by a combination of lenses that showed that our two eyes see the images differently and merge the two slightly different images (similar to those illustrated in Figures 1 and 2) into a singular form. Using a stereoscope he had invented, Wheatstone was able to first clarify how we see, second describe that paired images can appear as one image to a viewer, third convey that two similar flat images can appear to have depth when fused visually, and, finally, demonstrate that the world we see does not correspond to the kind of one

Figure 1: Two circles at different distances from the eyes, their centers in the same perpendicular, forming the outline of the frustum of a cone

Figure 2: A cube

point linear perspective artists had employed since the Renaissance. (In Renaissance perspective the sense of depth is created using vanishing points and a monocular orientation.)

Wheatstone's stereoscope had several noteworthy features. First, the design of the instrument was based on measurable distances between our eyes and was able to accommodate for the fact that we normally see with both of our eyes. Second, and what made the instrument most exciting scientifically, was that it was able to convey how the slightly different image formed on the retina of each eye is due to each eye's different position in space. While it was not empirically established (until the twentieth century) that our brains actually fuse the two slightly different images, Wheatstone's work did help verify that the composite image we see is a part of our perception of the relative distance of objects from us. Third, Wheatstone was able to convey that a converged perception is based on what each eye sees. Thus what we see does not look like a representation of depth on a flat surface. Nor does the viewer of the fused image see an exact counterpart of the object from which the drawings were drawn as the object is extended into space. Instead two slightly different visual experiences are merged to appear as a whole and the singular whole had a quality that differs from the perspectival depth of a singular form drawn on a flat surface. Finally, it was by deliberating choosing line drawings instead of complex images that Wheatstone was immediately able to emphasize how the perception of the paired images differed visually from images drawn with a traditional perspective. These paired simple drawings, being simple, also illustrated to his audience that the robustness they saw was not inscribed in the image per se or due to added cues. As he explained:

> For the purposes of illustration I have employed only outline figures, for had either shading or colouring been introduced it might be supposed that the effect was wholly or in part due to these circumstances, whereas by leaving them out of consideration no room is left to doubt that the entire effect of relief is owing to the simultaneous perception of the two monocular projections, one on each retina. (Wade, 1983, p. 72)

Visual Science and Photography

Today Wheatstone's work in vision and perception is often coupled with that of Sir David Brewster (1781–1868). Although the men were contemporaries and shared an interest in

visual science, their rivalry becomes clear when reading their correspondence, recorded debates, and scientific writings (Wade 1983). Both Brewster and Wheatstone, nonetheless, agreed the camera could aid empirical research. As a result, both men worked closely with two early photographic pioneers, William Henry Fox Talbot and Sir John Herschel. Eventually the fruits of these collaborations entered the culture as a whole and the many ways the nineteenth century imaging technologies were extended into innovative work in science and art reflect the early collaborations.

Brewster's and Wheatstone's theoretical controversies, while beyond the scope of this article, are relevant to how consciousness studies combines art, vision, and perceptual studies and thus need to be mentioned. Briefly, as Wade notes, the observations of Brewster and Wheatstone have a contemporary relevance due to the close parallels that can be found in theoretical stances taken today. In fact, the theoretical differences expressed over a century ago by Brewster and Wheatstone are like those found in contemporary theories on consciousness, perception, and vision. This has come about due to the fact that some theories are based upon analyses of the visual projection (as Brewster proposed) and some give more weight to inferential or cognitive processes (the approach Wheatstone favored). Indeed the nineteenth century theories have been rephrased rather than replaced (Wade, 1983).

A primary shared contribution is evident when we look closely at how technologies and the empirical research of both men furthered scientific understanding. Their research, obviously completed long before twentieth century imaging technologies offered images of brain processes, advanced scientific research by drawing upon the new ways the camera could depict the physical world. For example, one advantage photography brought to visual studies was its ability to render quickly. Originally the stereoscopic images were hand drawn and the camera's accuracy (with all of its initial limitations!) could permit one to put aside the tedium of making precise pairs of perspective drawings, with all of their possible errors. Photographers could also quickly produce complicated and realistic motifs. Thus, once Brewster invented the binocular camera and an easy to use stereoscope (in the 1840s) it became possible to fully appreciate how the stereoscopic experience differed from looking at flat images contrived to picture the world.

Before turning to photography as an art form it needs to be stressed that the stereographic photographs changed the scientific world and had some measure of contextual impact as well. Three contextual areas of interface are particularly important. First, photographic processes, like the stereogram and stereoscope, were invented in the 1830s. Thus photography and scientific advancements related to vision per se coincided chronologically and are logically paired contextually. Secondly, photography was independently invented by artists and scientists. The primary French contributors were artists (Nicephere Nièpce and Louis Jacques Mande Daguerre), while the primary English inventor (William Henry Fox Talbot) was trained in several sciences. Thirdly, both the invention of the stereoscope and photographic images clarify there is a difference between a superficial perception and the kind of active viewing that a practitioner often uses when producing innovative work. While some stereograms advanced science, many photographic stereograms were conceived for entertainment or to simply record the world. Likewise, while the public frequently saw photographs as a form of entertainment,

aesthetic photographs that expressed clear, subtle, visual statements were also printed by artists.

Aesthetic photography, in fact, was explored from every angle. The clear, crisp daguerreotypes, invented in France in 1839, were produced on silver-plated copper sheets. These images generally had a glittery, reflective surface and are exquisitely detailed. Talbot's 1839 photogenic drawings, on the other hand, were soft images. The drawing was produced when sensitized paper was exposed to light until an image becomes visible. The images were fixed with water and, when stabilized, lacked the detail of the daguerreotype. Calotypes, an extension of the photogenic process, were produced when sheets of paper were brushed with salt solution, dried, and then brushed with a silver nitrate solution. After being dried again, the paper was used in the camera. Unlike the daguerreotype, the calotype could be used to produce multiple copies of any image. The calotype required long exposure times, and although the image was crisp, like the photogenic drawing before it the calotype contained less detail than the competing daguerreotype.

These are only some of the early variations practitioners used in the basic process of fixing the image. Viewing the variations that were tried, even in this limited way, allows us to establish that many subtle perceptual differences defined the images as artists began to experiment with possibilities (Newhall, 1982; Trachtenberg, 1989). It is less obvious that (1) the term photography (chosen in 1855) simplified the vocabulary related to these new images, but not the contradictory responses artists brought to conceiving their products and (2) the camera informed the approach of many painters, (Kosinski, 1999), an area beyond the scope of this discussion.

Artistic Photography

By the mid nineteenth century many prominent photographers were producing singular and stereo photographs. Julia Margaret Cameron, for example, avoided the perfect resolution and minute details that glass negatives permitted opting instead for carefully directed light, soft focus, and long exposures – counted in minutes when others did all they could to reduce exposure to a matter of seconds (Daniel, 1999). All of these elements explain why her many portraits, although singular images, are nonetheless extraordinary. Carleton Watkins, on the other hand, worked with a stereo camera that allowed him to fuse two views when printing and to print stereograms. His artistry is particularly apparent when we look at his breathtaking photographic recordings of California's natural beauty. The practised, technologically astute, subtly Watkins cultivated was a quality frequently found in the work of those who focused on the artistic possibilities of photography. Moreover, much of the experimental work with landscape, portraiture, architectural depictions and scenes (often staged scenes) from human life displayed photographic artistry while documenting that photographers frequently produced sophisticated images that included state of the art science, state of the art technology, and an ever-expanding understanding of method.

Perhaps the best examples of the convergence of art, science, and innovative technologies are the photographs recorded with stereo cameras to register two slightly different images, the two lenses acting like two eyes. As noted above, these recordings could be combined in printing or printed as stereograms that could be fused visually with the use of a stereoscope. Artistic stereograms, often produced as commercial products, showed the

exquisite possibilities photography offered. Here, too, the work of Carleton Watkins is noteworthy, especially when we recognize that his prints display formal and aesthetic qualities that the traditional modernist chronology holds did not exist in the mid-19th century! Maria Morris Hambourg, Curator of Photography at the Metropolitan Museum of Art in New York, explains Watkin's aesthetic as follows:

> In landscape, as in human life, meaning lies less in objects than in relations, the links that tie specific incidents and entities together as an event or a place. In grasping myriad related connections and recording them photographically, Watkins created an intelligible world that maps and illustrates mental activity, mimicking the skeins of meaning our perceptions generate. His photographs awaken us to the exquisite pleasure of active seeing, inducing that conscious visual alertness we experience when viewing landscapes by Cézanne, for example. Only here the artist's mental calculations are not laid down in painted strokes. They merge diaphanously with the trees and dissolve on the surface of the objective world.

She continues:

> Looking at the photograph, we think we see the true structure of nature, its orderly scaffolding and superb textures merely disclosed; it takes real imaginative effort to recognize that no things in the picture nor the relations between them were self-evident. Everything – the slant of a shadow on fresh clapboards, the depth of the darkness in cracks in pine bark, the silkiness of slightly shimmering water – is the delicate trace of the artist's considered attention. (Hambourg, 1999, p. 16)

Hambourg's description of Watkins' work speaks only to Watkins' art. Others have placed this kind of artistry in a larger context. Crary, for example, proposes that we understand both nineteenth century photography and the avant-garde art of that century as overlapping components of a single social surface on which the modernization of 'vision' was everywhere taking place. This is to say that the developments in optics and vision, like photography and the emergence of modernist painting, can be seen as a part of a larger, more fundamental transformation occurring within Western culture.

Conclusion

Exploring historical innovations demonstrates that technology has fostered artistic and scientific practices in tandem and that significant cross-fertilization is often underplayed in historical chronologies. Studying historical innovations informed by both art and science, I would propose, can help us develop a better understanding of artistic and scientific creativity in general. Clarifying how innovative artists and scientists have turned to technology historically can also, no doubt, further our understanding of how technological collaborations advance creative practice today.

References

Crary, J. 1992. *Techniques of the Observer : On Vision and Modernity in the Nineteenth Century*. Cambridge: The MIT Press.

Daniel, M. 1999. Inventing a New Art: Early Photography from the Rubel Collection in the Metropolitan Museum of Art. *The Metropolitan Museum of Art Bulletin*, LVI (4)

Hambourg, M. M. 1999. 'Carleton Watkins: An Introduction', *Carleton Wilkins: The Art of Perception*. San Francisco: San Francisco Museum of Modern Art. pp. 8–17

Kosinski, D. M. 1999. *The Artist and the Camera: Degas to Picasso*. New Haven and London: Dallas Museum of Art: Distributed by Yale University Press

Newhall, B. 1982. *The History of Photography*. New York: The Museum of Modern Art, New York

Nickel, D. R. 1999. *Carleton Watkins: The Art of Perception*. San Francisco: San Francisco Museum of Modern Art

Trachtenberg, A. 1989. *Reading American Photographs: Images As History Mathew Brady to Walker Evans*. New York: Hill and Wang

Wade, N. J. (Ed.). 1983. *Brewster and Wheatstone on Vision*. London and New York: Academic Press, Inc.

Rendering the Viewer Conscious: interactivity and dynamic seeing

Tiffany Holmes

Interactive digital art is changing the role and behavior of the viewer. The title of this essay relates directly to this anthology's theme of 'reframing consciousness' in that, for the last three years, I have been making interactive installations that challenge viewers to reflect on their perceptions in experiencing art. Here I am not exploring the neurobiological mechanisms so much as I am examining how the viewer becomes engaged in a process of metacognition, or the act of seeing their own thoughts.

Before I discuss how a viewer navigates my installations, I need to point out that the navigation of everyday life has become an interactive electronic experience. Advances in technology have given us nearly total control over our physical and virtual environments. For example, caller ID empowers us to choose and regulate our telephone conversations, while personal digital assistants like the Palm Pilot provide wireless access to private information. These digital tools have given the masses new ways to autonomously connect with the world that was simply not possible a decade ago.

Currently, a range of artists are responding to these changes in our culture by making work that critiques this ongoing process of the technological enhancement and subsequent reconfiguration of reality. In particular, artists working with interactive digital media are in a unique position to question, challenge, and transform their viewers' perspectives on the tools and technologies that consolidate our world.

The central aim of most interactive art works is to put the viewer into an active role where they must learn how to interact with an interface to create the piece or make it progress. For example, in Char Davies' virtual reality piece, Osmose, viewers control their position in an underwater world by the rate and frequency of breathing. David Rokeby calls these sorts of discovery-oriented art works 'navigable structures' that require the participation of not a viewer but a navigator (Rokeby, p. 138).

I would argue that the most engaging component of interactive works is not the actual action or gesture performed by the navigator but rather, the process of actively learning to self-direct one's own passage through a piece. The interactive art experience is one that blends together two individualized narratives. The first is the story of mastering the interface and the second is about uncovering the content that the artist brings to the work.

In the rest of this paper, I will attempt to describe the learning or metacognitive experience of the individual that navigates both interface and content in three interactive works: *Littoral Zone, Phene-* and *Nosce Te Ipsum.* These three installations deal with differing models of interactive engagement and each one disables and or heightens the agency of the participant.

Littoral Zone

I became interested in making interactive art because I wanted to create a dynamic forum for play and experimentation with unfamiliar tools. In *Littoral Zone,* I chose to put the viewer within the confines of a virtual laboratory as a dissector of language.

At the beginning of the interactive animation, you construct a virtual 'wet mount' or a microscopic slide. You stab a word with a scalpel only to discover that the text swims away. Using forceps, you then grab a cantankerous letter to place on the slide. After dropping a blood-colored stain on the symbol, a cover slip floats mysteriously up to sheath the specimen.

In the simulacra of the digital laboratory, the navigator imitates the gestures of a dissector. Yet the insertion of text for *flesh* completely transforms the object of study. Many of the word specimens are slang terms like 'DICK', 'FUCK', and 'CUNT'. This substitution of profane language for a corporeal specimen is intended to lure the viewer into participating in the invasive gestures of dissection through humor. The process of dismembering a 'dirty' word playfully anesthetizes its crass sexual connotations. Once the letters are jumbled, the impudent word is silenced.

The word games employed in *Littoral Zone* place the alphabet under the lens of the microscope. This interactive animation asks the viewer to imagine language as a specimen for self-study. After learning the functions of the multiple tools, the viewer consciously participates in the 'destruction' of meaning in slicing apart the textual specimens with the scalpel.

Although the interface for *Littoral Zone* is a standard device, the mouse, navigators exhibit difficulty in learning the functions of the virtual tools set before them. First-time navigators of the animation would spend the first minute clicking every item visible. The incessant clicking sounds portray a feeling of anxiety on the part of the navigator.

Littoral Zone plays with paradigms of control that are prevalent in computer

Littoral Zone, interactive animation, 1998.

interfaces. The general assumption is that the one dictates desire with a mouse click. This paradigm becomes explicitly phallocentric with related interface tools such as the, quote, 'joystick'. *Littoral Zone* intermittently ascribes power to the viewer to disrupt these patterns of control. When you initially touch the mouse, you can manipulate the lab tools using basic rollover actions. However, as you spend more time with the mouse, you learn that 'something else' induces action in the piece.

Scripts written by me regulate the cycling of control in the animation and thus destabilize any clear sense of agency the navigator may have. I discovered that the process of giving power to and taking power from the navigator produced some frustration in the viewing population. Some people would leave the podium quickly because they felt they were not performing the piece correctly. These viewers did not consider that the piece might be directing their behaviors. Those who engaged with the piece for longer periods of time seemed to adjust to the push and pull of the animation.

Phene-

In the next piece, I considered ways that the virtual tools of *Littoral Zone* could become physical objects in space with interactive components that might challenge the navigator to discover their purpose. I wanted to escape the paradigms inherent in mouse-driven works.

As you approach *Phene-*, you hear garbled sounds that emanate from a microscope. Signs direct you to don gloves and inspect a group of slides. Bending over the microscope attempting to make sense of the visual samples, you twist the knob to focus the microscope. In this action, you focus not only the image but also the sound. The slide is 'named' by the computer voice as it comes into view.

Behind the microscope, a wall displays vessels, texts, and drawings that contain hybrid features. Many of the containers displayed reveal unusual contents. For example, a number of petri dishes seem to contain routine cultures. However, on closer inspection, colonies of bacteria reveal 'intelligent' behavior, having massed into simple word forms such as 'CAT'.

The focal point of the installation lies behind the exterior wall. Rounding the corner and entering the darkness, you immediately sense moisture emitted by vaporizers and a dank odor. Here you see an enormous petri dish illuminated by light from a projector mounted in the ceiling. Moving closer to the dish, you note that the specimen is composed of a rapidly changing animation layered atop a mass of fungal blooms.

Navigators 'interact' with the chimera via the process of 'dynamic seeing' with a magnifying glass. As the navigator positions the glass atop the specimen, small dots of light form that trigger a whole array of animated bodies to immediately swim out from beneath the lens. Photo sensors hidden beneath the dish activate the formation of the virtual life forms.

The viewer that grasps the magnifying

Petri dishes with cyanobacteria, 1999.

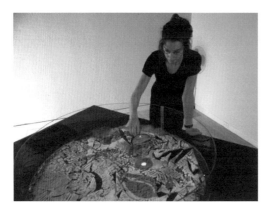

Navigator interacting with magnifying glass, Phene-, 1999

glass in *Phene-* must process a variety of sensory information and simultaneously learn the power of the tools. She smells the rot of the fungus, hears the sounds of breathing, and leans forward to examine the fluffy forms that grow up the walls of the dish. However, if the navigator fails to master the interface of the magnifying glass, they see only a fraction of the installation. If, as Marcel Duchamp once said of conceptual art, 'The spectator makes the picture', (Paz, 1975, p. 85) then only the navigator who learns to manipulate the lens fully apprehends *Phene-*. What this installation does is try to playfully teach the lesson of dynamic seeing by putting the seeing tools directly into the hands of the viewer with no prompting or direction.

Nosce Te Ipsum

The final work that I will discuss lures the viewer into the piece with the promise of visual self-realization in the work yet disrupts the process of self-imaging by re-forming another body. The title of the piece, *Nosce Te Ipsum*, is Latin for 'Know Thyself'. When you enter the darkened installation space, you view a projection on a large scrim suspended from the ceiling. The image consists of a simple contour drawing of an androgynous human figure.

As you move closer to the image, you see a line of words across a floor dotted with circular targets. As you walk forward, following the words, you trip a pressure sensor that triggers a change in the animation. Suddenly, layers pull back and reveal that beneath the body lies an interior composed of flesh, letters, and marks. Stepping on each target makes the body folds back on itself revealing layers of images that give way to further images. Upon stepping on the final sensor, your face, filmed in real time from a video camera, appears beneath the embedded layers. At this moment, the observer of the projection, becomes the observed.

Nosce Te Ipsum invites you, the viewer, to examine a representation of yourself as constructed by the artist. Yet in order to reveal the final image, you must participate in the dissective process in a cooperative manner. Your steps, timed as you choose, alter the projected body, penetrating the palimpsests of imagery that pull back, one after another, to reveal your face within the larger work. Stepping toward or away from the projection reverses the process and reforms the body, causing the layers to rapidly fuse, hiding your face in layers of imagery.

The multiple skins of visual data that comprise the interior of the projected body raise questions about the boundaries of bodies and their individual significance. If, as Rokeby argues, interactive interfaces act as 'transforming mirrors', then the navigators of *Nosce Te Ipsum* embraced their cameo appearances in the piece quite literally, head-on (Rokeby, p. 133). As I sat in the gallery, I observed individuals walk through the piece again and again

to perhaps verify that the system would produce a similar version of what they had experienced previously. Even though repeat performers knew that they would appear in video form in last layer, they still waved their hands to authenticate their real-time presence in the animation. This installation is about creating the desire for participants to dynamically see and lose themselves in one body that is also a collage of bodies, assembled from various sectors of our media-saturated world.

Polling the Viewer

At the opening of *Nosce Te Ipsum*, I distributed surveys in an attempt to investigate the metacognitive faculties of my navigating population. In other words, I wanted to collect some data about how individuals perceived their own reactions to the interactive art experience. Approximately fifty people took the time to fill out the forms. While the results of this survey are not statistically significant in any way due to the small size of the sample pool, the results are illuminating to informally evaluate and compare viewer responses to interactive art and oil paintings.

Individuals were asked to compare the experience of viewing paintings versus participating in *Nosce Te Ipsum*. The paintings were hung in a room that adjoined the installation space. The survey asked visitors to respond to this statement: 'Participating in a computer artwork is a more exciting experience than looking at any type of painting'. Thirty nine percent of the group disagreed with this statement while thirty nine percent were neutral on the topic. Only twenty two percent of those surveyed preferred interactive art experiences to painting exhibitions. Written comments on the survey corroborated the fact that people valued both paintings and interactive art but were unable to ascribe a higher value to either form of expression.

Putting a different spin on this comparative data reveals the most significant finding of this informal study: viewers spend more time viewing electronic artwork than they spend looking at paintings. Seventy two percent of the group claimed that they could not rate the experience of viewing interactive computer art higher than the act of viewing paintings. Yet eighty two percent of the surveyed populations claimed that they spent more time participating and watching others participate in *Nosce Te Ipsum* than in viewing the paintings that were on display.

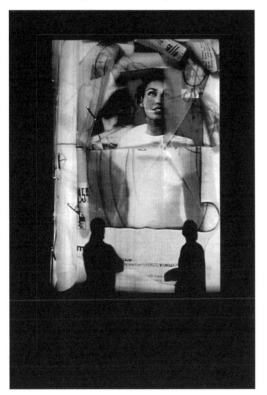

Nosce Te Ipsum, interactive animation, 1998.

Thus, while the majority of the viewing population could not identify a preference for a particular type of art, the majority did concede that the interactive art experience demanded more of their viewing time. It could be argued that the increased number of minutes spent observing or performing in an interactive artwork is directly correlated with the participant's desire to manipulate the interface and control the piece. Interactive computer art works are more engaging than static works in that they offer the navigator some degree of maneuverability in their interfaces. It is perhaps the possibility of agency, however small, that draws the contemporary viewer into the work for longer periods of time to explore its subtleties.

Conclusion

In so many ways, interactive art works are about gaining and relinquishing control over a particular technology. The learning process of mastering an unfamiliar interface makes the navigator much more cognizant of the self-reflexive relationship between oneself and a work of art. Of course all of our experiences with art are interactive on some level due to the inexplicable process of how we perceive the piece in our consciousness. Barbara Stafford writes about this issue of connecting external and internal experiences: 'Art constructs a tenuous point of contact between an infinite mass of precisely firing neurons and the chaos of our monadic inner atmosphere' (Stafford, p. 179). It is this cognitive friction, or the 'tenuous point of contact' that makes the process of dynamic seeing or metacognition such a rich area for artists to explore in work that embraces or challenges the participatory power of the viewer.

References

Paz, Octavio, 1978 *Marcel Duchamp* NY: Viking Press, The Castle of Purity p. 85

Rokeby, David, 1995 Transforming mirrors: Subjectivity and Control in Interactive Media, in Penny, Simon, (ed.) *Critical Issues in Electronic Media*, NY: State University of New York, p. 138

Stafford, Barbara, 1999 *Visual Analogy: Consciousness as the Art of Connecting*, Cambridge: MIT Press, p. 179

The Mind's Eye

Nina Czegledy

When people say that they can visualize something, they mean that they see it with their mind's eye. What does this mean and where is this inner eye?

'My mind, in its ordinary operation is a fairly complete picture gallery – not of finished paintings, but of impressionist notes', wrote Edward B Titchener in his *Lectures on the Experimental Psychology of Thought Processes* in 1909. As Arnheim (1969a) noted, Tichener's reference to painting and specifically to impressionism, is significant. Only with the impressionists did aesthetic theorists acknowledge the view that the pictorial image is a product of the mind and not only a representation of a physical object. When we form a mental picture, we seem to be able to manipulate it – but how? How accurate is our

description of what is really going on in our heads? Whereas visual imagery is a common occurrence, the question of how 'mental pictures' conform to the theory of cognition remains unresolved. Yet, visual mental imagery plays a key role in human consciousness, including information processing, memory, abstract reasoning, language comprehension and even the physical act of visualization (Kosslyn, 1999).

In cognitive science, visual mental imagery or 'seeing with the mind's eye' has been the subject of considerable controversy, especially concerning the underlying neural processes. Are mental images intrinsically different from thoughts expressed verbally? Is image information represented in a spatial format? How much is a person's perception of the blue sky due to memories of early visual experiences? Does mental imagery involve the activation of representations in the brain's visual cortex? Does an ability to generate strong mental imagery contribute to creativity? While in the last two decades there has been an intense effort to resolve these questions, most of the answers still elude us.

Issues surrounding mental imaging have a long-standing history. In ancient cultures it was already realized that one's memory can be reinforced if objects or actions are visualized. This process was widely used for healing by native Americans, Hindu yogis and the ancient Greeks. Kosslyn (1995) reminds us that Plato postulated that memories carved into the mind (like pictures carved into a wax tablet) were based on images.

Over time, interest in imagery has fluctuated. The advent of behaviourist critiques of cognitive psychology early in the 20th century which induced a long period of skepticism caused neglect of mental imagery research. With renewed interest in cognition in the 1970s, mental imagery again became a hot topic. Research on mental imagery in the 1970s and 1980s was mainly focused on demonstrating evidence for functional equivalence between perceived and imagined stimuli. Rigorous experimental analysis including (1) mental rotational studies by Cooper and Shepard (1984) which required subjects to discriminate between standard and mirror reflected versions of stimuli of line drawings or abstract three dimensional object, and (2) the mental scanning experiments by Kosslyn (1987) where subjects were timed on how long it took them to scan a mental map – shed light on the relationship between task performance on the one hand and perceived and imagined stimuli on the other. In these experiments, the systematic increase in reaction time provided evidence for a mental scanning process corresponding to the act of physical scanning over a visual display.

The functional equivalence studies described above lead to current research developments: the systematic cognitive neuroscience approach. In the last two decades Kosslyn (1995) reported that 'researchers began to use neuropsychological data to form theories of the structure of the processing system. And more recently, such data were used to characterize the nature of representation itself.'

Visual mental imagery is considered 'seeing' in the absence of the appropriate sensory input. However Kosslyn (1995a) proposed that mental image generation is distinct from perception, which requires and registers physically present stimuli that are physically present. Visual mental images are said to involve 'depictive' representations or picture-like qualities, and when stored in memory this information can affect information processing. This suggests that knowledge may fundamentally bias what one sees. Once a visualized scene is encoded in memory it can be recalled as an image. People often make use of

mental visual imagery to recall information. This recollection may be very detailed regarding shape, color, size, texture and spatial relations. According to Arnheim (1969b), Erich Jaensch is credited with recognizing the phenomenon of photographic memory which he termed 'eidetic recall'. He found that people endowed with eidetic recall were able to commit a geographic map to memory in such a detail that they could later recall names of rivers or towns which they were unaware of beforehand. Prisoners in long-term isolation are thought to be able to train themselves to recall, in painstaking detail, various scenes or physical objects from their former life Arnheim (1969c) describes Wilder Penfield's brain stimulation experiments in the 1950s; his patients experienced extremely vivid involuntary 'flash-backs' following brain stimulation. Recently Sierra (1999) revisited the 'flashbulb memory' issue. He discussed the suggestion that flashbulb memories are formed by the activity of an ancient brain mechanism evolved to capture emotional and cognitive information relevant to the survival of the individual or the group. While these assumptions are challenged, he felt the phenomenon remains an important area of research.

Visual perception, a complex process, is thought driven by sensation while its outcome depends on one's situational experiences. To be aware of an object or event the brain has to construct a multilevel, explicit, symbolic interpretation of part of the visual scene. Crick and Koch (1995) suggested that 'biological usefulness of visual consciousness in humans is to produce the best current interpretation of the visual scene in the light of past experience, either of ourselves or of our ancestors – embodied in our genes.'

According to Pani (1996), the puzzle of the formation of mental pictures presents three main problems: first, the incidence of mental images has been unpredictable, second, many common concepts cannot be depicted and third, the generated images characteristically do not resemble things accurately.

Clearly, memory and memorized images – deeply ingrained and often subconscious – serve to identify, interpret and supplement perception. These images or mental models also influence the ability to learn and translate learning into action. The mind seems to construct 'small-scale models' of reality that it uses to anticipate events. The models are considered psychological representations of real, hypothetical, or imaginary situations. Recent studies by Cocude et al (1999) compared mental images reconstructed of previous perceptual experience with those constructed from verbal descriptions. Neuro-imaging studies conducted by this group showed that the parieto-occipital cortex is involved in processing visual images, whether they are based on perceptual experience or constructed from linguistic inputs. In contrast, the Positron Emission Tomography (PET) studies provide no evidence that the primary visual cortex is engaged in the generation of visual images. In view of the contradictory results, Cocude suggested further studies to clarify the role of the early visual areas in mental visual imagery.

Farah (1995) argued that 'image generation is a process by which long term memory knowledge of the visual appearance of objects or scenes is used to create a short-term percept-like image.'

Do 'creative' people experience mental imagery differently than others? Clearly, the term creative can be applied to many activities or professions. Speaking of visual artists, Arnheim (1969d) suggested that an artist drawing an elephant in his studio

'may deny convincingly that he has an explicit picture of an animal in mind.' Yet, as he works, he will constantly re-examine the correctness of his work and modify it accordingly. What is his comparison? asked Arnheim. What is this inner design, or the *disegno interno?* – as Frederico Zuccari called it in 1607 to distinguish it from the *disegno esterno.*

Do mental imagery and visual perception involve common processing mechanisms? Over the last decade, the status of image generation as a functional component of the mind; the search for structural similarities between images and perceptual events; and the localization of neural structures involved in image generation, have been extensively investigated. It is now generally accepted that visual perception and mental visual imagery share some common underlying mechanisms with other major cognitive functions, such as language, memory, and movement (Behrman 1994). However, others propose only a limited degree of interaction between mental imagery and other independent cognitive functions (Goldenberg, 1993).

Current cognitive neuroscience approaches, including use of PET and functional Magnetic Resonance Imaging (fMRI) technologies have provided new insights into the anatomical and functional organization of the human visual system, as well as the cerebral localization of imagery processes. Based on these studies, Kosslyn (1995b) showed that visual images evoked from memory activate primary visual cortices.

The visual imagery abilities of patients with cortical blindness may provide some explanations. Goldenberg (1995) documented a patient with complete cortical blindness who denied being blind. Her pretended visual experiences could frequently be traced back to her subconscious translations of acoustic or tactile perceptions into mental visual images. Possibly her belief that she could see resulted from a confusion of mental visual images with non-visual percepts.

Studies of mentally retarded patients and those with brain injury have elucidated additional aspects of mental imaging. Courbois (1996) noted a marked deficit in imagery ability in persons with mental retardation. This lead him to hypothesize that the deficit might be the source of other difficulties they encountered in cognitive activities. Richardson (1995) studying patients with memory impairment as a result of brain injury or disease, found that training and instructions in the use of mental imagery could improve retention.

How does hearing impairment relate to mental imaging? Research studies with deaf people led Emmorey (1993) to conclude that both deaf and hearing American Sign Language (ASL) signers have an enhanced ability to generate relatively complex mental images. Thus, signers' enhanced visual imagery abilities may be tied to these specific linguistic requirements of ASL.

In the tribal societies of Africa and the Americas, hypnosis and guided mental imagery were used as an essential part of healing. Recently, guided imagery, in addition to clinical applications, has extended far beyond biomedicine into the realm of commercial use and internet advertising. Now, with the advent of psychoneuroimmunology, guided imagery, hypnosis, deep relaxation and meditation are being 'rediscovered' as important adjunctive treatments. In the experiments described by Kwekkeboom et al (1998) participants' anxiety scores were significantly higher after listening to guided imagery intervention. Based on her results predicted the likelihood of success when guided imagery was used to relieve cancer pain and its distress.

The advertising industry makes good use of guided mental imagery as evidenced in hardcopy media, television and lately internet promotions. 'Suki tapes' to relieve stress are available on the Suki Productions (2000) site and the Mental Edge Corporation (2000) promotes mental imagery guidance for improving skills in figure skating, rowing, tennis and wrestling. The psychotherapist, Dr. Patricia Palmer feels 'that guided imagery can be a powerful tool in accessing and mobilizing our inner healing resources in the area of complementary therapies for chronic and life threatening illnesses.' A good example of direct internet advertisement is the text of the 'Atlantis' Newsletter (2000) home page: 'Imagery's vast potential still lies undiscovered.... there is a wide gap between what is already known about imagery and what is routinely used. Atlantis, the Imagery Newsletter, bridges the gap for you.'

In summary, seeing is considered a complex and mostly intellectual exercise, whether expressed pictorially or verbally. The physical act of seeing is strongly influenced by memory, visual perceptions and cultural experiences. The ability for this multilevel interpretation might be acquired at an early age, or even embedded in our genes but mostly it is a learned process. In the sciences clarity of expression (or interpretation) is essential. Nevertheless, fine arts accommodates subtlety, and occasionally deliberate obscurity. In all instances, the image maker is a communicator. An understanding of the act of seeing is pertinent in the process of mental image creation. Although it appears now, that visual mental imagery and visual perception share common underlying mechanisms, there are several reports which show them to be dissociated, reflecting the basic modular organization of the visual cortex. Quoting Koster (1998): 'the binding of cellular activity in the processing-perceptual systems is more properly envisioned as a binding of the consciousness generated by each of them. It is this binding that gives us our integrated image of the visual world.'

References

Arnheim, R. 1969 *Visual Thinking*. Berkeley and Los Angeles: University of California Press. (a) p.107, (b) p.102, (c) p.103, (d) p. 9

Atlantis <http://www.imagerynet.com/atlantis/about.html>

Behrmann M., Moscovitch M., Winocur G. 1994. Intact visual imagery and impaired visual perception in a patient with visual agnosia. *J Exp Psychol Hum Percept Perform* 5: pp. 1068–87

Chatterjee A., Southwood M. H. 1995. Cortical blindness and visual imagery. *Neurology* 12:2189–95

Cooper L. A. 1995. Varieties of visual representation: how are we to analyze the concept of mental image. *Neuropsychologia* 33: pp. 1575–1582.

Cooper L. A., Shepard R. N.1984. Turning something over in the mind. *Scientific American 251*: pp. 106–117

Courbois Y, 1996. Evidence for visual imagery deficits in persons with mental retardation. *Am J Ment Retard 101*: pp. 130–48

Courtney S. M, Ungerleider L. G, 1997. What fMRI has taught us about human vision. *Curr Opin Neurobiol* 7: pp. 554–61

Crick F, Koch C (1995) Are we aware of neutral activity in primary visual cortex? *Nature 375*: pp. 121–123.

Emmorey K., Kosslyn S. M., Bellugi U. 1993. Visual imagery and visual-spatial language: enhanced imagery abilities in deaf and hearing ASL signers. *Cognition 46*: pp. 139–81

Farah M. J. 1995. Current issues in the neuropsychology of image generation. *Neuropsychologia 33*: pp. 1455–1471

Goldenberg G. 1993. The neural basis of mental imagery. Baillieres Clin *Neurol 2*: pp. 265–86

Goldenberg G, Mullbacher W, Nowak. 1995. A Imagery without perception – a case study of anosognosia for cortical blindness. *Neuropsychologia 33*: pp. 1373–82

Kosslyn S. M. 1987. Seeing and imaging in the cerebral hemisphere. A computational approach. *Psychological Review 94*:148–175.

Kosslyn S. M, Behrmann M and Jeannerod M. 1995a. The cognitive neuroscience of mental imagery. *Neuropsychologia 33*: pp. 1335–1344

Kosslyn S. M, Thompson WL, Kim IJ, Alpert NM. 1995b. Topographical representations of mental images in primary visual cortex. *Nature 378*(6556): pp. 496–8

Kosslyn S. M., Pascual-Leone A., Felician O., Camposano S., Keenan J. P., Thompson W. L., Ganis G., Sukel K. E., Alpert N. M. 1999. The role of area 17 in visual imagery: convergent evidence from PET and rTMS. *Science 2*;284(5411): pp. 167–70

Koster L. W. 1998. Three little words – vision, perception, seeing. *J Biol Photogr 66*: pp. 41–47

Kwekkeboom K, Huseby-Moore K., Ward S. 1998. Imaging ability and effective use of guided imagery. *Res Nurs Health 21*: pp. 189–98

Mental Edge <http://www.ultranet.com/~dupcak/sprtpsych.html>

Pani J. R. 1996. Mental imagery as the adaptationist views it. *Conscious Cogn 3*: pp. 288–326

Richardson J. T. 1995. The efficacy of imagery mnemonics in memory remediation. *Neuropsychologia 33*: pp. 1345–57

Sierra M, Berrios GE. 1999. Flashbulb memories and other repetitive images: a psychiatric perspective. *Compr Psychiatry 2*: pp. 115–125

Suki Productions. <http://www.sukiproductions.com/suggest.htm>

An independent media artist, curator and writer, Nina Czegledy divides her time between Canada and Europe.

Forms of Behaviour and a New Paradigm of Perception to the Production of New Sounds

Edson S. Zampronha

Traditional forms of sound synthesis are based on a static conception of ear perception (see, for instance, Roads 1994, De Poli 1991). The ear is supposed to have an inner buffer that stocks small temporary slices of sound so it can make a spectral analysis, in the same way a prism can be used to decompose light in different colours, the spectral analysis can decompose sound in frequencies and amplitudes. However, there is no evidence that this buffer exists in the human brain (Port, Cummins, McAuley, 1998). So it is perfectly possible to imagine that, at least partially, the way the brain process information is different from spectral analysis. My intent here is to present a hypothesis (with some evidence) that brain

processes behaviours, and not spectra, and this promotes an entry in another paradigm which has many consequences.

1. The traditional conception

As mentioned above, traditional forms of sound synthesis are based on a static conception of ear perception. In some way it is considered, explicitly or not, that human ear makes a spectral analysis to identify sounds. That is why, in this paradigm, sound synthesis was based in a method of spectral generation. If we consider human speech, for instance, the ear would slice the sound flow making a spectral analysis in each slice. So if we know the spectrum of each slice we can identify the sounds produced and, at the same time, re-synthesize them.

But for this to happen in the human brain a certain capacity of storage is needed in order to analyse each sound slice and identify its spectrum. However, this buffer does not exist in the brain (Port, Cummins, McAuley 1998). The traditional spectrum analysis, in fact, can be used with great success in machines or computers, but in spite of that it does not mean that the human ear works the same way. To clarify this, we can draw an analogy with movies. In movies we have a series of static pictures that, in a rapid succession, can give an illusion of movement. Each spectrum slice in human hearing could be related to each picture in movies. So, a rapid succession of slices could give the illusion of sound continuity. However, the eyes are neither like movies, nor the ear like these rapid succession of slices. If any spectrum analysis is done it has to be done without any buffer, and must open the path to imagining different models to explain auditory system and, as a consequence, different ways to create sounds.

2. Another hypothesis

It is possible to imagine a dynamical system that responds to a sound flow in a relational way. There is a machine that works in a similar way and can be used as an example: the Watt governor. As Gelder (1999) explains, the Watt governor is used in some machines to control the speed a wheel revolves. It is desired that the wheel should move in a constant speed. But the energy used to move the wheel comes from a steam flux generated by a furnace, and is therefore not constant. The effect of the Watt governor is to make the flux constant.

> It consisted of a vertical spindle geared into the main flywheel so that it rotated at a speed directly dependent upon that of the flywheel itself. Attached to the spindle by hinges were two arms, and on the end of each arm was a metal ball. As the spindle turned, 'centrifugal' force drove the balls outwards and hence upwards. By a clever arrangement, this arm motion was linked to the throttle valve (Gelder 1999, p. 93).

If the speed of the wheel increases, the arms go upward and the throttle valve closes proportionally. If the speed decreases, the arms go down and the throttle valve opens proportionally. As a result the speed is constant.

There is no buffer in this process to analyse the actual state in order to decide if the

throttle valve has to open or close. The Watt governor is relational according to the state of equilibrium desired.

Our ear can work in the same manner. Sounds enter the ear and by the eardrum they are transferred to the cochlea. Inside the cochlea some of the many cilia are moved according to the energy of the sound flow in a similar relational way to how the arms of the Watt governor are moved. This information is then transferred to the nervous system and processed by the brain (see an interesting explanation in Békési, 1960). In fact each of these cilia inside the cochlea is an independent system that responds to a specific range or frequency. In this sense we can say that we are arriving again at a spectral analysis. In one sense that is true, but without a buffer. The same way the Watt governor, there is no buffer to stock slices of information for later analysis. The relation between the sound flow and its decomposition is relational, without a buffer and without a symbolic algorithm. It is a relational algorithm embodied inside the ear system. The consequences of this change are very relevant.

Besides that, studies of taste reveal that it is more important how the cells behave when in contact with certain substances on the tongue than the average value of the cells level of activation or anything as a fixed 'taste spectrum' (which would require such a buffer) (Churchland, 1995). Therefore we can suppose something similar happens in the ear system, and state that the sound spectrum is less important then the behaviour cells have when in stimulated by the sound flow.

If we take the way cells behave as the most important fact in sound perception, we can at the same time establish a scale of behaviours according to its periodicity. Behaviour can be: periodic, semi-periodic, chaotic, a-periodic (or noisy). Sounds with periodic or semi-periodic behaviour are like some musical instruments: a long note played by a flute for instance. This sound is in fact semi-periodic. Purely periodic sounds are very rare in nature when compared with the amount of other sounds we can find. A-periodic sounds are noisy; for example, the sound of the sea. Chaotic sounds are, on the other hand, in an intermediary state between periodic and a-periodic ones. The sound of boiling water, many urban or nature sounds, and even human body sounds, for instance, are chaotic.

3. An experiment

Some experiments suggest that this hypothesis is highly probable. Take for example the sound of boiling water. The traditional procedure would cut this sound in small slices and make a spectral analysis of each slice. On the other hand, if we adopt the above hypothesis, we have to depart from a behaviour. Intuitively we can verify that the sound behaviour of boiling water is not periodic. But, at the same time, it is not a noisy sound. It is probably chaotic. Whether it is really chaotic or not can be verified by means of mathematical procedures (see Fiedler-Ferrara, Prado, 1994). We are not going to describe these procedures here.

To verify that our perception, at least in some cases, works based on behaviours rather than on spectral analysis, a specific mathematical equation that generates chaotic behaviour was selected. This equation is the well known logistic equation: $X_{n+1} = R*X_n*(1-X_n)$. That is, the next value X produced (i.e. $X_n + 1$) is conditioned by the value X_n we have at the moment. Values of X can vary from 0 to 1. R is the variable that

provides the key to the equation. When R is less than 3.56..., the equation has a periodic and predictable behaviour. However, when R is greater than 3.56 and smaller than 4.0 the equation starts to behave chaotically. We can not really explain why the equation changes its behaviour in this way (for a detailed analysis of the logistic equation see Fiedler-Ferrara, Prado, 1994).

The experiment consisted in taking simple wave forms (sinusoids) and making a succession of them according to the values obtained in the chaotic region of the logistic equation. (The frequency range was from 200Hz to 2000Hz.) After some attempts it was observed that when the value of R was around 3.83 or 3.9 the sound generated was similar to the sound of boiling water. The interesting thing was to observe that despite the fact only simple wave forms were being used (sinusoids), due to the chaotic behaviour of their succession, perception identifies this sound as being similar to the sound of boiling water which, in spectral analysis, would show a very complex set of sinusoids. As a consequence, we seem to identify the behaviour rather than the spectra.

Although this experience alone is not enough to prove the hypothesis adopted (because other variables would have to be isolated), it is a strong indicator that this hypothesis is very promising. This is the direction my research is pointing to nowadays. Among other things, other equations with chaotic behaviour are being tested, especially equations with multidimensional feature that may control different parameters simultaneously.

4. Some concluding observations

The most evident transformation in this process of sound generation is in the fact that ear perception is based on forms of behaviour rather than on spectral analysis. In other words the focus is on the process, and not on the object. On the one hand, traditional spectral analysis focuses the object, and analyses it trying to identify its constituent elements. On the other hand, what we are exploring it the hypothesis proposed here, is the process, the form of behaviour.

In one sense Pierre Schaeffer (1966) has already identified behaviour (or allure) as an important feature in his type-morphology of sound objects. However to him the allure was the result of the combination of other simpler elements. Differently, according to our hypothesis, these simpler elements are not really simpler. They are in fact periodic or semi-periodic behaviour. The ear system seems to perceive these simpler kinds of behaviour as a spectrum. But the moment it becomes more complex, this spectrum perception changes. Briefly, perception seems to be qualitatively different according to some degrees of complexity. Spectral analysis is then just a kind of behaviour perceived by the ear when the behaviour has low complexity.

This change in the focus is not localized. It spreads to many areas. In order to conclude, here are five examples of how this change of focus spreads in areas similar to what was presented above:

1. if what is perceived is not an object but a behaviour, what is perceived is not the product of an analysis but a property that emerges from the interaction between the sound flow and the neuronal system;
2. if perception is an emergent property we might infer that mind itself seems to be an emergent property, though difficult to prove empirically at the moment;

3. if perception is based on forms of behaviour, the door to interactivity is open because if it is a behaviour it can be changed by means of listener intervention;
4. by means of this hypothesis new forms of behaviour can be generated and so new sounds can be created and used in art, which can promote new forms of interaction with the auditory realm; and
5. these new sounds are the result of complexity, non-determination, and non-linearity. So, the result created is not convergent but divergent, which makes multiple points of view at the same time possible, even contradictory ones. In this context forms of behaviour gain a prominent role: the way we see is more important than what is seen, heuristics gives way to hermeneutics. To sum up: 'to be' – permanence – gives place to 'is being' – change.

References

Békésy, G. V. 1960. *Experiments in Hearing*. Cambridge (Massachusetts): Acoustical Society of America.

Churchland, P. M. 1995. *The Engine of Reason, the Seat of the Soul*. Cambridge (Massachusetts) e London: MIT.

De Poli, G.; Piccialli A.; Roads, C. (1991). *Representations of Musical Signals*. Cambridge (Massachusetts): MIT.

Fiedler-ferrara, N., and Prado C. P. C. 1994. *Caos*. São Paulo: Edgard Blücher.

Gelder, T. V. 1999. Revisiting the Dynamical Hypothesis. In *2ffl Seminário Avançado de Comunicação e Semiótica*. São Paulo, august 18th-20th 1999, pp. 91–102

Port, R. F., Cummins F., Mcauley J. D. 1998. Naive time, temporal patterns, and human audition in: Robert F. Port, Timothy van Gelder, *Mind as Motion*. Cambridge (Massachusetts) and London (England): MIT, pp. 339–371.

Roads, c. 1994. *Computer music tutorial*. Cambridge (Massachusetts): MIT.

Schaeffer, P. 1966. *Traité des Objets Musicaux*. [Nouvelle Édition]. Paris: Éditions du Seuil.

Edson Zampronha is Professor of Musical Composition at São Paulo State University (UNESP) and Post-doctorate researcher in semiotics at Pontifical Catholic University of São Paulo (PUC/SP).

Music Video, Technology and The Reversal of Perspective

Kevin Williams

For both Merleau-Ponty (1964) and Gebser (1991), the exchange and reversibility of expression and perception was a central concern. This exchange formulates an ecological theory of communication because it deals with interrelationships between organisms, their culture (including technologies), and the world. To illustrate this, they both used the conventions of classical perspective for example.

Classical perspective reveals an expression of the perceptible world. Perspective is not, however, a mirror, copy, or representation of the world, as is so often presupposed, but an interpretation of a visual perception of the world. More than resemblance, perspectival painting expresses a style of awareness. This style is a response to a communicative consciousness. In fact, the word perspective derives from the Latin persepectiva meaning

'seeing through', and the consciousness expressed in perspectival painting is a seeing through of space (Panofski, 1955). More precisely, perspectival painting expresses the emergence of an awareness of space that locates the seeing eye, the object seen, and the distance between them. By expressing space in a way that locates subject, object and distance across a two-dimensional plane, perspectival painting illuminates a perception of space and subject-object relations. Perspective is a way of perceiving the world, a way of making sense sensible.

As the development of brush and pigments lead to new possibilities in painting, contemporary electronic technologies lead to new possibilities for the expression and perception of the world. Grossberg (1989) suggests that understanding the logic of video is largely a matter of understanding aural-visual arrangements. I have called music video's aural-visual arrangements musical visuality, an expression of perception that reveals synesthetic communication and consciousness (Williams, 2000). As music video composes luminescence into musical patterns, it concretizes the awareness of the ways that one sense modality may be expressed through another – sound is manifest visually. It is a communicative interpenetration of music and vision whereby visuals dance via editing and CGI. Sound becomes, paradoxically, the focal point of MTV's vision: MTV's visual surface resonates with the depth of music; my eyes surf the ebb and flood of a Liquid Television; its sights dance 'on the edge of sonic fertility'. (Slusser, 1992, p. 341). Sound is revealed as the silent background and depth dimension of television (Altman, p. 1992).

Music video addresses less a viewer with a barrage of visual images, as is often claimed, than it hails an audience with a cacophony of musical images. It is not the eye, but the interplay of the senses that is enveloped in this sono-luminous dance. Musical visuality is an aesthetic structuring of perceptual experience – a response to consciousness and a technological apprehension of a communicative world. Understanding music video's aesthetic becomes a matter of understanding the conditions in which embodiment, technology and world have always allowed visuals to re-sound musically and music to be visualized.

MTV's style provides an opportunity to explore the implications of an ecological theory of communication for understanding a historical situation – the postmodern, postindustrial age of electronic communication. Indeed, style is more than a simple matter of aesthetics because it unfolds a way of making sense sensible. Moreover, an ecology of communication is concerned with the aesthetic and political relationships between the ways we experience the world, the ways we can experience the world, and the ways we are expected to experience the world – with the ways that experience is inscribed into particular sense-making patterns. Musical visuality is more than a style of video production; it awakens and brings to expression an awareness of the communicative possibilities of a polymorphous world.

The attempt express the latent possibilities of perception has been the goal of many artists:

Imagine an eye unruled by man-made laws of perspective, an eye unprejudiced by compositional logic, an eye which does not respond in the name of everything but which must

know each object encountered in life through an adventure of perception.... Imagine a world alive with incomprehensible objects and shimmering with an endless variety of movement and innumerable gradations of color. Imagine a world before the 'beginning was the word' (Brakhage, in Sobchack, 1992, pp. 90–91).

Brakhage's anti-logocentric comments speak to what music video has accomplished synesthetically. It has forsaken perspective, incorporated the dominant modes of realism, and rediscovered the possibilities of expressing the (seemingly) inexpressible and sublime – sound made visual.

Gillette (1986) notes that the relationships between a culture and the parameters that allow for expression are fed back through a particular technology that gives shape to ideas. Heidegger (1977) explores the Greek origin of technology as technikon – the activities and skills of the craftsman, the arts of the mind, the fine arts. He notes that technology is not simply a tool or means to an end, and 'modern technology' is not simply the application of power machinery to production. The significance of technology, he asserts, is not technological. Rather, it is a way of revealing, of bringing-forth from concealment into unconcealment. It makes us aware of that which was already there, but hidden from perception.

Take, for example, Muybridge's photographic studies of horses in motion (Solomon, 1972). These photographic studies resolved a bet over the question of whether or not all four hooves of a galloping horse leave the ground simultaneously. Using a series of cameras to perceive a horse's moving body, and photos to express that movement, Muybridge revealed the workings of the horse's body in a new way. His photos teach us something new about movement, even though they do not move. For a brief moment, all four hooves are off the ground. Photos make present that which was always there, but was latent.

Similarly, the movie camera opened other perceptual and expressive possibilities. Vertov (1923) describes the movie camera:

> I, a machine, am showing you a world, the likes of which only I can see.
> I free myself today and forever from human immobility, I am in constant movement, I approach and draw away from objects, I crawl under them, I move alongside the mouth of a running horse, I cut into a crowd at full speed, I run in front of running soldiers, I turn on my back, I rise with an airplane, I fall and soar together with falling and rising bodies.... My road is towards the creation of a fresh perception of the world. Thus, I decipher in a new way the world unknown to you (Berger, 1972, p. 17).

This machine extends human perception by enabling expression unrealizable without film technology (Sobchack, 1992, p. 184).

Technology is thus incorporated in expressing the myriad of ways the world may be perceived. As a 'bringing-forth', technology is less a tool than an act of poetics (Heidegger, 1977). Heidegger provides an understanding of technology as an integral, soulful, and intellectual comprehension of the significance of our world. His conception provides us with an understanding of the relationship between human, technology, and world as a communicative inter-relationship. This communicative understanding is radically different

from the notion that there is a ready-made world 'out there' waiting for science to discover, available to all people in all times; or that there is an image 'in here', imposed upon the world. Instead, we find a communicative engagement with our world at a given place-time, and the production of a significant world with interdisciplinary import.

However, Heidegger (1977) distinguishes technology from modern technology. Both are ways of revealing; but modern technology is less a 'bringing-forth' than a 'challenging' – which he calls enframing: 'the way in which the actual reveals itself as standing-reserve' (p. 329). Modern technology unreasonably demands that nature supply it with materials which can be extracted and stored. Thus we log old growth forests regardless of the possible consequences.

The windmill (a pre-modern technology) turns with the wind (revealing the winds energy) to use the wind, not to store the wind as a standing reserve. The mine (a modern technology) challenges a tract of land which is objectified and set-upon as a standing reserve of energy. The wind that blows the windmill regenerates; the mined land is depleted.

What does the above suggest for music video? It is clearly a mode of revealing and expressing fresh perceptual possibilities. It also runs the risk of enframing. Music videos are capable of acting on the world as a standing (image) reserve, objectifying social subjectivities such as age, class, gender, race, religion, sexual orientation, and so on.

Considering music video at a techno-poetic ecological level thus complements television theory that focuses on the role of the televisual apparatus in social reproduction, the politics of representation, and the cyclical perpetuation of production and consumption. It turns critical attention toward the creative and political activity of expression and perception that underlie communicative action (whose views are we viewing?). It also reminds us that all acts of technological mediation are embodied and lived relations with the world. When we accept a presentation as a representation, we have missed the communicative world for an objectification and political limitation of that world. If perspective is a linear extension from ego/eye to vanishing point, an imposition of a 'point of view', what happens when vision gives way to music, sight to synesthesia, as in the case of music video?

Perspective is literally a tele-vision: A vision (a way of seeing and comprehending) of things over distance. Music television's vision, however, along with much of twentieth century art, abolishes or reverses perspective. Questioning its spatialization of knowledge, and its propensity to measure things linearly, twentieth century art brought forth the displacement of perspective as central to the representation of the real. Picasso and Duchamp, for example, broke the conventions of spatial representation by introducing temporality to the two-dimensional canvas. Their paintings brought to sight a perception of time and movement (Gebser, 1991). Cubism's expression of a fractile subject, surrealism's expression of dream-imagery, unconscious and archetypal symbolism, and impressionism's expression of the temporal play of light and reflection, all brought to expression perceptions of the world diminished by classical, perspectival realism.

Moreover, Merleau-Ponty noted that while we accept perspective as empirical reality, it is not, strictly speaking, empirical. While the things I see appear to get smaller as they get farther from me, it is the 'things' and not the 'perspective' that I see. Perspective itself is

invisible – not a thing but a phenomenon. This invisibility is the condition for the possibility of perspectival vision. Accepting perspective as 'reality' institutes a hegemony of perception because it institutes an ideal as real. Indeed, perspective must be learned.

Turnbull (1962) tells the story of a Pygmy's first experience of perspectival space: 'Leaving the bush, it took some time for Kenge to comprehend that the "insects" he saw were not getting bigger, but were buffalo appearing larger. In the bush there was no visual horizon or vanishing point toward which one could imagine vector lines converging' (pp. 251–3). Perspective would be a potential experience unavailable to Kenge's consciousness until he left his village. In open space he witnessed the phenomenon of perspective for the first time – and learned how to comprehend it.

While perspectival thinking has been displaced as representation of reality in anthropology, philosophy and painting, it has taken up residence in photography, film and television. As in painting, video must express three-dimensional depth on a two-dimensional surface. While most camera optics are designed to 'see' perspectively, and the conventions of viewing allow people to accept television images as three-dimensional, tele-visual perspective must be aesthetically constructed. Music video often pushes video's technical possibilities to their extreme, and in so doing breaks the conventions of perspective and Hollywood realism.

Extreme visual effects create perspectival paradoxes. Radical zooming, tilting, and dollying; extreme narrow and wide-angle lenses radically shift the shape, sense and speed of linear perspective to a non-linear and a-perspectival expression. At this breaking point, sound and dance become the depth-dimension of the encounter.

Musical visuality re-frames consciousness by expanding our awareness of experience, technology, culture and world. While perspective, as an inscribed response to embodiment, technology and world, is literally a tele-vision, music video becomes a new 'perspective' (or way of grasping the world) because it breaks classical realism, and institutes a synesthetic hyperrealism. Perspective is reversed. We are enveloped in sonorous depth. Sight and sound intercommunicate an experience that is more integral than schizophrenic, more enveloped than distanced. Thus, music video concretizes an integral, embodied consciousness and world awareness – a consciousness not of linear and logical perspective, but of a-perspectival and musical interrelationships.

As literature provides a way to understand writing, and opera provides a way to understand singing, music video provides a way to understand videography. Providing a new form of expression based on an existing experience of perception, music video teaches us about the ecology of communication. The main objective of an ecological meditation on music video is to explore and describe phenomena, like sound and vision, and the interrelationships between persons, technology and world, as the foundation of communicative action. The study of perception and expression as a communicative and reversible circularity is, I suggest, important to the study of communication and mediation because it overcomes the inherent point to point(s) linearity presupposed by most commonly accepted communication models. Moreover, as I find music manifest in visual form, I find a deepened understanding of what it means to be a communicative body: I find a way to understand better my engagement with technology and the world.

References

Altman, R. 1992. *Sound Theory Sound Practice*. New York: Routledge.

Berger, J. 1972. *Ways of Seeing*. London: Penguin Books.

Gebser, J. 1991. *The Ever Present Origin*. Barstad, N. with Mickunas, A. Trans.. Athens: Ohio University Press.

Gillette, F. 1986. in Handhard, J. *Video Culture: A Critical Investigation*. New York: Gibbs M. Smith.

Grossberg, L. 1989. MTV: Swinging on the (Postmodern) Star. In Angus, I., Jhally, S. Eds. *Cultural Politics in Contemporary America*. New York: Routledge, pp. 254–268.

Heidegger, M. 1977. The Question Concerning Technology, Lovitt, W., Trans. In Martin Heidegger: *Basic Writings* Krell, D. Ed. New York: Harper and Row, pp. 287–317.

Merleau-Ponty, M. 1964. *Signs*. McCleary, R. Trans. Evanston: Northwestern University Press.

Panofski, E. 1955. *Meaning in the Visual Arts*. New York: Doubleday Anchor.

Slusser, G. 1992. Literary MTV. In McCaffery, L. *Storming the Reality Studio: A Casebook of Cyberpunk and Postmodern Fiction*. Durham: Duke University, pp. 334–342.

Sobchack, V. 1992. *The Address of the Eye: A Phenomenology of Film Experience*. Princeton: Princeton University.

Solomon, S. 1972. *The Film Idea*. New York: Harcourt Brace Jovanovich.

Turnbull, C. 1962. *The Forest People*. New York: Simon and Schuster.

Williams, K. 2000. *Why I Want My MTV: Music Video and Aesthetic Communication*. New Jersey: Hampton.

Paradigms of Change in Music and in Digital Communication

Dante Tanzi

Introduction

The use of information technologies has encouraged experimentation with new musical languages, conditioning the development of music-making as well as listening habits. We can agree with S. T. Pope that three recent developments based on the digital technology of the 1970s have given us three more 'degrees of freedom': freedom of gesture, freedom of production, freedom of availability (Pope, 1999). Analogous considerations can be made regarding to the more general changes that digital technologies have induced in communication processes, with special regard to the on-line communication, which is bringing new forms of cultural production to light which are linked to a different type of interpersonal relationship and to a different idea of creativity.

First of all it is be useful to propose a distinction between time dependent forms of change (also including musical phenomena), and those free of a chronological-historical dimension. Digital culture occupies a middle ground, offering a time-matter dimension which is able to be programmed and manipulated. This implies a change of perspective, linked to the evolution of cognitive profiles, implicated in the processes of the digitalisation of audio-visual knowledge, and related to the differentiation of the abilities required for using digital devices. As T Murray states, 'the technical ability to enfold the vicissitudes of

space and time in the elliptical repetition of parallel structure might be the most novel feature of the horizon of the digital' (Murray, 2000). Together with interactive practices, such mutations are pressing for continuous fluctuations within the individual and collective symbolic elaborations (Trumbo, 1996). Finally, on-line technologies are gradually modifying the relationships between the author and his own work, and it is presumable that compositional paradigms linked to a local idea of sound space will be not the same in a decentralised environment: but the direction of such changes seems to be more and more linked to the communicative importance and the social use of technological theories.

Digital culture, digital research

The use of new digital artifacts prefigures a relationship of co-determination (Taylor, Saarinen, 1992) between subjective instances, communicative interactions and types of technological tools, which contribute to redefining both the trajectories of the use of the new instruments and the cognitive requirements which should be able to identify new groupings of alternatives. In particular, communication technologies have introduced systems of proximity which are independent of physical space, and the content of relational aspects is put into question by cognitive styles linked to the decline of identity paradigms. An interactive on-line environment is characterised by the superposition of different meanings, channels and media spaces. Thus it is often necessary to be able to recognise in every uncertainty the opportunity for extrapolating a few answers, without necessarily filtering them (Ascott, 1994, 1998) through purposeful contents which characterise the shell of consciousness. As Bateson stated, receivers have to acquire the capability of creating contexts by means of learning or by a fortunate coincidence in randomness: since they must be ready to recognise the right discovery, when it arrives (Bateson, 1979).

I think, by the way, that there are some profound likenesses between the mobility of the conscious stressed by digital technologies with the thoughtful and productive habits of music making. Musical experience continually refers to the combination of dissimilar materials and languages and to a communicative environment which pivots on controlling the forms of change. In music the contextualisation of new contents is closely linked to the permissibility of multiple formal variations, through specific formulations and itineraries which spring from (and flow into) the dimension of sociability. In fact, just as freedom in juxtaposing harmonic materials is the reflection of a more ample reality of descriptions, which also stick to conviction through the complexity and autonomy of different cultures, the stratification of multiple time granularities, used with skill in contemporary music, is closely linked to the decline of uni-linear explanation models, as well as to the social-technical framework which influences communication forms in the era of digital technologies.

The innovations offered by digital technologies are related to very different expectations and follow different paths of social innervation. The realisation of instruments oriented towards the analysis, the synthesis and the manipulation of musical complex structures is actually received very differently, depending on where the stress is placed, whether it is on the abstract, innovative theoretical components rather than on the relational experiences generated or presumed so by innovation itself. Often the suggested variations are not able to condition the formation of musical meaning, as well as facilitate the construction of shared

frameworks: on the other hand, it is plausible that, in a distributed environment, research processes make use of paths able to quicken and emphasise the processes of general acceptance and of social validation: the paradigms proposed by on-line communication can fluidify cultural asymmetries and encourage an approach between research communication and communication tout court, solicit the creation of an audience able to receive and update the semantic outline of the new proposals, according to new declinations of music making.

Music, patterns and permanence

In the field of musical composition it is quite unusual to affirm that propositions, periods or timbres 'imply' one another or 'are implied' by them, unless one wishes at all costs to use a metaphor taken from the scientific sphere. A metaphor can be seen as a sort of preliminary to an act of musical creativity only if it succeeds in fascinating the author's imagination, so much as to have meaningful relevance in their works. In music there are practices which regulate the advantage of some of these solutions even in a rigid way within precise linguistic contexts; but, because they are expressive and communicative expressions, they are in the first place referable to the degree of understanding historically created between the author and audience, and only secondly to the typicality of the relationships which flow between musical structures.

The representation of musical relationships through strong ties (implication) is thus a type of patterning. However, this would make no sense within a consolidated communicative process, where the only needs are to stabilise the growth of musical knowledge and to fix them so that they can be reproduced and transferred. Instead the word implication can by right acquire a precise justification in case it is possible to reproduce the sequence of musical passages by means of suitable operators and formal methods. In fact they represent the implementation of generative models which allow us further power to manipulate it, while conserving musical information. Thus we ought to reflect on the appropriateness of the coordinates and of the assertions regarding the practice of composition and the fruition of music, in the era of numerical coding.

The possibility to transforming digital time-matter makes it possible nowadays to conceive of music as an abstract field of possibilities, able to take on real domains when it take forms, through functions 'passed down' through time with different degrees of freedom. In this context, the premises which favour a particular compositional process can be also considered reversible. During the constructions of musical structures the composer is oriented by his freedom of place hypotheses, materials and different directions of creative development in competition, proposed within a preliminary dimension, which can be recreated several times and in different ways. When an invention effort is constituted within the relationship of reciprocity between dynamic pattern and the result, in a struggle of interference and opposition, it is because the pattern relinquishes every prescription for becoming a tool which paves the way for the recognition of different forms of emergence (Lazzarato, 1996).

Within cognitive science, Varela has developed a vision of emergence as irreducibly contemporary to the way of acting and relating with a world which make sense: according to his vision, knowledge and action are ontological, and the world we know emerges

110

according to the history of structural combining (Varela, 1996). We could also say, by extension, that the ontological differences create in a constitutively dissimilar way the sound space, often escaping known linguistic rules. Surely, directionality over time and the predictability of musical events are fundamental connotations of a sonorous and symbolic continuum, based on the linearity of notation and on the balance between permanence-evidence. But creative processes add meaning to musical information by going beyond the mere evidence, and interpreting the gradual shift from 'less realised' to 'more realised' through the recognition of those meanings which are not directly constituted or generated by underlying or preceding processes (Bedau, 1997). The criticality of the relationship between operas and communication and thinking devices must also be mentioned. Lévy notices that in a deterritorialised semiotic plan the division between messages and operas, meant as micro-territories conferred to the authors, tend to disappear. The creative effort is gradually transferred from messages to devices; implication, from simply being only a conceptual or hermeneutical tool, becomes a form of art, which 'doesn't constitute operas: it makes processes emerge, it is looking for the possibilty for autonomous lives, it introduces into a growing and living word' (Lévy, 1995).

Technologies of change

Creative processes often make use of methods like juxtaposition, symmetry, contrast and analogy (Hofstadter, 1987). The analogies related to different systems of meaning can be represented by identical propositions, able to connote the differences which concern the physical nature of connected entities (Shaffer Williamson, 1995). In this way we can test, compare and mix the processes originating within different environments with identical constructive models, noting all the possible points of contact. Extracting configurations from specific contexts and immersing them into others is the same as creating structural analogies, and this represents a particular type of meaning production, connected with the interrelation between two or more different kinds of emergences. It has been shown how transferring codes of musical propositions towards other domains (Haus, Morini, 1992) requires the planning for many variation of time orientation and of linear prediction, which cease being a function of the background and became an explicit operator.

Analogous approaches are suggested by cyberspace technologies, since the flowing of objects and the frequent changing of contexts (Novak, 1992) often force web users to depend on analogy in order to reconstruct and understand the processes of change or to promote them. Since it is a widespread practice, on-line experimentation of transferring context is something very different from a methodical or science-oriented research, and for the moment it doesnt seem to be aimed at encouraging the creation of a domain within which to inscribe theoretical propositions. Instead, it seems to encourage a change of perceptive, creative and relational experience models (Trumbo, 1996), according to the hypothesis that in every field objects and their relationships can be considered impermanent and that any configuration used to declare a certain content, can be exonerated from the function of reference to something, and transferred into different domain. In this environment art forms are coming into being, which ignore the division between emission and reception, composition and interpretation, and which let the now non-audience experience other modes of communication and creation (Lévy, 1996).

Conclusion

Besides analogy-based creative processes, we are witnessing the establishment of a cognitive environments which favours negotiational models of knowledge (Ascott, 1994, Robinson, 1998), in part implied by distribution practices, in part bound to the possibility of defining consumption objects by means of personalized description levels. As active consumers know, many options can be negotiated by individualizing the cognitive devices, selecting the sources and the reception contexts, and the combining of objects and environments. On the net, musical objects are changing thanks to a vision which engages all languages in the research for different ways to understand each other. This make it less credible that the recognition of musical structures is only a result of predetermined models. It is plausible that downloading ready made music will gradually be accompanied and integrated by the use of queries, carried out for various musical information levels, each able to specify the nature of musical objects, and to extract their formal features. Thus many sorts of on-line negotiations are becoming increasingly routine, through different levels of 'working consumption' and awareness, as well as though the restrictions derived from low bandwidth and resolution.

References

Ascott, R., 1994. The Architecture of Cyberception, *Leonardo Electronic Almanac, Volume 2*, No. 8, ISAST.

Ascott, R. 1998. MASS 98 Keynote: Strategies of Media Art. *Leonardo Electronic Almanac, Volume 7*, No.1, ISAST.

Bateson, G. 1979. *Mind and Nature: A necessary unity*, NY E. P. Dutton, pp. 69–78.

Bedau, M. A. 1997. Weak Emergence, Philosophical Perspectives N. 11: Mind, Causation, and World, edited by J. E. Tomberlin , Boston, MA & Oxford UK , Blackwell Publishers, pp. 376–379.

Haus G., Morini P. 1992. 'TEMPER', a System for Music Synthesis from Animated Tessellations, *Leonardo* (Special issue on 'Visual Mathematics') *Journal of the ISAST, Vol. 25*, N. 3/4, San Francisco, CA, Pergamon Journals, pp. 355–360.

Hofstadter, D. R. 1987. *Ambigrammi: un microcosmo ideale per lo studio della creatività*, Florence, Italy, Hopeful Monster, pp. 101–137.

Lazzarato, M. 1996. *Videofilosofia. La percezione del tempo nel postfordismo*. Roma, Manifestolibri, pp. 49–96.

Lévy, P. 1995. *L' intelligenza collettiva. Per una antropologia del cyberspazio*. Milano, Feltrinelli Editore. pp. 128–132.

Murray, T. 2000. Digital Incompossibility: Cruising the Aesthetic of the Haze of the New Media, *CTHEORY, Vol 23*, No 1–2, Arthur and Marilouise Kroker Editors.

Novak, M. 1992. *Liquid Architectures in Cyberspace: First Steps*, edited by M. Benedikt. Cambridge, MA, USA, MIT Press, pp. 225–254.

Pope, S. T. 1999. Web.La.Radia: Social, Economic, and Political Aspects of Music and Digital Media, *Computer Music Journal, 23*:1, Cambridge MA, USA, MIT Press, pp. 49–56.

Robinson, W.N. Volkov, V. 1998. Supporting the Negotiation Life Cycle, *Communications of the ACM, Vol. 48*, N. 5, New York, ACM Press, pp. 95–102.

Shaffer Williamson D. 1995. *Symmetric Intuitions: Dynamic Geometry, Dynamic Art*, The Media Laboratory, MIT, http://dws.www.media.mit.edu/people/dws/papers/symint/index.html, Cambridge, MA, USA.

Tanzi, D. 1999. *Preliminary observation about music and decentralised environments*, ACM-SIGCHI Proceedings of Third Creativity & Cognition Conference, Loughborough UK, Loughborough University, pp. 88–92.

Taylor, M., Saarinen, E. 1992. Intellectuals and The New Media, excerpt from *Imagologies: Media Philosopy*, http://www.gold.net/ica/excerpt.htm

Trumbo, J. 1996. A Conceptual Approach to the Creation of Navigable Space in Multimedia Design, *Interactions of ACM, July/August*, ACM Press, New York, pp. 27–34.

Varela, F. 1998. Construction du réel et affect: expéience du sujet, performances et narrations, In: *Constructivisme et constructionisme social*, E. Goldbeter-Merinfeld (Ed.), Bruxelles, De Boeack Université, pp.277–282.

Dante Tanzi works at L.I.M. (Musical Informatics Laboratory), Computer Science Department, Milan University, under the scientific direction of G. Haus.

The Space of an Audiovisual Installation within a Real and a Virtual Environment

Dimitrios Charitos and Coti K

Introduction

This paper attempts to address the issue of the spatial experience in an audiovisual installation and particularly focuses on the issue of spatialising music. It documents the beginnings of an ongoing investigation into how such a spatialisation can be experienced in real and virtual space. This investigation was based on two audio-visual installations ('Lego Kit Box' and 'Lego-Submersion v1.0') created by the two authors, the former in real space and the latter in a virtual environment.

An installation (Archer et al, 1996, p. 5) is a term used for describing 'a kind of art making which rejects concentration on one subject in favour of consideration of the relationships between a number of elements or of the interaction between things and their contexts.' The emergence of video art and more recently of interactive and multimedia art has 'advanced the understanding of how the viewing of an art work progresses from the metaphysical, or psychological act, toward a perceptual understanding complete with physical experience and comprehension.' (Huffman, 1996, p. 201)

In the 1950s, John Cage had rejected the conventional conception of composition in music, as an internal relation of parts within a coherent musical whole. Instead he practised music-making, writing and installation as a process more akin to the chance encounters and stimuli that impinge upon us in everyday life (Archer et al, 1996, p. 26). His understanding of composition was more directed towards an idea of choosing randomly from among a set of possible options. This could be seen as 'a shift from art as object to art as process, from art as a "thing" to be addressed, to art as something which occurs in the encounter between the onlooker and a set of stimuli.'

Underlying the issue of spatialising music is the relationship between sound and architecture. 'Architecture is the art of design in space; music is the art of design in time... the properties of space and time are inseparable.... Without time and space matter is inconceivable. Space gives form and proportion; time supplies it with life and measure.' (Martin, 1994, pp. 8–9) However, our experience of space cannot be isolated from movement and time. Although environments which are the result of architectural design

and practice can only be experienced through movement, disregard for the parameter of time has indeed been one of the main drawbacks of most architectural representations. This parameter has recently been introduced to architectural representations through the use of time-based media like film, video and the computer.

During the 20th century, music has undergone a series of emancipations (Novak, in Martin, 1994, p. 70), regarding the concepts of dissonance (as witnessed in the work of Shonberg), noise (Varese), stochastic form (Xenakis), non-intention (Cage). These advances challenge architecture to confront, parallel and possibly exceed each of those emancipations by travelling away from its own conventional definitions. Recently many architects and artists (Marcos Novak, John Fraser, Char Davies, Stephen Perrella, Greg Lynn, Karl Chu, et al) have produced works, which either directly or indirectly challenge the boundaries of what is understood as designing space. On the other hand, despite 20th century's advances, music has not yet freed itself from the straight and narrow limitation of temporal linearity. This issue could be addressed by attempting to relate music with space.

2. 'Lego Kit Box' – An audiovisual installation in real space [1]

A way of relating music with space is by designing a three-dimensional environment, comprising certain visual and auditory elements, which encompasses the visitor [2] and affords a truly spatial experience. In order to achieve that, the musical piece should be decomposed to its constituent elements and the sound sources, which emit these elements, should be positioned within this environment. If the visitor can freely move within this environment then this movement allows for experiencing the various aspects of the environment in a subjective manner.

The central concept behind 'Lego Kit Box' was the idea of positioning a series of pre-recorded musical pieces (Coti K., 1999) within a certain three-dimensional environment and of accompanying them with visual content, relative to the conceptual context of the pieces. This was achieved by using 8 different sound sources [3], which played the 8 different channels, corresponding to the constituent elements that each musical piece was decomposed into. These sound sources (system of amplifiers and speakers) were appropriately positioned within the space of an old warehouse. Their position and the big enough distance among them was intended to afford the possibility of moving at certain areas within the environment and listening to a significantly different mix of the 8-channel musical pieces. Visitors were therefore given the opportunity to de-mix the music according to the way that they moved within the environment and positioned themselves relative to the sound sources. In this sense, each visitor experienced the environment in a uniquely subjective manner.

The auditory content of the installation was accompanied by 4 video monitors displaying 4 tapes of time-based visual content, which corresponded to 4 different thematic sets of imagery (nature, city, house, body), associated with everyday life in the urban environment. These monitors acted as very subtle elements of light, within an overall darkened space and induced movement within this space, consequently revealing the auditory experience. In addition to these visual elements, a dimly lit, very long, linear light tube defined the limits of the overall installation space within the larger space of the warehouse. The 4 video tapes comprised visual imagery from the real world, recorded and

edited in such a manner so as to avoid direct association with the specificities and role of depicted objects and to concentrate on their form and movement.

The process of treating real visual imagery in such a way was in accordance with the use of sound recordings from the real world, which was a fundamental characteristic underlying the composition of the musical pieces. These recordings captured significantly spatial auditory experiences. Subsequently these sounds were edited, digitally treated, often positioned out of context and accompanied by other real or digitally produced sounds, in order to produce a soundscape which existed as another parallel reality in its own right.

Following discussion with several visitors, we suggest that the spatial experience afforded by this installation was primarily auditory, as originally intended and that the affective impact of this experience was strong and visceral. However, the experience had a somehow passive character. This passiveness could be attributed to the linear character of the audiovisual content and to the sense that the visitor could do little to affect the way that the experience evolved apart from moving around and perceiving different aspects of the audiovisual display.

3. The nature of space in virtual environments

Recent software and hardware developments in the field of interactive three-dimensional graphics have made virtual reality technology more affordable and the authoring of virtual environments user-friendlier, for a wider audience of designers and artists around the world. The emergence of virtual environments (VEs) has made it possible to immerse a visitor into a synthetic world by means of multi-sensory (visual, auditory, tactile and kinaesthetic) display devices.

In trying to understand the nature of VEs as a medium for creating synthetic and not necessarily realistic worlds, it is significant to consider the intrinsic characteristics of space in VEs (Charitos, 1998):

- Space in a VE is non-contiguous. A visitor is able to teleport from one position within a VE to another remote position within the same VE or among different VEs. The positions from where one teleports and where one arrives are named portals. If two VEs are connected in this manner, they are not spatially related to each other in a three-dimensional, Cartesian context. They could be anywhere and indeed it becomes irrelevant where they are in relation to each other. In this sense, the structure of spaces within a VE can be hypertextual in nature.
- Benedikt (1991) elaborates on how the principles of real space may be violated in VEs. Accordingly, space may be seen as multidimensional; although all geometrical models of objects are designed in Cartesian space, we are not limited to three dimensions in a VE, because any surface may reveal other three-dimensional environments. VEs also allow for the interactive visualisation of data sets represented by 4D or higher-dimensional spaces, as witnessed in the work of Feiner & Beshers (1990) and Novak (1994).
- There exist no physical constraints or physical laws like gravity or friction in a VE unless we design and implement them. Such constraints should be determined by the specifications which define the VE and in accordance with the application task.
- A VE does not necessarily have scale consistency. The scale of perceived space in a VE is relative to the spatial context, which surrounds the visitor at each time.

• Time is not necessarily continuous in a VE. When a participant is being teleported, a new environment is being downloaded to the system and the downloading time cannot be mapped to a certain translation of the participant's viewpoint in the space of the VE. In this sense there may be a certain temporal discontinuity in the experience of a VE. Moreover the pace of time may be altered – slowed-down or speeded up – according to the requirements of the application.

Figure 1: Stills from 'Lego Kit Box' installation.

Sounds can be emitted within the simulation by several sources, triggered by events (intentional or unintentional user actions) and localised in three-dimensional space.

We suggest that VEs may be seen as an ideal platform for building synthetic worlds, not limited by realistic spatio-temporal constraints, thus experimenting and challenging the boundaries of what is currently understood as designing space and sound/music. According to Novak (in Martin, 1994, p. 64): 'we stand at the dawn of an era that will see the emancipation of architecture from matter. The intuition that allows us to even consider architecture as "frozen music" or music as "molten architecture" comes form a deep and ancient understanding that, in its very essence, architecture exceeds building, as music exceeds sound. Music, especially computer music, will have much to teach the new liquid and gravity free architecture. Architecture, in turn, will provide music with its greatest challenge: its emancipation from sound – and therefore linear time, inspiring instead a new navigable music of places. Together architecture and music will stand as the arts closest to the functioning of the human cognitive and affective apparatus.'

4. 'Lego-submersion v1.0' – An audiovisual installation in virtual space

'Lego-submersion v1.0' is a work in progress and an attempt to investigate the use of VEs as a medium for creating audiovisual installations. For the purpose of comparing the processes of designing such an installation in real and in virtual space, 'Lego-submersion v1.0' utilises the same musical pieces (Coti K., 1999) and aspects of the visual content (stills from the video tapes) displayed within 'Lego Kit box'.

This VE installation has been developed for a desktop VR system and uses a 6 degrees-of-freedom navigational input device. A series of content-objects function as landmarks (Charitos, 1997) or audiovisual content emitters within this installation. Each object emits one of the sound channels of a musical piece and on its surfaces an image is appropriately texture-mapped. The image, which is mapped on the surface of each object, conceptually corresponds to the sound emitted from this object. These objects are organised into 4 domains (Charitos, 1997). Each domain corresponds to one of the 4 musical pieces and one of the 4 different thematic sets of imagery (nature, city, house, body), presented in 'Lego Kit box'. A non-realistic kind of transparency effect has been achieved on the surfaces

of these objects by making use of single-sided polygons and by texture mapping the interiors of these objects.

Each of the 4 domains consists of a different universe (WorldUp, 1996). Each universe is spatially established by a spherical border (which is the furthest limit of user navigation) and a series of twisted structures, which create the context where the objects, displaying the audiovisual content, are arranged. Adopting VEs' characteristic of spatial non-contiguity, these 4 domains are not related within an overall, continuous, three-dimensional spatial context. A visitor can only move among them by means of teleportation via appropriately designed portals.

Following use of 'Lego-submersion v1.0' by a small number of visitors, it is suggested that this VE has not provided as strong or effective a spatial experience as the real environment installation. This is attributed to the limited visual output provided by the desktop VE system, the lack of 3D sound localisation hardware and the fact that the auditory display device was merely a set of headphones. Despite these technical limitations however, the intention of positioning the constituent elements of the musical pieces within

an environment is clearly satisfied within this VE installation. In order to achieve this effect, the threshold distance from each object at which the sound begun to be audible, was appropriately adjusted. As a result, visitors can substantially differentiate between the sounds emitted by each object as they move amongst them.

Additionally, visitors were given the impression that they had more active involvement in the way that the overall experience evolved. This was attributed to the fact that the sounds were interactively triggered by user navigation among the content-objects. This positive impact however, brought forward the need for appropriately designing the sound segments in an interactively evolving musical piece, bearing in mind the random manner in which these segments may be triggered.

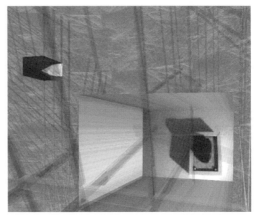

References

Archer, M., DeOliveira, N. Oxley, N. & Petry, M. 1996. *Installation Art.* London: Thames & Hudson Ltd.

Benedikt, M. 1991. *Cyberspace, First Steps.* London: The MIT Press.

Charitos, D. 1998. *The architectural aspect of designing*

Figures 2, 3: Views from 'Lego-submersion v1.0' virtual environment.

space in virtual environments. PhD thesis submitted to the Department of Architecture and Building Science. University of Strathclyde. Glasgow. UK.

Charitos, D. & Bridges, A.H. 1997. The Architectural Design of Information Spaces in Virtual Environments. In Ascott, R., ed. *Consciousness Reframed*. Newport: University of Wales College.(Proceedings of the 1st International Conference)

Coti K. 1999. Lego (CD). Athens: Studio 2 Recordings.

Feiner, S. & Beshers, C. 1990. Visualizing n-Dimensional Virtual Worlds with n-Vision. *Computer Graphics, Vol. 24*, Nr. 2, ACM Press, March 1990, pp. 37–38.

Huffman, K. R. 1996. Video, Networks and Architecture. In Druckrey, T. ed. *Electronic Culture*, Aperture Foundation.

Martin, E. 1994. Architecture as a Translation of Music. *Pamphlet Architecture 16*. Princeton Architectural Press.

Novak, M. 1994. A cyberspace chamber of the 4th dimension. Presentation in 'The redoubling of space in relation to architecture and urbanism' Seminar. Technische Universiteit Delft. December 1994.

World Up™ User's Guide. 1996. Mill Valley, CA: Sense8 Corporation.

Dimitrios Charitos is a research associate in the Department of Informatics, University of Athens.
Coti K is a freelance artist.

'Give us the Funk…' Machine Autonomy Meets Rhythmic Sensibility

Jonathan Bedworth and Ben Simmonds

Introduction

Our experience of technologically mediated music practice has led us to consider a particular set of potentials for music technology. Our concern here is with the nature of the musical role the machine is fulfilling in our music practice.

Here we discuss the issues that have arisen and what these may indicate for applying the techniques of Artificial Life to our musical processes. A predominant aspect of this is the manipulation of rhythm. We will attempt to contextualise these matters in relation to some wider musical observations, and then conclude with speculations for the shape of future technological development in furthering our musical aims.

Reflection on practice

Our intuitions about this technology arose originally through observations and thoughts arising from the particular concerns of our own musical collaborations, but we feel that these insights may be interesting to a broader audience interested in interactive art technology.

Music technology has shaped our collaborations; our interest is in developing devices that can perform certain roles within the studio environment, and not seeking to simulate

that environment in the machine by encoding it with our explicit musical knowledge, intentions and working practices.

Central to this desire is a seemingly paradoxical sense of both an extended creative reach and yet musical distance that occurs when applying technology to certain musical processes. Our sense of creative reach is, in some ways, easy to reflect on because our music would simply not be possible for us without the technology employed to create it.

However, it is almost that to engage with these machines is sometimes at the cost of disengaging from the creative musical flow that these same machines are helping to sustain.

Musical machines

Our musical machines can be considered passive and musically 'simple' by certain standards. There are no algorithmic composition or artificial intelligence techniques employed but instead we employ commonly available drum machines, sequencers and samplers.

We have found these devices to be extremely useful as malleable music representations, providing a high degree of visibility and access to the details of music structure. Simple musical technologies still provide many possibilities, depending on what you ask of, and how you relate to them. These technologies contribute a musical skeleton for the unfolding musical process.

However, while providing a largely transparent window onto the music, sequencers and drum machines essentially reflect a score-like representation system based on the idea of a linear musical development. The placement of musical events is represented by a list of MIDI events and sample position markers, and a single basic MIDI clock controls their execution. We have found limitations in our ability to manipulate the musical spacing of these events in real time.

We do not seek to employ technology to automate this creative process but wish to more deeply engage the machines with us in exploring it. We are therefore aiming to create technology that is suitably responsive to aspects of this dynamically changing musical environment. The 'problem' from a technological viewpoint concerns this desire to facilitate a closer, more adaptive relationship between the ongoing and changing intentions of the musician and the behaviour of the machine.

Embodied processes

This technology is only part of the story. To say we set out to explicitly 'explore' musical aspects is perhaps giving too much of a conceptual slant to the actual process that occurs. Much of our creative environment is largely un-conceptualised and seems to reside in tacit knowledge, felt intuition and physically embodied processes distributed between ourselves, technology and the wider environment of the music studio. The human relationships themselves, partly played out through technology, are as important as those just enacted through the technology. The result of this is the creation of music that could not have been achieved in individual as well as technological isolation.

The resulting music is seen as forming records of our various interactions in the studio rather than autonomously reflecting the embodiment of an idea in sound. Any 'meaning' is to be found just as much in the process as in the finished musical artefacts.

We have concluded that some of the musical distance arises from an incompatibility between the musical process as a communicative shared act and the technology used in pursuit of this.

The living art form

This communication seems to involve practice that is highly improvised, requiring successive, and often spontaneous, musical adaptations. So far no consistent strategy has been applied in our musical explorations. More often than not the rhythms, as with other musical elements, are found due to a complexity arising out of prior concepts, experimentation, and even errors and mistakes made during the creation process.

What we have observed happen is that a sense of what we want will shape itself through a tightly coupled process of hearing, evaluating and acting on musical results. Importantly, what we are hearing in the music may be more than our musical machines are actually playing at the time.

Our desire is to achieve a sense of 'aliveness' in the movement of music over time and for technology to perform an increased role in this emerging strategy. Many musical aspects are played, programmed, or digitally altered by the human musicians, often as the machines are playing. The problem with these techniques, used to combat the tendency for heavily quantized, static and repetitive music, is that they have resulted in increasingly time intensive refinements and revisions of the music's micro-rhythmic structure.

We liken this process to crafting some kind of material, which contains within it a set of unknown potentials. The materials are always throwing up possibilities along the way and may in turn guide further creative decisions, much in the same way as a fine woodcarver incorporates knots, bark and other features of his base materials into his final design. This approach reflects a kind of 'digital craft' (McCullough, 1996).

Somewhere in this complex there exists the prior musical experience and knowledge of the musician, whose aspects are potentially machine encodable, and their repertoire of skills developed over time, many aspects of which may resist encoding into the machine.

Human-machine symbiosis

In considering the issue of what musical 'knowledge' to actually encode in the machine it is interesting to reflect on the idea of human-machine symbiosis in music practice. Such symbiosis generates new musical terrains and facilitates their exploration. The music arises out of the interaction and neither party – person or machine – is capable of quite the same without the other, in the same way that a conversation is not quite the same without at least one other person being present. Lee 'Scratch' Perry, in describing his relationship to his studio environment, gives a good sense of this:

> The studio must be like a living thing. The machine must be live and intelligent. Then I put my mind into the machine by sending it through the controls and the knobs or into the jack panel. The jack panel is the brain itself, so you've got to patch up the brain and make the brain a living man, but the brain can take what you're sending into it and live. (cited in Toop, 1995)

Perry, while not claiming his studio was in any sense truly alive, feels the studio to possess a kind of autonomy whilst still being dependent on human input for its 'life'.

Symbiotic relationships exist between us and older, 'dumb', musical instruments, particularly the piano that for us serves as a counterbalance to all this digital technology. The genesis of our musical creativity is seemingly not found in the mind of any one individual, instead emerging through multiple distributed interactions in the wider environment. This has implications for the desirability of attempting to simulate an understanding of the musical environment within the machine, for example, by encoding it with explicit knowledge of our musical intentions.

Pursuing the 'creative machine' may detract from furthering the emergence of novel musical human-machine relationships. Instead, the behaviour of devices may reflect musical sensibility but the design need not necessarily be a representation of it. The principle aim is to explore novel ways of dynamically altering related musical aspects with simpler musical gestures that operate in an ever-changing environment of evolving intentions. This need is particularly apparent in relation to rhythm.

Rhythm is a dancer

Rhythm is the most perceptible and least material thing (Chernoff, 1979)

We both owe much to the influence of funk, hip-hop and elements of jazz on our collective sensibility. This might explain why one of the major musical aspects to have emerged is rhythm. More specifically this interest concerns a sense of creating fluid rhythmical transformations, exploring the shifting 'spaces' between musical events as they occur in time rather than pursuing ever more abstract time signatures. Within simple metrical frameworks, we subsequently seek to shift the dynamics of the rhythm over time, creating coherent shifting conjunctions of simple musical elements.

We situate this in contrast to a perceived view of future music as static and ambient, full of strange digitally enhanced sound transformations. Kodwo Eshun makes this point about the neglect of rhythm.

Traditionally, the music of the future is always beatless. To be futuristic is to jettison rhythm. ... The music of the future is weightless, transcendent, neatly converging with online disembodiment ... [It is] nothing but updated examples of an 18th [century] sublime. (Eshun, 1998)

We speculate, along with Eshun, that an important place will be given to the exploration of certain kinds of rhythms, whose form has more in common with the embodied rhythms of Afro-American music than the conceptualised rhythms of the avant-garde and experimental music traditions. Here new forms of music have arisen in synthesis with other western musical forms and technology. This is evident in the music of futuristic jazz pioneers Miles Davis and Herbie Hancock, the dub reggae of Lee 'Scratch' Perry and King Tubby, and the emergence of hip-hop. In utilising the computer the process of exploring and shaping these new rhythms has been likened to a kind of experimental enquiry, the results of which may evolve novel musical forms:

To go into space today means to go further into rhythm. Far from abandoning rhythm, the Futurist producer is the scientist who goes deeper into the break, who crosses the threshold of the human drummer in order to investigate the hyperdimensions of the dematerialised Breakbeat ... Moving into the possibility space of hyperrhythm, posthuman rhythm that's impossible to play, impossible to hear in a history of causation. (Eshun, 1998)

Artificial Life

A desire for a sense of rhythmic 'aliveness' in our music prompted research into the possible uses of Artificial Life techniques. With all these imminent possibilities it is easy to lose sight of the original and most important aims of practice. Why does an algorithmic approach necessarily become the right one just because the technology exists to enable it? It may be more a question of struggling to keep hold of the musical intention and exploring technology in relation to this, while at the same time recognising the shaping role that this technology has on the resulting intention.

The technology of Artificial Life has displayed what on the surface appears to highly complex and less predefined behaviour arising from what are essentially very simple processes acting in parallel. This large and diverse area of research provides a backbone of ideas and technologies, some seemingly irrelevant, which could be applied to our music creation processes.

The apparent complexity of rhythmical movement is simply the interactions of simpler rhythmical patterns. In this regard :

What is sometimes called 'nouvelle AI' [Artificial Life, situated robotics and genetic algorithms] sees behaviour as being controlled by an ongoing interaction between relatively low-level mechanisms in the system (robot or organism) and the constantly changing details of the environment. (Boden, 1996)

It is interesting that the behaviour of these devices and computer simulations can display emergent collective behaviour, such as the virtual birds that display flocking behaviour in *Boids* (Reynolds, 1987). However, if we are to retain rhythmic coherence a form of representation is needed that allows for more structured transformations of such collective elements. We are therefore seeking a richer form of collective behaviour as our model.

Neural networks seem interesting despite it having been found that much scientific work in neural networks has largely neglected the issue of time until recently (Harvey, 1996). It will not be enough merely to be able to predict an ordered sequence of events occurring over time. We are looking for methods that are adaptive *to* events as they occur *in* time; i.e. methods that are sensitive to the dynamics of time itself.

Promising research is being undertaken in situated robotics. Many robotics researchers now seek to design devices that can adapt dynamically to unmapped and changing physical environments instead of following pre encoded maps. In this way a six-legged robot can seemingly 'learn' to walk by co-ordinating its leg movements in time without explicit prior instruction. The resulting walking behaviour appears strangely insect-like. Importantly, it is interesting to note that it may not be so much that it moves like an insect but that the simple dynamics involved create the type of movement we recognise as insect-like.

Many of these real and computer simulated robots utilise neural networks particularly

suited to display adaptive rhythmical behaviour within uncertain environments. Networks of this general type have also been used to entrain themselves to musical metre (Gasser, Eck and Port, unpublished).

It's life Jim ... but not as we know it

Our musical environment reflects an exploration of unknown territory. Recent developments from robotics and neural networks display behaviour that promises to fit in well with this environment, behaviour that is sensitive and coherently adaptive to the changing rhythmic relationships that emerge. In the way that situated robots continuously adapt to their physical terrain we envisage a musical machine that can adapt to this unknown rhythmical 'terrain'. We hope this will also serve to further shape our practice and provide for further, highly adaptive musical possibilities for experiments in 'truly posthuman rhythm that's impossible to play'.

References

Boden, M. A. 1996. 'Autonomy and Artificiality'. In Boden, M. A., ed. *The Philosophy of Artificial Life*. Oxford: Oxford University Press, pp. 95–107.

Chernoff, J. 1979. *African Rhythm and African Sensibility*. Chicago: Chicago University Press, p. 23.

Eshun, K. 1998. *More Brilliant Than the Sun: Adventures in Sonic Fiction*, Quartet Books, p. 67, p. 68

Gasser, M., Eck, D., & Port, R., unpublished. 'Meter as Mechanism: A Neural Network that Learns Metrical Patterns', Indiana University Cognitive Science Technical Report 180.

Harvey, I. 1996. 'Untimed and Misrepresented: Connectionism and the Computer Metaphor', *AISB Quarterly, (96)*: pp. 20–27.

McCullough, M. 1996. *Abstracting Craft: the Practiced Digital Hand*, Cambridge, MA: MIT Press.

Reynolds, C. W. 1987. 'Flocks, Herds, and Schools: A Distributed Behavioural Model', *Computer Graphics, 21*(4): pp. 25–34.

Toop, D. 1995. *Ocean of Sound*, London: Serpents Tail, p. 113.

Jonathan Bedworth is a practicing musician, computer programmer, and currently completing a PhD in the interactive arts at CAiiA-STAR, University of Wales.

Ben Simmonds is a multimedia music composer, freelance music journalist and lecturer in music technology at Northbrook College, Worthing.

The Synesthetic Mediator

Malin Zimm

Synesthesia (Greek, syn- together and aisthesis- perception) is a neurological condition of involuntary cross-modal association, where a stimulation causes a perception in one or more different senses. It denotes the rare capacity to hear colours, taste shapes, or see music. It is an additive experience, where two or more senses are combined into a more complex sensation without losing their own identities.

Synesthetic architecture is about fusion, not only in the sense of joining materials together to enclose space, but as a method of joining ideas on all levels. My architectural proposal is an amplifier of sensations, in some levels taken to the extreme, where maximum reverses to minimum. The Synesthetic Mediator is a tool for inducing perceptual fusion, merging senses and combining concepts to release the energy of alternative perception. The structure will, by spatially causing a distortion of the senses, invoke the synesthetic multimodal state in order to deepen the direct experience into a meditative state of perception. The Synesthetic Mediator is a visitor centre in the back of your mind.

A spatially induced synesthetic experience is a preview of a future that undoubtedly will make use of new technology – in media, games and interfaces – to *simulate* and *stimulate* all senses to a higher degree. The Synesthetic Mediator illustrates the state of creative confusion that we are most often protected from. What we could be looking into is the immersion of the body into the digital realm and the introduction of a broadband of misbehaving senses: a perception process allowing us to experience sensory effects beyond the normal. The translation of biological impulses into computational commands by use of neural signals is part of the technical process that will lead to digital synesthesia.

Altered States of Perception

> I can reach my hand out and rub it along the back side of a curve. I can't feel where the top and bottom end: so it's like a column. It's cool to the touch, as if it were made of stone or glass. What is so wonderful about it, though, is its absolute smoothness. Perfectly smooth. I can't feel any pits or indentations in the surface, so it must not be made of granite or stone. Therefore, it must be made of glass.(Michael Watson, quoted in Cytowic, 1993)

The neurological condition known as synesthesia denotes involuntary physical experience in which the stimulation of one sense modality causes an additional perception in a different sense or senses. The above quote is a synesthete explaining his tactile experience of the taste of mint. This additional perception is regarded by the synesthete as a real and vivid experience, often outside the body, instead of imagined in the mind's eye.

Synesthesia is 'abnormal' only in being statistically rare. An estimated 1 in 25,000 people [1] has, not necessarily suffers from, synesthesia. It is in fact a normal brain process that is prematurely displayed to consciousness in a minority of individuals. Neurological research offers different theories of synesthetic mediation although many aspects of the condition still remain a medical mystery. Psychophysical experiments and measurements of cerebral metabolism indicate that synesthesia is a left-hemisphere function, relying on limbic brain elements more than cortex regions. The limbic system shares structures and pathways for attention, memory, emotion, and consciousness and is unique in its way to act on incomplete information. The limbic system enhances cortical processes by determining the value of incoming information before uploading it into consciousness as a perception. Continuously creating order from the incoherent sensory stream, it has the rare capacity of reducing entropy, due to the development of operating with optimal efficiency at the least

energy cost. Recent research has shown that infants do not discriminate between sensory input and that synesthesia could be a normal phase of the cognitive development. This supports the theory that synesthesia is a normal brain function in every one of us, but that its workings reach awareness in only a handful of people as a conscious peak of a normally unconscious neural process. In the dawn of humanity, we could have perceived the world synesthetically, an ability that disappeared as the evolutionary trend was an increasing anatomical separation of function. Synesthesia is a violation of conventional perception in a world that has emphasised objectivity and rational behaviour.

Inducing Synesthesia

The site-bound physical space of the Mediator is just like the human body: a container for individual experiences, a tool for communication, interaction and transportation. The experience of the physical space of the Mediator is secondary to this experience of the synesthetic features of the brain. The aim of the proposal is to induce a synesthetic experience in the visitors, by taking both architecture and function to the limits of perception, to the critical point where synesthesia might occur in 'normal' brains. Synesthesia can be induced in various ways, of which most include chemical interventions or surgery. How can we get the brain to produce synesthetic hallucinations as a normal response? Sensory deprivation proves to be an efficient method: the reaction of the neurological system in absence of any stimuli is – to invent its own. A brain deprived of external input starts to project an external reality. The Mediator is a device for breaking down sensory preconceptions, resulting in a zone of alteration and pulsation, misbehaving space ruled by confused time, where the individual inner perspective is the only true vantage point of perception.

The Stigmatised Site

The site for the project is located on the beach outside Sellafield nuclear power station in Cumbria, on the north west coast of England (Figure 1). The choice of site is partly motivated by the presence of waveforms ranging from high-frequency radiation to slow ocean waves and the topography of the dunes. Sellafield is Britain's largest nuclear power plant and the most controversial industrial site in the country: originally constructed to develop the atomic bomb, only later redefined to meet the increasing demand of electricity for British industry and households. The industrial complex has changed name three times during its operational history – from Windscale to Calder Hall to Sellafield – in an effort to erase the negative stigma of the name after various nuclear incidents. The site illustrates the fundamental questions of the project: fluctuating waveforms, energy and entropy, fusion and fission, deconditioning and rebranding. Sellafield is associated with the destructive forces of fission, the method that has been prevalent in most areas of research: releasing potential information and energy by dividing and splitting, by breaking entities down to parts. The Synesthetic Mediator attempts to counterbalance the hazardous process of the nuclear power plant, operating by the principles of fusion, focused on combining ideas rather than dissecting them.

Informotion

The common denominator of all sensory input is the mode in which it travels. Displacement of information is a result of travelling waves of energy. Sound, light, chemical and mechanical energy all translate into auditory, visual, olfactory and tactile experiences respectively. Since the brain is an electrochemical organ, the activity emanating from the processing of incoming data can be displayed in the form of brainwaves of different frequencies.

The observation of oscillations of matter has brought science to wave mechanics and a scale almost beyond comprehension, and still, nothing seems to come to a stop – everything is in motion. The architectural approach is inspired by the dynamic qualities of waveforms and the consistency by which all sensory perception is transferred. The building proposal is derived through a digital synesthetic reading of the site. Processed through synesthetic software, the recorded sound of the site, as well as the image of the site, were translated into two waveforms. The first waveform was accomplished by visualising captured sound from the site, using software called SoundView. The second waveform was derived by processing visual data from the site in MetaSynth, a software package that translates images into sound. The third waveform is the natural topology of the dunes and the beach. The three representational waveforms were finally extruded, scaled and intersected to form the architectural layout for the Mediator.

Dynamic Points of Convergence

The visitor will encounter a series of chambers, located on three different levels, corresponding to the conceptual organisation of the nervous system and the associative routes of synesthesia. The chambers on the first level aims at breaking down sensory preconceptions by distorting space and time. They also evoke an initial questioning of normal sensations and the body's relation to physical space. The entrance hall is the first step in the de-conditioning process. *The Time Delay Chamber* is blurring the boundaries of the interior and exterior space, where the exact view of the site is continuously displayed on the opaque interior walls with an eight hour delay. The illusion of displacement in time is achieved by a 360-degree view camera and a realtime projection on the interior walls which function as a domed screen. At 4 pm, you take shelter from the rain and enter the chamber where the walls display the view from 8 am and a man is walking a dog on the beach in the dimmed morning sunshine. You follow the pathway sloping further into the building, and enter the *Lie Detector*, a conference room and an indicator for the deceptiveness of the body. The conference table and the chairs are fitted with sensors that detect skin resistance and microphones that pick up signals for voice stress analysis. Indicators on the furniture allow the users to identify physiological changes when a subject is knowingly engaged in deception.

As you proceed further inside, you will be mentally prepared for the intermediate level chambers, spaces that require interaction. You pass by the *Whispering Gallery* and listen to the wall of memories, random recordings of previous visitors, and your comments are captured for other visitors to hear. *The Ray Forest Chamber* (Figure 2) down the path takes your picture and displays it on the floor as rays of coloured light. The rays work as a giant theremin, electromagnetic amplifiers translate the vision into sound so that each ray

Figure 1. The Stigmatised Site.

triggers a tone as you move, creating music from the image of yourself.

Getting ready for the sensory process to be bared to consciousness, you pursue to the chambers on the deepest level, extreme spatial conditions that will constitute the final immersion into alternative perception, and release the full potential of the mind.

The Anechoic Chamber (Figure 3) is an echo-free enclosure with a near total sound absorption level, achieved by surface area maximisation. Fibreglass sound absorbing wedges cover all six sides, also blurring the visual boundaries of the chamber, adding to the experience of the diminished sound levels that enables you to hear your own heartbeat and breathing. The brain compensates the loss of auditive input by heightened attention to all other senses, and hallucinations can occur after only a short while. *The Floating Crypt* (Figure 4) is located in the depth of the Mediator, featuring isotanks filled with body-tempered salt water. Sensory deprivation is synonymous with conditions of darkness, silence and a lack of a sensation of gravity. The float tank works like a de-conditioning tool, separating the body from all external stimuli and normal perceptual relations with the world. Ninety per cent of all the activity affecting our central nervous system is related to gravity. The lack of sensation of gravity therefore decreases sensitivity to and awareness of the external and internal reality. In floating condition the left hemisphere facilities of the brain are suspended and the right hemisphere ascends in dominance. This makes the iso-tank the most reliable mediator for inducing synesthesia, within controllable means.

The self-conscious system

Sensory input is processed in the unconscious levels of the mind before it reaches the higher cognitive levels in form of perception. Since language is a function of the 'higher', more abstract parts of the brain, the senses can not be described without the use of metaphors. The Glass Bead Game, described in the novel *Magister Ludi* by Herman Hesse in 1943, is a semantic mediation tool where metaphors are put into a system of rules where they reach beyond their initial linguistic function and turn into new constellations. The analogy of the Glass Bead Game is consistent with this project as an attempt to illustrate the maximum integration of the individual into a realm ruled by the understanding of links between ideas. The meditative discipline of the game takes place in a future where the players reconfigure the total contents and values of all cultures so as to devise surprising configurations that convey new insights. The circle is beginning to close between the Glass Bead Game and the media that, although unmentioned by Hesse, to this date has ineffably accomplished the ideas in the novel – the internet and the notion of hypertext. The introduction of a parallel virtual realm marks the transitional state from one way of thinking into another. The present society is the evolutionary stepping stone that Hesse refers to as 'the Age of the Feuilleton', a medial climate characterised by fragmented information. Hesse does not describe the game in detail but focus on the revolutionary power of this new model of the mind, something that appeals to a growing web community

Figure 2. The Ray Forest chamber *Figure 3. The Anechoic Chamber.* *Figure 4. The Floating Crypt*

of Glass Bead Game developers and players. Hesse tells us that the game soon developed to a high degree of flexibility and capacity for sublimation, and began to acquire something approaching a consciousness of itself and its possibilities. All different disciplines began to measure linguistic configurations: '... the visual arts soon followed, architecture having already led the way in establishing the links between visual art and mathematics.'

The Synesthetic Mediator provides a forum within which the principles of the Glass Bead Game can metamorphose into physical models. In a space where normal perception is challenged, the capacity to adapt, even if it means to engage in a process of unlearning, will be crucial. Architecture is the platform for multidimensional mediation and bi-sociation, linking conceptual frameworks that appear to have nothing in common. The neurological alchemist is a seer of patterns and maker of connections.

What are you waiting for? Let's perform. Let's open those neural floodgates. (Videodrome)

References

Baron-Cohen, Simon & Harrison, John 1997. *Synesthesia: Classic and Contemporary Readings*. Oxford: Blackwell.

Cronenburg, David 1982. Videodrome.

Cytowic, Richard E. 1989. *Synesthesia: A Union of the Senses*. New York: Springer Verlag.

Cytowic, Richard E. 1993. *The Man who Tasted Shapes*. Cambridge: MIT Press.

Hesse, Herman 1943. *Magister Ludi – The Glass Bead Game* (orig. title Das Glasperlenspiel) New York: Henry Holt & Co

www.microweb.com/ronpell/MusicVisualizers.html

www.uisoftware.com/PAGES_COM/ms_presentation. html (MetaSynth)

www.SwRI.edu/soundview.html

www.trustech.com (lie detector)

Notes

1 Michael Watson, synesthete: subject study by Dr Richard E. Cytowic in *The Man who Tasted Shapes*, Cambridge: MIT Press

2 http://www.cnn.com/HEALTH/9511/synesthesia/index.html (march 2000)

Location

Places of Mind: implications of narrative space for the architecture of information environments

Peter Anders

Virtual reality and cyberspace are extended spaces of the mind different from, yet related to, the spaces of fiction and ancient myth. These earlier spaces reveal how electronic media, too, may come to define our selves and our culture. Indeed, a better understanding of how we use space to think can lead to the design of better information environments. This paper will describe a range of traditional narrative spaces, revealing their varied relationships with the physical world. It will demonstrate the purposes of such spaces and how their function changes with their level of abstraction. A concluding review of current technologies will show how electronic environments carry on the traditions of these spaces in serving our cultural and psychological needs.

Narrative Space: Methodology for evaluation

In analyzing traditional narrative spaces I will use a methodology employed in my book Envisioning Cyberspace, (Anders, 1999), which presents artifacts and spaces in terms of a scale of abstraction (Figure 1). This scale ranges from the most concrete to the most abstract, appealing to our senses and intellect respectively. Our scale also ranges from perception to cognition, our ways of appreciating the concrete and abstract. We use this in the knowledge that the categories discussed are provisional, and that current or future examples may conflict with their definition. However the risk is worth taking. The methodology helps us distinguish important features of traditional narrative space and gives us a framework for evaluating electronic spatial simulation.

The Space of History

Of all the extended spaces that of history – the systematic, verifiable account of events – is most concrete. Events in historical space refer to specific people, places and times, all parts of our mundane experience. Accepted as nonfiction, it is valued by empirical cultures and is the foundation for Western societies.

History	Speculation	Legend	Fantasy	Myth	State
<Concrete <Perception					Abstract> Cognition>

Figure 1. Scale of abstraction for narrative space

Speculation Space

Speculation ranges from rumour to plans of action. Such projections, while beholden to the world of experience, are hybrids of fact and fiction. The plan for a building addition relies on historical, current facts, although it is an hypothetical space. While speculation is not entirely factual its fiction is grounded and believable. The building addition cannot float on air, for instance. To do so would require a move up the scale of abstraction away from concrete reality.

Legend Space

Legend describes historical people in fictional places or, conversely, fictional characters in actual settings. It keeps at least one foot on the ground. Like speculation legend may be hard to distinguish from history, for it is shared by the average citizen, its authorship unknown. But unlike speculation the fictional component of a legend may be fantastic. This magical component distinguishes legend from the more concrete categories of narrative space.

Fantasy Space

As we rise above legend to the levels of fantasy and fairy tales we increasingly encounter magic and the uncanny. These stories rely less upon material actuality than on symbols for cognitive and psychological states. Changes brought about by symbols are described in a magical way though the symbols themselves refer to the concrete world.

Fairy tales and folktales, in addition to defining a culture may also be didactic. They use fiction to relay psychological and cultural truths to children in fairy tales (Bettelheim, 1977), and to adults through folk tales and parables. Magic often draws attention to important moments of the tale, marking it in the readers mind.

Authorship of the original fairy tales is often hard to determine as they are a part of popular culture – similar to legend. Yet unlike legend the space of fairy tales and fable is stylized and general: a forest, a castle, the sea. They are not as specific as legendary places that may be cited by name. Likewise the characters that populate fairy tales are stylized, often drawn as types rather than defined as individuals.

Mythic Space

Myth, like folk tales and fables can be used for instruction, but its purpose is to offer spiritual guidance. Its characters are archetypal ideals, deities. This is reflected in the surroundings they inhabit. These may symbolize aspiration (the heavens) or death (the underworld) more than actual locations. Actions take place in no-time – eternity – or, in origin myths, are so far removed from the present that the rules of reality do not prevail.

Myths situate us in the world of man and nature. While fictitious, they are psychologically true (Campbell, 1959). The entities and actions presented may be magical but their emotional structure is rooted in our everyday experience. Lust, jealousy, and anger among the gods engage the reader, however magical their actions may appear. Myth promulgates faith, provides spiritual guidance and assures the longevity of cultural

institutions. It is used by spiritual leaders to convey meaning and cultural value, while legend and folk tales are a part of common culture.

State Space

At the highest level of our scale we find the conceptual spaces of religious and philosophical tradition. These are metaphors for states of mind. Heaven and Hell belong to this category as does the void of Nirvana. Such spaces are absolutes – resting places of the soul. Tellingly, they are rarely scenes of action in myth, for nothing really happens there. They are terminals to the road of life – beyond them lies nothing.

Even in this brief summary we can see trends that follow the ascent to abstraction. As we rise, we note a change of audience from the commoner to a select, sometimes religious elite. The use changes from conveying facts to conveying values. And the subject itself changes: the concrete extreme is specific to time and place while idealized beings populate eternity at the other end. Heroes and gods occupy our minds more than they do places on earth.

Cyberspace: The space of electronic media

In the ensuing discussion we will review the fictional spaces of electronic media with respect to the present scale. Electronic media space is distinct from its precursors. Unlike text or painting electronic media is active and so resembles more the oral traditions of narration and theatre. Also, unlike the traditional spaces of narrative, cyberspace is inhabited by users through their interaction within it.

Electronic media convey spaces that appear incidental to the content. A telephone call gives the illusion of intimacy even though the topic of discussion may be impersonal. The story told by a talk-show guest occurs in a space distinct from the television studio seen by the viewers. The space influences, but is not dependent upon, the content. This media space differs from the conventional text or image as traditional media artifacts are confronted directly. Choices for engagement are limited to the illusion offered versus the physical artifact, painting or book. There is no tacit intermediate space as with electronic media. It is this space that we will now relate to the illusory spaces of fiction. I will present the spaces by comparing them to the categories discussed earlier: history, speculation, legend, fantasy, myth, and state (Figure.2).

Analog Media

History, the category that relies most upon perception of the world, is already well-documented by conventional broadcast media, radio and television. Electronic, analog media can be used for immediate, live coverage of events. The space between events and

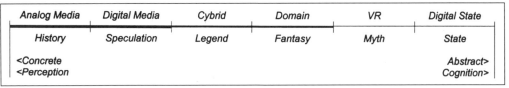

Analog Media	Digital Media	Cybrid	Domain	VR	Digital State
History	Speculation	Legend	Fantasy	Myth	State
<Concrete <Perception					Abstract> Cognition>

Figure 2. Scale of abstraction for electronic media space (top) compared with narrative space.

viewer collapses. Returning to our earlier example, the studios space of the talk-show is directly apparent to us. The space of analog media warps our own, collapsing remoteness into immediacy. These media are nearly ideal for uses served by history, journalism, and direct narrative.

Digital Space

Analog media have little separating events from the viewer. The processing of digital media, however, involves translational steps to turn input into digital information, and then to reverse the process to generate output. This means two more translations than with analog media, and therefore two more chances for error and manipulation to slip in. Digital media for this reason are attended by doubt. Doubt makes everything a potential fiction.

Digital media, particularly digital text and graphics used 'realistically', hold a position similar to that of speculation. We see this in the gossip of BBS chat rooms, and plans generated using computer-aided design. Both contain fictional elements but even these fictions are grounded in reality, differing only in medium from their mundane equivalents.

Domain Space

It's no coincidence that fairy tale and fantasy themes are already popular in multi-user domains and digital Worlds. These online, role-playing environments require users to assume an identity – or avatar – for participation. Many users capitalize on the masking effect of the avatar to hide their real identities (Turkle, 1984). These digital environments – while referring to the concrete world – are not subject to its laws. Magical actions are as common in these spaces as they are in fairy tales (Anders, 1996). For this reason the space of online domains may be considered at a level of abstraction comparable to folk and fairytales. They share many attributes, (1) they are used to foster communities, (2) their authorship is often unclear since many participate in their creation, (3) they serve a dual purpose for entertaining users and serving as a learning environment for role-playing, (4) they contain fact-based characters (avatar) and fanciful beings (agents and bots), (5) they are popular and accessible to the average user.

VR Space

While the domains just discussed are technically virtual realities they emphasize user representation and social interaction often at the expense of experiential quality. However, virtual reality (VR) changes character once this quality is improved – the user and use change as well. Owing to expense and accessibility this level of VR is limited to those who can work with its technology. Recent work by artists in this medium contain features that recall, sometimes deliberately, the spaces of mythology. Like mythology the space of VR is often autonomous, free from geographical locale. Some of its authors, such as Char Davies, use it to convey meaning and values which, while not necessarily religious, are often philosophical.

As in mythic space the actions within VR are sometimes magical despite the ground planes, fixed light sources, recognizable objects and behaviours that relate to the material world. Unlike experience in domain space the user is unlikely to encounter someone else in VR. This changes the nature of VR space from being social to theatrical. The user is

conscious of artifice despite the apparent freedom of interaction within it. This, too, recalls the space of myth as theatre where players enact the ancient tales of culture.

Digital state space

At the extreme of abstract space – that occupied by metaphysical poles such as Heaven and Hell – are electronic spaces that present states of being. Unlike VR and mythic space these are free of overt physical reference. Instead, they are often manifest processes innate to computing. As a result the space of artists working at this level is often disorienting as it makes few concessions to anthropic parameters of display. Without orientation, down and up do not matter; all ordinates, scales and dimensions are arbitrary. Each user's experience is unique, the spaces self-sufficient, closed to outside reference. Changes in such states are meaningless to the user. Effectively, as in comparable spaces of narrative, nothing changes there. Ironically, the lack of reference in state space means its contents are not symbols, but simply traces as concrete as the natural markings on stone. At this level abstract and concrete begin to merge.

Cybrid space

Suspended between these ideal states and mundane, historical space – midway down our scale – is legend, the unique blend of fiction and verifiable fact. Cybrids – the products of Augmented Reality and Ambient Computing (Anders, 1999) – occupy this position on our scale and comprise integral yet distinct physical and cyberspaces. Augmented reality allows objects that only exist within the computer to be grafted onto the physical environment. Ambient – or distributed – computing makes the physical environment responsive to changes brought about through users or other agencies. Taken to its extreme the environment appears animate, equivalent to the magic, responsive world of our childhood. Similarly, Augmented Reality recalls tales of the paranormal, of mysterious places annexed to our world.

Like myth, legend is used to define a group of people with common customs. But unlike myth legend has a greater fidelity to actual details people and places. Objects, buildings, and features of the landscape offer a mnemonic structure lacing together cultural narratives. Seeing a mountain or an abandoned house triggers memories, tales otherwise forgotten. The physical recalls the invisible. In turn, the invisible holds truths latent in our perceived world.

The model that legend offers cybrids' technologies, augmented reality and ambient computing, is that of a communal memory palace (Yates, 1966) – the structures of which are seen in the features of mundane reality. Legend acknowledges that consciousness is only partly empirical, that psychology and culture play an equal or greater role. Legend's comparable technologies may become media by which values, meaning, and solidarity are transmitted from one generation to the next.

Conclusions

Comparison of the fictional spaces of current technology with those of traditional narrative reveals many similarities and explains their success in the popular mind. This paper has shown how narrative, fictional space serves to maintains a culture's identity and preserves

its values. These purposes were explained in light of the spaces' dependency upon the perceived and cognitive worlds. Cyberspace – in its many forms – extends this tradition into the electronic realm.

A crucial difference between the spaces of conventional narrative in cyberspace is that with the latter, users engage and interact with their surroundings. Multi-user domains and digital worlds – for all their fantasy – foster the interaction of real people. Their spaces form an architecture – a designed social setting.

Yet the connection with architecture is not literal, for as we ascend the scale of abstraction we lose many ties to materiality. The spaces are metaphors and no longer serve utilitarian purposes of buildings and other structures. Only at the scale's midrange, occupied by augmented reality and ambient computing, do we still have an integral link with the physical world. Here we find the rich blend of material fact and the magic of symbols – of places haunted by the structures of memory.

References

Anders, Peter. 1996. Envisioning cyberspace: The design of on-line communities, in *Design computation: Collaboration, reasoning, pedagogy*. McIntosh, P. and F, Ozel, eds. Proceedings of ACADIA 1996 Conference, Tucson, Arizona. pp. 55–67

Anders, Peter. 1999. *Envisioning Cyberspace*. New York: McGraw-Hill, pp. 47–50

Bettelheim, Bruno. 1977. *The uses of enchantment: The meaning and importance of fairy tales*. New York: Vintage Books, pp. 111–116

Campbell, Joseph. 1959. *The masks of God: Primitive mythology*. New York: Viking Penguin Inc. p. 48

Turkle, Sherry. 1984. *The second self: Computers and the human spirit*. New York: Simon and Shuster, p. 82

Yates, Frances. 1966. *The art of memory*. Chicago: The University of Chicago Press, pp. 27–49

Crystal Palace to Media Museum: a conceptual framework for experience and sight

Kylie Message

This study is about process: at the level of story-telling or history-making (exhibition content), and at the level of methodological and exhibition display (structure). Narrative structure and form bring into being a certain view or perspective of a specific moment or fragment that becomes privileged as content that is then framed within the narrative structure which articulates its existence. However, the structural framework itself is methodological and itself expresses processes of dominant story-telling. This form-content relationship is evident in museological exhibitions and displays, and may be further examined through the emerging focus on new technologies within the museum space. New technologies allow the construction of new presentation methods and new modes of spectatorship within the museum context. This change at the fundamental level of production may motivate a more direct relationship between the viewer and story or object

or exhibit, but whilst the technology is itself new, it is itself part of the spectacle. Unlike traditional museum display technologies which render invisible the ideology by which they provide the framework for certain dominant historical narratives, exhibitions which employ new technologies encourage spectators to gain an understanding that the mode of presentation itself contributes at an elemental level to the production of history.

This structural outline also happens to be the condition for most fairy tales, and can be clearly mapped through the formulaic principles arising from it. For example, in *The New Melusina*, Von Goethe (1987) presents a fairy tale in which the formal structure itself replicates the narrative events. It is a story within the space of the story, just as this story tells the tale of a universe within a universe. The box of Goethe's story here becomes a paradigm for any space with contained and finite dimensions that appears to itself extend toward infinity. Representing Goethe's tale as a model of a model allows us to address the structure of the model itself. Despite its fundamental role in bringing a story into being, the structuring principle is always subsumed to the content it displays. Most often it becomes invisible, as the reader or viewer clamors for information and meaning, happy to fly over a structure so familiar that it can be disregarded. This reduces the formative structure to a facilitator or a tool.

The structuring principle is inherent within all systems that represent or display, and Goethe's simple tale itself may effectively be taken as the paradigmatic model for the generic story form(ula). This includes the two dimensional and imagined textual space of narrative trajectories, the space of virtual or electronic space and its representations, and the fully three dimensional physical space of built environments. Implicit within all these forms of experiential space, the structuring principle becomes increasingly invisible as its displays become increasingly complex. An illustration of the structure may be best provided as an image of that space existing in between Goethe's boxes of content. The indiscernibility of this structure may, paradoxically, be best illustrated by another trope or boxed segment: Joseph Paxton's Crystal Palace (which he designed for 'The Great Exhibition of the Works of Industry of all Nations, 1851'). As this three-dimensional trope illustrates, such indiscernible structure is more closely aligned with the line and two-dimensional surface than with the privileged mass. This three-dimensional example is as much an image, and as much a story, as it is a building. It is the ideal structural trope because it can translate easily from and into any of these fields.

The glass and steel architecture of the Crystal Palace is significant not in terms of its built formal outcome, but as the ideal representation of a pure and indiscernible structure. This example is unique due to the fragmentation of contemporary spectatorial experience (that was provoked by the overall effect of the structure as a built environment through the transgression of boundaries dividing such dualisms as interior and exterior). The site itself causes a twist in the formula (familiar to spectators), whereby the inability to perceive an overall image results in fragmented vision which is recuperated into an alternative overall image through large scale storytelling. This inversion of the usual process provides traces allowing us to perceive the structural practice that would otherwise be invisible.

In specific and real terms, the object and form of Goethe's narrative translates directly to a physical structure which, in the words of contemporary commentators, provided not only the structurally impossible dimensions of the magical casket, but the magical influence that

accompanies these dimensions. The elfin palace in Goethe's tale certainly finds its equivalent in Paxton's Crystal Palace. In turn, the Crystal Palace becomes a paradigmatic model for other structures that are, also like Goethe's box, contained and finite but which produce an effect of the universal and infinite upon those who look at it, move within it, or comment upon it. This is undoubtedly the space of the fairy tale, being the prolonged point at which myth and reality come into contact. The indiscernibility fundamental to both Goethe's elfin Palace and Paxton's Crystal Palace, produces a sense of impossibility in the structure itself. The point of proximity from which such impossibility is generated may precisely be the point or moment at which the building itself converges with the stories it inspires (and vice-versa). This point itself is indiscernible and shifting, but perceptible in the words of those who choose to articulate their experience of it, or to adopt the Crystal Palace as a metaphor. The latter project is perhaps addressed best by the Russian storyteller, Fyodor Dostoyevsky (1972) who, in 1864, stated: 'Let us grant that a building of crystal is a castle in the air, that by the laws of nature it is a sheer impossibility....'

The notion of the impossibility of the building should also be considered literally, in terms of its actual fabrication. Impossibility is a trope that is no less present or evident in 'eye-witness' descriptions of the building than in Dostoyevsky's figurative employment of it. In 1863, Richard Lucae provided an apparently scientific explanation to argue the literal metaphysics embodied by the Crystal Palace. He claims that: 'No material overcomes matter as much as glass.... It transports us out into the infinite world' (Schivelbusch 1986). This account provides a useful paradox. Firstly, we are told that glass can and does de-materialize. In this capacity it is itself immaterial, it is a facilitator with no physical status. And yet, in order to bring this transformative effect into being (so that we ourselves can be transported to an infinite world), the glass structure must first be erected. Similarly, these authors metaphorize the architecture as it was perceived and experienced, and this indicates that despite being an impossibility, the effect of the light, glass and atmosphere has a physical manifestation. The invisible-structural role that is performed by the glass walls of the Crystal Palace as it is represented by these writers is spectral. Besides being ghost-like, a specter is a 'thing that is thought to be seen but has no material existence' (Sykes 1982). In concurrence, Mrs Merrifield's essay for the Official Catalogue of the event notes that 'for practical purposes the effect of the interior of the building resembles that of the open air. It is perhaps the only building in the world in which the "atmosphere" is perceptible' (Merrifield 1970). The dissemination of the material form of the Crystal Palace into the atmosphere beyond seems largely to have been the perceptual shock of the 1851 Exhibition.

Irrational faith in the transcendental metaphysics of the Crystal Palace glass led people to distrust their own perception. Bound up by the rhetoric proclaiming a modern day fairy land of sublime effect and proportions, people were overwhelmed; not only by the magnificent beauty of the Palace, but by the enormous scale of the event, exhibits, noise and crowds. Charles Dickens records feeling 'used up by the Exhibition', explaining 'I don't say there is nothing in it: there's too much'. Contributing to the emerging pattern of distrust in visual perception, is the oppressive condition infusing 'so many sights in one' (Victoria and Albert Museum, 1950). And William Thackeray responded to this extreme and heightened version of museum fatigue in his poem Mr. Molony's Account of the

Crystal Palace, in which the protagonist's 'sight / Was dazzled quite / And [he] couldn't see for staring' (Hobhouse 1950). Mr. Molony is, in effect, blinded by the act of looking. The harder he tries, the more he stares, the more dazzled and distracted his eyes become.

Siegried Giedion (1962) also describes how the enormous extent of glass in the vaulting 'almost blinded contemporary spectators, who were unaccustomed to the amount of light that was admitted'. Replacing the effect of a concentrated universal and holistic singular image, was a multiplicitous and fragmented cacophony of visual sights demanding immediate attention and consumption. To an extent this stemmed from the architecture itself. The predominance of flat scenarios and the consistent light refracting through the glass provided no contrast relief in the form of shadows or otherwise. This provided an extreme perceptual shock, whereby spectators experienced the site as if there were no poles of measurement. Absence of shadow or shade robbed them of the ability to judge distance and depth, and the effect may have been akin to walking through a series of layered two dimensional planes. Space seemed absent due to the spectators' inability to see boundaries, but the sensory experience seemed to go on infinitely.

The Times (1851) claimed that the eyes were not to be trusted, when it stated that 'no one could be content with simply what he saw'. The Exhibition's wonder and awe outreaches the domain of the human eye, and the distrust is further peddled with the claim that the Exhibition 'was felt to be more than what was seen'. This bizarre situation resulted in a disorienting experience that was defined as being simultaneously transcendental, illuminous, and profane. This condition normalized the de-materialized and magical atmosphere of the building at the expense of any trust in vision. Problematizing the function of sight, Richard Lucae claims that: 'It is, in my opinion, extraordinarily difficult to arrive at a clear perception of the effect of form and scale in this incorporeal space' (Schivelbusch, 1986). The space is incorporeal, but it is vision which is unable to contain a complete representation of it.

The effect of this fragmented vision is an extreme de-materialization of the world. It would appear that this de-massification is also responsible for the extreme rhetoric framing the experience. Each fragment of the building is dislodged from the whole by untrusting eyes. In order to replace these fragments into the universal scheme, each piece is narrativized. The eyes may not be able to replace the 'cutout' piece in the context of the image of the whole, but the fragment may be recuperated fully and gloriously into an alternative meta-narrative structure and emerging fairy tale. In this manner, the structure of the building is equivalent to the narrative of a story.

Both the Crystal Palace and Goethe's (world within a world within a) box are paradigms. These paradigms are architectures which function explicitly as narratives. The secondary paradigm underlying and motivating this study of these contained narrative segments, is the movement which each makes within its own circumscribed space. This movement is, in many ways, the movement that the reader or spectator makes when engaging with a text, image, or space. The Crystal Palace provides a physical model that epitomizes the point that is central to all fairy tales. This point is that the mode of display not only facilitates, but dictates, spectatorial experience. A precondition of this is that the mode of display (structure) renders itself invisible in the act of displaying. In other words, it is necessary that the formal structure is subsumed and rendered invisible to the content

that it not only supports but brings into being. This is evidenced by the glass and steel construction of the Crystal Palace which lacked an overall image once the spectator moved from outside to inside the walls. The overall image enjoyed by the spectator as they approached the building from afar was negated as they entered the interior space. The overall impression of the structure was lost to the heightened immediacy of the vibrant fragment. Retrospective accounts produce an effect of this contradiction, by producing fairy tale like narratives that alone seem able to account for the shifting focus of experience. The Crystal Palace epitomizes this relationship between structure and form, and its effect is clearly evident in contemporary spectatorial accounts.

Awareness of the process/condition between structure and form as it is exemplified by the Crystal Palace becomes vital in regard to the construction of museums in a contemporary context. Equally concerned with telling stories as presenting facts, the museums currently being produced benefit enormously from referencing this structural ingenuity. While it is clearly the case that many superficial similarities exist between the built environments, an example most analogous to the Crystal Palace (in terms of both cause and effect) is the media museum. Despite technologies that differ vastly from those employed by the 1851 Great Exhibition, media museums provide a spectatorial experience that results not exclusively from the traditionally privileged artefacts on display, but from the mode in which these artefacts are displayed. In a sense, these structures aim to bring into being the display itself in order to present the structure itself as an object on display. Indeed, they tease the structure into accepting a performative role, aiming to represent the process by which objects and artefacts are themselves represented. As with the fragmented vision and subsequent storytelling processes that commentators employed in order to respond to the Crystal Palace, these rogue displays of display technologies themselves entice and subvert traditional audience expectations.

References

Dostoyevsky, F. 1972. *Notes From Underground / The Double*. Trans. Coulson, J. London: Penguin, p. 42

Giedion, S. 1962. *Space, Time and Architecture*. Cambridge: MIT, p. 255

Von Goethe, J. W. 1987. *Tales for Transformation*. Trans. Thompson, S. San Francisco: City Lights, pp. 44–61

Hobhouse, C. 1950. *1851 and the Crystal Palace*. London: John Murray, p. 175

Merrifield, Mrs. 1851. Essay on the Harmony of Colors, as Exemplified in the Exhibition. In *The Art Journal*. 1970. The Crystal Palace Exhibition. Illustrated Catalogue: London 1851. New York: Dover, p. ii

Schivelbusch, W. 1986. *The Railway Journey: The Industrialization of Time and Space in the 19th Century*. Berkeley: California UP, p. 48

Sykes, J. B., (ed.) 1982. *The Concise Oxford Dictionary of Current English*. Oxford: Oxford, p.1019

The Times, 2 May 1851

Victoria and Albert Museum. 1950. *The Great Exhibition of 1851: A Commemorative Album*. London: His Majesty's Stationary Office, p. 26

Kylie Message is currently completing a PhD at The University of Melbourne. She is currently teaching Exhibition Design at the National School of Design, in Melbourne, and Cinema Studies at the University of Melbourne.

Disturbing Territories

Shaun Murray

> Everything that is static is condemned to death, nothing that lives can exist without transformation. (Sanford Kwinfer)

A series of geomorphologically and ecologically special locations in the Rhone corridor (such as salt pans and gorges that flash flood) are linked to each other with a complex web of feedback loops and retrosensing devices. The project centres on the harnessing of natural phenomena and complex ecological networks within the unique environmental conditions of the Rhone. By making use of modern technologies, including caged light and magneto-rheorological compounds, these naturally fluid systems will be amplified and distorted to form self-regulating, interactive configurations, with endless possibilities for adaptation and transformation. The drawings show vacillating objects which use elemental forces as their spatial input. In addition, input from receptors of noise, temperature and movement will be sampled by a program control monitor which responds by selecting a number of base mathematical descriptions, each parametrically variable in terms of speed, amplitude, direction. Other than is customary in architectural form, time and information is dynamically linked. As well as collecting and collating ecological information for research uses, this network provides the means for the human body, as sensor, to be 'plugged' directly into its adoptive environment. At various critical localities the body becomes yet another component of the network, influencing the environment; and simultaneously being acted on by diverse factors. Within these frameworks intricate mechanisms will form hyperaesthetic connections [augmented and distorted sensations], for the modern tourist – blurring the threshold between the natural and the artificially natural.

Exploding images like those in Figure 1 are more aesthetic simulations of potentials rather than concrete realities.

Water Vacillation
This locality is 'Les Gorges du Fier' which at 300 metres long and 60 metres deep, is classified among the largest curiosities of the Alps. Inside these throats of water one can admire a giant pot of water. Towards the exit of the throats is the impressive aspect of 'la mer des rochers', a labyrinth eroded by the river 'Le Fier'. Along the gallery there is a scale showing the heights reached by the river in flood, including September 1960, when it rose 27m above its normal level.

Gallery
Allows you to scrutinise without any danger the depth of the abyss, where the river 'Le Fier' scours and groans. Your biometric features are calibrated and used to establish the intensity of the experience and the altered state of effects within the vacillating object.

Figure 1.

Sensors connect the individual's physical actions to fluidity in real-time projection and real-time sound manipulation.

Cradle

Interaction with the tourist, the cradle acts as the interface between the active and reactive spaces. Here two cradles swing over the gorge to the 'point of immersion' into the vacillating object. This fluid space harnesses your body and prepares you for easy insertion. Once inside the pressure-sensitive floor will trigger a 'silicon glow' around the cradle to show it has become activated. The colour of the light absorbed and emitted can be tuned depending on the activities in the chauvet caves. In the cradle you 'listen' for visual signals from the other sites through the phonoscope which is an instrument for translating sound vibrations into visible images.

Vacillating object

Suspended in the gorge, the vacillating object uses flash floods as its spatial input. Turbulent water cascades into a number of miniature turbines that sit on the length of the sp(l)ine, with a series of release gates which can be opened to spurt out water when the pressure is too great. Information projectiles retain a ring of waterspouts, which can be inflated and deflated.

This assembly in each array will be fitted with a microprocessor. Output from the turbine system will be used to drive the device.

The tourist slides down the calibrated foot rack, which can be adjusted to enable them to gaze into the throat and become a buoyant embodiment of the object. Inside they will be presented with three mathematically related images through different filters via a digital interface, described as F1, F2, and F3. Each image has been adjusted to present other sites in real time, act as an instrument for translating sound vibrations into visible images and a pressure-sensitive backrest which controls the light source along the length of the sp(l)ine. All three filters are adjusted by the vasodilator, which acts like a muscle as they gaze down the watery throats.

When the gorge flash floods a 'critical threshold' is reached, at which point the vacillating object, restrained, begins to writhe frantically, like a wild dog on a leash. As the water cascades all around, the gut descends beneath the water and causes the sp(l)ine to coil up until it exerts its potential energy in a dramatic whiplash effect.

Figure 2.

Earth Distortion
The land around Cruas is the thinnest part of the Earth's crust in France, and is subject to frequent movements, which might or might not become more serious. And with the great towers of Cruas-Meysse nuclear power station not far away, the territory becomes a critical catalyst.

Earth movements
Cruas was developed as an ecological retreat. The implicit challenge was to develop a form that would disappear into the terrain, but would lodge vividly in the imagination – a sort of psychological involution. I chose a flat stretch of land that is visually linked to the nuclear power station. This locality has the simple program of exhibition and conference spaces. A series of contour distortions blister the landscape into a field of giant looking sandworms, which writhe programmatically.

The design was based on the metastable aggregation of architecture and information. The form itself is shaped by the fluid deformation of ellipses spaced over lengths of more than 45 metres. In the exhibition space, which has no horizontal floors, and no external relation to the horizon, walking becomes related to falling. The deformation of the land is extended in the constant metamorphosis of the environment, which reacts interactively with the frequent earth movements. Visitors of the centre will be encapsulated by means of 17 different lights; touch and pulling sensors, all of which cause this constant reshaping of the human body.

The conference space is on three sliding platforms, which migrate slowly around each other as a fluid deformation of space, set on a sublayer. The surface of the elliptical structure is built up of a composite containing 'environmentally responsive polymers', which can change their state depending on the thermal properties of its environment.

The site becomes a play of dermic forces; the projected flesh spreads out, slips and bends like a surface of variable curvature on an abstract plane. If the seismic activity increases there is the possibility that a 'critical threshold' could be reached, whereby the elliptical structure will writhe frantically and cause subsequent contortions to the existing spaces.

Fire Absorption
On 24th December 1994, speleologists discovered a cavern that had not been entered during the last 20,000 years. The Chauvet cave, as it is called, contains Palaeolithic paintings of lions, bears, rhinos and many other animals. Carbon dating has shown that some of the paintings in the Chauvet cave are over 30,000 years old.

Inflammable interface [spatial light]
On this south facing entrance, a series of 'light sails' are cast out on suspended pneumatic poles which, trap and manipulate light.

Inside the cavern is the 'inflammable interface' which runs along the labyrinth of galleries and rooms. Here you receive a backpack containing three telescopic armatures, which can rotate in 3 modes of movement, to allow you a personalised light source to follow you along the labyrinth of galleries and rooms. Beneath your feet is a footbridge

with an intelligent floor, networked to a light sp(l)ine overhead. The personalised lights are programmed to move around the cave walls, sequentially framing specific cave paintings, to enable the viewer to receive a personal dialogue with the space and paintings. With the superimposition of four or five systems of projection, the cave becomes a dance of kaleidoscopic geometries. Each time you visit you can chose from a multitude of programmed patterns of light on the cave paintings which will enable you to look more intensely at the work and not to receive a repeated spatial and visual experience.

Under the stark glare of your personalised light a breathtaking backdrop unfolds: gigantic columns of white and orange calc-spar, alternating translucent and nacreous, splendid draperies of minerals, sparkling carpets.... Scattered on the ground are the bones of bears; the walls are scratched with claw marks.... Suddenly, the image of a horse appears before you.

Kinetic volume of caged light is the culmination of this encapsulating spatial lightscape. The proposed device, based in one of the back 'rooms', hauntingly frames large polychrome panoramic compositions of paintings and engravings between 4 and 12 metres long. Centred in this space is an elliptical hydraulically muffled glass platform with two huge rotating surface mirrors that fan out a laser ray as the referential surface. In this 'light cage' a swarm of dots moves, pursuing one another, thus behaving like a virtual creature commanded by the movements of the platform. An increase in movement generates more light and the whole room begins to glow. During electrical storms, lightning is conducted through 'light spikes' located above the cave, which then pulses through the light sp[l]ine into the light cage. Resulting in an intensely iridescent light, illuminating the extent of the cavern.

Air Turbulence

On top of an isolated spur of rock, thrust out from Les Alpilles, and with steep ravines on either side, Les Baux de Provence is dramatic, beautiful, a shade sinister and melancholy. It is still tangled ruins, crowned by the wreck of a castle that seems to grow from the rock itself. The Mistral wind howls through the broken ramparts like banshees calling for vengeance. Icily cold, it screams down the Rhone valley from the northwest, with gusts reaching 130mph, tearing out trees, stripping roofs, and blowing away cars. But the Mistral has its merits: it blows away clouds and dust, and keeps the skies of Provence crystal clear. The Mistral is triggered by a set of specific meteorological conditions, one of, which is the presence of a depression centred in the Gulf of Genoa, off the coast of northern Italy. The region is an impressive meteorological laboratory, an 'incandescent battlefield' of meteorological conditions.

Air turbulence

The proposed devices sit on the edge of the spur of rock. The combination of high mountains and the surrounding flat delta leads to a dramatic contrast in air temperature and wind pressure. Initially the ribbon structures are compacted in thin slots forged into the rock. The devices are programmatically triggered at different wind speeds, whereby a release mechanism catapults the ribbon structure out over the rock face. The ribbons are

made in an aerofoil shape so as to produce enough lift to support the weight of them. The shape of the aerofoil is determined from the different trajectories of the wind. The ribbons are made up of a series of wind volumes, which can expand at various rates of movement, depending on the different wind speed, and pressure, which is prevalent. Once the device has been catapulted out over the rock face it calculates the wind speed and detects air pollutants and moisture content through a series of filters within the ribbon structure itself. When the wind becomes extremely violent (180mph), it causes the 'critical threshold' to be reached, whereby the ribbon structures expand to their maximum extension. Then they suddenly and dramatically lash out against the rock face in what appears to be an attempt to tear them away from the rock face.

Condensation

The terminating locality is deep in the salt marshes and extensive shallow lagoons of the Rhone. It highlights the everyday events which occur in the theatre around it. It is a surface which is penetrated from exterior to interior by objects displaced in the landscape. Frequently the surface is inert – just a shimmering backdrop to events. But it is a surface of potential, carrying a latent charge, which may suddenly be released. In response to the stimuli captured from the surrounding localities it can dissolve into movement – supple fluidity or complex patterns – oscillating between solid and fluid. It is a translation surface which responds to the landscape strategy – a sort of entropic transfer device, but one which will be capable of registering any pattern or sequence that can be generated mathematically.

The second environment is the critical path, which performs a spatial dialogue when any extreme geomorphologic and ecological events occur or the critical threshold is reached. Its main structural characteristic is five transmembrane helices with connecting loops. This space has the ability to expand and compress if any of the critical thresholds of the localities have been reached. Visitors will be informed by the structure in a responsive way. The oscillations of the structure will depend on which and how many critical conditions are reached. This is performed by the regulator, which adjusts the tension of each structural helix independently, which in turn affects the spatial conditions. This space expresses the spatial interactions of all the localities and becomes an enchanted loom of spatial inputs. Visual and kinetic weaves blur the threshold between the natural and artificial.

Implications of proposal

Nature evolves its own fluctuating systems, in which diverse ecological phenomena combine to create a fluid whole. What I have aimed to achieve in this proposal is to graft onto that network my own system of augmented architectural possibilities. Thus the natural is united with the cultural potential of modern technologies. The architecture learns to respond and conduct a dialogue with the environment. This interactive architecture makes the viewer, plugged into the system at the localities, the focal point, the hub of the intervention. Elemental forces caress and tease the body with gently fluctuating movements. Yet a shocking contrast is experienced when the system suddenly reaches 'critical threshold'. The potential energy of these environmental forces manifests itself in violent and exhilarating effects.

The localities discussed in this dissertation are highly specified and intimately linked to each other in a complex web of feed back loops and retrosensing devices. This creates 'transparent windows between each locality. Ultimately they are hybridised embryonic catalysts, whereby the tourist gains an intense morphogenesis (alternative spatial experience) within special locations and destination. The natural body being integrated into a concentrated cultural and spatial experience of landscape.

It gives voice to architecture because architecture is no longer an object of perception but rather a system of communications.

References

Grizell R. 1991. *The Rhone Valley & Savoy.* London: Christopher Helm Publishers Ltd.

Cache B. 1995. *Earth Moves: The Furnishing of Territories.* Michael Speaks (ed.), Anne Boyman (trans.), MIT Press (Cambridge, Mass).

Ball P. 1997. *Made to Measure: New materials for the 21st century.* Princeton University Press.

Joannopoulos J D. 1995. *Photonic Crystals: Moulding the Flow of Light.* Princeton University Press.

A Handful of Light. 27 June 1998. *New Scientist*, pp. 36–39.

S.N.P.N. 1992. *Fiches Camargue.* SNPN: Reserve Nationale de Camargue.

Being @ Installations: the space-time of technoetics

Royden Hunt

I. Introduction

The increasing pace of mutual influence across the fields of art, consciousness studies and technology has prompted the introduction of Roy Ascott's neologism 'Technoetics'. The two images of the installation Seeing is Believing by Jessica Stockholder (1999) beautifully presents and sums up this triune aspect of technoetics. I will reserve my comments on this installation until the conclusion of my paper. Technoetics attempts to provide a new concept which embraces the interaction of art, consciousness and technology in the context of cyberspace and virtual reality. This paper will illustrate and examine the way installation art and its interactive versions can focus attention on perceptions of space, movement and hence on time, as key features which span across the three elements of technoetics. I will try to demonstrate that the space-time of technoetics has properties which keep in balance the art, consciousess and the technology; and not only in balance, but also in a relationship of true synthesis, in contrast to relationships of synergism or even of symbiosis.

My first thesis is that the technoetics of cyberspace needs to reflect the lessons offered by examples of non-interactive installation art in which the art-science dialogue is particularly manifest. My second is that these installations demonstrate a need for a new model of

space-time perception which is equally required for a fully adequate concept of technoetics. I am supported in this thesis by the descriptions which a number of interactive-installation artists have given of the effects of their work on those who experience these art forms. Thus for example, Char Davies (1998) describes her approach as 'intended to re-affirm the role of the subjectively-experienced felt body in cyberspace, in direct contrast to its usual absence or objectification in virtual worlds.' Even in her early work OSMOSE, she was pointing to the potential of the medium 'to dehabituate our sensibilities and allow for the resensitisation of the perception of being... for exploring consciousness as it is experienced subjectively, as it is felt'.

Monical Fluschman and Wolfgang Straus (1998) state: 'It is our goal to bring persons "into contact" with the world, with each other and themselves. We are therefore on the track of man's lost senses in a bid to restore these with the aid of technology.'

What aspects of our consciousness of space-time are therefore important in installations?

In the first part of the paper I try to answer this question in terms of three artists whose work strongly involves the science-art interaction. The second part outlines a novel philosophical view of space-time perception which can do justice to the insights given by these artists. And I then conclude with the claim that an adequate concept of technoetics should include this philosophical understanding of our perception of space-time in order to balance its three elements equally and remove the human tendency to create an ideology out of each of them.

II. The Space-Time of Installations

Firstly, the installations of Simon Robertshaw (1993) often convey the spatial and temporal experiences of people confined to public institutions such as mental hospitals. His interpretations have been profoundly influenced by his readings of the French poststructuralist Michael Foucault. The installation The Observatory is modeled on the famous design called 'Panopticon' for buildings such as prisons and hospitals by the Victorian philosopher Jeremy Bentham. This design enabled a surveillance over the cells of many inmates from a single central observation chamber. In the installation, on a tight circle of industrially-embossed glass screens and the enclosed floor space, Robershaw projects images of the brain as the biologically-constructed self, and of society as enclosed by the socio-technological construction of reality. These are examples of what the early Foucault called 'epistemes' of power-knowledge relationships, which structured both space and time. But it is worth noting that in the final interviews of his life, Foucault spoke again of that noetic space in which the human subject can stand back from the 'epistemes' and, as Vaclav Havel has put it, 'live in the truth'.

My second installation artist is Jan Fabre (1995) who is a Flemish artist working in Antwerp, with a studio and centre for the study of the cultural traditions of Flanders. Much of his work continues the Flemish tradition of the mystical and visionary, the symbolic and fantastic. But Jan Fabre's relationship to the sciences derives from the influence of his famous French great-grandfather, the entomologist Jean-Henri Fabre, whose studies of the social life of insects aroused great interest in the early part of this century. The world of insects and animals therefore feature prominently in Jan Fabre's

drawings and installations. It is as if he is caught, like us, in a space between genetics and culture as no generation has been before – in the time of the human genome project and unprecedented advances in genetic engineering and cloning.

Hence we find in Fabre a need to empathise with the world of feeling and emotion but also an unmistakable quest for meaning in his complex images, and a meditative philosophical aspect to his work. There is even a refusal to be pinned down by critical opinion which could limit his art forms to the ideologically acceptable or 'politically correct'. He is expressing a realisation of the ontological significance of Being's 'openness to possibility' – both cosmic and psychic, and that all human beings have a deep sense of this inherent freedom as part of their nature.

In recent installations Fabre has used brightly-coloured Mediterranean scarab (beetle) carcasses. The dead beetles seem alive as they shimmer with colour. He forms them into lines and formations which characterise the social life of insects, but also symbolise the strategies and tactics of human battlefields. His recent video-installation at the Natural History Museum, London, was called 'Consilience', in an obvious reference to the book of the same name by the American entomologist E. O. Wilson, where genome and environment, nature and nurture are described as being in synergistic relationship.

And the metamorphosis which characterises the life of insects is also a recurring theme in Jan Fabre's work: time, change and yet transcendence of change are there, indicating the universal and perennial significance of art – the combination of freedom and form. And therefore Fabre metamorphoses the beautiful iridescent scarabs into human and angelic figures. The word 'angelus' means messenger and so the angel images are in the realm of the hermeneutic, of the reflexive, interpretive, noetic space. Hermes was the Greek messenger God. But Fabre juxtaposes these figures with the landscapes of insect hordes too. So while Fabre is necessarily and willingly part of a culture which is profoundly influenced by science and technology, his art re-enchants our experience with bodily and spiritual insight.

My last example of installation art is that of Susan Hiller who worked originally in the United States as a research anthropologist, but after her PhD became disillusioned with the narrowness of this science and turned to art as an alternative way to be a 'full participant' in the culture in which she lived, now in the United Kingdom.

Her book *Thinking about Art* (Hiller, 1996), gives a valuable insight into her understanding of the cultural context of the creative process. In her words, a work of art is 'a place where one thinks, feels and acts and where the different kinds of ways an artist thinks – the personal, perceptual, formal, social and theoretical – emerge and problematise one another.' These and many other insights in her book form a collection of illustrations of the philosophical points I will make in Part III.

Her most celebrated installation is probably the one called 'Monument', in which 41 photographs of 19th century and early 20th century monumental plaques are mounted in a 4 metre diamond shape on the gallery wall. Hiller came across these plaques in an unfrequented London cemetery. They commemorate the deaths of individuals who gave their lives in attempting to save others from dangerous situations, as can be seen from the details of the inscriptions on the plaques.

The wall-mounted installation is accompanied by a park bench and a tape recording of

Susan Hiller's voice which involves the listener in her experience of the installation. She makes clear the cultural space-time of this experience, in that the 'now' of the looking and the hearing – the instants of perception – take place against the 'duration' of the two modes of existence of each individual commemorated in the plaque – their years alive and the interval since their death, as recorded by the date on the plaque. In this she discovers again the understanding of time, originally described by the 19th century Italian philosopher Antonio Rosmini (1797–1855) as the relation between the instants of perception and the duration of experience in terms of past, present and the (possibility of) the future.

III. A Philosophy of Perception and The Space-time of Technoetics

As Char Davies and others working in VR and the above installation artists all indicate, drawing on insights from Gaston Bechelard and Merleau-Ponty, the significance of spatiality lies in the human experience of what Rosmini, a century before them, called a 'fundamental feeling' (FF) of our own bodies. This feeling is largely at the subconscious level but can be raised into consciousness by suitable meditative techniques and by the experience of the installations themselves. So Char Davies describes the immersive virtual environments of OSMOSE and EPHEMERE as 'Landscape, Earth, Body, Being, Space and Time'.

Sensory inputs modify this FF to give individual sensations, but the FF integrates them, as sometimes enhanced in synesthesia. This internal, bodily FF is the source of the sense of individuality and self and is therefore subjective. The sensory inputs related to the external world should therefore be referred to as 'extra-subjective'. This distinction removes the ambiguities of body-mind duality which at present plague consciousness studies. The subjective FF contains a feeling of space which is in itself not shaped nor limited by the body surfaces, until the limits of the felt body are defined by touch sensations on its surface. Such a surface can only be located in the felt space of the FF because this space extends on both sides of the surface. Movement into spaces outside the body then generates a subjective sense of time, and the importance of movement in both dance and in and through installations (real and virtual) for the generation of subjective space-time is clear.

The 'extra-subjective' investigation of space and time gives rise to our scientific and technological expressions of these phenomena, which can then be seen as related to but distinct from their subjective counterparts. The 'real' world is therefore composed of 'feelings' and 'the felt'. This composition is again usually at the subconscious level but attention to sensory inputs reveals they are always distinguishable. The feelings are always subjective, whether they arise in combination with our own body as the felt, or with the felt bodies in the extra-subjective world. Interactive VR techniques draw attention to this feeling/felt union in experience and particularly to the spatiality of the FF and the extra-subjective inputs which lead to a consciousness and an exploration of this space, as we have seen particularly but not exclusively in the immersive techniques of Char Davies.

However, human perception and the creative imagination which depends on it, always work together with a noetic, intellectual space of ideas, in which reflection on bodily and sensory experience takes place. The objective, noetic space of knowledge contains the elements of possibility (openness) and necessity (order and principle). These match the

elements of uncertainty and complexity, together with lawfulness, found in the 'real' spaces of the subjective and the extra-subjective or 'scientific/technological'.

IV. Conclusion

So we can agree with Susan Hiller (1996) when she says that Art views life through a cultural lens, but also that 'artists may offer "paraconceptual" notions of culture by revealing the extent to which shared conceptual models are inadequate, because they exclude or deny some part of reality'.

She, like Simon Robertshaw and Jan Fabre, sees art as capable of challenging the ideologies, metanarratives and stereotypes often erected in and by individual cultures. Unfortunately, it is all too clear that technology too can become one of these.

Those who entered Jessica Stockholder's installation, which I illustrated at the head of this paper, felt this tension profoundly. The magnificent space was felt tangibly and the colours enraptured the senses. But the dark lines of communication ended in the clutter and heat of overloaded information. The huge white screen asked us to bring to consciousness what was subliminally being presented to us there by unseen influences behind the closed door of the portakabin that had been moved into our space-time.

Rosmini would therefore say that the art forms described here can distinguish the necessary from the sufficient and the part from the whole, and therefore can bring themselves into balance with consciousness and a technology which attempts to embrace them. The universal aspects of Being in its forms of bodily-felt reality, the noetic and the ability to be evaluative in a constantly changing world , can therefore also be brought together in the concept of the Technoetic. I hope then to have justified my title, and that Being @ Installations can indeed demonstrate a unifying Space-time for Technoetics.

References

Davies, C. 1998. Changing Space – VR as an Arena of Being. In Beckman, J., (ed.) *The Virtual Dimension*. Boston: Princeton Architectural Press.

Fabre, J. 1995. *The Lime Twig Man*. Ostfildern: Cantz Verlag.

Fluschman, M and Straus, W. 1998. Images of the Body in the House of Illusion. In Sommerer, C. and Mignonneau, L. *Art @ Science*. Vienna: Springer-Verlag. p. 134

Hiller, S. 1996. *Thinking About Art – Conversations With Susan Hiller*. Manchester, UK: Manchester University Press, pp. 3–4.

Robertshaw, S. 1993. The Observatory. Wrexham: *Oriel 31*, Powys and Clwyd County Council.

Stockholder, J. 1999. *Seeing is Believing*. Installation, Centre for Visual Arts, Cardiff. September–November, 1999.

Notes

Rosmini, A. 1797–1855. The recent English translations of his philosophical works are published by Rosmini House, Woodbine Road, Durham, DH1 5DR, UK. Particular attention is drawn to the treatment of the perception of space and time given in the volumes entitled The Origin of Thought and Anthropology as an Aid to Moral Science.

Royden Hunt is organising lecturer in philosophy-related courses at the Centre for Lifelong Learning, Cardiff University.

Evolutionary Algorithms in Support of Architectural Ground Plan Design

Tomor Elezkurtaj

A Brief History of AI in Computer Aided Architectural Design

The history of computer aided architectural design is not without irony. Starting with raising hopes of turning creative design into a scientifically disciplined method of problem solving (see e.g. Alexander, 1964), the computer eventually entered the architectural business as a down-to-earth means of saving costs. Instead of substituting the human designer, the computer proved a useful tool for drawing and constructing, a convenient mailbox and filing cabinet. Today, creative design is as intuitive, non-scientific and chaotic as it has ever been. The most conspicuous jobs done by computers in architecture are sophisticated presentation and on-line co-operation.

The high rising hopes of the early days were fuelled by the then impressive progresses of symbolic AI. The approach of symbolic AI to human intelligence is that of programming the use of language. Language is a broad concept, encompassing the use of words, symbols and even shapes. The way suggesting itself of combining CAAD with symbolic AI is formalizing shape grammars. Shape grammars are sets of forms, symbols and rules defining the way in which, e.g. meaningful architectural plans are composed of elements symbolizing walls, ceilings, windows, doors, stairs etc. Plans are meaningful only if they are well formed, i.e. that the elements are clearly defined and manipulated according to syntactical rules. Take a shape grammar rich enough for composing architectural plans, formalize it, program it, and you have enabled the machine to enter a trial-and-error process of producing plans which, in turn, are capable of being evaluated and selected in the manner candidate moves in chess are.

Remarkably, the use of computer driven shape grammars came close to passing the architectural Turing test. Computerized grammars came up with examples of mock Palladian villas and fake Frank Lloyd Wright prairie houses. It would be hard to identify these imitations as fakes if trustworthily presented as long-forgotten originals (figure 1). (See Koning & Eizenberg, 1981, and Stiny & Mitchell, 1981.) Nonetheless, symbolic AI never came up with modules suitable for commercial CAAD software. The reason is that design strategies promising in architecture resist being reduced to a calculus of winning.

The problem of winning a chess match is well defined. The problem of winning an architectural competition is ill defined. In chess, problem solving consists in scanning alternatives that are given. Even though problem solving in architecture may consist of adapting existing designs, creative solutions tend to result from redefining the problem in certain ways. It is not unusual, to say the least, that the solution results from redefining the problem until a design favored for heterogeneous reasons arguably becomes a solution. In chess, redefining the problem to be solved is forbidden. In architecture, the problem to be solved is systematically open to revision since function in architecture is an open concept.

The strategy of problem solving pursued by symbolic AI was that of decomposing complex problems into simpler problems until a level of elementary problems is reached. This strategy proved successful in areas where two conditions are fulfilled. The first condition is that such a level of elementary problems in fact exists; the second condition is that the solutions of these elementary problems can be formalized. In creative architectural design, neither of these conditions is fulfilled. Preparation of the design problems to be solved by manipulating shape grammars thus consisted in a radical re-interpretation of what architecture means. It consisted in consistently disregarding the functional aspect of architecture. The 'sentences' formed by the use of shape grammars were only ever syntactically well formed. The search strategies only ever looked for solutions satisfying the formal prerequisites for being a possibly meaningful plan. The meaning itself was elaborately kept out of the process. The designs emulating the famous examples did so by restricting themselves to the purely formal aspect of the shapes being manipulated. The design strategies were successful because of, not in spite of, disregarding any pragmatic or semantic meaning of the designs produced.

Emulating a style of design is one thing. Helping the designer to be creative is another. In the first case the emphasis is on reproduction, in the latter case it is on exploration. Exploration in architectural design is only rarely a play of form. Whether or not it is consciously guided by functional viewpoints, it obeys functional criteria as long as it is supposed to be architectural design and not just graphics. Exploration in architectural design may very well include re-interpretation of functional requirements. Functional requirements, however, that are fixed and accepted can be disregarded only at the cost of turning exploration into an idle play of forms. In order to facilitate and not just inspire exploration, the software should be capable of obeying functional requirements to a certain, non-vanishing, extent.

As soon as function is involved, the strategy of solving the problem by way of its final analysis comes to an end. The functional description of a building and thus of its components never is complete. Without giving a complete description of the function to be served by the architecture, the problem of architectural design remains ill defined and open to interpretation. Creative human design is capable of turning the vice of being ill defined into the chance of inventing things never seen before. The question then

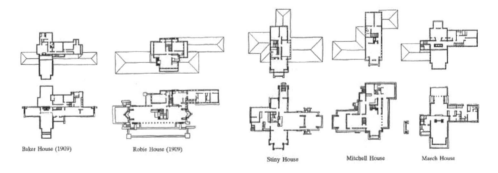

Baker House (1909) Robie House (1909)

Stiny House Mitchell House March House

Figure 1. originals (1,2) and imitations (3,4,5)

becomes: how is it possible to circumvent the need of a final analysis without foregoing the powers of AI?

It is new AI that offers a non-analytic approach to problems such as these. New AI differs from old, symbolic, AI in that the paradigm of intelligent behaviour has shifted. Instead of human language, it is now biological life that provides the paradigm cases of intelligent strategies. These strategies are not closer to, but even further away than good old symbolic AI from human way understanding the problem we are dealing with. Evolutionary algorithms simulate a generative process that is explicitly supposed to be 'blind'. There is no understanding and thus no meaning whatsoever in the way in which artificial evolution works. Nevertheless, evolutionary processes are the most creative and inventive known. Though allegedly primitive in comparison with biological evolution, these strategies have proved capable problem solvers in various fields of engineering. Goldberg, 1989 and Mitchell, 1996 serve as introductory texts. Although they have yet to be applied to architecture, Frazer (1995) offers a general presentation of the idea and an overview of the approaches which have so far surfaced.

Artificial Evolution

The approach presented makes use of the fact that a good deal of the functional requirements to be observed in floor plan layout can be expressed in terms of proportion

$$
W = \begin{bmatrix} -\theta & w_{12} & w_{13} & w_{14} & \cdots & w_{1n} \\ w_{21} & \theta & w_{23} & w_{24} & \cdots & w_{2n} \\ w_{31} & w_{32} & \theta & w_{34} & \cdots & w_{3n} \\ w_{41} & w_{42} & w_{43} & \theta & & \vdots \\ \vdots & \vdots & \vdots & & & w_{n-1,n} \\ w_{n1} & w_{n2} & w_{n3} & \cdots & w_{n,n-1} & \theta \end{bmatrix}
\qquad
T = \begin{bmatrix} -\theta & t_{12} & t_{13} & t_{14} & \cdots & t_{1n} \\ t_{21} & \theta & t_{23} & t_{24} & \cdots & t_{2n} \\ t_{31} & t_{32} & \theta & t_{34} & \cdots & t_{3n} \\ t_{41} & t_{42} & t_{43} & \theta & & \vdots \\ \vdots & \vdots & \vdots & & & t_{n-1,n} \\ t_{n1} & t_{n2} & t_{n3} & \cdots & t_{n,n-1} & \theta \end{bmatrix}
$$

$$
W_T = \sum_{i=1}^{n}\sum_{j=1}^{n} \left(w_{ij} * t_{ij} \right) \quad w_{ij} \, L \, \Sigma; \quad t_{ij} \, L \, (0,1)
$$

Example:

$$
T = \begin{bmatrix} -\theta & 1 & 1 & 0 & 0 & 1 \\ 1 & \theta & 1 & 1 & 1 & 1 \\ 1 & 1 & \theta & 1 & 0 & 0 \\ 0 & 1 & 1 & \theta & 1 & 0 \\ 0 & 1 & 0 & 1 & \theta & 0 \\ 1 & 1 & 0 & 0 & 0 & \theta \end{bmatrix}
$$

Figure 2.

and topology. The fitness functions that the system is supposed to optimise are restricted to (1) eliminating gap between and overlap of the rooms to be accommodated, (2) approximating the proportions preferred, and (3) optimising the neighbourhood relations between the rooms. The rest is left to the human designer who interactively intervenes into the game of artificial evolution as displayed on the screen.

The strategy of eliminating the gaps and overlaps that occur when the rooms are fitted into the outline consists of a mutation driven evolutionary strategy. The fitness function minimizes the sum total of gap, overlap, and overflow. After being initiated, a population of design variants is subject to random change concerning position and proportion. Selection acts through reproduction from generation to generation. The fitter a variant, the higher is its reproduction rate. The proportion preferred is approximated through filtering probabilities.

The search space of this particular problem is characterised by a multitude of global optima. Since the risk of being caught in a local optimum is minimal, this simple strategy is adopted for reasons of speed. The search space of optimising the neighbourhood relations between the rooms is much more complex. Moreover, the search space asks to be worked through more thoroughly. In order to accomplish this, a genetic algorithm (GA) is adopted which combines mutation with cross-over.

The operation performed by the GA is a kind of re-interpretation of the rooms arranged. It changes the functions attributed to the rooms in order to optimise the neighbourhood relations. The output of the GA is thus turned into an input of the strategy fitting in the rooms and vice versa. The fitness that the GA is supposed to maximise is measured in terms of the weights specified in the topological matrix (W). Elements wij of this symmetric matrix express the importance of the neighbourhood of rooms i and j. The weights wij are specified by the user. Solutions of the arrangement problem have the form of matrix T. The value of element tij is 1 in the case that rooms i and j are neighbours and 0 when they are not. The fitness function (WT Æ max) to be maximised sums the products wij * tij (see Figure 2).

The reason for adopting this mixed strategy lies, among other things, in speeding up the process. Speed is crucial for interaction with the user. In the same way in which strategies

Figure 3.

Figure 4.

TYPE: ACCESS BALCONY (SOUTH ORIENTATED)

1	CABINETT	5	SHOWER	9	KITCHEN
2	STOREROOM	6	BATH	10	OFFICE
3	ENTRY	7	WASHBASIN	11	BEDROOM
4	WC	8	LIVINGROOM NORTH	12	DINING ROOM
				13	LIVINGROOM SOUTH

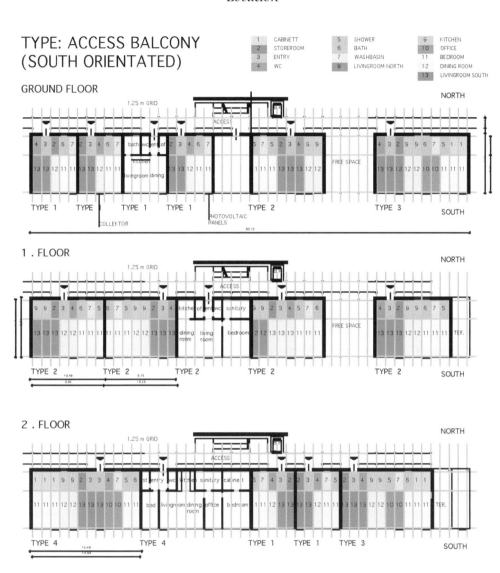

GROUND FLOOR

NORTH

1.25 m GRID

ACCESS

FREE SPACE

TYPE 1 TYPE TYPE 1 TYPE 1 TYPE 2 TYPE 3 SOUTH

COLLEKTOR PHOTOVOLTAIC PANELS

1 . FLOOR

NORTH

1.25 m GRID

ACCESS

FREE SPACE

TYPE 2 TYPE 2 TYPE 2 TYPE 2 TYPE 2 SOUTH TER.

2 . FLOOR

NORTH

1.25 m GRID

ACCESS

TYPE 4 TYPE 4 TYPE 1 TYPE 1 TYPE 3 SOUTH TER.

Figure 5.

Evolutionary Strategy and GA interact, their interplay interacts with the interventions on the part of the user. The user intervenes into the game of artificial evolution via mouse and editing. The interface through which the user interacts (see Figure 3) with the system is characterised by the following features:

- The design variant being the fittest at the moment is displayed on the screen.
- The arrangement as well as the geometry of the rooms can be changed via the mouse (see Figure 4).
- The weights of the neighbourhood relations can be edited during the run.

Application and Outlook

The subject of the studio was solar architecture. The designs developed with the help of the tool were recalculated concerning energy use and solar gains of the building. The outlines proving viable in these regards were fed back into the system. Christian Kadletz, the student who is the author of the project presented (see Figure 5), was using both the design tool and the performance calculator for the first time.

The steps of development at the system lying ahead of the version presented in this paper are generalisations, in the main. First, the rectangularity of the rooms and outlines waits to be generalised by allowing any angles and higher polygons. Second, the floors treated separately thus far wait of being dealt with in a more integral manner by expressing the neighbourhood relations in three dimensions. Another route of generalisation lies in adapting the system for purposes of town planning.

References

Alexander, Christopher 1964. *Notes on the Synthesis of Form*. Cambridge, Mass: Harvard University Press

Frazer, John 1995. *An Evolutionary Architecture*. London: Architectural Association

Goldberg, David E 1989. *Genetic Algorithms in Science, Optimization, and Machine Learning*. Reading, Mass: Addison Wesley

Holland, John H. 1995. *Hidden Order*. Reading, Mass: Addison Wesley

Koning H. & Eisenberg, J. 1981. The language of the prairie: Frank Lloyd Wright's prairie houses, in *Environment and Planning* B 8, pp. 295–323

Mitchell, M. 1996. *An Introduction to Genetic Algorithms*. Cambridge, Mass: MIT Press

Stiny, Georg & Mitchell, J. William 1981. The Palladian Grammar, in *Environment and Planning* B 5, no 1, pp. 5–18

Tomor B Elezkurtaj is a lecturer and a visiting research assistant at the Department of Computer Aided Planning and Architecture at the Vienna University of Technology.

Mind Theory

There is No Intelligence

Ted Krueger

The concept of Intelligence, it would seem, is an important one for the field of Artificial Intelligence and for those who would instantiate its findings in other venues. A working definition of the concept that could guide and focus these efforts is in order. In fact, it is difficult to understand how one could proceed without reference to such a definition.

Aleksander (1981) disagrees: 'Rather than becoming embroiled in the controversy which surrounds the nature of human intelligence, the practitioners of artificial intelligence have generally chosen to define their goals in empirical and operational terms rather than theoretical ones. On this basis, a definition of intelligence becomes unnecessary.' When Turing (1950) considered the question 'Can machines think?', he avoided definitions for either 'machine' or 'think', and proposed instead an empirical criterion now known as the Turing Test. In Intelligence without Reason, Brooks (1991) prefers 'to stay with a more informal notion of intelligence being the sort of stuff that humans do, pretty much all the time.'

In each of these cases, behaviours are the operative index. A general reticence to become directly involved with the concept of intelligence is extremely common. Could it be that this uneasiness indicates a deeper and more systemic problem? The inability to suggest the nature of 'Intelligence' with any precision may be due to the fact that it *simply does not exist*.

In this paper, then, no attempt will be made either to supply the missing definition, or to justify the 'heads-down' research trajectories common to many technical disciplines. Instead, I wish to interrogate the concept of intelligence itself, its explanatory capacity and its operation within a cultural context. I will argue that intelligence is an unnecessary and non-functional concept that can be eliminated to good effect. Without recourse to 'Intelligence', it becomes necessary to develop a closer specification for the origin and development of behaviours. Whether the subject matter is biological or synthetic, it is this closer specification that has value both as description and explanation. It is also critical to attempts to generate within synthetic production the kinds of behaviour that we consider intelligent.

Contemporary understandings of Intelligence develop out of the testing programs instituted in an effort to differentiate between French children that under-performed their colleagues due to their laziness rather than their stupidity (Gregory 1981, p. 296). It had predictive and explanatory objectives. As Gregory notes, if the relationship between behaviour and intelligence does not exit, its place in history will be comparable to the powers of ancient magic in having guided judgments and decisions for 'frighteningly absurd reasons'.

Notions of a general intelligence, the kind implied in the common use of the term, may not be a singular trait – what Gregory (1981) termed a 'Golden Egg' – but rather a collection

of what are taken to be innate capacities. Gardner catalogues many types of intelligence as 'relatively autonomous human intellectual competencies' Gardner (1983, p. 8). These include linguistic, musical, logical-mathematical, spatial, bodily-kinesthetic, interpersonal, and intrapersonal intelligences. In addition, natural and existential intelligences have been proposed.

General intelligence may be thought of as a higher-order variable that is a composite of a variety of less general abilities. Gardner counters the notion of intelligence as a statistically aggregated single index by specifying more closely a relationship between specific behavioural realms and specific capabilities of the agent. In this sense, perhaps it is a step in the right direction. It may be taken as an indicator of serious concern about the explanatory capacity of the general notion.

Should we then also suggest 'Linux' intelligence, and one for the bakers of soufflés? That is, if this process is continued into increasingly more specific categories will the end result be satisfactory? On the basis of factor analysis, Guilford and Hoepfner (1971, p.19) list 120 intelligences or discrete human capabilities. How could one know the point at which to stop this process? The 'multiple intelligence' perspective offers the opportunity for an infinite regress elaborating an otherwise fuzzy concept without questioning or clarifying the basic relationships. Whether one posits a general trait or a series of individual ones, the structure of the argument has remained unchanged. It is this structure which is inadequate.

How can we know intelligence? Specifically what is its relationship to behaviour?

Behaviour which is exhibited in a specific context is evaluated as appropriate to some degree (or not) and this level of appropriateness then is taken to be an indicator of a trait inherent to the agent in question – its intelligence. Someone must be making these observations. This may be the agent observing itself. When I hit my thumb with the hammer, I am inclined to think 'That was Stupid!'. So then, there are also judgments made. These include the range of behaviours that are possible within the circumstances and an evaluation of the effectiveness or appropriateness of the behaviour relative to that range and relative to a goal. None of these are objective measures, but follow from the opinions of the observer.

Brooks (1991, p. 17) makes the following observations: 'Intelligence is determined by the dynamics of interaction with the world', and 'Intelligence is in the eye of the beholder'. While intelligence is commonly thought to be an innate capacity of the organism, it can not be measured by any direct or objective means. All indications that we can gather about it are wholly through the agency of behaviour, a behaviour that owes some of its genesis to the context in which it occurs. While intelligence is supposed to stand in a causal relationship to behaviour, it is an inference that can only be made on the basis of the behaviour in which it is thought to result.

Intelligence is therefore an inference based on an opinion.

The role of cultural relativism in the evaluation of intelligence has been the source of debate for many years. While it is not possible to review this extensive literature within the confines of the present paper, it is referenced here as evidence that the judgmental role is widely recognized and understood to be extremely problematic.

It is important to understand what the concept of intelligence is to do for us and at what

level it operates. Intelligence is supposed to be an innate property of the being or system under consideration. It is however based entirely on the explanatory needs of the observer and not upon the structure the system itself.

We posit intelligence when we observe what we think is an intelligent behaviour. This representation occurs in the realm of the observation and is functional primarily because of its predictive capacity for other events that may take place within the observational realm. The organism behaves as if it had intelligence. This is an important distinction because, even if intelligence functions as a explanatory concept for an observer, it implies nothing about the function of the concept at the level of the agent itself. This disjunction in levels of analysis allows for one to have intelligent machines, environments, or individuals without having an underlying intelligence within the agent. Contrary to intuition, intelligent behaviour does not imply an intelligence within the agent. I claim that an attribution on the part of an observer is independent of any causal mechanism which must be posited as a property of the organism.

Intelligence is supposed to have a generative link to behaviour. Intelligence is an innate and invariant non-physical property that sets limits on the performance of certain behaviours of interest that are carried out by some physical entity. This implies a split between generator and operator. Intelligence exists apart from matter and apart from behaviour, separate from specific operations in the world. The organism and its behaviour are seen as passive resultants in a dialectic between innate capabilities and the challenges imposed by the environment.

Is it helpful to characterize intelligence in this dualistic fashion? How does intelligence function in the realm of cultural discourse? The black box nature of intelligence makes it possible to seem as if we understand something when in fact we have simply deferred to a socially acceptable label for an empty box. By treating intelligence as an explanatory device it seems as if we have given an account of something. We can all politely nod in agreement, yet these references serve to mask or block an operational understanding of the behaviours in question by appearing to give an explanation when they do not. It is exactly this more principled account which is required for an understanding of biological entities, and that could form the basis for efforts to generate intelligent behaviours in synthetic agents.

Another way to approach the issue is to inquire about what is lost if we eliminate the notion of intelligence altogether. One might suggest that having criticized intelligence as a black box concept, its removal does no more than to reconstitute the box at the level of the organism itself. This is simply neo-behaviourism. Without the concept of intelligence to function as a causal linking device between behaviours separated by time or context we have no longer a predictive capacity. If we can have intelligent behaviour without an underlying intelligence, we have effects without causes – what kind of epistemology is that?

Behaviourist input and output analysis, the stimulus and response, is an essentially computational model. In this respect the organism is a 'black box'. I argue that the concept of intelligence has essentially the same effect not by making the organism opaque but by emptying it of significance. Oyama (1985) has spent considerable effort to critique the nature-nurture debate within developmental psychology. She argues: 'Amid all this shuttling between opposites, the organism is often reduced to an epiphenomenon – at best a battlefield where internal and external forces contend for causal primacy, or a patchwork, fashioned partly from

the inside and partly from the outside. One gains little sense of an integrated and active organism from such presentations' (Oyama 1992, p. 228).

I will not claim that the relationship of intelligence to behaviour is that same as that between nature and nurture. Indeed that opposition operates in attempts to characterize the ontogeny of intelligence itself, which lies to one side of the equation only. Oyama's insight is still useful here, if one realizes that in the use of intelligence as an explanatory device, much of the same pacification of the organism has taken place. To deny the place of the organism in the equation is to attempt a wholesale extraction of this intelligence from the realm of the biological, and to transfer it to synthetic production. Intelligence is an essence to be bottled and exported, spirit to be re-embodied, or software that can run on other substrates. Intelligence, it is hoped, has all the properties of a symbol system. Gardner, in fact, characterizes the 'multiple intelligence theory' as a symbol system approach, but organisms are not digital computers (van Gelder, 1999).

A more accurate explanation for cognition and behaviour can be assembled from research in biology and cognition. In place of a single cause and a simple linear relationship as suggested by the employment of intelligence as explanation, Maturana and Varela (1992, p.166) propose that 'every process of cognition is necessarily based on the organism as a unity and on the operational closure of its nervous system; hence it follows that all knowing is doing as sensory-effector correlations in the realms of structural coupling in which the nervous system exists'.

It is this notion of 'structural coupling' which I believe can effectively stand in for the old notion of intelligence. The organism is an essentially autonomous and closed system in which relations of cause and effect cannot be enacted across the boundary defining the organism from its medium. The organism only has access to the internal states of its sensory apparatus that correspond to the conditions of its media. This internal state does not represent a world at large. An organism has internal states based on its sensory apparatus and realizes changes of state based on the operation of its effectors. It is from the regularities in the relationships of sensor states to effector states by which the organism 'brings forth the world'.

It is important to note that the possession of internal state is insufficient in itself. The internal state of the organism does not 'represent' the state of the world. Cognizance of the world develops out of the dynamics of the internal states in conjunction with the dynamics of the effector functions. This, then, is not a neo-behaviourist position. There are no inputs and outputs, but instead dynamic correlation between the states of the organism and the conditions of its media. The notion of cause and effect, with its hierarchy and directionality, are replaced by iterative mutually-interacting co-dependent processes that unfold in time (van Gelder, 1997).

Clark, Kirsh, Hutchins and Norman, among others, have all argued that human cognitive competencies develop less out of innate capacities of the organism's brain than from a continuum which unites nervous system and environment by means of the body and through its dynamics.

If we hope to instill intelligent behaviours in synthetic constructions, we must do so by reproducing the conditions from which they arise, not by perfuming the mechanisms with essences we have ourselves distilled.

The concept of intelligence is a 19th century phenomena with a social agenda. In its brief

existence, it has gained a powerful and prominent role in the way in which we understand ourselves and the products of our culture. It is time to come to a clarification, and I have claimed here that this is best accomplished by an abandonment of the concept. The production of intelligent cultural artifacts may well prove to be one of the significant contributions of contemporary culture. It is important to clear away the conceptual cobwebs so that we can initiate a disciplined consideration of issues of interface to adaptive, autonomous, and intelligent synthetic production.

References

Aleksander, I. and Burnett, P. 1981. *Thinking Machines: The Search for Artificial Intelligence*. NYC: Knoff

Brooks, R. 1991. Intelligence without Reason, *AI Memo 1293*. Cambridge, MA: MIT Artificial Intelligence Laboratory, available at:
http://www.ai.mit.edu/people/brooks/papers/AIM-1293.pdf

Gardner, H. 1983. *Frames of Mind: The theory of Multiple Intelligences*. NYC: Basic Books

Gregory, R. 1981. *Mind in Science*. Cambridge, UK: Cambridge University Press,

Guilford, J. and Hoepfner, R. 1971. *The Analysis of Intelligence*. NYC: McGraw-Hill

Maturana, H. and Varela, F. 1992. *Tree of Knowledge*. Boston: Shambhala

Oyama, S. 1985. *The Ontogeny of Information*. Cambridge, UK: Cambridge University Press

Oyama, S., 1992. Is Phylogeny Recapitualting Ontogeny? in Varela, F. and Dupuy, J-P., *Understanding Origins. Boston Studies in the Philosophy of Science Vol. 130*. Dordrecht, NL: Kluwer Academic Publishers

van Gelder, T. 1997. The Dynamical Hypothesis in *Cognitive Science*, manuscript version of Oct.97, available at: http://www.arts.unimelb.edu.au/~tgelder/Publications.html

van Gelder, T. 1999, *Revisiting the Dynamical Hypothesis, Preprint No.2/99*, University of Melbourne, Department of Philosophy, available at :
http:// www.arts.unimelb.edu.au/~tgelder/Publications.html

Turing, A. 1950. Computing Machinery and Intelligence, in *Mind, vol.LIX* No, 236, available at:
http://www.abelard.org/turpap/turpap.htm

Toward a Theory of Creative Inklings

Liane Gabora

It is perhaps not so baffling that we have the ability to develop, refine, and manifest a creative idea, once it has been conceived. But what sort of a system could spawn the initial seed of creativity from which an idea grows? This paper looks at how the mind is structured in such a way that we·can experience a glimmer of insight or inkling of artistic inspiration.

1. Memory is Distributed (but Constrained)

Before we can explore how the contents of the mind are harnessed in a unique and innovative way, it is necessary to look briefly at how experiences are encoded in memory, and how they participate in subsequent experiences through contextual reminding events.

 If the mind stored each experience in just one memory location as a computer does

(Figure 1a), then in order for one experience to evoke a reminding of a previous experience, it would have to be identical to that previous experience. And since the space of possible experiences is so vast that no two ever are exactly identical, this kind of organization would be pretty useless. On the other hand, if any experience could activate any memory location (Figure 1b), the memory would be subject to crosstalk, a phenomenon wherein nonorthogonal patterns interfere. For the mind to be capable of evolving a stream of coherent yet potentially creative thought, the degree to which an experiences is distributed must lie between these extremes; that is, the size of the sphere of activated memory locations must fall within an intermediate range. A given instant of experience activates not just one location in memory, nor does it activate every location to an equal degree, but activation is distributed across many memory locations, with degree of activation decreasing with distance from the most activated one, which we call k (Figure 1c). The further a concept is from k, the less activation it not only receives from the current stimulus but in turn contributes to the next instant of experience, and the more likely its contribution is cancelled out by that of other simultaneously activated locations. A wide activation function means that locations relatively far from k still get activated. In other words, neurons have a lower activation threshold, so more fire in response to a given stimulus.

2. Memory is Content Addressable

There is a systematic relationship between the content of an experience (not just as the subject matter, but the qualitative feel of it) and the memory locations where it gets stored (and from which material for the next instant of experience is evoked). In a computer, this kind of one-to-one correspondence is accomplished by assigning each possible input a unique address in memory. Retrieval is thus simply a matter of looking at the address in the address register and fetching the item at the specified location. The distributed nature of human memory prohibits this, but content addressability is still achievable as follows. The pattern of features (or phase relations) that constitutes a given experience induces a chain reaction wherein some neurons are inhibited and others excited. The address of a neuron is thus the pattern of excitatory and inhibitory synapses that make it fire. Since correlated qualia patterns get stored in overlapping locations, what emerges is that the system appears to retrieve experiences that are similar, or concepts that are relevant, to the current

Figure 1. (a) A one-to-one correspondence between input and memory, as in a computer. (b) A distributed memory, as in some neural networks. (c) A constrained distributed memory, as in neural networks that use a radial basis function for the activation function. This is closest to how human memory works.

experience. As a result, the entire memory does not have to be searched in order for, for example, one painting to remind you of another.

3. A Distributed, Content-addressable Memory can be Creative

A distributed, content addressable memory has advantages and disadvantages. Since stored items are 'smooshed' together in overlapping locations, at a high level of resolution, an item is never retrieved in exactly the form it was stored. Your new experience of it is reinterpreted in the context of similar experiences, and colored by events that have taken place since the last time you thought of it, as well as current stimuli, goals, and desires. Thus it is more accurate to think of the evoking process as reconstruction rather than retrieval.

Although this 'smooshing'/reconstruction is a source of inaccuracy, it enables the emergence of abstractions—concepts such as 'depth' with fewer dimensions than any of their instances. Abstractions unite stored experiences into an interconnected mental model of reality, or (from a first person standpoint) subjective worldview (Gabora 1998). The more abstract the concept, the greater the number of others potentially evoked by it. For instance, your concept of 'depth' is deeply woven throughout the matrix of concepts that constitute your worldview. It is latent in experiences as varied as 'deep swimming pool', 'deep-fried zucchini', and 'deeply moving book'; it derives its existence from these instances. The identification of an abstraction is a creative act. Often, however, when we think of creativity, we think of the invention of artifacts that merge lower-dimensional entities into something more complex than its constituents; for example, a dance is more than its steps. The 'smooshed' nature of human memory is the wellspring of both sorts of creativity. The more interwoven the mind is with abstractions, the more different ways of funneling an experience through the conceptual network, abstracting something new out of it, and manifesting the essence, or feel of it, through the constraints of an artistic medium (Gabora 2000).

4. The Creative Inkling

The current array of sensory stimuli can be viewed as a perturbation that impinges on the current spatio-temporal pattern of activated memory locations to create a new constellation of activated locations. You could say the perturbation collapses the conceptual network into a phenomenally manifested state; it reveals one 'slice' through the distribution of possibilities that was inherent in the conceptual network (Aerts & Gabora, 1999). In a sense, the perturbation tests the integrity of a certain portion of the worldview, the size of the portion tested depending on the activation function. At the risk of mixing metaphors, you could say it's like throwing a ball against a wall and observing how it responds. The more flexible the material the ball is made of, the more it 'gives' when it makes contact. Similarly, the wider the activation function, the greater the portion of the worldview that makes contact with the world at that instant. Much as irregularities in the bounced ball cause its path to deflect, constrictions (repressed memories) or gaps (inconsistencies) in the 'collapsed' portion of the worldview may cause tension and thereby indicate a need for creative release, revision, or reconstruction. (Of course, so long as the ball doesn't completely deflate and slide down the wall, you're doing fine.)

161

An inkling, then, is a collapse on an association or relationship amongst memories or concepts that, although their distribution regions overlap, were stored there at different times, and have never before been simultaneously perturbed, and evoked in the same collapse (Figure 2). Though it is a reconstructed blend, something never actually experienced, it can still be said to have been evoked from memory. It's like getting a 'bite' on many fishing rods at once, and when you reel them in you get a fish that is a mixture of the characteristics of the various fish that bit.

5. Mental States Conducive to Creativity

If the activation function is large, a greater diversity of memory locations participate in the encoding of an instant of experience and release of 'ingredients' for the next instant. The more locations activated, the more they in turn activate, and so on; thus streams of thought tend to last longer. However, consecutive instants are less correlated because a concept from the periphery of the sphere of activated locations can pull the content of the next instant of experience far from its predecessor. New stimuli less readily command attention because they must compete with what has been set in motion by previous stimuli. If, however, something does manage to attract attention, it can get thoroughly assimilated into the matrix of abstractions, and thereby become increasingly decoupled from the stimulus that initially triggered it.

In the long run, since the relationship between one thought and the next could be so remote that a stream of thought lacks continuity, a large activation function would be untenable. However, in the short run, since there is a high probability of 'catching' new combinations of memories or concepts, it is conducive to creativity. The more features of the environment one attends or is sensitive to, the more memory locations potentially involved in its storage; thus, a large activation function may manifest as a state of defocused attention or heightened sensitivity. There is in fact experimental evidence that both defocused attention (Dewing & Battye, 1971; Dykes & McGhie, 1976; Mendelsohn, 1976), and high sensitivity (Martindale & Armstrong, 1974; Martindale, 1977), including sensitivity to subliminal impressions (Smith & Van de Meer, 1994) are associated with creativity.

Figure 2. Schematic diagram of stimulus activating two dimensions of memory. Each vertex represents a possible memory location, and black dots represent actual locations. If many memories are stored in locations near k, they blend to generate the next experience.

One measure of creativity is the steepness of an individual's associative hierarchies (Martindale, 1999; Mednick, 1962). This is measured experimentally by comparing the number of words that individual generates in response to stimulus

words on a word association test. Those who generate only a few words in response to the stimulus (e.g. 'chair' in response to 'table') have a steep associative hierarchy. Those who, after running out of the usual responses, go on to generate unusual ones (e.g. 'elbow' in response to 'table') have a flat associative hierarchy. This is what one would expect with a wide activation function.

6. The Creative Being as a Conduit

To make this more concrete let us take an example. Sometimes freestyle dancers find themselves 'doing moves', but unable to lose themselves to the music. The dancing feels and looks planned, does not touch the heart. Dance demands that the music be allowed to have its way with you, to forge new channels of expression through the constraints of your body, to use you to unearth something new. Perhaps this state, and its analog in other creative endeavors, derives from a state of defocused attention – thus widened activation function – such that whatever gets evoked, whether the logic of the association is apparent or not, can surface to the next instant of awareness.

7. Pattern in Underlying Reality as Conceptual Linkage Disequilibrium

Let us look at the effect an inkling has on the conceptual network or worldview. The biological concepts of linkage equilibrium and disequilibrium are useful for gaining perspective on what is happening here. The closer together two genes are on a chromosome, the greater the degree to which they are linked. Linkage equilibrium is defined as random association amongst alleles of linked genes. Consider the following example:

A and a are equally common alleles of Gene 1.
B and b are equally common alleles of Gene 2.
Genes 1 and 2 are linked (nearby on same chromosome).

There are four possible combinations of genes 1 and 2: AB, Ab, aB, and ab. If these occur with equal frequency, the system is in a state of linkage equilibrium. If not, it is in a state of linkage disequilibrium. Disequilibrium starts out high, but tends to decrease over time because mutation and recombination break down arbitrary associations between pairs of linked alleles. However, at loci where this does not happen, one can infer that some combinations are fitter, or more adapted to the constraints of the environment, than others. Thus when disequilibrium does not go away, it reflects some structure, regularity, or pattern in the world.

What does this have to do with creativity? Like genes, the features of memories and concepts are connected through arbitrary associations as well as meaningful ones. We often have difficulty applying an idea or problem-solving technique to situations other than the one where it was originally encountered, and conversely, exposure to one problem-solving technique interferes with ability to solve a problem using another technique (Luchins, 1942). This phenomenon, referred to as mental set, plays a role in cultural evolution analogous to that of linkage in biological evolution. To incorporate more subtlety into the way we carve up reality, we must first melt away arbitrary linkages amongst the discernable features of memories and concepts, thereby increasing the degree of equilibrium. As we destroy patterns

of association that exist because of the historical contingencies of a particular domain, we stoke the fire for the forging of associations that reflect genuine structure in the world of human experience which may manifest in several or perhaps all domains. This needn't be an intellectual process. For example, one might have a sudden glimmer of insight into how the feeling of a particularly emotional experience could be extricated from the specifics of that experience, and re-manifest itself as, say, a piece of music.

Acknowledgments
I would like to acknowledge the support of the Center Leo Apostel and Flanders AWI-grant Caw96/54a. And I guess I have to thank my cat Inkling for inspiration.

References
Aerts & Gabora 1999. Lecture Ten, *Quantum Mind: Quantum approaches to understanding the mind.* http://www.consciousness.arizona.edu/Millennium/

Dewing, K. & Battye, G. 1971. Attentional deployment and non-verbal fluency. *Journal of Personality and Social Psychology, 17,* 214–218.

Dykes, M. & McGhie, A. 1976. A comparative study of attentional strategies in schizophrenics and highly creative normal subjects. *British Journal of Psychiatry, 128,* 50–56.

Gabora, L. 1998. Autocatalytic closure in a cognitive system: A tentative scenario for the origin of culture. *Psycholoquy, 9* (67) http://www.cogsci.soton.ac.uk/cgi/psyc/newpsy?9.67 [adap-org/9901002]

Gabora, L. 2000. The beer can theory of creativity. In (P. Bentley & D. Corne, Eds.) *Creative Evolutionary Systems.* London: Morgan Kauffman.

Karmiloff-Smith, A. 1992. *Beyond Modularity: A Developmental Perspective on Cognitive Science.* Boston: MIT Press.

Luchins, A.S. 1942. Mechanization in problem solving. *Psychological Monographs, 54,* No. 248.

Martindale, C. 1977. Creativity, consciousness, and cortical arousal. *Journal of Altered States of Consciousness, 3,* 69–87.

Martindale, C. 1999. Biological bases of creativity. In (Sternberg, R. J., Ed.) *Handbook of creativity.* Cambridge: Cambridge University Press, pp. 137–152.

Martindale, C. & Armstrong, J. 1974. The relationship of creativity to cortical activation and its operant control. *Journal of Genetic Psychology, 124,* pp. 311–320.

Mednick, S. A. 1962. The associative basis of the creative process. *Psychological Review, 69,* 220–232.

Mendelsohn, G. A. 1976. Associative and attentional processes in creative performance. *Journal of Personality, 44,* pp. 341–369.

Smith, G. J. W. & Van de Meer, G. 1994. Creativity through psychosomatics. *Creativity Research Journal, 7,* 159–170.

Liane Gabora is based at Center Leo Apostel, Vrije Universiteit Brussel, Belgium.

The Bicameral Mind and the Split-Brain Human Computer Interface

Gregory P. Garvey

Whether we like it or not, the human mind is constantly being split, like a house divided, between the part that stands for the known, and the part that stands for the knower. (Antonio Damasio The Feeling of What Happens)[1]

A *split-brain human computer user interface* targets the user's visual and auditory pathways and delivers two independent dynamic audio-visual streams simultaneously to each hemisphere of the brain.

A head mounted display permits the user to comfortably watch one digital video seen only by the left eye while watching a different digital video seen only by the right eye. At the same time, the user hears separate audio in the right and left ears. The user can interactively control the playback of the digital video by pressing buttons with the left and right hand.

Although inspired by the research with split-brain patients conducted by Roger Sperry, Michael Gazzaniga, J. E. Bogen [2] and others, this interface is designed to work with the capabilities of the normal rather than the abnormal brain. This approach to user interface design is similar in motivation to research in wearable computing [3], enhanced interaction and augmented virtual reality. While it is intriguing to consider methods to enhance and extend natural human perception and intelligence, or even induce 'extended consciousness' or a state of 'artificial congnitive dissonance' the primary motivation of this design is to provide a dedicated and novel interface for the creation of a new and different kind of aesthetic experience for an interactive documentary drama.

The initial prototype of the interface was developed for a multi-media artwork entitled: *Anita und Clarence in der Hölle: An Opera for Split-brains in Modular Parts.* [4] This work is a digital video database consisting of the C-SPAN Videotape Archives [5] of the 1991 United States Senate Judicary Committee Hearings on the nomination of Clarence Thomas to the U.S. Supreme Court. It is also an interactive documentary which accommodates different viewing styles from passive watching to active interaction and tells the story of how Anita Hill came forward to accuse United States Supreme Court Nominee Clarence Thomas of sexual harassment. The final Senate vote confirmed Clarence Thomas' nomination and he was sworn in as 106th Supreme Court Justice on October 18, 1991. This epic drama played out on the national televised stage with overtones of gender and racial issues in a lurid spectacle of 'she said, he said'. A split-brain human computer user interface directly presents the contradictory testimony of Anita Hill and Clarence Thomas simultaneously to each hemisphere of the brain.

Splitting the Brain

The view of the world seen by each eye can be divided in half by a line at the nose into the left and right visual fields. The light coming from each visual field is refracted and inverted through the lens of the eye to the opposite side retina (see Figure 1).

The temporal retina of the left eye together with the nasal retina of the right eye, sees the right visual field while the temporal retina of the right eye together with the nasal retina of the left eye, sees the left visual field. The overlap of the visual fields is essential for stereo depth perception of binocular vision (see Figure 2).

The split-brain effect requires that the visible image be seen only by the nasal (closest to the nose) half of the retina. As the optic nerve leaves the eye, fibres from the nasal half of the retinas cross at the optic chiasma and continue along the optic track to the opposite side brain hemisphere. The fibres from the temporal half of the retinas do not cross but continue to the same side hemisphere [6].

Viewing Modes

The prototype was developed and tested using a Virtual Research Systems V-6 Head Mounted Display which supports two 640x480 60Hz VGA Active Matrix Liquid Crystal Displays. The split-brain effect requires that the resolution of the digital video be less than half the display resolution. The image could be then registered along the outside (temporal edge) or the inside (nasal edge) of each LCD. Two possible placements of the digital video afforded two viewing modes: *Convergence and Divergence* (see Figure 3).

Divergence Mode delivers the digital video to each nasal retina and therefore to the opposite side hemisphere of the brain. What is seen by the right nasal retina goes to the left hemisphere and vice versa. To achieve this, the digital video image is registered along the left (outside) edge of the left LCD (therefore by refraction the inverted image is seen only by the nasal retina of the left eye) while the digital video is also registered along the right (outside) edge of the right LCD (the inverted image seen only by the nasal retina of the right eye). Neither eye can see what the other eye sees. The viewer tends to keep the eyes fixed straight ahead as attention is naturally focused on the two moving images. [7] The majority of first time users/viewers can quickly and comfortably view both digital videos as completely separated independent images (see Figure 4).

Figure. 1: *Visual Fields.* Figure. 2: *Visual Pathways*

Convergence Mode positions the digital video on the right (inside edge) edge of the left LCD while the digital video is registered on the left (inside edge) of the right LCD. The digital video is seen only by the temporal half of the retinas of each eye and is routed to the same side hemisphere. With Convergence Mode the two image appear to be superimposed and overlap. The brain appears to be attempting to integrate and fuse the two images into one image with unpredictable results. At least a third of the users experienced difficulty in fusing the images.

Figure. 3: Divergence Mode

Figure. 4: Convergence Mode

Background

'Split-brain' studies were performed on patients who had undergone a commissurotomy. This surgical procedure severs the bundle of fibres known as the corpus callosum which permits communication between the left and right hemisphere. This treatment was used for patients with severe epilepsy where seizures spread from one hemisphere to the other and could not be controlled by alternative therapies. [7]

The 'split-brain' research led to results indicating the localization and lateralization of skills in one hemisphere or the other. For the majority of the 'normal' population who are right handed, the left hemisphere is verbal and analytic, while the right is nonverbal and is superior in spatial reasoning. J. E. Bogen identified two ways of knowing [8] which paired together complementary left/right brain cognitive styles such as convergent/divergent, lineal/nonlineal and analytic/holistic.

Researchers described these 'split-brain' patients as having effectively 'two brains' which often displayed contradictory behaviour. In the early 1970s during the Watergate political scandal, Gazzaniga documented a split-brain patient who when asked his opinion of former United States President Richard Nixon, his right hemisphere reported 'dislike', while his left responded 'like'. [9] This disassociation is striking because it suggests that this individual harbors two different selves. It also suggests that although this patient's two hemispheres were exposed to the same information about Richard Nixon they drew very different conclusions. This in turn challenge our conventional notion of selfhood.

In another study of a split-brain patient who developed a capacity for speech in the right hemisphere, Gazzaniga presented two stories separately to the left and right hemisphere. When read by a normal subject these two stories would be read as one complete story. The split-brain patient first reports only what the left or normally verbal hemisphere sees. Then the right hemisphere reports what it read and when the patient is asked a third time to explain what was read, a third story is told made up of what was read by both hemispheres and embellished by items not contained in either source story. [10] Gazzaniga attributes to the left hemisphere a 'creative narrative talent' which he calls 'the

interpreter mechanism' which 'is constantly looking for order and reason, even when there is none – which leads it continually to make mistakes. It tends to overgeneralize, frequently constructing a potential past as opposed to a true one.' [11]

Robert Ornstein points out that the left brain tends to choose one meaning in order to achieve a goal or to act, while the right can entertain multiple interpretations. 'A long line of research shows that this hemisphere selects words very differently than the left does. The right hemisphere has an ability to hold lots of different meanings of a word available for use while, by contrast, the left hemisphere quickly selects a single meaning. People with damaged right hemispheres thus have difficulty with jokes because they cannot hold the different meanings of a word or phrase in mind for comparison.' [12]

Gazzaniga presents a modular theory of brain function to account for observed hemispheric localization and laterialization of skills and capabilities. The brain and mind are built 'from discrete units – or modules – that carry out specific functions' such as facial recognition, understanding speech or listening to music.'

For Gazzaniga the left hemisphere plays an essential role of interpreting this cacaphony of automatic processes and creates a personal story: 'an on-going narrative, the self-image we have been building in our mind for years'. [13]

With his Multiple Drafts hypothesis Daniel Dennett extends the 'strong AI' position taken by Marvin Minsky in *Society of Mind* [14]. Both view the self as a convenient fiction. Dennett is unconvinced by claims for Multiple Personality Disorder and split-brain personalities: 'the life of a second rudimentary self lasts a few minutes at most, not much time to accrue the sort of autobiography of which fully fledged selves are made'.[15]

Even after a commissurotomy deeper structures of the brain that affect emotions and physiology remain intact. A split-brain is more like the shape of a Y than two separated halves. It is these very deep structures which sense and govern basic body states and according to Antonio Damasio, contribute to the formation of a pre-conscious biological proto-self. [16] He then distinguishes core consciousness, which occurs when the brain forms a nonverbal account representing 'both the organism (the proto-self) and the object'. Core consciousness coupled with memory generates an auto-biographical self which permits extended consciousness, 'i.e. the ability to generate a sense of individual perspective, ownership, and agency over a large compass of knowledge than surveyed in core consciousness'. [17]

Damasio maintains that core consciousness creates an ongoing nonverbal narrative about the self. In noting that: 'the left hemisphere of humans is prone to fabricating verbal narratives that do not necessarily accord wih the truth', he suggests that verbal translations are too unreliable to yield the consistency required for the story of the knowing self.

According to Damasio, both Dennett and Julian Jaynes in his account of the evolution of conscious as recorded in the written record, refer not to core consciousness but rather to extended consciousness as a post-language phenomenon. Jaynes' provocative theory suggests that the origins of the myths of the gods is due to voices heard in the right hemisphere. [18] These hallucinated voices would be produced in the area of the right hemisphere that corresponds to the auditory centre known as Wernicke's area in the left hemisphere. These two areas are connected by the anterior commissures and would permit

the voices produced in the right hemisphere to be heard by the auditory area's in the left hemisphere. Eventually, over several millennia, the voices of the gods fell silent due to the rise of the culture of rational consciousness of the dominant left hemisphere. Today, the voices of gods only linger in those who society labels as schizophrenic.

The popularity of books filled with random dot stereograms which generate pseudo-stereopic images suggest that we can learn new techniques for seeing an 'enhanced' reality. When the images presented to each eye are significantly different then as Francis Crick and Cristof Koch [19] showed, binocular rivalry occurs: 'one sees not the two inputs superimposed but first one input, then the other, and so on in alternation'. Yet the *Land Warrior* system developed by the U.S. Army proceeds on the premise that it is possible to learn to accommodate a separate input to one eye while the other eye is free to observe the environment.

Steve Mann, a developer of wearable technology since the 1970s, has also designed a monocular display system, called the Bi-foveated WearCam, which uses 'natural foveation, arising from the symbiotic relationship between human and machine'. Mann sees technology as a natural extension of 'humanistic intelligence' and perception. At the minimum, a split-brain interface configures information in a different way. Yet with the promise of increasing miniaturization through the advent of nano-technologies, is it not possible that we could once again hear the voices of the gods?

Notes

1 Damasio, A. 1999. *The Feeling of What Happens: Body and Emotion in the Making of Consciousness* New York: Harcourt Brace & Company, p. 191

2 Sperry, R. W. Gazzaniga, M.S. and Bogen, J. E. 1969. Interhemispheric relationships: The neocortical commissures; syndromes of their disconnection, In Vinken, P. J. and G. W. Bruyon, ed. *Handbook of Clinical Neurology*, Amsterdam: North-Holland, vol. 4: pp. 273–90.

3 Rekimoto, J. 1994. *The World Through the Computer: A New Human-Computer Interaction Style Based on Wearable Computers*, Technical Report SCSL-TR-94-013, Sony Computer Science Laboratories.

4 A working prototype of this project was developed during a residency in 1999 at the Banff Centre in Alberta, Canada and was funded in part by the Canada Council for the Arts.

5 C-SPAN Archives, 1991. Clarence Thomas Confirmation Hearings, West Lafayette, IN

6 Wade, N. J., Swanston, M. 1991, *Visual Perception: An Introduction*, London and New York: Routledge, p. 70

7 Gazzaniga, M. S., 1983. Right Hemisphere Language Following Brain Bisection: A 20-Year Perspective, In *American Psychologist, 38*(5), pp. 525–537. Copyright 1983 by the American Psychological Association.

8 Bogen, J.E. 1975 *Some Educational Aspects of Hemispheric Specialization.* Los Angeles: U.C.L.A. Educator 17, pp. 24–32

9 Gazzaniga, S. 1985. *The Social Brain: Discovering the Networks of the Mind.* New York: Basic Books

10 Gazzaniga, 1983.

11 Gazzaniga, M. S. 1998. The Split-brain Revisited, In *Scientific American, vol. 279*, no. 1 p. 54

12 Ornstein, R. 1997. *The Right Mind*, New York: Harcourt Brace & Company. p. 87.

13 Gazzaniga, M. S. 1998. *The Mind's Past.* Berkeley: University of California Press. pp. 23–27

14 Minsky, M. 1985. *The Society of Mind.* New York: Simon and Schuster.

15 Dennett, D. 1991. *Consciousness Explained.* New York: Penguin Putnam Inc, p. 425

16 Damasio, A. 1999. *The Feeling of What Happens: Body and Emotion in the Making of Consciousness* New York: Harcourt Brace & Company, p. 154.

17 Ibid pp. 192–198.

18 Jaynes, J. 1976. *The Origins of Consciousness and the Breakdown of the Bicameral Mind.* Boston: Houghton Mifflin, pp. 104–106

19 Crick F. , Koch C, 1992, The Problem of Consciousness, In *Scientific American, 267*(3), p. 155.

Gregory P. Garvey is Visiting Fellow in the Arts and Associate Professor at Quinnipiac University in Connecticut.

Attractors and Vectors: the nature of the meme in visual art

Nicholas Tresilian

Closed Images

For five centuries, from ca 1450 to 1950, the visual art of the West was produced exclusively in the form of compact, closed images, scaled to lie within the natural human cone-of-vision – typically easel-paintings or free-standing sculptures, unique and aesthetically self-sufficient, isolated from their visual environment by a frame or plinth. By this closure paintings and sculptures positioned the human eye outside the art-image looking in. They defined the art-user as a passive observer, in a relationship of critical judgment with the work

Open Images

Since the 1950s Western artists have been struggling towards a new methodology of artistic production, complementary to that of the compact closed image, the environmentally-scaled open image – a wrap-around, walk-through permeable structure extending beyond the human cone-of-vision in all directions, which re-positions the eye inside the image looking out, and simultaneously re-defines the art-user as an active participant in the realisation of the image itself.

The new open images first made their way onto the world stage in a number of guises – happenings, art-environments, land art, installations, artist placements, contextual and site-specific art, sociological art, systemic art, cybernetic art, etc. By the end of the twentieth century they had consolidated into three parallel and overlapping strands of activity – indoor installations, outdoor exstallations (such as Rachel Whiteread's *House*) and electronic netstallations. By then, too, much contemporary painting and sculpture had scaled up to the expanded proportions of the open image. Every indication seems now to suggest that the open image is taking over from the closed image as the new creative platform for visual art.

The Question of Authenticity

Every time art moves from an old creative platform to a new one, it raises again the question of generic authenticity. It used to be asked: if figural images equate with art, how also can non-figural images? Now it is: how can art be 'closed' in one period of history and 'open' in the next?

The question matters. Currently the closed image still attracts most of the serious money available for art. Artists wishing to explore the potentials of the open image have access to the international 'travelling circus' of annual, biennial and quinquennial group exhibitions, but these are unreliable as a source of income. Most artists therefore have to teach. They are fortunate if they can find – or create – teaching environments such as CAiiA where the open image is at the core of the pedagogical agenda.

Enter the Meme

Is it possible to nominate a quantum of communication which possesses the salient characteristics of art, and which at the same time can take both 'closed' and 'open' forms?

The quantum which immediately offers itself for consideration is the meme, Dawkins' proposed self-replicating unit of culture. (Dawkins, 1976). The issue of the meme's spontaneous self-replication remains tendentious until it has been tested against our knowledge of systematically creative cultures such as science and art. But the meme itself, as a concept, offers a potential starting-point for a consideration of communication in terms of content.

Closed and Open Memes

Let us consider as a 'meme' any unit of communication in which some distinctive set of semantic values may be identified. A pop song may be a meme, but so may the concert at which it is performed. A product may be a meme, but so may the 'brand' by which its commercial values are marketed. Stars, celebrities, soaps, and peoples' princesses are memes, but so are the life-styles associated with them and imitated by millions. A well-known shop may be a meme, but so, equally, may the well-known shopping-mall which contains it. Songs, products, stars, celebrities, peoples' princesses, soaps and shops are *closed* memes, each with its own individual semantic identify. Rock-concerts, brands, life-styles, shopping-malls and fan-clubs are *open* memes, each with its own equally individual semantic identity. We are outsiders in relation to the one genre and insiders in relation to the other. Memes may be closed or open, it seems, without prejudice to their memetic authenticity. Closed and open art-images must therefore in principle have equal validity in the universe of memes. But can the universe of memes in any practical way equated with the universe of art?

Shannon Blocks the Way

The Latin root of the term 'art' has the meaning 'to fit'. Art's problem has long been that it does not 'fit' the West's conventional concepts of communication as a distributive trade – a transmission of information by means of some operational vector from a Sender to a Receiver.

In recent decades there have been attempts to challenge this one-way trend of thought about communication. The French Structuralists sought to distinguish between the signifier and the signified. McLuhan and his followers pursued the distinction between the *medium* and the *message*. But neither of these proto-theories was expressed in terms which could be equated with the one supremely authoritative scientific text on communication of the last 50-odd years – Claude Shannon's Mathematical Theory.

Information Theory Revisited

Shannon's first great insight, for which he is justly renowned, was that the 'information' H in a given message can be represented statistically by the negative of the formula for the thermodynamic quantity known as 'entropy'. In mathematical terms information could therefore be described as 'negative entropy'

$$H = - K \Sigma \, p_i \log p_i$$

– where K is a positive constant and pi is the probability of state 'i' of the states (1–n) of the message (Shannon & Weaver, 1949, p. 50). In this single equation Shannon effectively demonstrates the seamless continuity of nature and culture and at the same time indicates that information is energy writ small. It is the 'e = mc2' of cultural theory.

In classical thermodynamics entropy measures the inefficiency of a gas in the process of doing work – the energy consumed by the gas itself, for instance, in the process of expanding to drive a piston. Shannon's second great insight was that large ensembles of information in the process of communication would incur statistical inefficiencies similar to those incurred by gases. The production of 'signal' will always be accompanied by a certain production of 'noise'. Our quantum of communication, the meme, must be conceived of as a state of potential for both negative and positive entropy, a natural hybrid of signal and noise.

Shannon's own instincts as an engineer led him to seek to suppress this apparent contradiction in the nature of communication itself, in the interest of maximising efficiencies of transmission. His celebrated 9th ('Capacity') Theorem (Shannon & Weaver, 1949, p. 71) states that when the information H to be transmitted exactly matches the information-capacity C of the transmission channel, with appropriate coding the information may always transmitted with an arbitrarily small amount of noise. For Shannon the single objective of communication was to maximise signal and minimise noise. Emblematically:

$$H_{information} >> H_{entropy} \geq \varepsilon$$

In this way Shannon configured his concept of communication as closely as possible to the demands of classical rationality. His residual arbitrarily small amount of noise in a rational message became in effect the communications equivalent of Planck's constant in the Uncertainty Relations of Heisenberg – an amount of uncertainty so small that it could be ignored for events on a normal scale of experience.

The Meme as Vector

In the universe according to Shannon a meme would be a package of pure information to be transported from A to B with minimal ambiguity by some appropriate point-to-point or point-to-multi-point vector – an alpha-numeric text, a blue-print, a telephone line, a broadcast tv signal, a digital bit-stream. It is clear that a large class of rational memes exists which are configured for transmission in this way – reports, orders, invoices, computer programmes, road-signs, statements of account, balance sheets, contracts, legal codices, photographs, inventories, databases, scientific formulae, architectural plans, designs for technological equipment, etc. For all these, Shannon's Mathematical Theory is an adequate if idealised description.

The Meme as Attractor

It is equally clear that rational memes belong in a different region of communication from memes such as the *Mona Lisa*, the ceiling of the Sistine Chapel, Jackson Pollock's *Blue Poles* and the late paintings of Mark Rothko. Works of art may or may not distribute information – the Sistine Chapel ceiling plainly distributes more information than *Blue Poles* – but that is patently not their main function. Works of art deliver their primary cultural value as attractors. Attractors bind meaning rather than distribute it, their value is implicated in their physical presence, they communicate with *us* when we bond, or couple, or identify sensorily and psychologically with *them*. They are cognitively 'sticky'. They produce a form of meaning which is certainly not strictly rational in the sense of Aristotle, Boole and Shannon, but which is substantive in another sense. I propose the term 'relational' meaning for non-empty communication with an attractor. The field of relational meaning extends upwards from the bonding of the chick with the hen to the bonding of the child with the rag-doll, and upwards again to embrace the inexhaustibly complex Sistine Chapel ceiling – and the inexhaustibly aleatory *Blue Poles*. It also clearly embraces movies, movie-stars, celebrities, soaps ... football matches, rock concerts, life-styles and shopping malls. The memes of art only occupy one small, privileged region of the great 'ocean of attraction' of contemporary mass culture.

By Way of Prigogine

The notion of the semantic attractor seems to have been utterly foreign to Shannon's mind. But if communication after Shannon can replicate the idiom of thermo-dynamics, then thermo-dynamics certainly has something to tell us about the nature of communication – more at present, I believe, than chaos theory.

In his *Thermodynamics of Irreversible Process* (Prigogine, 1955, p. 83), Ilya Prigogine discusses the stability of stationary states in systems far from equilibrium.

> When a system is in a state of minimum entropy production then... it cannot leave this state by a spontaneous irreversible change. If, a result of some fluctuation, it deviates slightly from this state, internal changes will take place and bring the system back to its initial state, which may be referred to as a stable state; the transformations which occur in such a state may be called stable transformations (ibid).

173

Prigogine then went on to represent entropy production going on in a spontaneously self-regulating system such as a biological organism

> It is clear that a positive entropy production [the diS/dt due to the closed processes of the system] has to be compensated for by a negative flow of entropy [the deS/dt from its open processes] in such a way that the total time variation of the entropy [dS/dt] is zero.

$$dS/dt = d_iS/dt + d_eS/dt = 0 \quad \text{(ibid)}$$

Thanks to Shannon, Prigogine's equation, albeit formally modeling a thermodynamic process, can equally be taken as a model for a unit of communication in which equal amounts of information and entropy spontaneously balance out to zero.

$$H_{\text{information}} \equiv -H_{\text{entropy}}$$

– therefore

$$H_{\text{information}} - H_{\text{entropy}} = 0$$

From a semantic point of view what we have here is a condensed representation – an emblem – of the characteristics of the attracting meme. Spontaneity, equilibrium, implicated meaning, the juxtaposition of opposites, autonomy – all these are values classically – though not exclusively – associated with aesthetic attractors. The systematic juxtaposition of figural signal and noise which is the characteristic visual 'signature' of pre-Western/primitive art directly replicates the cross-saturated dynamics of Prigogine's stationary state equation.

It is initially more difficult to align the Prigogine equation with the perfectly organised 'noiseless' complexity in 3-D space of the traditional Western closed image. But here once again Shannon can be prayed in aid. The Capacity Theorem already quoted contains the provision that should the information H in the message exceed the capacity C of the channel, the surplus information will 'read out' as noise in the channel output. From the slope of the accompanying graph for the entropy-increase it is be inferred that the noise may also be equalised with the signal. By pragmatically overloading the optic system, it seems, the Old Masters in effect 'hid' the attractor subliminally 'within' the vector – a source of much interpretative confusion in figural art ever since!

The 'binding' of meaning must be assumed to come about when the art-user calibrates their negative and positive entropy-flows ('thoughts' and 'emotions') to those of the image itself, allowing the processes of the conscious mind to be captured in an analogous cycle of stable transformations – the experience of a stable 'truth' in its relational form. Effectively the art-image (in this respect an adult version of the child's rag-doll) leverages the production of relational meaning in the observer's mind.

The Meme as Dual Organisation

This is not to say communication as represented by Prigogine supplants or negates communication as represented by Shannon. It is rather the case that we must think of the meme, our fundamental quantum of communication, as possessing the quality which Levi-Strauss called 'dual organisation'. Like the quantum of action, a state of energetic potentiality which when collapsed becomes either a particle or a wave, the meme is a quantum of meaning with the potentiality of becoming either a vector (information > entropy) or an attractor (information = entropy) – or in the much more complex universe of human communication, some weighted combination of both.

Weighting the Meme

It is the way that the meme is weighted towards rational or relational meaning that seems finally to enable us to distinguish conceptually between the memes of art and the memes of mass culture. In the memes of mass culture, the attractor is characteristically subordinate to some vector of rational interest. Attractors oil the wheels of human discourse and leverage the modern economy. Attractors drive ratings, sales, profits, votes, memberships, followings, fame. But ratings, sales, profits, votes, etc, are in themselves rational rather than relational objectives, and in the domain of mass culture, relational attractors ultimately live or die by their success or failure in delivering for the rational vector.

Vive la Différence

Here finally is where art asserts its difference. In art the rational vector, if it is present at all (it is present in figural but not in abstract art), is canonically subordinate to the attractor. Thus for instance the traditional reclining nude in the artist's studio is a rational vector subordinated to the purpose of producing an aesthetic attractor. Art's special exposure to the priorities of the attractor over the vector may help to explain why it continues to compel attention, whether its memes at a given point in historical time happen to be 'closed' or 'open'. Only in art is the attracting meme allowed its full cultural pre-eminence. Better understanding of the attracting meme may in turn allow art to move forward.

References

Dawkins, R. 1976. *The Selfish Gene* Oxford: University Press, p. 206

Prigogine, I. 1955. *Thermodynamics of Irreversible Process*. New York: Interscience Publishers, p. 83

Shannon C.E & Weaver, W. 1949. *The Mathematical Theory of Communication*. Illinois: University of Illinois Press, p. 50

Nicholas Tresilian F.R.S.A is an art-historian, broadcaster and director of the media company GWR Group plc for which he has developed radio networks in Central Europe.

Geo-Aesthetics of Quasi-Objects

Milan Jaros

From Cosmos to Nature

For Aristotle the Cosmos was a purposeful unity of things, gods and humans, a grand organism at equilibrium. However, after centuries of scholastic speculations the credibility of the claim that there is an omniscient external law became seriously undermined. Since this law is God's law, man can free himself only if he takes His place. Galileo separated humans from things, from nature. The intellectual intuition of the Greeks was replaced by sensory perception. In order to reconcile philosophy and Galilean science Kant divided the world into two realms, phenomenal and noumenal. Knowledge is the knowledge of phenomena, the domain of Pure Reason. It requires a priori forms of perception of time and space. What cannot be present in time and space, the beginning of time, god, freedom, belongs to the realm of Ideas. These are thoughts that do not have presentations. They are thinkable but unknowable. In Critique of Practical Reason the Ideas acquire a positive content via the moral law. For any actualization of the theoretical necessity of individual freedom to take place there must be a connection between them. This connection is developed in the Critique of Judgement. In it Kant considers reflective judgements (aesthetics), i.e. when the particular is given and the aim is to find the universal. However, Kant's morality and beauty remain only a potentiality. For if one knew, for example, how to be moral then morality would be the object of science! However, we can still use Ideas as regulative principles. Although we do not comprehend moral commands it is sufficient to comprehend their incomprehensibility. Because the unknowability of the moral law is known it orients human actions.

The laws of physics (e.g. Newton's laws of motion) are not universal (i.e. there is 'motion' that is not correctly described by Newtonian mechanics). Indeed, no system of knowledge is universal in the sense of the Critique of Pure Reason. Furthermore, the advent of genetic engineering, networking, and nanotechnology invading human organs offer ample evidence that the technoscience of the late 20th century radically altered the material condition of humanity and rendered the assumptions (e.g. of universality and autonomy) legitimating Kantian modernity inadequate. Nature lost the status of a neutral referent. Any knowledge system has always only a finite (bounded) domain of applicability! The world of 'things' became inseparable from the way humans 'experience' things (e.g. Rabinow, 1992).

Geo-philosophy of Quasi-Objects

Deleuze and Guattari (hereafter referred to as D&G) put forward a new vocabulary that provides a working alternative to the language of Kant's Critiques. For D&G subject and object is 'poor approximation' to thought; 'thinking is neither a line drawn between subject and object ...thinking takes place in the relationship between the territory and the earth'. (D&G, 1994). The textual analysis and the analytic tradition in philosophy both belong to

the last stage of the critical tradition grounded in the (Newtonian) temporal metaphors. The Deleuzian intervention turns to novel 'spatial' metaphors ('territory'). This is a move from text to territory (Bogue, 1997). Mapping avoids specifying subjects and objects, and how they interact. It is about pathways, not about cause and effect. The unconscious is a rhizome of 'machinic interactions through which we are articulated to the system of force and power surrounding us.' '...today nature has become inseparable from culture' (Bosteels, 1998). This cartography requires a view of incorporeal events that are neither given in advance as in Newtonian science nor generalized after the observation or application of laws of nature to data. It is neither deductive nor inductive. Experiment is now a world (quasi-object) creating event, not a disinterested (autonomous) application of universal (a priori) laws! The map 'expresses the identity of a journey, and what one journeys through' (ibid, p.167). It 'engenders the territory' in question.

Registration of Quasi-Objects

What 'is' a thing today? This is no longer just an academic topic but also a problem of practical significance, for example, in space management (e.g. Soja, 1996) and computer science. When is a program a thing? For example, how is it to be patented? Smith (1996) proposes to address the problem by turning to the 'machinic' language of D&G. He introduces a dynamic definition of objectness and intentionality via the concept of registration: 'We should not think about what it is to be an object but what it is to act, ... or be treated as an object'.

Intentionality will be reconstructed not in terms of 'meaning' but in terms of 'being meaningful'. Registration means 'to find there, to be a certain way, to carve the world into.' For example, there is a table over there. It means: the overall situation of the 'world was such as to sustain the truth ... of the intentional act of there being a table' (ibid, p.194). An object cannot be object 'on its own'. Registration amounts to moving from 'knowledge' to 'knowing something'. One has to work in order that an object (e.g. a garden) remains the kind of thing it is! Hence physics is just one registration of the world, namely one in which objects are eliminated e.g. in a Galilean manner. Smith gives an example. One receives two copies of (the same) book; one comes from a friend and the other from a foe. It matters how the book was registered. They can only be thought identical!

It has been recognized that the most difficult problem for Deleuzian theory of culture, and material culture in particular, is 'how to express (record, communicate) the coming into itself of a fragmented or quasi-object' (Buchanan, 1997). Registration is a way of grounding the Deleuzian reappraisal of human finitude. In the act of registration the idealized Galilean 'state of things' meets (is projected upon) the (quasi-local) boundary conditions which turn it into an event (bring it into the world). The real reappears via (dynamics of) registration in the shape of act-objects. The act of registration then amounts to specifying a (finite) set of parameters and boundary (spatial and temporal) conditions accounting for the given state of matter and its evolution and makes it amenable for communication. The Kantian 'representations' become 'actualized' (assigned material and temporal finitude) in the (multiple and contingent act(s) of) 'measurement'. The transition from one registration to another can now be identified and recorded in terms of a 'transformation matrix'. This matrix is a scheme, an 'operator' to take us from one set of

'parameters' or 'variables' to another, from one 'territory' to another. It has a meaning on its own (e.g. as a set of multidimensional matching relations or an 'order parameter'), outside of any 'calculations'. Now, of course, the theorist is herself 'part' of the boundary markings.

Passagen 2000: Journeys-As-Act-Objects

In his Passagen project of the late 1930s Walter Benjamin (1999) makes a generic move to escape Kantian and Hegelian Universal History. He sets out to account for the shift in the material condition of humanity in the course of capitalist modernity, i.e. between 17th and 19th centuries. Benjamin's method is to assemble a graphic (visual, material) representation of 'truth' in which material images make visible the philosophical concepts underlying them. He wants to demonstrate the multiple meanings such concepts acquire (presence in many different domains of material life) that previously were held to be autonomous. His Passagen becomes a material counterpoint to abstract projects like Heidegger's whose chief aim was to oppose the Kantian distinction between nature and history.

For Benjamin the characteristic feature of modernity has been systematic destruction of traditional bonds and narratives grounding the intuitive notion of order. He chose the 19th century Paris as his empirical domain in which to show how this slaughter has taken place. Instead of Hegelian continuity and linear causal chains on which to hang meta-narratives he finds artefacts coexisting as fragments as if scattered by a giant explosion across the sacred Parisian ground. He uses allegory to join the isolated fragments of reality. In his collection of artefacts individual fragments which retained 'old' meaning (ornaments, etc) are stitched together along crossing lines, in a web like discontinuous pattern.

Benjamin's aim is not, however, Heideggerian debunking of technoscience. Nor does he anticipate the unleashing by technology of active, self-organizing and heterogenous bio-matter. He wants to recover under the fragmentary appearance of reality an irreducible material trace of *Ur-history*, of an originary history of signs and bonds. Hidden under the surface mask of Universal History is the trickster of theology animating technology. Behind the phantasmagoria of capitalist progress lie eternal returns. The backbone of his project is the Jungian archetype(s) of capitalist (19th century) modernity. The gambler and the flâneur personify the empty time of bourgeois modernity, the whore personifies the commodity form, the decorative mirrors and interiors consumer subjectivism, mechanical dolls are emblematic of worker's existence, the store cashier is an allegory of the cashbox.

What are the corresponding 'archetypes' today? Where are the equivalents of arcades, promenades, reading rooms? Should we think of flâneurs on the Web, man-made whores, intelligent pianos, human clones full of nanodevices? Since the 1930s whatever was left of the memory of traditional bonds has been fatally weakened by the victorious Capital. Amidst the debris of overlapping fragments laid bare and empty by this slaughter (e.g. Baudrillard, 1996; Danto, 1997) there remain as the only potential source of order the structure formative mechanisms associated with the pseudo-practices mimicking Galilean (linear) and post-Galilean (fractal) mathematisation of the world. The trickster who pulls the strings animating act-object assemblages of today is no longer Benjamin's shaman-theologian playing with 'Ur' or 'baroque' ornaments but a pseudo-mathematician

manipulator-mixer. Indeed, it was repetition (versus rhythm), limit (versus excess), instability (versus metamorphosis), complexity, the approximate, etc. that Omar Calabrese (1992) chose to characterize the 'sign of the time' of today. The visible sign today does not 'represent' a face, a landscape or 'injured body' (a 'thing' out there) recognizable by the 'meaning' granted to it by a place in shared even if fragmented narrative. Nor does it 'represent representation'. Instead it is made so as to put before us whatever brings to life a 'driving engine', a pseudo-formula, prescription, an arrow pointing from of A to B(s). It is also this reference to the type of motion or relation, located at the site of experience, which makes the event recordable and communicable. It creates a (virtual) 'skeleton' on which to 'hang' the 'chaotically attachable' components (garments, roofs, rails, etc.) that give the material meaning to the body of a quasi-object. For example, in the catalogue introducing ABRACADABRA (The Tate Gallery, London, Sept. 1999) it is declared that 'art is ...a territory of exchange', art(efact) that needs to be 'animated'. For instance, the 'territory of exchange' of the 'Loop' – a huge 'sculpture' in the form of the sign of infinity – is 'mapped' by the 'variables' of the principles of 'analogy', 'evolutionary mutations', 'problems of absolute symmetry', in the domain of 'urban lifeworld'. Most of what one 'sees' appears to be interchangeable with other equally powerful 'parts', colours and shapes. If the whole retains certain solidity and encouragement for the visitor to 'enter' it is mainly because of the 'visibility' of the 'virtual machine' or at least a promise of it.

The archetypes of today are best sought not in the shape of contemporary equivalents of whores, flâneurs, and alienated workers populating the arcades of Paris of Napoleon III but as classes of generic ('machinic', 'virtual' or 'real') drivers. Passagen of 2000 AD would then resemble the genome project. The latter amounts to producing a closed book of human 'bio-maps' encapsulating the future and past history of humanity in its bio-being. Accordingly, Passagen 2000 could be conceived as a closed book of maps of 'journeys-as-act-objects'. The results of the genome project take the form of graphic sequences ('maps') of large and small letters representing units of genetic material ('molecules') and their (chemical) relations. Similarly, maps of journeys of act-objects or quasi-objects could be constructed in the form of (multidimensional) diagrams whose coordinates are the variables spanning the event-and-territory in question. However, to ground such mapping it would be necessary to establish links between territories and their defining coordinate-variables and boundary conditions. The role of such 'transmission matrices' would be that of the genetic code and equations describing the link between the chemical composition of the molecular sequences 'grounding' the genome programme.

Conclusions

The 20th century science gave humans the power to make heterogenous 'artefacts'. The objective is never completely closed. We have been 'doing away with the analysis of (Galilean) subjectivity' (Jameson, 1994). This leads to 'territorialization' of knowledge. When the Galilean separation of minds and things is relaxed experimentation 'creates' quasi-objects that constitute themselves 'as world'. Instead of static 'autonomous' objects it is more profitable to consider objectness as a dynamic capacity to be affected and affecting. This notion restores directionality to the sites of making and connecting. It is this directionality that the Kantian Critiques took away and transferred it into the

transcendental positing mind. The Kantian 'as if' can now at best apply to the constitutive dynamic relations of assemblage-like units. It is one of the outstanding challenges for creative thought today to develop this dynamic vocabulary further and furnish humanity with constitutive 'knowledge maps' spanning the 'order parameter space' in a manner analogous to the maps of bio-being of the genome project.

References

Baudrillard, J. 1996. *The Perfect Crime*. Trans. Turner, C. London: Verso.

Bogue, D. 1997. Art and Territory. *The South Atlantic Quarterly* 96:3, pp. 466–82

Bosteels, B. 1998. From Text to Territory. In *Deleuze and Guattari*, Eds. Kaufman, E. and Heller, K.J. Minneapolis: Univ. of Minnesota Press, p. 156

Benjamin, W. 1999. *The Arcades Project*. Trans. Eiland, H. and McLaughlin, K. Cambridge: Harvard U.P.

Buchanan, I. 1998. Deleuze and Cultural Studies. *The South Atlantic Quarterly* 98:3, p. 486

Calabrese, O. 1992. *Neo-baroque: a Sign of the Times*. Princeton: Princeton U.P.

Danto, A. C. 1997. *After the End of Art*. Princeton: Princeton U.P.

Deleuze, G. and Guattari, F. 1994. *What is Philosophy?* Trans. Tomlinson, H. and Burchell, G. New York: Columbia U.P., p. 85

Jameson, F. 1994. *Seeds of Time*. New York:Columbia, p. 38

Rabinow, P. 1992. Artificiality and Enlightenment: From Sociobiology to Biosociality, in *Incorporations*. Eds. Crary, J. and Kwinter, S. New York: MIT Press, pp. 234–252

Smith, B. C. 1996. *On the Origin of Objects*. Cambridge: MIT Press, p. 36

Soja, E.W. 1996. *Thirdspace*. Oxford: Blackwell.

Milan Jaros is Professor of Theoretical Physics and Director of the Centre for Research in Knowledge Science and Society at Newcastle University, Newcastle upon Tyne, UK.

A Quantum Mechanical model of Consciousness

John Cowley

Human consciousness appears to involve the almost instantaneous (atemporal) integration of a myriad elements of sensory data into such holistic phenomena as colour appreciation, tune recognition and concept development, collectively referred to as qualia (Marshal, 1989). It is generally accepted (Gilman et al, 1987), that such cognitive integration is related to the extra cellular current flow produced by the summated post synaptic potentials in synchronously active pyramidal cells of the cerebral cortex (neural integration). Experimentally controlled changes in cognitive activity appear to be directly related to (in temporal synchrony with) the patterns of electrical activity recorded at the surface of the brain by an electroencephalogram (EEG).

Investigating what initiates (sustains and disrupts) temporal synchrony and induces coherent neural activity, is one of the major themes evident in current research into consciousness. Several researchers (Hameroff and Penrose, 1996) suggest that the

existence of a quantum coherent state within the brain would provide a mechanism for coherent neural activity and the instantaneous integration of sensory data. Supporters of the Copenhagen/von Neumann-Wigner quantum theory (Stapp, 2000) suggest that our conscious thoughts have no logical place within classical physical theory. According to Stapp, our universe could be considered as having an 'informational' structure, rather than consisting of 'rock-like' particles.

The electromagnetic wave model of consciousness (EMW) and the universe

Using increasingly more powerful particle accelerators to collide particles into each other seems to produce an ever increasing array of smaller particles with 'strange' names and unusual properties (Gell-Mann, 1994). Since nuclear energy has demonstrated the reality of Einstein's classic equation $e = mc^2$, it follows quite logically that all such particles are linked by mass/energy relationships. Particles could be described quite simply as 'parcels' of energy. At the classical level, the universe is the complex and highly structured whole which represents the 'sum' of all its mass/energy. However, according to the precepts of quantum mechanics, this sum is far from being a simple addition of the constituent parts. To understand this more clearly it is necessary to examine the nature of individual particles such as electrons and photons.

According to EMW, electrons are 'wormholes' in space connecting the quantum level to the classical level. At the classical level electrons may be considered as the building blocks of all matter, and protons, neutrons and all their constituent quarks are merely electrons in 'disguise' (Phipps, 1986). Photons are quantum level objects whose production at the classical level is closely associated with changes to the energy levels of electrons. At the quantum level, electrons are energy outlets which 'condense' energy to a point at the classical end of the wormhole.

At the quantum level time is symmetrical, past and present have no meaning and time reversal is possible. Quantum dimensions are measured on the Planck scale (10-33cm, 10-43sec), the irreducible dimension of position space which encompasses the entire Universe. At the quantum level all is potential, nothing is 'real' in the classical sense, nothing is 'alive' in the classical sense and yet in a quantum sense, everything, all life, is eternal. How does one explain such an apparent paradox?

EMW suggests that the potential contained at the quantum level is infinite, it has no measure in the classical sense and hence there is no need to theorise additional universes, since they would all be contained within the one Universe. The potential of the quantum level literally bursts through into the classical level through the wormholes that are electrons. The power to burst forth is what we classically refer to as energy. This energy is in effect the 'life' force which brings into being all classical reality, bundles of life energy. Literally everything is alive in the sense that it contains the life force. Living organisms, microbes to humans, are organised to harness this life force in increasingly complex ways and demonstrate the phenomenon we refer to as 'consciousness'.

Life forms, as we know them, are all organised on the same basic plan. They are quantum level 'receivers' able to tune in to quantum information. Deoxyribonucleic acid (DNA) is the complex structure which is ultimately responsible for a living organism's ability to receive and make use of quantum level information and for turning potential for

life into living organisms. Since there is unlimited potential within the quantum level, there is unlimited potential for life forms suited to the different physical conditions existing at the classical level (natural selection). The ultimate question is what is the source of this eternal, immeasurable life force at the quantum level?

The accepted biological viewpoint is one which views all life forms as the expression of genes (segments of DNA), modified by environment (Crick, 1994). Genes contain information on how to build an organism and the environment, internal and external, fine tunes the outcomes. Natural selection favours some genes over others and organisms 'evolve' in response to this test of their fitness. However, this begs the question as to what is the source of the information contained in one's genes? The generally accepted answer to this question is that the particular arrangement of four different chemical bases in the DNA chain (codons), determines the selection and arrangement of amino acids into proteins (flesh) and hence the physical plan of the living organism. But what determines the particular arrangement of chemical bases for different organisms?

According to EMW, DNA is a quantum level receiver which is itself continually being modified by quantum level forces, in order to receive quantum level information which is destined to lead to certain outcomes at the classical level. Since at the quantum level time is symmetrical and past and present have no meaning, one of the major differences between the quantum level (the source of information) and the classical level (the outworking of this information), is that the classical level has an end point, a purpose. It follows logically that the information supplied to the DNA of living organisms has a purpose in time and is therefore not randomly controlled at the classical level. This would seriously challenge our current concepts of evolution in which natural selection modifies DNA on the basis of fitness for survival and reproduction.

What are quantum mechanical waves?

According to deBroglie (Coughlan and Dodd,1991), every particle (and field) within the universe has a quantum mechanical wave function, y (psi). The EMW model suggests that this quantum mechanical wave function (quantum wavefunction) may be considered as a pulse of virtual particles which emanates from every object in the universe. The quantum wavefunction y contains the total information about any object, because virtual particles have the potential to reduce in total (in mass) into classical particles and become the object itself. For smaller particles such as electrons this does happen and helps to explain why electrons appear to jump from one level to another around the nucleus of the atom. Larger particles have very complex quantum waves which could require extraordinary conditions (not impossible) to reduce totally and this may preclude the quantum transportation of large objects. This pulse of virtual particles is theoretically capable of instantaneous travel from any point in the universe to any other. However, an equation developed by de Broglie in 1923, indicates that the velocity of y depends on the relative speed of two objects, 'communicating', at the quantum level: vy = c2/vp (if vp is small, vy appears almost instantaneous).

EMW maintains that consciousness is the phenomenon we associate with the reduction of the wavefunction, the moment when potential becomes actual, when virtual becomes real, when quantum becomes classical. Consciousness overarches the quantum and

classical levels (states) and produces the mental state evidenced by qualia (Chalmers, 1996). It may prove impossible to measure consciousness, since successful attempts to measure the quantum wave function reduces the wave function – the pulse of virtual particles changes (in part) into classical particles. Consciousness could be described as the process by which God communicates with the universe and with man.

The biology of consciousness:

According to EMW, sensory reception and perception at the classical level differs from sensory reception and perception at the quantum level. From the generally accepted viewpoint of classical physics, each human organism is bounded by its own space-time coordinates and everything else (the environment) is made up of particles and fields situated within local space-time (light cone limitation). From the generally accepted viewpoint of biology, sensory reception occurs at the interface between organism and environment and is mediated by specialized receptors (the eye, ear, and so on). Information about the environment (combined with somatosensory information) is transmitted as electrochemical signals to the 'brain' for processing. Electrochemical signals (rate of discharge and temporal patterning) are directed, via synaptic connections between neurons, to predetermined sites within the brain where perception occurs. Temporal coding (Engel et al, 1997) would allow for the multiplexing of information potentially increasing the flexibility of the 'neural net' (Crick, 1994). It has been suggested by some researchers (Baddeley, 1992) that sensory reception combines with recognition of prior learning (memory) stimulating cognitive integration. The transfer of information to memory via the hippocampus may be partly responsible for introducing temporal sequencing and the perception of time (subjective).

At the quantum level, the potential processes involved in 'extra-sensory' reception and perception involve the reduction of the quantum wave function. EMW proposes that any quantum wave function has the potential to synchronize with a quantum field present in the cells of living organisms to form a coherent quantum field of shared information. This shared information field offers many potential choices for the organism to 'select' from. Although it is theoretically possible for all cells in multicellular organisms to form shared quantum fields, neurons have the synaptic connections and the structural complexity (neural architecture) to utilize more of the field's information. Probably only a fraction of the total information contained in a quantum coherent field is utilized by any organism. Selecting information reduces part of the shared quantum information field into a classical state. The reduction of the quantum wave function y may represent a predetermined subconscious 'choice', possibly determined by the 'survival' needs of the organism inherent in the structure of its DNA (RNA in viruses).

Quantum coherent states in microtubules (Penrose, 1994) could be the neurological correlates of consciousness (NCC) by resonating (the writer's terminology), or adjusting phase (again, the writer's terminology) to extract selected information from the quantum wave function. Resonance would simultaneously result in the 'reduction' of substantial numbers of virtual particles into classical particles, thus providing the necessary electrons to 'fuel' the chemical reactions which would then energize the movement of classical electrochemical signals along nerves and across synapses. The electromagnetic wave is

proposed as the default classical state produced on reduction of the wave function y –
hence the electromagnetic wave model of consciousness (EMW).

According to the EMW model, the reduction of the quantum wavefunction y in the
microtubules of neurons could be the trigger for an unconscious response in the brain,
which in turn sets up a pathway for the transfer of classical information. This unconscious
response would precede conscious awareness of having made a decision (selection) in
possible agreement with Libet's research findings (Libet, Gleason, Wright & Pearl, 1983).
Humans would not normally be conscious of the information contained in the quantum
wavefunction, although 'feelings' may well be associated with its collapse (Stapp, 2000)
Under 'exceptional' circumstances the resonance produced in the microtubules could
induce a macro level quantum state within the brain resulting in phenomena such as
precognition and extra-sensory perception. Exceptional circumstances could involve a range
of psychological states involving heightened states of awareness, hypnosis, or trance-like
states induced by drugs, or deep meditation.

The implications of a quantum mechanical model of consciousness

The classical Copenhagen interpretation of quantum mechanics is highly subjective and
observer dependent. It suggests that the collapse of the quantum wave function (the virtual
world) into the world that invades our natural senses (the 'real' world), is determined by an
act of observation (the observer's mind, or before human existence, the mind of God).
Hence, it could be claimed that a quantum mechanical model of consciousness has certain
metaphysical/spiritual implications. Many questions have been raised on the Quantum-
Mind Electronic Forum (quantum-mind@listserv.arizona.edu), regarding a possible
relationship between the quantum wave function and the human soul. The reader may find
the following synopsis of the writer's postings to the forum on this subject stimulating, if
somewhat controversial.

The soul is frequently described in the Bible as a combination of the mind, the emotions
and the will. Since consciousness is strongly linked to the mind (thoughts), the emotions
(the feel of the feel) and the will (making choices), there could be a strong case for linking
consciousness to the biblical concept of soul. It follows that a quantum mechanical model
of consciousness could also link the collapse of the quantum wave function to the
manifestation of the metaphysical/spiritual entity we refer to as the soul. The
electromagnetic wave model of consciousness 'pictures' the soul being manifest at the
interface between quantum and classical where the quantum wave function is at the point
of collapse (continuous present tense).

The soul connects to the body (the brain) as the classical part of the interface by some
yet-to-be-confirmed neural correlate of consciousness (NCC). The Penrose/Hameroff model
suggests orchestrated reduction, dynamically involving quantum gravity and structurally
involving tubulins in the cytoskeleton. The soul is seen to connect directly to the quantum
realm (possibly at the same NCC), because thoughts, emotions and choices are seen to be
quantum mechanical in their nature (they are non local). Maybe God does not 'play dice'
with the universe, but the quantum realm seems to have more in common with His eternal
abode than our earthly one. Maybe if we ask the right questions, God rather than nature
will provide the answers.

References

Baddeley, A. (1992) Working memory. *Science, 255,* 556–559.

Chalmers, D. (1996) *Toward a Theory of Consciousness.* Oxford Press, New York.

Coughlan, G. D., & Dodd, J. E. (1991) *The ideas of particle physics. 2nd Ed.* Cambridge: Cambridge University Press.

Crick, F. (1994). *The astonishing hypothesis: The scientific search for the soul.* New York: Touchstone.

Engel, A.K., Fries, P., Roelfsema, P. R., Konig, P and Singer, W. (1997) *Temporal Binding, Binocular Rivalry, and Consciousness.* Target Article, ASSC Electronic Seminar. WWW.

Gell-Mann, M. (1994) *The Quark and the Jaguar.* W.H. Freeman, New York.

Gilman, S. & Newman, S. W. (1987). *Essentials of Clinical Neuroanatomy and Neurophysiology.* Philadelphia: F. A. Davies Company.

Hameroff, S. & Penrose, R (1996) Conscious events as orchestrated space-time selections. *Journal of Consciousness Studies, 3*(1), 36–53.

Libet, Gleason, Wright & Pearl (1983) Time of conscious intention to act in relation to onset of cerebral activity (Readiness Potential). *Brain, 106,* 623–642.

Marshall, I. N. (1989) Consciousness and Bose-Einstein condensates. *New Ideas in Psychology, 7* (1), 73-83.

Phipps, T. E. (1986) *Heretical Verities: Mathematical Themes in Physical Description.* Classic Non Fiction. Urbana.

Stapp, H.P. (2000) Decoherence and Quantum Theory of Mind: Closing the Gap between Being and Knowing. Cambridge article in Press, February 2000.

John Cowley is currently the principal of Christian College in Wollongong, NSW.

Conceptor: a model of selected consciousness features including emergence of basic speech structures in early childhood

Konrad R. Fialkowski & Boleslaw K. Szymanski

We have proposed that an information-processing machine called conceptor can model some aspects of consciousness. Conceptor was designed as a technical device for information processing (Fialkowski, 1995) that utilizes neither numerical representation (numbers) nor numerical operations (arithmetic), as opposed to computers. It was found to posses some features that may be appropriate for modeling elements of consciousness (Fialkowski, 1999a).

Conceptor is an attribute-based machine that automatically generates concepts from descriptors of a dynamically changing environment. The conceptor is connected to its environment thorough its input that periodically produces a set of descriptors characterizing the current state of the environment. Conceptor's main task is to create, in a solely inductive manner, a coherent and condensed representation of reality (constituting its working environment) that is derived exclusively from observations of that reality. In this

185

approach the concepts are dynamic entities, growing from concept seeds and can be created at any level of the conceptor processing. The conceptor itself establishes connections between related concepts in growth. Both the concepts and the connections are dynamically adjusted by new information from input.

The representation of the environment established in the conceptor can be probed through directives. The result is an 'illumination' of all concepts transitively related to those listed in a directive. The illumination is defined by both the character and strength of the relations. The conceptor design also facilitates conditional directives. The if-directive is the equivalent of a gedanken experiment, answering, for example, a query what would the representation be if two unrelated concepts were equivalent.

The soundness of the proposed approach can be derived inductively from the uniformity of the conceptor processing at all levels and the successful simulation of its lowest level.

An entry point for considering some properties of the conceptor for consciousness modeling was Dennett's (1992, p. 256) statement that: '...cognitive scientists (...) are right to insist that you don't really have a good model of consciousness until you solve the problem of what functions it [the brain] performs and how it performs them – mechanically, without benefit of Mind. As Philip Johnson-Laird puts it, "Any scientific theory of the mind has to treat it as an automaton" (Johnson-Laird, 1983, p. 477). (emphasis added).

The conceptor has been designed as an automaton. The following conceptor's features have been stressed for consciousness modeling (Fialkowski 1999a,b) and later developed by us towards modeling of more advanced consciousness features including, as discussed later here, basic speech structures.

1. According to Dennett (p. 166): '...an element of content becomes conscious (...) not by entering some functionally defined and anatomically located system, but by changing state right where it is: by acquiring some property (...). The idea that consciousness is a *mode of action* of the brain rather than a *subsystem* of the brain has much to recommend it ' (see e.g. Kinsbourne, 1980; Neumann, 1990; Crick and Koch, 1990). (emphasis added). The conceptor offers, as a model, all features suggested by the researchers quoted above. In the conceptor, illumination is a 'mode of action' and may be performed in any part of the network 'by acquiring some property right where it is'.

2. Two researchers: Marr (1982) and Jackendoff (1987) propose three levels of analysis present in the mental phenomenon. Conceptor offers three such levels.

3. If illumination can be treated in terms of 'what the conceptor is conscious of', then the performance of the conceptor is in agreement with both Jackendoff's and Johnson-Lairds's claims that whatever we are conscious of is rather a result of processing than processing itself. Illumination is not processing, but a result of it. Each illumination results from the processing being performed at the lowest level and is a kind of its representation.

4. In the conceptor, initiation of an illumination is performed through activation of one or many own nests, according to the directive executed. This activation procedure reveals some resemblance to the 'searchlight' approach proposed by Crick (1984).

5. The conceptor's architecture at the lowest and the medium level may offer an answer to Dennett's (p. 271) quandary:

...the cortex must be a medium in which unstable connection patterns can rapidly alter these transient contents of the whole 'space' – without, of course, erasing long-term memory in the process. How can these two very different sorts of 'representation' coexist in the same medium at the same time?

In the conceptor the long-term memory is bound to the lowest level and remains unchanged whatever reading request is directed to it. On the other hand, illumination is performed in a short-term memory that is superimposed on the long-term memory. All rapid changes resulting from reading different concepts take place in the short-term memory.

6. The conceptor fulfils Fodor's (1983) requirements for isotropy as any of the things it has learned can contribute to any of the things with which it is currently confronted.
7. The conceptor is an implementation of Treisman's (1988) claim that seeing should be distinguished from identifying. Conceptor's samples are 'separate temporary episodic representations' (as Treisman put it). They are a 'preamble' for identifying an object (concept).
8. In the conceptor, (as Dennett, p. 277, put it): 'Simple or overlearned tasks (...) can be routinely executed without the enlistment of extra forces, and hence unconsciously...).' Conceptor offers processing possibilities for such tasks without invoking any reference to its knowledge base.

Apart from the discussed above aspects of the conceptor's modeling potential further research indicated new possibilities yielded by a functional unit of the machine called non-numerical correlator. It was designed for identification of time correlations between different concepts. In that instance, the following procedure is applied:

For any concept A selected for the identification of a correlated time pattern, all samples preceding the concept until a certain time horizon are taken from input short-term memory and memorized in the correlator for the analysis. It is to be noted that the time factor is implicitly incorporated in the samples as they are memorized in the same sequence as their input into the conceptor. When the selected concept A appears in the conceptor for the second time, the samples preceding A in the second appearance are merged with the samples of the first appearance of concept A. Their merger, however, is specific. In the merged samples, the samples closest to each other are those that originated in similar time spans before occurrence of each A, i.e. those two that have appeared just before the first and the second occurrences of the concept A, preceded by the two samples that occurred the moment before, and so on. After at least three such mergers, an automatic search for a pattern preceding the occurrences of concept A may begin. For the three occurrences of concept A, all subsets of the descriptors from the preceding samples that occurred three times could be considered concepts and/or descriptors correlated with concept A. They are memorized together with their original time layout derived from the merged samples. The pattern so identified is verified in the same way with each new occurrence of concept A (i.e. the processing takes place for four merged samples, for five of them, and so on).

The method is a remote analog of the detection of a signal from below the noise level. With the increase in the number of merged samples, some patterns that only sometimes precede A may be also detected through a higher than average presence in the merged sample.

In the simplest case the pattern could be a concept B preceding A. Then one could adopt the hypothesis that B is a cause for A. This hypothesis could be considered valid as long as the occurrences of B are close to A.

Generally a pattern correlated with a concept is a 'story' involving a time display of many concepts.

In particular, a statement of a relation between concepts B and A established by the correlator and memorized constitutes a basic element of the conceptor's representation. It may be considered as a phrase in a simple internal conceptor's language. If the conceptor were exposed to speech learning, what we would need to change in its processing?

Elements of speech come from the environment in the form of acoustic signals. Referring to the conceptor's processing modalities (Fialkowski 1995, 1999a) the appropriately coded acoustic signals are processed like other sensory information, i.e. they could establish their own nests at the sensory level after at least three repetitions. When being 'thought of' (in the conceptor framework this means a generation of the identifier on request) in parallel to the sensory nests, token nests would be established for them. In the process of teaching and as a result thereof, these token concepts would be structurally connected (e.g. with 'part of' relation asserted) to those concepts that were target objects in the teaching process. In this context speech is a 'supplier of token concepts' that may be subsequently used as proxies for other concepts, as well as become names of concepts derived from the processing of token concepts. We found that such concepts without any internal structures had been proposed by Fodor (1998, p.121) in his conceptual atomism approach.

Provided that sentences of spoken, natural language reflect the results of internal processing of information, the conceptor would have an 'innate' ability to produce phrases of the following structure:

"token concept B' " – "token concept of relation R' " / "token concept of A' ".

i.e. a word representing B bound (denoted by "–") to a word representing an action R; those two related (denoted by "/") to a word representing A.

The 'passive form' should be emphasized by the conceptor in its language productions as the concept reflecting the result of an action is a focal point and may record many causes of this action (many token concepts of type A'). Moreover, B' and R' may (but do not have to) be represented by one token concept. Thus, in the conceptor framework,

a basic syntactic construction is not necessarily an independent faculty of speech (or natural language) but may result from the mode of the internal information representation in the brain.

The construction is common for internal records and is context-independent. It is a

mechanism for pre-pairing syntactic properties with their semantic correlates discussed, for example, by Pinker (1984, p. 41). The mechanism for pre-pairing, however, is the feature of consciousness representation and not a part of speech acquisition mechanism. Hence, speech acquisition mechanism acts on the pre-paired representation in order to establish a vocal expression for already internally existing pattern.

It implies, however, that prior to speech there must have been a language-oriented modus operandi in brain. The idea has its origins in Chomsky's view of the existence of a template for the grammar of all human languages, a view shared by other researchers including one of us (Fialkowski 1994a, b).

It also implies that during child development, acquisition of speech should follow, or at least should be concurrent with, emergence of consciousness (as presented by Macphail, 1998). Even though the, common construction of the internal records of token concepts is innate, concrete word constructions are the result of a conscious process. (In the conceptor it is invoking concepts to the internal scene on request.) Thus, according to the model provided by conceptor, speech constructions cannot precede emergence of consciousness during a child development.

References

Crick F. 1984. Function of the Thalamic Reticular Complex: The Searchlight Hypothesis. *Proceedings of the National Academy of Science, 81*, pp. 4586–90.

Crick F. and Koch C. 1990. Towards a Neurobiological Theory of Consciousness. *Seminars in the Neurosciences*, pp. 263–275.

Dennett D. C. 1992. *Consciousness Explained.* Allen Lane the Penguin Press.

Fialkowski K. R. 1994a. On the Evolution of Language, Current Anthropology, 35, pp. 445–448.

Fialkowski K. R. 1994b. Preadaptation to Language and Speech: a three phase scenario, *Social Neuroscience Bulletin, 7*, pp. 31–35.

Fialkowski K. R. 1995. A Conceptor: an Idea and a Design Philosophy, *Archiwum Informatyki Teoretycznej i Stosowanej* (Archives of Theoretical and Applied Computer Science), 7; pp. 193–210 (in English).

Fialkowski K. R. 1999a. Conceptor – towards a modelling of consciousness, Dept. of Computer Science, RPI, Technical Report No. 99 – 4.

Fialkowski K. R. 1999b. Conceptor – a step towards a modelling of consciousness? Tokyo '99 Conference: Toward a Science of Consciousness Fundamental Approaches, May 25–28.

Fodor J. 1983. *The Modularity of Mind.* Cambridge MA: MIT Press/A Bradford Book.

Fodor J. 1998. *Concept; Where Cognitive Science Went Wrong* Clarendon Press.

Jackendoff R. 1987. *Consciousness and the Computational Mind.* Cambridge MA: MIT Press/A Brandford Book.

Johnson-Laird P. 1983. *Mental Models: Towards a Cognitive Science of Language, Inference and Consciousness.* Cambridge: Cambridge University Press.

Kinsbourne M. 1980. *Brain-based Limitations of Mind, Body and Mind: Past, Present and Future.* ed. R. W. Rieber, , New York: Academic Press, pp. 155–175.

Macphail E. M. 1998. *The Evolution of Consciousness*, Oxford University Press.

Marr D. 1982. *Vision..* San Francisco: Freeman.

Neumann O. 1990. Some Aspects of Phenomenal Consciousness and Their Possible Functional Correlates presented at the conference 'The Phenomenal Mind – How Is It Possible and Why Is It Necessary?' Zentrum fuer Interdisciplinaere Forschung, Bilfeld, Germany, May 14–17.

Pinker S. 1984. *Language Learnability and Language Development*, MIT Press.

Treisman A. 1988. Features and Objects: The Fourteen Bartlett Memorial Lecture, *Quarterly Journal of Experimental Psychology, 40A*, pp. 201–237.

Rensselaer Polytechnic Institute, Troy, NY, USA.

The Twin-data-stream Theory of Consciousness

Paul Ableman

This article is predicated on the idea that consciousness is a definable attribute with specific characteristics that can be described theoretically and demonstrated by laboratory experiments. It also proposes that consciousness is unitary and is essentially the same in all forms of animal life, from at least the level of unicellular organisms to that of human beings. The consciousness of human beings, however, has a unique characteristic which is responsible for the immense differences in kind and significance between human consciousness and that of all other animals. Because of this characteristic, in one crucial aspect, the gap between the consciousness of an amoeba and a gorilla is less than that between the consciousness of a gorilla and of a human being. The relevant characteristic is, of course, language.

I am unable to include in this paper any reports of laboratory tests since none have, as yet, been performed. I should also state that I am not a scientist by either training or practice, although I am keenly interested in science. I am, however, a professional writer and my theory proposes that human consciousness is not merely dependent upon, but actually constructed from, language. My twin-data-stream theory is expounded in some detail in my book, *The Secret of Consciousness* (1999). In a brief article such as this I will only be able to touch on its essentials.

According to the theory, consciousness is the turbulent meeting of two continual and pulsed streams of data. The first of these streams channels into the brain all the data available to the organism that can be derived from sensory and proprioceptive monitoring. On entering the brain this stream is split into three identical sub-streams. One of these impacts directly on consciousness, one on the archival memory – which is the name I have conferred on the dynamic store containing all past data derived from monitoring – and one on a short term memory lasting approximately sixteen hours, which is roughly the waking period between major sleep episodes.

The second master data stream derives from the impact of the first stream on the archival memory. This evokes a complementary stream of relevant guidance data from past experience by means of a transponder-like mechanism. The process is completely automatic and continuous when the organism is awake. In both animals and humans, the meeting of the data stream from environmental and proprioceptive monitoring with the data stream from the archival memory is in fact consciousness. It is important to stress that the data collision does not generate consciousness but is itself consciousness. The purpose of this

mechanism, devised initially by and for unicellular organisms in accordance with the classic Darwinian evolutionary sifting processes, is to employ the knowledge that the organism has gained from past experience in order to provide guidance in the present and thus enhance the animal's ability to inhabit the future.

The frequency of mind or consciousness generation is approximately 10 cycles per second – that of the alpha wave of the electroencephalogram. An encephalographic tracing is in fact a graphic representation of the power surges required for the generation of human or animal consciousness. The stream or cloud of data evoked from the archival memory by the impact of the environmental monitoring stream is filtered through a cascade of screens which remove all but the most immediately relevant constituents. Each burst of data evoked from the archival memory every tenth of a second may contain hundreds of thousands of what I call data particles or *sensons*. However, considerations of disposable time suggest that perhaps only as small a quantity as one-thousandth of one percent of this data actually passes through the screens and becomes mind.

The fact that consciousness, in both human and animals, is not continuous but pulsed is responsible, in humans, for phenomena varying from epilepsy to the ability to view film and television as continuous narrative. The major significance of this is to shift conceptual emphasis in the study of consciousness from the dimension of space to that of time. In virtually all studies of the mind the underlying assumption is that, like the brain, it is a more or less static entity. This is because the brain has traditionally been seen as an organ analogous to the liver or the heart. But while most of the organs of the body are essentially mechanical devices, such as pumps and filters, the brain is an electro-chemical processor, and its product, which is the mind, is pulsed, dynamic and hence essentially more temporal than spatial. I refer in this paper to the ceaseless meetings of complex data flows as if they occurred at a few specific loci, but this is simply a device to maximize conceptual clarity. The actual loci will, of course, consist of single cells, or small clusters of them, located at innumerable sites throughout the cerebro-neural system. At these sites neuronal impulses perpetually fuse to generate fractional components of the global, but distributed phenomenon which is consciousness.

If my twin-data-theory can be proved, it seems inevitable that the study of brain anatomy will increasingly be concerned with determining how the brain can initiate and harmonize huge numbers of complex flows of data deriving from different neuro-cerebral regions to meetings that must occur, with temporal tolerances of only a few milliseconds. Indeed the twin-data stream theory proposes that time and consciousness are so interlocked that if either of the main data streams that generate consciousness is impeded the brain will begin to malfunction and this process may proceed to the death of the organism.

When sleep begins consciousness ceases. The mind is switched off and the brain becomes an automatic electro-chemical processor operating without any conscious supervision. In sleep, there is no longer any executive authority left in the body. In place of its diurnal task of generating consciousness the brain is now totally occupied in filing and cross-referencing the entire sensory input of the preceding waking period. This data has been held in the short-term memory and is now reactivated for permanent storage in the archival memory. REM sleep is a visible demonstration of this process. The movements of the eyeballs are recapitulating, although at a faster rate, all the movements they made

throughout the preceding waking period. To give an adequate indication of the brain's nocturnal task, in a much abbreviated form, it is perhaps best to use a metaphor: the nocturnal brain may be likened to that of a great library given the task each night not only of housing hundreds of thousands of new volumes but also of cross-referencing these additions amongst the thousands of millions of existing books and finally of reorganizing the full range of storage and cataloguing facilities of the entire institution in order to provide users with easier and more rapid access to information.

Every animal, including man, awakens each morning with a new mind. Much of it will, of course, have been relatively unaffected by nocturnal processing but all of it will have been changed to some extent. A confirmation of this astonishing fact can be found in the unexplained observation that memories are often sharper and more comprehensive on the day after remembered events occurred than on the same day. This is because by then the nocturnal brain will have processed them into many loci and thus made them more accessible.

Dreams are byproducts of the nocturnal processing activity of the brain. They are glimpses obtained by returning consciousness of the filing and cross-referencing activity of the nocturnal brain. Sadly they have no inherent significance and are of no, or only indirect, value as aids to the diagnosis of mental states. A dream is an interaction between the unconscious data processing activity of the nocturnal brain and the diurnal reanimation of consciousness on awakening. It is therefore pointless to speculate as to whether a person dreams even when unaware of the dream. The awareness is the dream.

The difference between an animal mind and a human mind is the difference between simple and complex consciousness. The human mind consists of simple consciousness fused with self-consciousness and is thus complex. Self-consciousness is wholly and exclusively the product of language. It is impossible for any organism lacking complex syntactical language to be aware of itself. It can only be coextensive with its own instinctual and genetic imperatives. It does not matter how large the animal's brain may be if the species to which it belongs has not achieved true language; the individuals of that species will be unable to deploy self-consciousness. This is because sensory impressions alone cannot make possible conceptual separation of a mind from the rest of the universe. This can only be achieved with language. It is unlikely, therefore, that even large-brained animals such as dolphins or elephants can have more true self-consciousness than amoebas.

A human being is not, however, merely an animal that uses language in the sense that certain animals other than man use primitive tools. This is because the use of tools and the use of language are not true analogues. A chimpanzee using a termite twig and a chimpanzee not so engaged are in all essentials the same being. A human being using language is a fundamentally different kind of entity from any non-linguistic animal. This difference can be highlighted by stating that the concept of an animal using language is a contradiction that leads to a classic infinite regress. In order to use and understand language the animal would need to be already in possession of language. We may mention Wittgenstein's observation that if a lion could speak we would not be able to understand it. In reality, we would be able to understand it without much difficulty but it would no longer be a lion. What we cannot understand, because it has no semantic content, is the roar of a lion. The only viable definition of a human being therefore is 'the language component of

an animal capable of deploying language'. In other words we must confront the challenging concept that human beings do not use language. They are language.

A human being is a verbal entity continually assembled and reassembled (probably at a frequency of ten manifestations per second) in the neural tissue of what, without its presence, would be an animal lacking self-consciousness. However, this assertion does not imply that a human being's mind is materially different from an animal's mind. The brains of both human beings and animals are precisely the same kind of electro-chemical processor. No scanning system yet devised could detect the difference conferred by language upon the neuro-cerebral system of an animal. And yet the physically undetectable linguistic entity, which is represented on this planet exclusively by the human species, represents what is probably the most significant development in the evolution of life since the original transition from non-sentient to living matter.

My twin-data-stream theory is radical but self-consistent. It maintains that a human being is not a substantial or even continuous entity but a linguistic one. This linguistic entity is actually switched off for a third of the animal's life-span. It is, moreover, generated at a particular frequency (probably ten or twelve cycles per second) in a way analogous to a film passing through a motion picture projector. I find this is a disturbing concept, and doubtless others will feel the same. What evidence do I have that the theory is scientifically sound?

The most important is a datum I cannot claim as evidence since it had already been published at the time I predicted it although I was not aware of the fact. I claim in my book that it would go a long way towards substantiating my theory if some analogy to REM sleep could be found in another sense organ. I specified the inner ear as a possible site. I have since discovered that inner ear twitches fitting the necessary criteria have been located and remain unexplained. Needless to say this phenomenon bolsters my belief in the validity of my subjective researches very considerably. But in addition my theory provides what at least seem to be highly plausible explanations for quite a few strange observations for which brain scientists have as yet found no answer. I have space here to mention only a few.

On the cover of my book is a painting by the artist Isia Leviant showing blue rings on an optically complex disc and appropriately called Enigma. Most people seem to see the blue rings spinning round. Professor Semir Zeki, one of the most prominent workers in the field of the optical properties of the brain, concedes that science has no explanation for this phenomenon. My theory states that it is the product of strobing – the strobing of mind generation inside the skull rather than of a flashing light source outside it.

It is known that sufferers from Korsakov Syndrome are afflicted by a double deficit of memory. They have virtually no short-term memory and a long-term memory that is stocked only up to the time at which viral disease or alcoholism initiated the Korsakov condition. How are the two facts related? In my theory, when the short-term memory was destroyed it ceased to provide the data necessary for the nocturnal brain to process it into the vast archival memory. Again, infantile amnesia, which puzzles orthodox science, is easily explained by my theory. The infant cannot recall the experience of being a human baby because it never was a human baby. It was only a pre-linguistic animal incapable of generating verbal data which is the only kind susceptible to later conscious recall.

Although I could mention perhaps a dozen significant phenomena for which science

has as yet no convincing explanation but which are explicable in terms of the twin-data-stream theory of consciousness, I will specify just one more. It is known that human beings blind from birth do not have REM sleep. Again science has no explanation but, according to the twin-data-stream theory, it is because the blind do not, and never have, acquired diurnal visual impressions that will then be recapitulated during nocturnal processing.

I mention this last phenomenon because it is relevant to a relatively simple and inexpensive way in which the validity of the twin-data-stream theory could be tested. If a subject's waking eye movements were recorded under controlled conditions it should not be too challenging also to record the REM during the subsequent sleep period and see if the two recordings showed significant correlations.

If the twin-data-stream theory could be validated in would undoubtedly have profound effects on many aspects of human culture and almost certainly lead to improvements in the treatment of certain neuro-cerebral malfunctions including schizophrenia.

Reference

Paul Ableman (1999) *The secret of consciousness: how the brain tells 'the story of me'* London; New York: Marion Boyars.

Kantian Descriptive Metaphysics and Artificial Consciousness

Susan A. J. Stuart and Chris H. Dobbyn

Introduction

Research in Artificial Intelligence (AI), Artificial Life (A-Life) and Cognitive Science has not yet provided answers to any of the most perplexing questions about the mind, such as the nature of consciousness or of the self. In this article we make a suggestion for a new approach.

We begin by setting our project in the broader context of AI, and argue that little recent research really addresses the question of what are the necessary requirements for conscious experience to be possible. Kant does address this question in his transcendental psychology and we believe this approach is worthy of re-examination in the current debate about the mind.

There is a general assumption that if we could produce a conscious system its consciousness would be of a qualitatively different kind from our own. But this assumption, we believe, is symptomatic of the general approach presently employed, in which systems are situated in a world, virtual or actual, whose properties are a given which the system is required to discover. We believe this approach is flawed, and instead propose that, in order to qualify for any form of consciousness, a system would have to instantiate a perceptual and interpretative framework similar to the one which, Kant argues, dictates how we intuit,

order and unify our experience. We state the Kantian paradigm and propose an architecture that would have to be implemented in a conscious artificial system.

Artificial Intelligence and Artificial Consciousness
Research in AI has, until recently, been dominated by two paradigmatic approaches. The first, traditional symbolic AI, is an information processing approach characterised by being serial, rule-governed, symbolic and modular. It assumes that machines can be engineered to emulate particular mental skills, such as natural language processing, by basing the system on a specialised symbolic model of the required activity. The second, a connectionist approach, is characterised by being parallel, non-rule-governed, non-symbolic and distributed. Connectionists do not deny that some aspects of intelligent behaviour are rule-governed; rather they claim that rule-governed behaviour will emerge from low-level, non-symbolic, interactions among simple distributed processing units (Rumelhart & McClelland, 1986). These two approaches have been challenged by roboticists, led by Brooks (1991), who argue that huge areas of intelligent activity, such as obstacle avoidance, will emerge from the interaction of simple modules with specialised sensing and control functions, in robots that interact in real-time with real physical environments.

Consciousness and self-consciousness have never been the central preoccupation of research in AI, but a serious and sustained enquiry into the potential consciousness of an artificial system has come from Aleksander (1996). Firmly in the connectionist camp, and starting from the premise that conscious sensations result from the firing patterns of neurons, Aleksander describes a system, MAGNUS, that he claims may have some of the necessary conditions for self-consciousness. Such a machine requires outer sensory neurons connected to inner neurons whose firing patterns handle perception and perceptual memory, the labeling of inner perceptual states, particularly with temporal tags, and autonomous functions not present to consciousness. These firing states in inner neurons are learnt through a transfer of activity from outer sensory neurons, which is termed 'iconic transfer'. Inner states are sustained through feedback loops, even in the absence of stimulus from outer neurons, giving the system a capacity for prediction and imagination. 'Self-consciousness' can then arise in MAGNUS from feedback between sensory neurons and actuator neurons which leads to inner representations of the machine's own output and the possible effects of such outputs.

We believe MAGNUS contains many of the components we are advocating for the architecture of a self-conscious artificial system. We take this up in a later section.

Kantian Descriptive Metaphysics
In his first *Critique* Kant (1929) details his transcendental psychology in which he sets out the necessary conditions for subjective human experience. In it 'Kant attempts to show what the limiting features must be of any notion of experience which we can make intelligible to ourselves.' (Strawson, 1966, p. 24) It is these 'limiting features' of experience and the intelligibility of their manifestation that we are interested here.

In general Kant argues that there can be inner subjective experience only if there is outer experience – that is, experience of an objective world. And if we examine what in particular is required for experience to be of an objective world, we find that amongst other

things it must be first of all experience of a world of objects structured in space and time. Secondly, it must be a world of objects unified by a universal system of causal relations. This is the basic requirement for conscious human experience, the epistemic conditions of knowledge, and Kant describes it as a *descriptive metaphysic*. 'Metaphysic' because it is true a priori of any experience that it will be intuited, ordered and unified in a particular way, and 'descriptive' because it describes the form experience will take regardless of any particular content.

In our experience of this objective world Kant claims that 'Objects must conform to knowledge'. Kant is not just claiming that our view of the experienced world is mediated by the sort of being we are; rather he is claiming that the nature of our human faculties themselves actually determines that the experienced world must have certain features. We can, therefore, know that the experienced world possesses these features quite apart from any empirical investigation of it. Crucially, we can know *a priori* that our experience of the world will be spatio-temporal, that is, it will consist of a structure of spatio-temporally ordered items which exist independently of anyone's particular awarenesses of them, and which are interconnected by causal laws.

Thus it is a condition of the possibility of any human experience that these things are true of it. Our sensible faculty consists of spatial and temporal intuitions, and our faculty of understanding consists of concepts or categories, rules for ordering and unifying our world. (We mention only the category of causality because Kant picks it out in the Introduction to the Critique (1929) as central to the development of his critical philosophy.)

In the setting out of these a priori forms of intuition and categories of our understanding Brook (1994) takes Kant to be talking about psychological realities of some kind and he suggests '... a reading that takes Kant to be making claims ... about the actual nature and functioning of the mind, not just about some sort of "logically necessary conditions" that may tell us little or nothing about what actually goes on in a mind'. (Brook, 1994, p. 5)

Brook is mostly concerned with awareness of content or with the thing that has this content, and this is a different emphasis to the one offered in this article. We are concerned with providing an account of the necessary minimum requirements for conscious experience. 'Stripped of the jargon of transcendental necessity, what interested (Kant) were the most general constraints on anything that could function as a mind – a mind, at least, that is dependent on sensible input as we are'. (Brook, 1994, p. 5)

Similarly Kitcher says that Kant's 'Transcendental psychology offers an idealization of cognitive functioning; as such, it can provide guidance about the sorts of mental equipment that empirical researchers need to look for.' (Kitcher, 1990, p. 206) We believe with Kitcher that Kant's transcendental psychology provides 'an idealization of cognitive functioning', and as such it is a descriptive metaphysic, but we want to argue further that if we interpret it as a prescriptive metaphysic it becomes normative, allowing us to set out what a mind must be like if it is to reason and know. With this in mind we offer the Kantian paradigm as a prescriptive metaphysic which will permit us to examine the 'actual nature and functioning of the mind'.

We now argue that we need to start at the base level – the intuitional level – developing a system that has an outer sense and an inner sense, and then examine how it will

conceptualise its world. Thus, we need to provide the system with its own descriptive metaphysics; a more fundamental approach than is at present being employed.

Discussion

A number of problems arise from the employment of the Kantian paradigm. We note six – instantiation, 'I'/self, recognition, emergence, reason and imagination – and offer responses to four. Reason and imagination are not addressed.

The main problem is one of instantiation. Kant is setting out a descriptive metaphysics and is not concerned with its physical instantiation. We have overcome this problem by interpreting Kant's metaphysics prescriptively so that we can ask in what way his system might be prescriptive of the psychology of an artificial system.

Kant uses transcendental arguments to delimit the logically necessary conditions for experience, but if a prescriptive approach is adopted the issues become empirical, and we can ask practical questions like (1) What is the basic system requirement for consciousness? and, (2) How different could that system's cognitive repertoire be from our own for it still to be recognisable as conscious? With regard to (1) we need to ask how elastic is the notion of consciousness that we're dealing with; is it human consciousness or some form of reduced consciousness? These two questions can be summed up by 'Where are the boundaries for conscious experience?'

With regard to (2) we find that four kinds of recognition are possible: (i) third person recognition, which is based on the observation of behaviour, and which produces the a posteriori ascription of mental states; (ii) instantiator recognition, which produces the a priori ascription of mental states or, more fundamentally, the form that those states will take; (iii) first person recognition, which would be the reflexive ascription of a mental state, and would be synthetic a priori in Kant's sense; and (iv) conceptual recognition where it is possible to conceive of a system being conscious if a particular set of things are true of it.

If we opt for a prescriptive metaphysics then we could argue that we could not recognise, in the sense of conceive of, any other system that did not have a particular cognitive structure. So that if we put to one side for a moment the perennial problem of other minds, we find that we can recognise consciousness in other human beings by recognitional methods (i) and (iv). And, if we are to make human consciousness our goal in AI/A-Life then we would need to create a system with spatial and temporal intuitions, *a priori* categories, imagination and a reflexive ability so that it can identify its thoughts as its own. This artificial system would be recognisably conscious in all four ways.

If, however, we make an insect our AI/A-Life goal, then we may find our prescription is much less daunting. For it to be recognisably conscious it might require only spatial and temporal intuitions plus a map-forming representational system. It is clear that this would not be conscious experience of a human kind but it may be recognisable as conscious given a suitably elastic notion of consciousness. So, we might say that this conscious experience of the environment is recognisable in senses (i), (ii) – though the mental states are mapped representations not hopes, desires, and so on – and (iv), but not (iii) which requires reflexivity, the possibility of recognising your mental (and physical) states as your own.

Thus if the concept of consciousness is elastic enough we could argue that a reduced

consciousness, perhaps with an outer sense but no with (or a revised) simple map-forming inner sense, was possible, but that it would be pragmatic for an artificial system to have a non-revised inner and outer sense just as humans do. It would be pragmatic because it would provide it with the ability to distinguish subjective experience from objective fact, which is one of the pre-requisites for 'I' thoughts, or in this case the emergence of a reflexive ability to think 'I' thoughts. In this way we want to make a virtue of a 'stripped down' notion of consciousness; consciousness with no, or a revised, inner sense, and which does not require a reflexive capability.

Finally, there is the question of emergence. It is at least theoretically possible to engineer a system with the necessary conditions for the emergence of conscious experience. However, emergence is, in some ways, the opposite of engineering. Emergent properties seem to appear unpredictably from non-linear interactions between simple deterministic components, in ways which have not been engineered in advance. But the distinction between systems that are engineered and systems that are emergent is, in practice, always unclear. Systems such as MAGNUS, that show emergent behaviour, have been structured in a certain way by their designers to bring about that emergence; and it has been an objection often raised against connectionists that their systems have been carefully pre-structured to give the results that are expected of them (Fodor & Pylyshyn, 1988). But even in humans it is an open question to what degree the development of mental capacity is genetically determined, or acquired through experience. We believe that there is no such thing as a purely emergent, un-engineered system, but we are neutral as to the engineering techniques that would have to be employed in constructing the kind of system we are proposing here.

Conclusions

The instantiation problem has been addressed and can be resolved by interpreting Kant's system prescriptively. The 'I'/self problem has been resolved to some degree if we accept a less rigid notion of consciousness and, having established the minimal requirement for conscious experience we can now go on to ask, what sort of a priori categories would a more sophisticated self-conscious system require: 'what are the general features of the combinatorial powers a mind needs if it is to apply concepts to intuitions?' (Brook, 1994, p. 3). It is the answers to these questions that will lead us to a firmer understanding of the nature of conscious and self-conscious experience.

References

Aleksander, I. (1996) *Impossible Minds*, Imperial College Press

Brook, A. (1994) *Kant and the Mind*, CUP

Brooks, R. (1991) Intelligence Without Representation, *Artificial Intelligence, 1991, Vol.47*, No.1–3, pp. 139–159

Clark, A. (1996) Happy Couplings: Emergence and Explanatory Interlock in *The Philosophy of Artificial Life*, ed. Boden. Oxford University Press

Fodor J. A. and Pylyshyn Z. W. (1988) Connectionism and cognitive architecture: a critical analysis *Cognition 28*

Kant, I. (1929) *Critique of Pure Reason*, trans. Norman Kemp Smith, Macmillan

Kirsh, D. (1991) Today the Earwig, Tomorrow Man?, *Artificial Intelligence 47*, pp. 161–184

Kitcher, P. (1990) *Kant's Transcendental Psychology*, Oxford University Press

Rumelhart, D.E. and McClelland, J.L. (1986) On Learning the Past Tenses of English Verbs in *Parallel Distributed Processing, Explorations in the Microstructure of Cognition, Vol. 2*: Psychological and Biological Models, MIT Press 1986

Strawson, P. (1966) *The Bounds of Sense*, Methuen

Susan Stuart is a Lecturer in Philosophy at the University of Glasgow.
Chris Dobbyn is the Director of Consultancy in the School of Computing and Mathematical Sciences at Oxford Brookes University.

Towards a Physics of Subjectivity

Stephen Jones

Part I

In my paper in *Reframing Consciousness* (Jones, 1998), I demonstrated that the information we have of the world must be physically embodied. To recap: what we get in the physical world is the information that is available to us from its sources, which are difference relations among aspects of the 'objective world'. These difference relations comprise physically embodied order in various material and energetic impacts on our sensory end organs. This physically embodied order only becomes discernable through the myriad of differences between things, i.e. their difference relations.

Difference relations also occur in our brains, where sense data from out there undergo a sequence of transforms spreading news of this sense data throughout the network as physiologically embodied information. Some of these transforms have 'survival' value, becoming useful to consciousness thus making up our subjective experience of our external and internal worlds, and to which we attach meaning. They are what philosophers call 'qualia' and must consist in physical matter and energy, since information cannot be possible without material embodiement. The brain does not produce non-physical stuff because, being a physical system using energy to maintain itself and process difference relations into information, it is bound by the 2nd Law of Thermodynamics (in essence, 'there is no such thing as a free lunch').

Thus the qualia derived from some actual object are what the brain physiology makes of the input stimulus it receives. Qualia are the actual state of our sensory transform subsystems at some moment. They are not information about some subsystem they are the information in that subsystem, i.e., its current state. How is one's present state, mood or whatever produced from this current state? It is my view that the brain operates as a large-scale complex of cascaded neural nets and that the overall state of this network will tend to pull its subnets into a condition which may be easily re-formed by some event. This is consciousness as context in the present. The overall state of the net includes emotional states, as well as rational states and bodily orientation, etc. It will be strongly formed by our history in the world since we are the accumulated history of our sense data and our reflection upon it. As memory this is recapitulation of our acculturation. Various classes of

qualial groups, such as concepts of danger or concepts of physics, will have important weight in this overall net phase-space depending on current context.

Thus qualia are information in those aspects of the network phase-space of neural subnets and complexes which become accessible to consciousness by contributing useful information into our self-regulation in the world. Qualia, as what we are consciously experiencing, are a subset of the phase-spaces of all the transformative systems in the brain. And all of this only requires physically embodied information, or at least such of it as remains available after layers of processing.

So what actually is information? It is not the matter or energy of the universe, rather, it is carried in the difference relations among the particulars of matter and energy and our perception of those relations. Information comes in the difference relations between things which give those particulars their properties. Thus relations are somehow more fundamental than the things between which the relations hold. Further, it is through relations that conglomerates of parts become coherent entities, i.e. relations show how an ensemble of parts can emerge as a whole having properties unpredicted by the separate properties of the parts.

Thus relations must be considered within the fundamental pantheon. Perhaps relations are the fundamental factor since, were it not for the operation of the relations among them, objects would be undetectable and the universe would remain in an unchanging, pre-collapse state of potentia as far as we are concerned. But, of course, we wouldn't be here to be concerned anyway.

It is the detection of relations which pulls things out of their superposed quantum potentials and into the perceived universe, and their transformation into information allows us to perceive and explain them. It is because we perceive the world through its relations that the physical world we know exists. But this world of relations, being informational, is the world of the rules of procedure for the evolution of objects and particulars in the universe. As it is the world that we know, is it possible that we actually see right into the heart of things? Our subjective experience is of a world of apparently manifest objects and structures. Is it possible that if we can remove our entanglement in, our attachment to, the world of material things – through, say, meditation – that we really can see to the heart of things? Is this what is meant by enlightenment?

Part II

Physics is explanation and, as such, relations must acquire a fundamental role in explanation. Physics describes how geometrical entities combine and evolve via their relations. Relations hold a system of parts together by the coupling of the parts, the combination of particles being essentially mechanical. Particulars bump into each other and, in having certain relations to each other, combine in particular ways. Physics, as the processes of sets of particulars and their relations, may also be described as cellular automata. Stanislaw Ulam (1974) set up a model of physics in which the basic elements are all identical except for position. They spread out over a geometry in configuration determined by the properties of that geometry. They combine and evolve according to the rules of procedure effecting the relations among each particle and the way those relations evolve over time as they are expressed.

A geometry is a description of the relations of abstract entities which can be developed into an algebra. The abstractness of this geometry means that any system, physical or cognitive, can be represented in it. Ultimately the application of developed geometries (e.g. by Einstein) is onto the ground of physics. The minimum size of the 'particles' of the ground may be infinitesimal or it may be at the level of the Planck scale (10–34m). If it is quantal then the growth in scale is embedded in the relations operating at each level of description. That is, as we go up the levels of scale we can describe the ways particles combine through what amount to dynamical rules of procedure. In building a description of materiality one might start with the smallest finite 'object' of the universe and develop a set of procedures by which the object evolves over time.

But how do we know these things? How do we know about the rules of procedure operating for any physical system? How do we develop explanations based on our experience of the world? This is where quantum mechanics comes in.

Information is a product of observation and the observer perturbs the world in such a way as to cause it to precipitate information related to the observation. With quantum mechanics the role of the observer is written into the formalism and thus physics describes our knowledge of the world rather than its ontology. That is, quantum physics performs acts of measurement which precipitate items of knowledge through difference relations over time. These difference relations depend on the kind of measurement being made and consequently the properties of an object are defined by its relations with the observational probe.

But what are we in all of this? We are biological entities who, through consciousness, have overlaid within us a cultural process. At the physical level we share with the rest of the world the relational processes of that which manifests from raw potential relations into actualised physical relational complexes. Manifest particulars of a system become available on actualisation, entering relations with other manifest particles, becoming coherent as emerged, higher-level relational complexes which we know as objects. The relations between the particulars hold the system together. The particulars, could they lack the relations, would be unable to form the system. The relations are the 'glue'. But the objects may in fact be precipitations of relations. As in cellular automata, the rules of procedure are the way the dynamics of the relations proceed. Right down to the smallest possible level, sets of relations produce coherent 'objects' which by multiple complexing enter levels of observation that we are able to handle.

The cultural level in intersection with the biological level produces a multi-level transformational process which, at the pre-conscious level, develops information about our physical and cultural contexts. It then provides, on flagging or on request, more or less information into the consciousness loop, where, on the basis of what we make of that information, we operate within the world, develop our knowledge of it and grow into consistency with our cultural context.

Selves are a particular form of multi-feedback, multi-level relational processes in a biological package which provide the basis of our individuation in the world. Our reflections of others' 'impacts' on us form our communication in the world. Our relations with the physical and cultural worlds produce complex systems of internal and external difference relations, capable of being brought into informational and relational sympathy with other selves or productions.

Living relational complexes are resonant informational phase-spaces affected by other relational complexes setting up sympathetic local oscillations in some aspect of the individual complex. Communication is guaranteed by the construction, within a human relational complex, of a means for inducing in that complex a set of meaningful sympathetic informational structures.

Individual relational complexes are like internal cellular automata. They are formed up out of small informational units by the rules of procedure provided as hardwired brain anatomy and by software rules constructed in us through our history and culture. Larger coherent thought patterns and the like emerge within the overall activity of the brain becoming in us what we think of as ideas, desires, fears and all the other behaviours that we operate with in the social world.

Complexes of relations then induce rhizomatic spreading of relations with other surrounding complexes. As various complexes enter into some kind of synchrony their information, being relational sub-complexes, can be transmitted across to other complexes (i.e. other persons) by a resonance process operating as language and other cultural processes.

Part III

What is the relationship between the information that is our subjective experience and the physics that explains the way matter behaves? There are two kinds of explanations of the physical world. Quantum mechanics covers the microscopic world of atoms and particles and classical physics covers the macroscopic world in which we live day-to-day. Although the classical world consists in microphysical processes its properties are mysteriously different from those of the quantum world. Resolving the disjunction between these two 'systems' is one of the great problems of contemporary science.

In quantum mechanics there is no uncontroversial solution to the question of how the classical world develops from the quantum world. Some sort of 'cut' must operate between these two worlds since we do not perceive the world as being in a state of fuzzy 'dissolve', despite the superposition of states in the quantum world. In the standard Copenhagen interpretation a collapse of the wave-function occurs on the act of measurement or observation of a quantum system, but there is no clear statement of where in the measurement this cut might occur. Given that Schrödinger's formalism includes a knowledge function (Stapp, 1993), it is often considered that this cut is induced by a conscious act of observation.

Alternatively, Michael Lockwood (1989) observes that due to the difficulties in establishing where the cut occurs, it is possible that the universe, and everything in it, is one single entangled whole. That is, Lockwood suggests that collapse of the wave-function may be unnecessary. But then how do we come to experience clear and distinct objects rather than a fuzzy whole of superposed states? He suggests that although all the possible states of the universe exist fully superposed, our conscious selection presents us with only those states which are directly related to our experiential context at the time. That is, the world we know is our preferred selection of possible states.

If the process of collapse of the wave-function is unnecessary then Lockwood's proposal seems a satisfactory way of dealing with our capacity to discover clear and distinct 'objects'.

The question of how it is that we come to make some particular selection are then matters of socialisation, cultural context and our desires and are the domain of neuroscience and the cognitive sciences.

Now it is highly likely that the universe is a globally entangled system. But even if it is only a complex set of locally entangled systems each of these will undergo unitary evolution and will be in a state in which all properties are fully superposed. This then renders the quantum system an undifferentiated whole, and the collapse of the wavefunction, or the selection of preferred states, must bring any macro-physical entities out of their superposed condition into the distinct and differentiable condition that we might recognise as objecthood. Difference becomes detectable as classical information and this is what we need for experience. So the having of an experience becomes a classical process and the qualia which represent that experience are matters of classical information embodied in a hot, wet environment, the brain, in which one would have thought very little useful quantum action could take place because of the almost instantaneous decoherence that must occur within.

Although the brain, like the rest of materiality, is a quantum system more or less entangled it produces clear and distinct experiences which show us clear and distinct objects and properties. Therefore, experience as such is a classical process and will be best understood within the discourse of the non-linear dynamics of complex cascades of neural networks as educated by the cultural environment in which the 'system' grows up.

Conclusion

To conclude, it is very possible that the universe is in fact always and forever an entangled, whole, unitary quantum system and that the macrophysical world that we know is not a function of any kind of collapse occurring within the quantum system but is simply the contents of our minds, i.e. our knowledge of things. This means that the universe any individual or cultural group lives in is a fully consistent physical universe having different behavioural rules as a function of the knowledge that we have of that world. That is, our culture sets up our universe. For example, tribal cultures have a kind of universe in which spirits operate and are able, under certain kinds of special circumstances, to communicate with those spirits. This is still a perfectly consistent physical universe within their system. It is as though the universe had a kind of pulldown menu system operating and that culture provides the menu choices available to any particular cultural system or group.

References

Jones, S. 1998, Can there be non-embodied information? in Ascott, R. (ed.) *Reframing Consciousness*, Exeter, UK and Portland, Oregon: Intellect Books, pp. 6–11.

Lockwood, M. 1989. *Mind, Brain and the Quantum: The Compound 'I'*. Oxford: Blackwell, ch.12.

Stapp, H. P. 1993. *Mind, Brain and Quantum Mechanics*, Berlin: Springer Verlag. and Stapp, H. P. 1996. 'Chance, choice and consciousness: a causal quantum theory of the mind/brain'. Paper presented at Towards a Science of Consciousness II.

Ulam, S. 1974, Random Processes and Transformations, in S. Ulam, *Sets, Numbers and Universes*, Cambridge: MIT Press, pp. 326–337.

Authors

Email Address

Authors	Email Address
Paul Ableman	paul_ableman@hotmail.com
Peter Anders	ptr@mindspace.net
Roy Ascott	Roy_Ascott@compuserve.com
Jonathan Bedworth & Ben Simmonds	JonBeds@aol.com,
	Ben@Burnsunit.junglelink.co.uk
Dimitrios Charitos, K Coti	vedesign@otenet.gr,
	cotik@otenet.gr
John Cowley	wccs@1earth.net
Nina Czegledy	czegledy@interlog.com
Tomor Elezkurtaj, Georg Franck	Tomor@osiris.iemar.tuwien.ac.at,
	Franck@osiris.iemar.tuwien.ac.at,
Konrad R Fialkowski, Boleslaw K Szymanski	konradf@cs.rpi.edu,
	szymansk@cs.rpi.edu
Tania Fraga	taniaf@soc.plym.ac.uk
Liane Gabora	lgabora@vub.ac.be
Gregory P Garvey	greg.garvey@quinnipiac.edu
Christiane Heibach	christiane.heibach@okay.net
Bill Hill	whill@flsouthern.edu
Tiffany Holmes	tgholmes@umich.edu
Royden Hunt	royden.hunt@talk21.com
Amy Ione	ione@Lmi.net
Milan Jaros	Milan.Jaros@ncl.ac.uk
Stephen Jones	sjones@culture.com.au
Rhona Justice-Malloy	justi1rd@cmich.edu
Eduardo Kac	ekac@artic.edu
Ted Krueger	tkrueger@comp.uark.edu
Kylie Message	kmessage@alphalink.com.au
Tsutomu Miyasato	miyasato@mic.atr.co.jp
Shaun Murray	shaun.murray@virgin.net
Michio Okuma, Isao Todo	moku@post.me.ynu.ac.jp,
Robert Pepperell	pepperell@cwcom.net
Mike Phillips, Peter Ride,	
Mark Lavelle, Simon Turley	mikep@soc.plym.ac.uk
Richard Povall	r.povall@mdx.ac.uk
Michael Punt	mpunt@easynet.co.uk
Kathleen Rogers	k@kathleen5.freeserve.co.uk
John Sanfey	john.sanfey@btinternet.com
Bill Seaman	seaman@ucla.edu
Susan Stuart, Chris Dobbyn	s.stuart@philosophy.arts.gla.ac.uk,
	c.dobbyn@brookes.ac.uk
Dante Tanzi	tanzi@dsi.unimi.it
Nicholas Tresilian	nicholas.tresilian@musicradio.com
Victoria Vesna	vesna@arts.ucla.edu
Kevin Williams	kwilliam@shepherd.wvnet.edu
Edson S Zampronha	zampra@osite.com.br
Malin Zimm	malinzimm@hotmail.com